The Art of CASTING IN IRON

How to Make Appliances, Chains, and Statues and Repair Broken Castings the Old-Fashioned Way

Simpson Bolland

Skyhorse Publishing

Editorial notes and editing copyright © 2011 by Skyhorse Publishing, Inc.

All Rights Reserved. No part of this book may be reproduced in any manner without the express written consent of the publisher, except in the case of brief excerpts in critical reviews or articles. All inquiries should be addressed to Skyhorse Publishing, 307 West 36th Street, 11th Floor, New York, NY 10018.

Skyhorse Publishing books may be purchased in bulk at special discounts for sales promotion, corporate gifts, fund-raising, or educational purposes. Special editions can also be created to specifications. For details, contact the Special Sales Department, Skyhorse Publishing, 307 West 36th Street, 11th Floor, New York, NY 10018 or info@skyhorsepublishing.com.

Skyhorse® and Skyhorse Publishing® are registered trademarks of Skyhorse Publishing, Inc.®, a Delaware corporation.

www.skyhorsepublishing.com

10 9 8 7 6 5 4 3 2 1

Library of Congress Cataloging-in-Publication Data

Bolland, Simpson.
 [Iron founder supplement]
 The art of casting in iron : how to make appliances, chains, and statues and repair broken castings the old-fashioned way / Simpson Bolland.
 p. cm.
 Originally published: The "iron founder" supplement. New York : J. Wiley & Sons, 1893.
 ISBN 978-1-61608-183-6 (pbk. : alk. paper)
 1. Iron founding. I. Title. II. Title: How to make appliances, chains, and statues and repair broken castings the old-fashioned way.
 TS230.B69 Suppl. 2011
 672.2--dc22
 2010038861

Printed in Canada

INTRODUCTION.

This book is intended by the author to complete the work begun in "The Iron Founder," for which reason it is called a "Supplement" to the former. Whilst "The Iron Founder"—as stated in the preface to said book—may in all respects be considered a moulder's book, for the reason that the subjects treated are directly in line with the manipulations called forth in the actual daily practice of the moulder, the "Supplement" embraces every other subject concomitant with such practice, all of which it is essential that every moulder should possess some knowledge of, even if he does not aspire to the dignity of an expert in the whole art of moulding.

The author realizes the difficulty of presenting these somewhat dry and matter-of-fact subjects in a manner calculated to command the attention of such as are not directly interested in foundry affairs, and his daily experience in the foundry has convinced him that very few of the rank and file, even amongst moulders themselves, care to peruse the apparently tiresome pages of a book devoted exclusively to matters with which they are brought into daily contact. It has been his aim, therefore, to treat the various subjects in a manner somewhat different to the methods usually adopted for the ordinary text-book, and by this means excite a healthy desire, if possible, for a more extended knowledge of what is herein

attempted to be explained. At the same time care has been taken to avoid the introduction of anything that would in any sense detract from its worth as an elementary treatise on such phases of the moulder's art as are duly shown forth in the table of contents.

The all-important subject of "Mixing Cast Iron" is discussed in these pages from a somewhat different standpoint to that usually taken. Foundry equipment and appliances receive special notice in detail, including a table of dimensions for ladles, and the latest application of machinery for moulding as well as other purposes in the foundry. Melting in Cupolas and Reverberatory Furnaces occupies a prominent place in the book; and the original table of instructions for the management of cupolas will no doubt be appreciated by all who, for lack of time or a disinclination to ponder these subjects, are not in possession of such data.

The founding of "Chilled Car-wheels" is fully explained and suitably illustrated, as also is the production of "Malleable-iron Castings," etc.

The measurement of castings necessarily introduces some arithmetic, but knowing the antipathy usually manifested by those who unfortunately know little of these matters, the author has shorn it of all mystification, and, by a few practical illustrations, endeavored to make it sufficiently plain to be understood by any one who will make the effort, no matter how deficient his previous education may have been.

Of late years the modeler and sculptor have been gradually establishing themselves as a part of our foundry system, and not a few of our modern structures are being supplied, internally and externally, with some elegant examples of art work in cast iron, which have been produced at foundries heretofore engaged only on the ruder castings for construction. This has brought us into close

contact with a branch of the art hitherto considered exclusive, and entirely beyond the ordinary moulder's ability to produce; but the author knows, from personal experience, that all such exclusiveness is fast disappearing, and, owing to the numerous inquiries he has received from many quarters asking for information upon these subjects, has deemed it wise to insert in these pages an account of the methods generally pursued in the art of "Statue Founding," as well as "Pattern Modelling,"—in clay and wax, and "Taking Casts,"—all of which are kindred subjects, a want of the knowledge of which has a depreciative effect on the moulders of the present day.

<div style="text-align: right;">SIMPSON BOLLAND.</div>

NEW YORK, *November*, 1893.

CONTENTS.

	PAGE
Evolution of the Iron Founder's Art...	1
Blast-blowers. A description of the several kinds of Blowing-engines used in the past, as well as some of those in use at the present day	18
Mixing Cast Iron	22
Foundry Cupolas. The Art of Melting Iron in them, with Table of full instructions for their erection and management	34
Reverberatory or Air Furnaces. Their use for the purpose of melting Cast Iron fully explained	55
Casting One Hundred Tons of Cast Iron, showing the construction and use of the necessary equipment for pouring heavy castings: Dams, Receivers, Air-furnaces, Ladles, with Table of Capacity of, Runners, etc.	67
Castings. How to obtain their Measurement and reckon their Weights; also, the Nature and Qualities of the Materials used in producing them. Percentage in the Foundry. Important Facts. Formulæ. Tables, etc.	81
Foundry Appliances, including Block and Plate Methods of Moulding; Gear Moulding by Machinery, and a description of some Modern Moulding-machines	126
Chains, Beams, Slings, Hooks, Ropes, etc., for lifting and handling all classes of work in the Foundry	159
Pouring, Flowing-off, and Feeding Castings	170
Studs, Chaplets, and Anchors. How to Use and how to Avoid using them	198
High-class Moulding Explained by a description of different ways of moulding a Four-way Ventilating-shaft	216
Sectional Moulding for Heavy Green-sand Work, including Draw-backs, Critical Green-sand Cores, etc., or some things beyond the Capacity of the Moulding machine.	228

CONTENTS.

	PAGE
Hydraulic Cylinder-moulding under difficulties; or, Big Castings in Little Foundries	250
The Founding of Statues in Iron and Bronze. Explaining the *Cire perdue* and other processes; with a review of the Art as practised by the ancients and up to the present time	261
The Art of Taking Casts. Explaining the substances used: Plaster-of-Paris, Bees-wax, Dough, Bread-crumbs, Glue, etc. To take a Cast in Metal from any small Animal, Insect, or Vegetable. To take a Cast in Plaster from a Person's Face. To take Casts from Medals. To take Casts in Isinglass, Elastic Moulds, etc	283
Pattern-modelling in Clay	289
To Mould a Spiral Post	292
The "Berlin" Fine Cast-iron Work	295
Malleable Iron Castings. The processes of their manufacture explained, including Annealing, Practical and Theoretical	296
Chilled Car-wheels. Full instructions for Pattern, Moulding Flasks, Cores, Chills, Metal-mixing, Casting, Annealing, Testing, with an explanation of the Theory of Chilling Castings	307
Fire-clays and Fire-bricks	321
Ganister	323
Graphite or Plumbago	324
Fuel	325
Annealing	328
How to Repair Broken or Cracked Castings. The Foundry Methods of "Burning" all classes of work fully explained and illustrated	329
Beams of Cast Iron. Some of their properties described. Useful information relating thereto	344
Wrought or Malleable Iron. A brief description of its manufacture from the Pig Iron. Refining, Puddling, Shingling, etc	346
Steel. How the different kinds are produced: Blister Steel, Shear Steel, Cast Steel, including Siemens-Martin, Bessemer, etc	350
Enamel for Heavy Castings, Pipes, etc	353
Black Varnish for Ironwork	354
Varnish for Pipes and Ironwork	354
Varnishes for Patterns	354
Cement for Cast Iron	355
Mineral Wool. The phenomena of its production explained	355

CONTENTS.

	PAGE
To distinguish Wrought and Cast Iron from Steel	856
Tinning	856
New Tinning Process	856
Kustitiens Metal for Tinning	857
Tin Plate, Crystallized	857
To Tin Iron Pots and other Domestic Articles	858
To Tin Cast-iron Studs and Chaplets	858
Case-hardening Cast Iron	858
To Chill Cast Iron very hard	859
To Soften Cast Iron	859
To Scale, Clean, and Pickle Cast Iron	859
To Remove Rust from Cast Iron	860
To Scour Cast Iron, Zinc, or Brass	860
To Solder Gray Cast Iron	860
To deposit Copper upon Cast Iron	861
To Bronze Iron Castings	861
Brassing Cast Iron	861
Green Bronze on Iron Castings	862
Bronze for Cast Iron, without the use of Metal or Alloy	862
To Galvanize Gray-iron Castings	862
To Galvanize Cast Iron through	863
Japanning Castings	863
To Enamel Cast Iron and Hollow Ware	864
Useful Interest Rules	865
Interest Table	866
Weights and Measures	867
Areas of Circles and Sides of Squares of Equal Area	872
Wages Table	873

THE IRON-FOUNDER SUPPLEMENT

EVOLUTION OF THE IRON-FOUNDER'S ART.

The term "founding" is applied by many persons to all processes connected with the manufacture of articles in metal, whether the finished product has been forged from the malleable metal or cast in moulds. This generalization is entirely misleading, and it has made all the more difficult the work of placing the origin of iron-founding as an art. Iron-founding, in its proper sense, is the art of preparing moulds from plastic materials of such a nature as will successfully resist the intense heat of the molten iron,—as loam or sand,—in which may be formed the object to be produced in iron, the process being completed when the iron has been melted, run into the mould, and permitted to solidify.

Of the antiquity of working in brass and iron, as well as the more precious metals, there is abundant evidence, including mentions of the subject in the earliest books of the Bible. That the iron of the Hebrew records was not cast iron is made to appear with much significance in Isaiah xlviii. 4 (supposed to be about 700 B.C.): "Because I know thou art obstinate, and thy neck is an iron sinew," —the latter word being a plain indication of the quality of toughness common to iron in a malleable condition. Further evidence in support of this hypothesis is found in

Psalms cvii. 16: "For He hath broken the gates of brass and cut the bars of iron asunder." A marked distinction is here observed in the methods of spoliation: if the iron had not been malleable, there would have been no necessity for the cutting. Some knowledge of smelting iron must have been known to the ancients; otherwise neither Tubal-Cain nor his Hebrew successors could have accomplished the forged-iron work with which they are credited.

An ancient method of smelting, still employed by the natives of India, is very simple and effective, probably the same as that used by the Israelites during their term of bondage in Egypt. On the whole, it is probable that, while malleable iron was in common use among the ancients, they were practically unacquainted with cast iron and its uses; and it is more than probable that the mention of iron sculpture by the Greek writers referred to objects which had been beaten out by hammering, and not cast in moulds, as was the case, undoubtedly, in their bronze work, the antiquity of the art of casting in bronze and the precious metals being well established. The processes employed were probably similar to the *cire-perdue* process.*

Much stress is laid on the statement of Pausanias (A.D. 120) that Theodorus the Samian was the first to discover the art of casting in iron and making statues of it, about 440 B.C.; if he was, the secret must have died with him, there being no evidence of the art at that time extending beyond his island home in the Mediterranean. We must confess that the state of the mechanic arts then existing do not harmonize with probability in Pausanias's statement; because to mould statues in cast iron would have demanded a knowledge of materials and a degree of skill very superior

* *Cire perdue* (literally, lost wax).—A French term applied to the process of bronze casting, wherein the article to be cast is first modelled in wax; the wax model being then inclosed in plastic clay, upon heating which the wax melts and runs out, leaving the mould.

to and much more exacting than that to which statue-founders had hitherto been accustomed in the *cire-perdue* processes no doubt then prevalent. But further on he says, "To make statues of iron is most difficult and laborious;" from which we are almost tempted to believe that the noble islander did accomplish something of the kind, after all, and left the world no wiser as to the methods he pursued.

As time advanced, a growing demand for implements of war, as well as for the more peaceful implements of agriculture and other domestic arts, created the necessity for improved systems of producing malleable iron for such purposes. But about the early part of the sixteenth century larger furnaces for the manufacture of cast or pig iron were introduced in some parts of Europe, such iron being subsequently converted into malleable or wrought iron in the forge-hearth.

A patent was granted in England about the year 1544 for a new process of making cast iron, but works written much later than this date make no mention of castings being made from this metal: which seems strange, when it is certain that castings had been made from the earliest ages from other metals and their alloys. About 1740, we are informed, iron cannon were successfully cast in the South of England by workmen who were afterwards taken across the Channel to teach the Frenchmen this new art. At this time there were very few furnaces that would produce more than one ton of pig iron per day; consequently, where the foundry operations were of more than ordinary magnitude, a number of these miniature blast-furnaces might have been seen at work together.

Réaumur, the great French metallurgist, published in 1722 an interesting account of the methods then practised by him. The remelting of the pig iron had previously been conducted in crucibles, but he conceived the idea of

facilitating foundry operations by melting his metal in direct contact with the fuel, using for this purpose what may be taken as the forerunner of the cupola at present in use. A shaft was provided which fitted the top of the crucible, into which the iron and fuel were charged at the top in alternate layers; the blast, produced by two large blacksmith's bellows, was forced in at the lower end of the shaft, and maintained at a vigorous rate until the requisite quantity of iron was melted, after which the shaft was removed, the débris cleared away, and the crucible, containing the molten iron, was emptied into the moulds. From this we may date the beginning of modern foundry methods.

It was not till after Réaumur's death, in 1757, that these primitive cupolas came into anything like general use, though the itinerant founders of his day evidently were not slow to discover their practicability as portable furnaces. He thus ingeniously describes these tinker-founders: "There are founders who do nothing every day but to melt cast-iron and no other metal. Their number is not large, and I do not know whether there are more than one or two in Paris. These founders travel through the country, and make their appearance gradually in different provinces. They make cast-iron weights, plates for different purposes, cast new and patch old hollow-ware. These founders buy the pig iron they want from peddlers, who gather cast-iron scrap in the villages in the vicinity of Paris. This scrap is exchanged for apples; a man with scales in one hand, leading a horse laden with poor fruit, does the business, exchanging apples for iron, weight for weight."

The "Philosophical Transactions" of the Royal Society of London for 1747, reviewing the art of making cast iron with pit-coal, and casting articles therefrom,—something which had been taking place, secretly, at the foundry of Abraham Darby, Colebrookdale, England, from 1713,—

speaks of it as a curiosity. This enterprising gentleman hailed from Bristol, having leased the iron-works at Colebrookdale in the year 1707, when it consisted of a single small furnace and foundry. Before locating at Colebrookdale Mr. Darby had engaged as an apprentice a young Welsh shepherd named John Thomas, who accompanied his master and worked in the foundry. The lad observing the ineffectual attempts of a Dutch moulder, thought he saw the reasons for the man's failure, and was allowed to try his hand, the result being that with the assistance of his master an iron pot was successfully cast. A secret agreement was entered into between the two to keep the secret, which was loyally kept on the part of the boy, who was ever the friend of his master's family when, in afterlife, they were sorely tried. The great secret of the whole process consisted in effectually leading away the gases generated in the core when the molten iron entered the mould, which, if left confined, must inevitably burst the core and thus spoil the cast. Simple as this may seem at this day, the knowledge of making such casts in iron was so limited at that time that they were enabled to keep their secret for almost a century afterwards.

Abraham Darby died 1717, when his new enterprise was in a flourishing condition, and was succeeded by his son, who was named after him; and it was through the indefatigable exertions of the latter that coke instead of charcoal was finally used in smelting, about the year 1760. Iron-founding received an impetus at this period of its history such as it had never before experienced. The steam-engine of Watt, coming into use at this time, developed the iron manufactures at a wonderful rate, as by its means blast power was increased, and all rude contrivances, as blacksmith's bellows, and rotary machines driven by horses or oxen, which had been employed for creating blast

in furnaces, were gradually abandoned in favor of the blowing engines driven by steam.

Castings in iron for the early engines of Watt and Boulton were made at Colebrookdale, as were also those for the first cast-iron bridge, which was erected over the Severn, close to the works, by the third Abraham Darby, and opened for traffic in 1779. To meet the growing demands of this newly awakened industry the Darby firm had soon to open other works at Ketley and Horsehay, and branches of the same firm were established at Liverpool and Bristol; also, agencies for the disposal of machinery, manufactured by this firm for mining purposes, were opened at Truro and Newcastle. The renown of this pioneer foundry has spread throughout the world; their reputation as manufacturers of modern machinery is only equalled by their perhaps greater renown as producers of the highest-class art work of every description in cast iron and bronze. The days of long ago are still forcibly indicated by relics which are still treasured with the greatest care, although the works generally are for the greater part modern in arrangement and equipment. An old furnace may be seen on supporting beams, dated "1658," and three others have "Abraham Darby, 1777" inscribed on them. One old foundry has a plate over the door with "1774" on it, and they still retain possession of the old cylinder, 4 inches diameter and about 36 inches stroke, which originally belonged to Trevethick's first locomotive.

We can conceive of the difficulties attending the early efforts of our forefathers in the manipulation of such castings as were needed by the pioneer engineers, whose demand for fine iron castings would steadily increase as the practicability of steam-power became manifest. About the year 1769 steam was universally recognized as the chief motive power, and was gradually applied to all descriptions of machinery. No doubt failure often resulted

when trials were first made on castings of the nature required. All this new work had to be done by moulders, who, necessarily without knowledge of the nature of materials, must grope their way with absolutely nothing but hard and inexorable experience to guide them. Under such adverse circumstances there was no other way to success but hard endeavor; if a casting was bad, it was necessary to try again, and again if need be, hoping to discover the cause of failure and avoid next time the errors of preceding trials arising from ignorance of first principles. It is a lamentable fact that, although a century has since passed, the rank and file of moulders are to-day working on the same indefinite lines.

The change from castings of a very ordinary type to the superior kinds required for steam- and blowing-engines, as well as machinery of all descriptions, which at this time was being rapidly changed from wood to iron, must have been almost bewildering, as nearly all parts of the engine, including crank, connecting-rod, and beam, were then made in cast iron, of elaborate design and intricate in the extreme. Good moulders must certainly have been everywhere in great demand, especially such as were able to make castings that must of necessity be made in loam and dry sand. Examples of high-class moulding were set in those early days, which, with very few exceptions, have abided with us, unaltered, to this day.

About this time the old devices for manufacturing woollen and cotton goods were supplanted by Arkwright's "throstle" and Crompton's spinning-mule, which in time were built up almost exclusively of cast iron. Wooden bridges began to disappear in all directions, and cast-iron structures were erected in their stead. The great Henry Cort, of Gosport, England, invented a method of rolling iron instead of hammering (1783), and from this event a demand for still another class of heavy castings was in-

angurated; while later on, about 1807, paddles were introduced for the propulsion of ships, which called for superior castings suitable for marine engines. Subsequently, about 1836, the screw-propeller usurped to some extent the unwieldy paddle, and with the advent of this remarkable device arose the finest example of moulding yet seen. That the iron-founders of the past were invariably equal to the occasion is eminently proved by the casting of the screw-propeller, which to this day is moulded after plans discovered by our predecessors during the early days of steamboating. The advent of hydraulic machinery caused a demand for castings of such magnitude as to make the erection of special plants for the production of this class of work an absolute necessity. Improvements in agricultural and textile industries also demanded the erection of massive foundries,

Up to thirty years ago very few of the improved methods of moulding now practised had been introduced in the foundries; nor had any one competent foundryman or engineer attempted to supplant the cumbrous and ungainly equipments of the past by the very elegant and efficacious appliances now found in mammoth model foundries. The ponderous and slow wooden cranes have, by a gradual process of evolution, merged into machines of wonderful efficacy, and are now almost automatically controlled. The overhead trolley for conveying molten iron direct from the cupola to every part of the foundry is an improvement on the old system of hand-carrying, necessitated by the magnitude of some foundries in which the distance from the cupola to the furthermost parts of the shop is great; and, where such devices cannot be applied conveniently, we see well-kept tracks with switches in every available direction, on which handy trucks, specially constructed for this purpose, are used for conveying, with ease and despatch, every material used in foundry

operations. For the time honored wheelbarrows has been substituted the conveyer, which hauls everything to its destination entirely clear of the foundry floor. Where once all the iron and fuel were carried by hand to the cupola scaffold, we have now, in some places at least, elegant provision of either electric, steam, or hydraulic appliances for performing this work. The old rule-of-thumb methods of charging the cupola have at last given place to the more sensible and economical system of weighing all material in correct proportion. Attention has been given to many minor things also. We have seen even the riddle superseded first by the common upright screen and then by the swinging and sliding machine riddles, and now the revolving screen is to be seen in many foundries. Cleansing-mills, provided with an exhauster to carry off the dust, have superseded the primitive method of scrubbing sand off the castings with stone and wire brush. Loam mills of infinite variety and degrees of effectiveness are to be seen, where once the click of the chopper was to be heard. Some of the modes devised for clamping together the flasks, seen now almost everywhere, are ingenious in the extreme, and it is pleasing to observe how common at this time is Nasmyth's great invention, the geared ladle. Once it was thought that hay and straw rope must always be twisted in the primitive fashion; but this also has yielded to the spirit of invention, and the rope-spinning machine is throwing off bands, well spun and true. Machines too numerous to mention have been invented during the past thirty years, which, without the aid of a costly pattern, will make either spur, bevel, mitre, mortise, or worm wheels. The extraordinary progress of the cast-iron-pipe industry, with reference to equipment, has been such as to make that branch of moulding almost independent of skilled labor. The same may be said of many other classes of work where large quantities of

duplicate castings are in demand, such work being now produced in the several moulding-machines with a facility and dispatch impossible by the old methods of ramming by hand.

The invention of plaster-blocks paved the way for the improved systems of plate-moulding which immediately succeeded them, introducing the interchangeable modes of flask-pairing and the earlier kinds of stripping-plates, the latter principle constituting the chief element of success in the modern moulding-machine.

One of the greatest aids to modern founding is the system of tests, chemical and physical, to which in some firms the pig iron is subjected before it is charged into the cupola. When eminent chemists inform us that whatever quality of iron the iron-founder demands can be furnished by the furnace manager, it would seem that it only remains for the foundryman to acquire such chemical knowledge as will enable him to know the exact measure of every element needed to produce the desired quality of iron, and thus, by chemical analysis, determine all his mixtures. Keep's tests are no doubt the most comprehensive of any of the physical tests for this purpose which have yet appeared, as they embrace every element necessary for discovering the nature and quality of cast iron.

At present we seem to be on the eve of great changes; and it is somewhat difficult and hazardous to predict the channels which future progress in iron-founding will take. Owing to the system of dividing labor, now becoming so prevalent, it is simply impossible for the ordinary workman to master the details of founding: this, coupled with general lack of education, leaves him, in a measure, incompetent to manage even ordinary establishments intelligently; but how utterly incompetent are such men for becoming heads of the magnificently equipped foundries now being constructed! To operate such establishments

it has been thought advisable by some to change the order somewhat, and engage the services of an educated engineer, so that the efforts of the foreman moulder shall be directed in paths which run in harmony with known physical laws.

When so much has been accomplished by the uneducated founder in the past, what are we entitled to expect in the future from this added intelligence? Time will show. The age is pregnant with ideas. The full blaze of scientific knowledge is lighting up dark and hitherto mysterious nooks in which nature has hidden many precious secrets. To suppose that the useful and noble art of iron-founding will not share in the riches thus lavishly obtained would be to rank it as among the least progressive of the mechanic arts; whereas recent advances show that it is no longer wedded to ancient ideas and methods, but is eager to embrace any and all sound improvement.

The consideration of the possibilities in foundry practice forces itself upon the attention of practical men who now thoroughly understand these possibilities. Indifference is giving way to active research and investigation, with reference to the supply of suitable material and equipment. Schools of technology will yet be brought to see the importance of giving the foundry more substantial recognition. One of the best modern moulding-machines owes its origin to experiments, conducted by its inventor, in the foundry of the Stevens Institute,—a fact which might be profitably borne in mind by the faculties of other technical schools, which, as a rule, are wofully deficient in means for teaching the art of founding.

The introduction of some late inventions for melting iron indicates the march of progress in this particular very forcibly. Every effort is now put forth to prevent the immense waste of heat which occurs in ordinary cupola melting, by a disposition of the tuyeres such as will burn

the ascending combustible gases without heating the fuel to incandescence, in which instance the developed heat preheats the iron and fuel before it reaches the melting zone. What may we not expect in the prevention of heat-waste when we find that electricity has at last been successfully applied for melting cast iron? It is claimed for the "Taussig" electric system of melting cast iron in exhausted chambers that oxidation and creation of air-bubbles are avoided, and that the cost for driving the dynamos is 50 per cent less than would ordinarily be required for melting by the best practice.

The advent of the chemist in the foundry marks a new era in iron-founding, and is perhaps the surest indication of a desire for thorough advancement, as by his aid the indecision and doubt hitherto existing must ultimately cease. Mixing of different brands of cast iron, as well as the alloying of cast iron with other metals, to obtain a higher degree of homogeneity, or any other special quality in the resultant casting, will, under such qualified direction, be more easy of accomplishment.

Given superior direction, we may confidently anticipate the time when, by the united efforts of the scholar and the trained artisan, the art of iron-founding, in neither equipment nor skill, shall be second to any of the iron industries.

BLAST. BLOWERS.

A DESCRIPTION OF THE SEVERAL KINDS OF BLOWING-ENGINES USED IN THE PAST, AS WELL AS SOME OF THOSE IN USE AT THE PRESENT DAY.

BLOWING-MACHINES, as applied in the foundry, are all such as are made to produce a current of air to assist the combustion within the cupola, etc.

There is no doubt of the common bellows of to-day being about as old a contrivance for this purpose as can be found anywhere.

The Catalan forges of some parts of Europe furnish an interesting example of a blowing-machine called a *'Tromp.'* One great objection to its use is that it can only be employed where it is convenient to provide a fall of some yards of water. The reservoir above has a plug in the bottom, which fits a conical-shaped hole connecting with a wooden pipe extending down to the wind-chest below. The water, by means of sloping holes provided at the top of the pipe, carries air down with it. The wind-chest, shown in article "Melting Cast Iron in Cupolas," is provided with holes, one for the water to pass away, and the other, connecting with the nozzle-pipe, permits the air to escape in that direction. The water as it falls strikes a platform set there to receive it, the effect of which is to separate the air from the water. The height of drop determines the strength of the blast.

Another form of blower that has found favor in times past is two wooden boxes with open sides, and made to slip one over the other. The blast is produced by moving the upper enclosing box up and down over the other, and

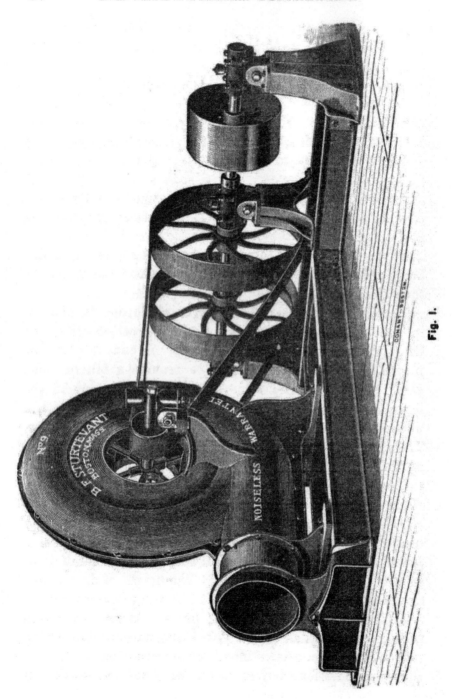

Fig. 1.

may be hinged for an easier motion. The lower box is provided with a valve opening inwards, and has a nozzle attached.

A very simple form of bellows is made by the Chinese, which resembles the blowing-engine very much in its action. It is composed of a long square box, provided with a piston which fits all its sides, and a nozzle at the closed end. When the piston is pulled from the nozzle it opens valves to admit the air, but as soon as the movement is reversed the valves close and the air escapes at the nozzle.

Fan-blowers seem to have been in use about 1729, or perhaps before, as one Teral is supposed to have invented one about that time. Smeaton erected blowing-engines at the Carron Ironworks in 1760; and it would seem that most all the first of the modern blowing-machines were composed of cylinders having pistons, all varying more or less in the application of the power to drive them and obtain a steady current of air. A blast-machine common in times past was two cylinders connected, one of which was provided with a discharge-pipe. The first downward stroke of piston number one drives the air into cylinder number two through a valve in the foot-box, which rises with the pressure; simultaneously with the movement downwards of piston number one, piston number two ascends as far as it may be forced, when it immediately returns, shutting the valve and forcing the air through the discharge-pipe, while piston number one ascends, filling the cylinder with air, which is again driven into cylinder number two and ejected as in the first instance, etc.

The cylinder and piston type of blowing-engines prevail in nearly all the blast furnace systems. At first they were made to force the blast with every alternate motion of the piston, and when a number of these were attached to the same crank-shaft run by a water-wheel they succeeded in

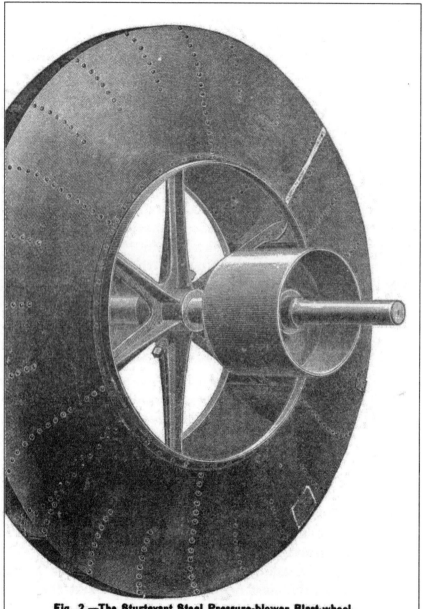

Fig. 2.—The Sturtevant Steel Pressure-blower Blast-wheel.

producing a steadier pressure than was possible with only one cylinder.

The water-wheel has now been superseded by steam at most places, some preferring to have steam and blast cylinder in line on one bed horizontally, with both pistons on the same rod, and others favoring the same principle applied vertically. The very large engines, however, are invariably operated by a steam and blast cylinder on opposite ends of the same bed, vertically, with a beam to connect their pistons.

Fan-blast machines are now employed in many foundries. The common form of fan consists of three or more spokes of a rimless wheel, tipped with vanes, and made to rotate in a cylindrical chest. There are openings on both sides round the spindle for the admission of air, which, sucked in by the centrifugal action of the fan as it quickly rotates, flows towards the vanes, and is driven through an exit pipe attached to another part of the cylinder.

There are numerous varieties of these engines, which latter have become subjects for the exercise of the ingenuity of modern inventors in this line.

The compound blowing-fan of Schiele's consists of two fans combined on the same shaft so as to act successively on the same air. By the first the air is driven into a chamber between the fans at a pressure of 6 ounces; the second receives the air at this pressure, and by further compression delivers the same into the furnace at a pressure of 12 ounces per square inch.

The Sturtevant pressure-blower, Fig. 1, has spoked wheels, Figs. 2 and 3, having conical annular disks, mounted on an axis, Fig. 3, driven by two belts, to prevent any tendency to wobbling. The air enters between the spokes round the axis, and is driven forcibly by the curved floats, which span the space between the annular disks, being

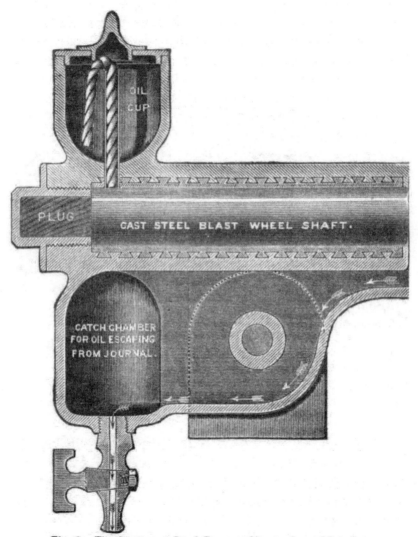

Fig. 3.—The Sturtevant Steel Pressure-blower Journal-bearing.

discharged into a peripheral receiving-chamber, whence it reaches the eduction-pipe.

The Mackenzie pressure-blower, Fig. 4, is in common use in this country as well as in Europe. The blades are attached to fan boxes which revolve on a fixed centre shaft. Motion is imparted to them by means of a cylinder, to

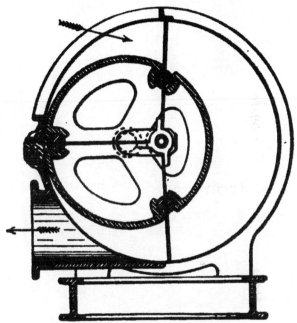

Fig. 4.—Section of Mackenzie Blower.

which are attached the driving-pulleys. Half rolls in the cylinder act as guides for the blades, allowing them to work smoothly in and out as the cylinder revolves. At each revolution the entire space back of the cylinder, between two blades, is filled and emptied three times.

Other rotary blowers are on the principle of the rotary pump or rotary engine, having two portions which revolve in apposition.

Root's pressure-blower, Fig. 5, is similar in principle to the foregoing; it acts by regular displacement of the air

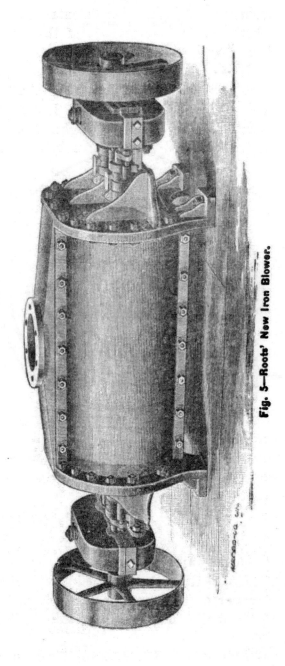

Fig. 5—Roots' New Iron Blower.

at each revolution. A pair of horizontal shafts, geared together at both ends, traverse a case of the form of two semi-cylinders, Fig. 6, separated by a rectangle equal in depth to the diameter of the semi-cylinders, and in width to the distance between the centres of the shafts. These shafts carry a pair of solid arms, each having a section somewhat resembling a figure of eight, the action of which as they revolve takes the air in by an aperture at

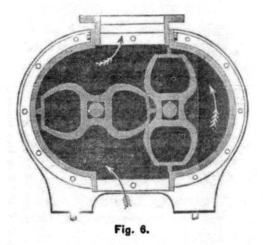

Fig. 6.

the bottom of the machine, and expels it with considerable pressure, if required, at the top.

The *'Steam Jet'* is another form of blower now frequently adopted, but may with more correctness be described as a substitute for the blower.

'Herbertz's Steam Jet Cupola' works by means of atmospheric air *breathed* or *sucked* into the furnace by a jet of steam placed in the upper part of the shaft. This cupola requires no motive force, and the vacuum produced in the shaft by the suction allows every stage of the smelting process to be observed by the means of valves and tubes placed at different heights, thereby furnishing a convenient means of controlling the work.

MIXING CAST IRON.

It is the business of the iron-founder to produce castings which will best meet all of the numerous demands—fineness combined with hardness, fineness combined with softness, strength to resist pressures and strains, etc.

He must also be able, by a judicious selection of different brands of iron, to produce mixtures which will meet the almost impossible demands created by faults in construction, as well as the countless conditions which, owing to the nature of the case, are imperative, and can only be met successfully by correct mixtures.

Now, is it not true that these emergencies are met, in a great majority of cases, by the merest chance, and not until after great loss has been sustained from repeated experimenting is success achieved? And, be it remembered, such success is at best only partial, for owing to the lack of correct data the whole experience must inevitably be repeated whenever the emergency again presents itself.

I would ask, What guide has the founder ever had ordinarily, other than the bare statement that No. 1 iron is all such as shows large crystals, smooth and bright, soft almost to sponginess in some cases, and that all such irons are to be chosen for use in the production of light castings; whilst No. 2 is to be recognized as being lighter in color, and to have smaller crystals than No. 1, eminently adapted for general work, machinery castings, etc.; and again, that No. 3 is all such iron as shows a greater density than No. 2, with a slight mottle indicated, and that this latter is to be used for the heaviest work?

This, strange as it may seem, is about all that the average founder knows about cast iron. Is it any wonder that so many blunders are made?

It is no uncommon thing to hear of some founder who has met with a difficulty, caused by a too free use of No. 1 iron, trying to overcome the same by making still further additions to his mixture of the same brand,—this because of the generally accepted idea that No. 1 iron is the panacea for all evils of whatever nature.

Such a person, wise in his own conceit, would ridicule the idea of overcoming his difficulty by means directly opposite to those he was pursuing; nevertheless, such a course would in all probability be the only one to take if success is to be assured.

Not unfrequently, when I have failed to obtain a degree of softness which was satisfactory by the use of No. 1 irons, I have had no difficulty whatever when No. 2 of a different brand has been substituted, and it has been no uncommon thing in my experience to discover that the scrap-pile contained the most valuable stock in hand: in fact, I know of one foundry in particular where strictly assorted scrap is used almost exclusively, with very excellent results; but that is because of the superior knowledge of the foreman, who has devoted himself to the study of such matters.

It will not be out of place just here to relate an experience of my own which bears directly upon this subject.

Some years ago I was called upon to take charge of a foundry where they had been experiencing considerable trouble with their iron. Castings innumerable were being rejected owing to their extreme hardness, and it had become imperative that steps be taken to check by some means the enormous losses they were sustaining.

Close at hand was found a stack of No. 3 pig iron which had long been voted useless; this was flanked by an unsightly mass of promiscuous scrap, which under the circum-

stances it was considered impossible to use. In addition to all this, I was shown another pile of scrap, remote from the foundry, which represented the accumulations of years, and footed up to the respectable sum of about 400 tons.

It was not long before I discovered what had caused this extraordinary waste, one chief cause being that the mixtures were arranged by one of the officials in the office, whose only claim to distinction in that line of business arose from the fact that he had, in some remote period of his life, held a minor position at a smelting-furnace. His method was to take portions of the several brands, either alone or in varying mixture, and make a crucible test of a very limited kind, and from such tests a formula was made out for the guidance of the foreman, with the result as above stated.

To overcome these evils recourse was had to very stringent measures: the services of the quondam mixer were dispensed with at once, and those of a metallurgical chemist engaged, by the aid of whom I was enabled in six months to use up every pound of this so-called obnoxious iron, to the great satisfaction of my employer, from whom I received the highest encomiums.

I would here observe that there was no "Scotch" or No. 1 irons used to effect this result. After a careful analysis had been made of all the irons on hand, and their natures distinctly noted, suitable mixtures for the various kinds of work were made, and all upon a strictly chemical basis, with astonishingly successful results.

The medium through which all this was accomplished was a brand of iron (on hand) which was exceedingly high in *silicon*, and it was the wonderful results produced by its agency on this occasion which changed all my cherished ideas in regard to mixing of metals on the old lines.

My firm conviction now is that the mixing of irons cannot be intelligently carried on unless *chemical analysis*

forms the basis of procedure; and before attempting to give any absolute data for the guidance of others in the mixing of irons by this method, I would ask the reader to look to me, not as a master in these matters, but as a student who has just touched on the edge of a new truth and desires that others equally interested may share in the discovery.

Mr. Turner, demonstrator of chemistry, Mason College, says: "(1) Pure cast iron—i.e., iron and carbon only—even if obtainable, would not be the most suitable material for use in the foundry; (2) that cast iron containing excessive amounts of other constituents is equally unsuitable for foundry purposes; (3) that the ill effects of one constituent can at best be only imperfectly neutralized by the addition of another constituent; (4) that there is a suitable proportion for each constituent present in cast iron. This proportion depends upon the character of the product which is desired, and upon the proportion of other elements present; (5) that variations in the proportion of *silicon* afford a trustworthy and inexpensive means of producing a cast-iron of any required mechanical character which is possible with the material employed."

In support of the fifth clause, relating to *silicon*, we quote from William Kent, in *American Machinist*, February 20th, 1890, where he says that "Mr. Charles Wood claims for himself, assisted by Mr. Stead, the discovery that *silicon* had the power of reducing the combined carbon into uncombined carbon, or, in other words, to convert white iron into gray iron." Experiments made at numerous foundries in France had completely established the fact, and confirmed the statements made by Mr. Wood.

The custom of purchasing irons by their fracture, Mr. Wood said, in order to obtain sound castings, was a great mistake and must be abandoned. He admitted that hitherto it had been the only practical system known, and that founders in order to make soft castings had always gone to

Scotch No. 1 or like rich brands to mix with other qualities in order to produce this result; but he had shown that the commonest iron, such as mottled and white, could be reduced to any degree of softness by a proper mixture of silicon iron; and an iron-founder by following this rule, *and studying analysis of the irons at his command,* could now produce in his cupola the exact quality of iron most suitable to his castings, instead of as hitherto depending upon special and expensive brands, which were often very uncertain in producing what was required, although the *fracture* might be all that was desired, whilst the only explanation was to be found in *analysis.*

Such evidence, coupled with personal observation and constant practice, forces us to the conclusion that a new era is dawning upon us in so far as relates to this subject, and already do we notice astonishing results from the adoption of the method of chemical analysis in the production of cast-iron car-wheels. We quote from the same authority, who says: "Some years ago it was thought that only 'Hanging Rock' or 'Salisbury' cold-blast charcoal irons were good enough for car-wheels, and these irons brought very much higher prices than other irons. The chemists at length discovered that the peculiar characteristic was that they were lower in *silicon* than hot-blast and coke irons, and reasoned therefrom: (1) that if other irons could be found having identical *analysis,* they would be equally good in quality; (2) that if the *silicon* in coke and other hot-blast irons could be reduced to the same percentage that existed in these cold-blast irons, either by partial blowing in a converter or by diluting the iron in the cupola with irons or steel that contained little or no *silicon* (such as steel-rail ends), the same results would be found. Practical experiments demonstrated the truth of these theories; and now there is probably more iron used in making car-wheels than the whole product of the 'Hanging Rock' and

the 'Salisbury' districts, these irons no longer bringing the fancy prices, relatively to other irons, that they once did: irons formerly considered not good enough are now in demand for the purpose, and the cost of the iron used in a car-wheel is greatly reduced.

"The time is probably not far distant when pig iron for foundry purposes will be bought and sold on *analysis*, just as iron for Bessemer and other steel now is; and the results will be stronger and cheaper castings, more certainty in quality of product, lower prices for fancy brands of iron sold on their old reputations, and higher prices for scrap, white iron, silver gray, and other varieties hitherto undervalued."

I shall now attempt to give an account of some of the chemical substances found in irons of different kinds, and how to combine them to obtain certain results.

With the view of becoming better acquainted with the nature of 'pig iron,' let us determine what influence carbon, manganese, sulphur, phosphorus, and silicon have upon it.

It must be understood that the strength of cast iron depends on (1) the amount of weakening impurities present; (2) the proportion existing between the *combined* and the *graphitic* carbon.

According to their influence on the properties of cast-iron, the elements mentioned may be classified into two groups: (1) Softeners—graphitic carbon and silicon. (2) Hardeners—combined carbon, manganese, sulphur, and phosphorus.

GRAPHITIC CARBON.

Carbon existing as graphite in cast iron makes it soft and tough, and increases its fluidity.

When molten iron solidifies, the liberation of the carbon occurs at the instant of crystallization.

Silicon added to iron produces graphite.

The amount of graphite in gray irons varies from about 1.5 to 3.5 per cent.

In Scotch irons the graphitic carbon should not be below 3.0 per cent.

COMBINED CARBON.

Combined carbon in proper proportion to graphitic carbon increases the strength of cast iron.

Cast iron which contains too much combined carbon becomes harder and more brittle in proportion, and shrinks more in cooling than does graphitic carbon.

Sudden cooling of the metal prevents the liberation of carbon as graphite, and retains it in the state of combination with the iron.

Repeated remelting increases the combined carbon, and when *silicon* is taken from iron the combined carbon is also increased.

For soft castings the mixture should not contain over 0.2 per cent of combined carbon, but for strong castings 0.4 to 0.8 per cent is admissible, and in some cases even more.

So-called "Scotch" irons or "softeners" should contain a maximum of graphitic and a minimum of combined carbon. The best brands of these irons sometimes contain less than 0.1 per cent of combined carbon.

MANGANESE.

Manganese tends to the formation of combined carbon, reduces the tensile strength, makes the iron hard and brittle, causes more waste by reason of the formation of additional slag, and acts in a contrary direction to *silicon*.

Manganese in foundry irons varies from mere traces to over 2.0 per cent.

For the reasons as herein stated, manganese can only be tolerated in very strong castings, and even then should not exceed in the mixture over 0.5 per cent.

SULPHUR.

Sulphur contributes to retain the carbon in the combined state, and probably also promotes the formation of combined carbon, and consequently hardens the castings.

In foundry irons this element should not exceed 0.1 per cent.

PHOSPHORUS.

Phosphorus causes hardness and brittleness by lowering the separation of graphite, but increases fluidity.

Phosphorus in foundry irons varies from 0.2 to 1.0 per cent, and sometimes even more; but for best results in foundry mixtures, it should not exceed 0.5 per cent, or, preferably, 0.3 per cent.

The injurious effects of phosphorus become more apparent in proportion as the percentage of combined carbon increases.

High phosphorus is desirable only in cases where great fluidity, regardless of strength, is the chief desideratum.

SILICON.

Silicon increases fluidity, and reduces hardness and shrinkage of castings by its influence on the combined carbon, changing it into graphitic; but after the bulk of the carbon has become graphitic, through an addition of silicon, any further addition of silicon hardens the casting.

In the foundry the problem is to have the right proportions of combined and graphitic carbon in the resultant castings, and the fundamental laws in foundry practice are, that in white pig iron an addition of *silicon* precipitates the combined carbon in the form of graphitic carbon, and causes gray iron to be produced, and that in gray pig iron the expulsion of *silicon* converts the graphitic carbon into combined carbon and produces white iron.

The variations, within certain limits, in the proportions of silicon, afford a reliable means of producing castings of any mechanical character which is possible with the materials employed; but the percentage of *silicon* required depends greatly upon the condition in which the carbon exists in the iron to begin with, viz., in an iron when the bulk of the carbon is already graphitic, more silicon may weaken the casting and make it brittle.

Thus by a judicious use of *silicon* the proportioning of the carbon may be accomplished according to the wish of the founder.

The amount of silicon producing the maximum of strength is about 1.8 to 2.0 per cent when a white base is used.

The strongest castings are obtained from irons which, when melted alone, will produce sound castings with the least amount of graphite, and each addition of *silicon* to such iron will decrease strength.

When strength is desired, it should also be borne in mind

that the phosphorus, sulphur, and manganese must be kept low, or within certain limits.

Gray foundry irons contain from 1.0 to 5.0 per cent, ferro silicons from 5.0 to 14.0 per cent, and castings will vary from 1.5 to 3.0 per cent of silicon.

In figuring for the silicon contained in scrap-iron the following will be found a safe estimate: 1.5 per cent for scrap from castings which show a gray fracture; 1.0 per cent for such as show a mottled fracture; 0.5 per cent for turnings (cast) when clean; 0.0 per cent when rusty, and the same for burnt iron.

The percentage of silicon to be figured for in white pig iron is about 0.5.

In the paper written by W. J. Keep, Detroit, Mich., entitled "Silicon in Cast Iron," the whole subject is treated in a masterly manner, and all who carefully peruse its pages must inevitably agree with that illustrious investigator in the conclusions he draws with regard to the wonderful element which he so ably discusses. In the last clause of his paper he says: "We have seen, however, that a white iron which will invariably give porous and brittle castings can be made solid and strong by the addition of silicon; that a further addition of silicon will turn the iron gray, and that as the grayness increases the iron will grow weaker; that excessive silicon will again lighten the grain, and cause a hard and brittle as well as a very weak iron; that the only softening and shrinkage-lessening influence of silicon is exerted during the time when graphite is being produced, and that silicon of itself is not a softener or a lessener of shrinkage, but through its influence on carbon, and only during a certain stage, it does produce these effects."

From the foregoing it must be inferred that if founders are to keep pace with this age of discovery they must be willing to leave the old beaten tracks of indecision and

doubt, and seize upon the more tangible methods which science reveals to us every day.

The suggestions herein contained should, I think, go far towards making what has hitherto seemed a mystery appear as a problem easy of solution: for instance, a casting is required that shall meet certain conditions; a careful study of the foregoing will enable the founder to know what proportion of the several elements may with safety be allowed to enter into the mixture, and knowing from previous *analysis* what the stock consists of, he can at once decide which course to pursue, and all this with a positiveness which is simplicity itself.

The reader will also see how effectually this method will eradicate the old foundry nomenclature, as, instead of the present distinguishing terms as applied to cast iron in stock, we should know them according to analysis, as brands high, medium, or low in one or more of their constituent elements.

Of course a thorough knowledge of this proposed innovation will mark a new era in the prices of cast iron, as before stated, because the demands for so-called No. 1 irons will not necessarily be as urgent as is now the case; and I am surprised that employers have not before now grasped the situation, for it is no exaggeration to say that if the services of the metallurgical chemist were more generally insisted upon, and the proposed method adopted in its entirety, an immense saving would be effected, as lower grades of iron could be used with absolute certainty.

It must not be supposed that the founder can, under any circumstances, omit the care and supervision always requisite where the best practice is to be obtained.

While scrap, so-called, ceases under the proposed change to be a drug, and becomes in some instances a prime necessity, every precaution must be taken to insure its successful reduction in the cupola; all such as is very dirty

should be thoroughly cleaned, and when there is a large quantity of very fine scrap it is preferable to charge it all together, at the last of the heat, mixed with as much high silicon iron as will insure its conversion into a desirable mixture.

When it is remembered that scrap, especially such as has been frequently remelted, contains a larger amount of combined carbon than the original pig from which it was made, there will be no difficulty in understanding that such scrap, judiciously used, will neutralize any tendency to sponginess which may be inherent in the pig, such mixtures to be proportioned according to the degree of fineness desired in the resultant casting.

Too little care is exercised in the choice of a man to attend the cupola; and if employers could be made to see how much they lose every year through sheer incompetency in the management of that important department, we should soon see a different class of men employed. An ignorant man cannot be expected to take any interest in mixtures, economy, and the numberless other important factors which are indispensable where the best results are looked for.

A carefully kept record of every day's melting is absolutely necessary,—for, however precise the mixtures may be made, there will always be neutralizing influences, more or less, at work to make such a course indispensable,—the several adverse results can be noted, and the reasons for such inquired into.

Physical tests must also be taken; for it must be borne in mind that in this business nothing is absolute, so many things, unavoidable sometimes (conflicting, nevertheless), such as different degrees of heat, rapid melting or the opposite, and countless other contingencies exist; and these make it imperative that test-bars be made each melt, with the view of ascertaining the exact amount of shrinkage,

tendency to sink or draw, tendency to chill, degree of hardness, strength, etc., all of which make useful data for future reference.

FOUNDRY CUPOLAS.

THE ART OF MELTING IRON IN THEM, WITH TABLE OF FULL EXPLANATIONS FOR THEIR ERECTION AND MANAGEMENT.

The cupola is now one of the most important factors in foundry economy. Its management commands the attention of the founder to a far greater extent to-day than it has ever done in the past. No matter what pains may be taken to insure a good and safe mould, every attempt in that direction will be neutralized if the molten iron supplied for filling it is not in every sense up to that standard of excellence which a right use of the materials employed warrants us to expect.

The truth of the above has been so often demonstrated, that any further allusion to the fact would be superfluous here. The science of melting in cupolas seems to have made very slow progress, until it was seen by some of the advanced thinkers on the subject that there was "money in it"; then the services of the engineer and scientist were enlisted in the cause, and specialists in the manufacture of cupolas and blowers were to be found everywhere.

A result of this change in the order of things is that, instead of working, as has hitherto been the case, by the "rule of thumb," we are now enabled to measure, with a degree of accuracy almost marvellous, the air, fuel, capacity

of cupola, and pressure of blast, etc., required to melt a given quantity of iron in a specified time. True, we do not always accomplish this with the degree of accuracy above spoken of, but in nearly every case of failure the cause may be traced to the non-fulfilment of the known conditions.

It must be remembered that the intelligence of the melter has not grown with the steady improvements now being established in nearly all of our leading establishments; consequently it requires the constant attention of foreman or manager to insure a correct manipulation of improved cupolas and their adjuncts.

The thoughtful founder has profited to an appreciable extent by reason of the claims for recognition made by the manufacturers of cupolas and blowers, for in order to substantiate such claims they have flooded the market with catalogues and pamphlets, which contain an elucidation of the science of melting such as cannot be found anywhere else.

This literature, made purposely plain, has been read extensively, with very good results: a better feeling has been established between the workman and the scholar, and there is now no doubt in the mind of the practical founder that the day of mystery is past, for very much if not all of the mystery has been scattered by those very scholars whom he has always been taught to despise.

The good resulting from this improved education in matters relating to the melting of iron in cupolas is nowhere seen to better advantage than in the erection and management of what may be called the common cupola, which, notwithstanding the immense number of patent ones sold, still finds a place in every land, and I suppose always will. It must strike the interested observer that, after all, there is not very much difference in the construction of cupolas. Most of the so-called 'improved' have

made their début within the last thirty-five years, and very many of them have, after a short trial, been changed back to the old style, with considerable profit to those interested.

Others are simply 'tolerated' because they are neither better nor worse than the old style; and not a few of the really meritorious cupolas are producing minimized results from the simple cause that there is not sufficient intelligence expended on their management. In a number of cases, when the formulas furnished by the patentees for guidance in the management of their cupolas are followed to the letter, very excellent results ensue, both time and money being saved by adopting them; but as these formulas are carefully prepared by experts, and are in the main reliable, we need not inquire into their respective merits, but proceed at once to an exposition of the construction and management of the common cupola, for, on account of the extra cost of erection, joined to the strict management required for the successful working of most patent cupolas, there will, I presume, always be a demand for the former.

The blast-furnace, in some form or other, has always had a place in the metallurgical arts, and dates back to the earlier dynasties of the ancient empire of Egypt; true, they were very simple contrivances, but that which was accomplished is made to appear all the more wonderful in view of their simplicity. The Catalan furnace is a type of some of these old-time smelting processes, and, primitive as they were, could be found in use in some parts of Europe a few years back; these were simply a hole in the ground, with walled sides, into which a copper tuyere pipe penetrated. When the charcoal and ore had been properly placed within this hole the blast was forced through the tuyere pipe by some of the antiquated methods then in vogue, until the molten iron was produced.

At Fig. 7 will be seen a longitudinal vertical section of the Catalan furnace, which, as will be observed, has no

chimneys. On the left of the figure is seen the lower part of the tromp or blowing engine; the blast is produced by means of a fall of water of about twenty-five feet through a tube into the cistern below, to whose upper part the blast-pipe is connected, the water escaping through a pipe below. This apparatus is on the outside of the building, and is said to afford a continuous blast of great regularity.

Now if we continue the walls of this primitive contrivance, what do we obtain in reality other than the cupola of

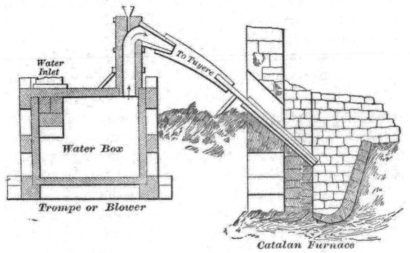

Fig. 7.

to-day, exact in every particular so far as the principles involved for melting iron are concerned?

Fig. 8 shows sections and elevation of what was considered a good type of cupola fifty years ago, and of which type there are large numbers still working in England and in parts of the European continent, as well as still a few in some of the remote parts of this country. There is really no essential difference betwixt the cupola shown at Fig. 8 and that seen at Fig. 9, except that, instead of the bottom resting on a solid foundation, as at Fig. 8, the one at Fig. 9 is supported by four columns A, which allows for

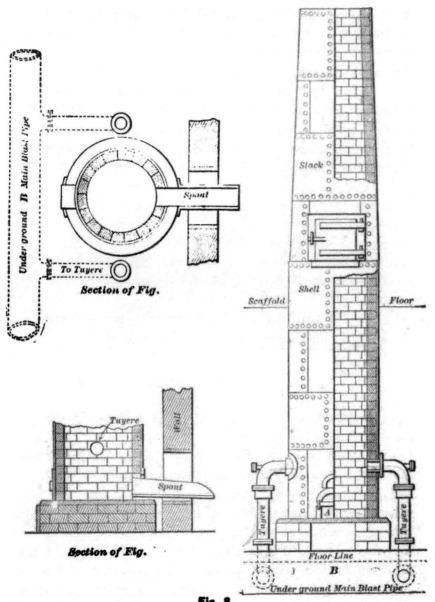

Fig. 8.

the dropping out of the whole contents of the cupola at once, swing-doors *B* being provided for that purpose, whilst in the former case the cupola, when done working, must be raked out with hooks through large apertures *A* provided for the purpose.

Another feature which commands attention is the substitution of a wind-box round the cupola, connecting with a system of pipes above, for the underground arrangement shown at *B, B,* Fig. 8; this allows for the multiplication of tuyeres or any other changes which experience may suggest, being made with very little trouble or expense.

A careful examination of Fig. 9, aided by the table which accompanies this article, will enable any one to build a cupola after the pattern shown, which pattern is, to all intents and purposes, what we may call a common cupola, in contradistinction to all such as are protected by letters patent.

Let us now consider in detail the various requirements for the erection and management of such a cupola.

LOCATION OF CUPOLA.

What shall be its capacity, and where shall it be located? are very important points to be considered. With regard to the latter query, due care should always be exercised to choose a location which will be equidistant from all its parts, for, whether the iron is carried in shanks, run on trucks, or changed from crane to crane in ladles, this disposition will give an equal and rapid distribution.

A very good axiom is that of Mr. Kirk's, who, in his very excellent work "Founding of Metals," says: "It is easier to wheel pig iron to a cupola than it is to carry molten iron away from it."

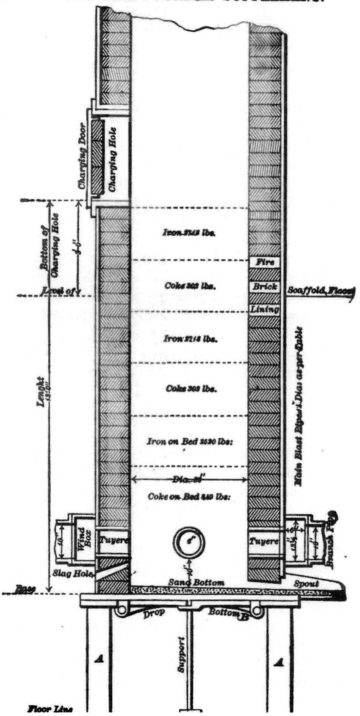

CAPACITY OF CUPOLA.

The accompanying table will be of service in determining the capacity of cupola needed for the production of a given quantity of iron in a specified time.

First, ascertain the amount of iron which is likely to be needed at each cast, and the length of time which can be devoted profitably to its disposal; and supposing that two hours is all that can be spared for that purpose, and that ten tons is the amount which must be melted, find in the column "Melting Capacity per hour in Pounds" the nearest figure to five tons per hour, which is found to be 10,760 pounds per hour, opposite to which, in the column "Diameter of Cupola's Inside Lining," will be found 48 inches: this will be the size of cupola required to furnish ten tons of molten iron in two hours.

Or suppose that the heats were likely to average six tons, with an occasional increase up to ten, then it might not be thought wise to incur the extra expense consequent on working a 48-inch cupola; in which case, by following the directions given, it will be found that a 40-inch cupola would answer the purpose for 6 tons, but would require an additional hour's time for melting whenever the 10-ton heat came along.

Let it be understood that the quotations in the table are not supposed to be all that can be melted in the hour by some of the very excellently equipped cupolas now in the market, but are simply the amounts which a common cupola under ordinary circumstances may be expected to melt in the time specified.

HEIGHT OF CUPOLA.

What is meant by height of cupola is the distance from the base to the bottom side of the charging hole.

TABLE

SHOWING HEIGHTS, DEPTH OF BOTTOM, QUANTITY OF FUEL ON BED, PROPORTION OF FUEL AND IRON IN CHARGES, DIAMETER OF MAIN BLAST-PIPES, NUMBER OF TUYERES, BLAST-PRESSURE, SIZES OF BLOWERS AND POWER OF ENGINES, MELTING CAPACITY PER HOUR, AND TOTAL MELTING CAPACITY OF ALL CUPOLAS FROM 24 INCHES TO 84 INCHES IN DIAMETER.

Diameter of Cupola inside of lining, in Inches.	Height of Cupola from bottom plate to bottom of charging door, in Feet.	Depth, from sand bed to under side of tuyeres, in Inches.	Amount of Fuel required on bed, in Pounds.	First charge of Iron, in Pounds.	Succeeding charges of Fuel, in Pounds.	Succeeding charges of Iron, in Pounds.	Diameter of Main Blast-pipe when not exceeding 100 feet in length, in Inches.	Number of Tuyeres 6 inches diameter required for each Cupola designated.	Number and Dimensions of flat Tuyeres equivalent to the 6-inch round ones.		Blast-pressure required, in Ounces.	Sizes of Root Blower, designated by their number.	Horse-power of Engine to drive Root Blower.	Sizes of Sturtevant Blower, designated by their number.	Horse-power of Engine to drive Sturtevant Blower.	Melting Capacity per hour, in Pounds.	Total Melting Capacity, in Pounds.
In.	Feet.	In.	Lbs.	Lbs.	Lbs.	Lbs.	In.	No.	No.	Dimension.	Oz.	No.	H.-P.	No.	H.-P.	Lbs.	Lbs.
24	10	10	300	900	50	500	10	1.5	2	10″×2″	6	½	½	2	1	1,500	6,000
26	10	10	390	1,170	92	888	10	2.	2	14″×2″	6	1	1	2	1	2,000	8,000
28	10	10	480	1,440	134	1,206	10	2.6	3	12″×2″	6	1	1¼	3	1	2,500	10,000
30	12	10	570	1,710	176	1,584	12	2.6	3	12½″×2″	7	1	1¼	3	2	3,000	12,000
32	12	10	660	1,980	218	1,962	12	3.3	4	12″×2″	7	1	1½	3	2	3,500	14,000
34	12	10	750	2,250	260	2,340	12	3.3	4	12″×2″	7	1	2	3	2	4,000	16,000
36	12	10	840	2,520	302	2,718	14	3.7	4	13½″×2″	8	2	2¼	4	3	4,320	18,280
40	12	10	930	2,730	344	3,096	14	5.	6	12″×2″	8	2	2½	4	3	5,640	22,560

FOUNDRY CUPOLAS.

40	13	10	1,020	3,060	356	3,474	14	5.	6	19" × 2"	8	2	4	4	3	6,460	25,840
42	13	10	1,110	3,330	425	3,852	16	5.3	6	11¼" × 2¼"	10	3	6	5	5¼	7,550	30,200
44	13	10	1,200	3,600	470	4,230	16	5.3	6	11¼" × 2¼"	10	3	7¾	5	5¼	8,640	34,560
46	13	10	1,290	3,870	512	4,608	16	5.3	6	13¼" × 2¼"	10	3	8¾	5	5¼	9,730	38,920
48	13	10	1,380	4,140	554	4,986	18	6.3	6	13¼" × 2¼"	12	4	10	6	5¼	10,760	43,040
50	13	10	1,470	4,410	596	5,364	18	6.3	6	11¼" × 2¼"	12	4	12	6	9¼	11,790	47,160
52	14	10	1,560	4,680	638	5,742	18	8.	8	13¼" × 2¼"	12	4	13	6	9¼	12,880	51,280
54	14	10	1,650	4,950	680	6,120	20	10.7	8	13¼" × 2¼"	14	5	14	7	9¼	13,850	55,400
56	14	10	1,740	5,220	722	6,498	20	10.7	8	16¼" × 2¼"	14	5	16	7	9¼	14,880	59,520
58	14	10	1,830	5,490	764	6,876	20	12.2	8	17¼" × 2¼"	14	5	17¾	7	16	15,910	63,640
60	14	10	1,920	5,760	806	7,254	22	12.2	8	17¼" × 2¼"	14	5	18¾	8	16	16,940	67,760
62	14	10	2,010	6,030	848	7,632	22	13.7	8	16¼" × 3"	14	5	20	8	16	18,340	73,860
64	14	10	2,100	6,300	890	8,110	22	13.7	8	16¼" × 3"	14	5	22	8	22	19,770	79,080
66	15	10	2,190	6,570	932	8,888	22	15.4	8	16¼" × 3"	14	6	23	8	22	21,800	84,800
68	15	10	2,280	6,840	974	8,766	22	15.4	10	16¼" × 3"	14	6	25	8	22	22,680	90,520
70	15	10	2,370	7,110	1,016	9,144	22	17.1	10	16¼" × 3"	16	6	27	9	22	24,060	96,240
72	15	10	2,460	7,380	1,058	9,522	24	19.	10	16¼" × 3¼"	16	6	28	9	35	26,070	104,280
74	16	10	2,550	7,650	1,100	9,000	24	23.9	12	16¼" × 3¼"	16	6	35	9	35	27,980	111,920
76	16	10	2,640	7,920	1,142	10,278	24	23.9	12	16¼" × 3¼"	16	6	37	9	35	29,890	119,560
78	16	10	2,730	8,190	1,184	10,656	24	26.	12	16¼" × 3¼"	16	6	40	9	35	31,800	127,200
80	16	10	2,820	8,460	1,226	11,134	24	26.	12	16¼" × 3¼"	16	7	42	9	35	33,710	134,840
82	16	10	2,910	8,730	1,268	11,412	24	28.	14	17" × 3¼"	16	7	45	9	35	35,620	142,480
84	16	10	3,000	9,000	1,310	11,790	26	31.	16	18" × 3¼"	16	7	47	10	43	37,530	150,120

Height in cupolas is important, as all low cupolas lose a considerable amount of combustible gas, which escapes unburnt; whereas when a sufficient height is allowed a large quantity of this gas mixes with the oxygen above and ignites, thus giving off heat available for combustion.

Should it be required to know what height to make a 50-inch cupola, find 50 inches in the column "Diameter of Cupolas," opposite to which, in the column "Height of Cupola" from base to bottom side of charging hole, will be found 14 feet, so that a 50-inch cupola should have a height of 14 feet.

The height of any other cupola from 24 inches to 84 inches diameter may be found in the same manner.

DEPTH OF BOTTOM OF CUPOLA.

Depth of bottom is the distance from the sand bed, after it has been formed at the bottom of the cupola, up to the under side of the tuyeres.

It will be seen in the table (pp. 42, 43), that all the amounts for fuel are based upon a bottom of 10 inches deep, and any departure from this depth must be met by a corresponding change in the quantity of fuel used on the bed; more in proportion as the depth is increased, and less when it is made shallower.

AMOUNT OF FUEL REQUIRED ON THE BED.

The column, "Amount of Fuel required on Bed, in Pounds," will, I hope, be found serviceable; it is based on the supposition that the cupola is a straight one all through, and, as before stated, that the bottom is 10 inches deep. If the bottom be more, as in those of the Colliau type, then additional fuel will be needed.

The amounts being given in pounds, answers for both coal and coke, for, should coal be used, it would reach about 15 inches above the tuyeres; the same weight of coke would bring it up to about 22 inches above the tuyeres, which is a reliable amount to stock with.

FIRST CHARGE OF IRON.

The amounts given in this column of the table are safe figures to work upon in every instance, yet it will always be in order, after proving the ability of the bed to carry the load quoted, to make a slow and gradual increase of the load until it is fully demonstrated just how much burden the bed will carry; for, as before stated, these figures represent the safe load under ordinary conditions, as to fuel and blast, in a common cupola, and not what may be accomplished when the most elegant practice is essayed.

SUCCEEDING CHARGES OF FUEL AND IRON.

By consulting the columns relating to succeeding charges of fuel and iron, it will be seen that the highest proportions are not favored, for the simple reason that successful melting with any greater proportion of iron to fuel is not the rule, but, rather, the exception.

Whenever we see that iron has been melted in prime condition in the proportion of 12 pounds of iron to one of fuel, we may reasonably expect that the talent, material, and cupola have all been up to the highest degree of excellence.

DIAMETER OF MAIN BLAST-PIPE.

The table gives the diameters of main blast-pipes for all cupolas from 24 to 84 inches diameter.

No part of the foundry economy has been more neglected than this; go where you will, there seems to have been blundering in this particular: especially is this the case in some old firms which have made additions to their moulding capacity from time to time, necessitating the erection of other cupolas, which have been connected to the old conducting pipe, no matter whether it was adequate to the task of furnishing sufficient blast or not. This is not wise, as the loss by friction in pipes that are too small causes a greater demand on the engine and blower, which, being pushed to their extreme limit, in order if possible to maintain a full head of blast, causes a loss from undue wear and tear, which would in a very short time pay the expense of a new and larger set of pipes.

But this is not all: the increased capacity of the pipes in such a case is absolutely necessary, in order to supply the exact quantity of air for perfect combustion, without which we must look in vain for a regular supply of soft fluid iron. This latter want alone ought to be, if properly understood, a sufficient incentive to make us look well after the main blast-pipe.

The sizes given opposite each cupola are of sufficient area for all lengths up to 100 feet.

TUYERES FOR CUPOLA.

It will be seen that two columns are devoted to the number and sizes of tuyeres requisite for the successful working of each cupola; one gives the number of pipes 6 inches diameter, and the other gives the number and dimensions of rectangular tuyeres which are their equivalent in area.

From these two columns any other arrangement or disposition of tuyeres may be made, which shall answer in their totality to the areas given in the table.

FOUNDRY CUPOLAS. 47

By referring to the column, "Number of Tuyeres 6 inches diameter," etc., it will be found that the 60-inch cupola would require a little over 13½ such tuyeres to furnish a sufficient volume of blast to insure successful melt-

Section through *A*
Fig. 10.

ing, and opposite to this, in the column for Flat Tuyeres, will be found that 8 flat tuyeres 16½ inches by 3 inches would be their equivalent; and by the same method it *is* seen that the 24-inch cupola would need one and a half

round tuyeres 6 inches diameter, or two flat ones 10½ inches by 2 inches.

When cupolas exceed 60 inches in diameter, the increase should begin somewhere above the tuyeres, after the manner shown at Fig. 10, which represents the lower portion of a cupola 84 inches diameter above the tuyeres and 60 inches diameter below. This method is absolutely necessary in all common cupolas above 60 inches, because it is not possible to force the blast to the middle of the stock, effectively, at any greater diameter.

On no consideration must the tuyere area be reduced; this is to all intents and purposes an 84-inch cupola, and must, as is seen in the table, have tuyere area equal to 31 pipes 6 inches diameter, or 16 flat tuyeres 16 inches by 3½ inches.

If it is found that the given number of flat tuyeres exceed in circumference that of the diminished part of the cupola, they can be shortened, allowing the decreased length to be added to the depth, or they may be built in on end, as seen in Fig. 10; by so doing we arrive at a modified form of the famous Blakeney cupola.

Various methods have been adopted to overcome the difficulty of reaching the middle of the furnace with a sufficient volume of blast to insure perfect combustion amongst others, in particular, we notice the Mackenzie cupola, which, they claim, differs from all others in having a continuous tuyere that allows the blast to enter the fuel at all points. This construction, they further claim, brings the blast to the centre of the furnace with the least possible resistance and the smallest amount of power. The method of introducing the blast into the Makenzie cupola is illustrated at Fig. 11.

Another highly important point in this connection is to arrange the tuyeres in such a manner as will concentrate the fire at the melting-point into the smallest possible

compass, so that the metal in fusion will have less space to traverse while exposed to the oxidizine influence of the blast.

To accomplish this, recourse has been had to the placing of additional rows of tuyeres in some instances—the 'Stewart rapid cupola' having three rows, and notably

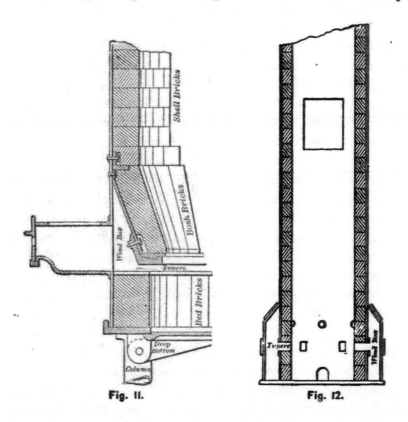

Fig. 11. Fig. 12.

the 'Colliau cupola furnace,' which has two rows of tuyeres.

The patentees of the Colliau claim that their records show the most economy in fuel and iron, the greatest rapidity in fusion, and the largest amount of iron melted in a given time and size, as well as the greatest quantity of iron melted in a cupola without clogging.

It will be seen by consulting Fig. 12, which is a representation of a Colliau cupola, that it is in all respects, except the tuyeres, a common cupola; therefore, whatever its superiority over other common ones may be, all the credit is due to the ingenious disposition of the tuyeres.

BLAST-PRESSURE.

Accurate experiments made by experts in this branch of science prove beyond doubt that about 30,000 cubic feet of air are consumed in melting a ton of iron, which, if reduced to a solid, would weigh about 2400 pounds, or more than both iron and fuel. In reference to this important subject an authority says: " When the proper quantity of air is supplied, the combustion of the fuel is perfect, and carbonic-acid gas is the result. When the supply of air is insufficient, the combustion is imperfect, and carbonic oxide-gas is the result. The amount of heat evolved in these two cases is as fifteen to four and a half ($15 : 4\frac{1}{2}$), showing a loss of over two thirds of the heat by imperfect combustion. Though the difference between perfect and imperfect combustion is so astonishing, it is seldom taken into account by foundrymen, and most of them are unconsciously submitting to a great loss, which can be easily remedied."

It is not always true that we obtain the most rapid melting when we are forcing into the cupola the largest quantity of air. Some time is required, says the authority previously quoted, to elevate the temperature of the air supplied to the point that it will enter into combustion. If more air than this is supplied, it rapidly absorbs heat, reduces the temperature, and retards combustion, and the fire in the cupola may be extinguished with too much blast, as the flame of the lamp is blown out with the breath.

When all these conditions are well understood by the

student in cupola practice, he will then realize how important it is that the requisite amount of pressure, and no more, be maintained during the whole process of melting.

In the table will be found a column, Blast Pressure Required, in Ounces, which gives the amount of pressure required for each-sized cupola.

BLOWERS AND ENGINES.

The blowers chosen as standards for this table are the Root and Sturtevant; should any other be used, it is important that their capacity be measured, so that any difference may be noted, and due allowance made.

Should it be required to know what size of Root blower would be most suitable for supplying blast to a 42-inch cupola, it will be found to be a No. 3, opposite to which number is 6 horse-power, being the power of engine needed for a No. 3 Root blower; and by the same method, if for the same-sized cupola a Sturtevant blower was desired, the number of blower will be a No. 5, but the engine is 5½ horse-power. Be sure that the engine is of sufficient power to insure a full or maximum blast, and if possible have it free from any other machinery.

TOTAL MELTING CAPACITY OF CUPOLAS.

The figures given in the column, Total Melting Capacity of Cupolas, in Pounds, are not meant as absolute (to do that would be impossible; the melting capacity of any cupola is influenced, for good or bad, by the amount of intelligence which is brought to bear upon its management); they are approximate under ordinary circumstances, and will be of assistance in selecting a suitable cupola for the work in hand.

SLAG IN CUPOLAS.

A certain amount of slag is necessary to protect the molten iron which has fallen to the bottom from the action of the blast: if it was not there, the iron would suffer from decarbonization, and would consequently be less fluid.

When slag from any cause forms in too great abundance, it should be led away by inserting a hole a little below the tuyeres, through which it will find its way as the iron rises in the bottom.

In the event of clean iron and fuel, slag seldom forms to any appreciable extent in small heats; this renders any preparation for its withdrawal unnecessary, but when the cupola is to be taxed to its utmost capacity it is then incumbent on the melter to flux the charges all through the heat, carrying the slag away in the manner directed.

The best flux for this purpose is the chips from a white marble yard; this is a much purer limestone than any other of the carbonates, and requires less melting. About 6 pounds to the ton of iron will give good results when all is clean, as it suffices to keep the cupola open during a long heat without flooding at the tap-hole, at the same time it softens the cinder, and makes it much easier to chip out afterwards.

When fuel is bad, or iron is dirty, or both together, it becomes imperative that the slag be kept running all the time, otherwise the cupola will clog up gradually, and become useless before half its work is completed.

FUEL FOR CUPOLAS.

Without doubt, the best fuel for melting iron is coke, simply because it requires less blast, makes hotter iron, and melts faster than coal. When coal must be used, care

should be exercised in its selection. All anthracites which are bright, black, hard, and free from slate will melt iron admirably. The size of the coal used affects the melting to an appreciable extent, and for the best results small cupolas should be charged with the size called 'egg,' a still larger grade for medium-sized cupolas, and what is called 'lump' will answer for all large cupolas when care is taken to pack it carefully on the charges.

LINING AND REPAIRING CUPOLAS.

For many years I have demonstrated the fact that the best man to line or build up a cupola is an intelligent cupola-man, who will see to it that every brick is rubbed well down on its fellow; also, that it fits the shell as close as it is possible to make it.

For best results the mortar should be as near as possible of the same nature as the bricks. When requested to do so, the dealers can always supply the right article. Any attempt to make this mortar from the clays and sands in ordinary use should be scouted, as the bricks soon become loose if inferior clay is used in their setting, and this brings about an early collapse of the whole structure.

Too little attention is usually paid to the nature of the materials supplied the melter for repairs; hence a new-lined cupola, which ought to last from one to two years, is used up in half the time, and sometimes less. If the best silicious sand and the most refractory fire-clay was used for this purpose, there would be a great saving effected in the course of a year.

A good melter will note the form of the inside of his cupola when it has been newly lined, and endeavor by careful mending every morning to maintain the original shape. If he finds it is wearing fast at the melting part, he will not endeavor to preventthat by pressing into the

cavity large quantities of wet clay, for he knows that by so doing it is more than likely that the whole patch would fall away as soon as the great heat to which it is subjected comes upon it.

If it is found that the bricks are wearing fast at that part, the right course to pursue is to rub well on a thin coat of daubing each day, until it is thought advisable to chip out a course or two at the bad spot, and make good with new bricks.

CHARGING THE CUPOLA.

As the table serves the purpose of explaining, approximately, the amounts of fuel and iron to be charged on the various-sized cupolas, it only remains to be said that, in order to obtain the best results at the cupola, choice must be made of the most intelligent of the unskilled help in the foundry from which to train a skilful melter.

Let him be taught the importance of strict observation, taking care to duly mark every change in the operations of melting, and make note of the results; and whilst it will always be his pleasure to do as his foreman instructs, he must cultivate a spirit of self-reliance, which every day's experience will serve to strengthen and solidify.

The pleasure of having a melter who can be trusted to do as he is instructed, and who can also be depended upon for the intelligent performance of all the details connected with the successful management of cupolas, is known to no one better than the writer of these pages.

REVERBERATORY OR AIR FURNACES.

THEIR USE FOR THE PURPOSE OF MELTING CAST IRON FULLY EXPLAINED.

Reverberatory, or, as they are more frequently called, 'wind or air furnaces,' to distinguish them from those worked with compressed air or blast, are not as commonly used for general purposes now as they were formerly, for manifest reasons, some of which it would perhaps be well to inquire into.

In the first place it is claimed that they are too expensive in their working, requiring, as they do, more than twice the amount of fuel that is needed in the cupola for the production of good hot iron; but an extensive practice has convinced me that even such considerations would have been overlooked on particular occasions if there had been a good reverberatory furnace in the shop.

Too frequently castings are needed which, if common justice were done to all parties concerned, ought to have been cast from the reverberatory furnace; and in the sometimes oft-repeated effort to produce iron of the desired homogeneousness in the cupola the cost of production in the end has been very far in excess of what it would have been had the proper furnace for the job been on hand.

Another of the prime causes for this discontinuance is the great lack of knowledge manifested in their construction and management, owing to which, failures have attended the efforts of quite a number of founders who have endeavored to establish their use, and they have been forced to abandon the enterprise and fall back disappointed to the cupola again.

This should not be the case, nor need there be any such giving up: the business can be learned, like any other, by hard application and industry; and no better incentive to this could be adduced than to inform all such as have failed in learning the art, that throughout the whole of Europe the reverberatory is as common as the cupola furnace is here.

Do not understand me as urging their general adoption in place of the cupola: in view of the latter's great utility such a proposition would be preposterous in the extreme. But I do maintain that if they were built and held in readiness for emergencies, which are constantly occurring, it would reveal a greater wisdom on the part of our leading founders.

It cannot be denied that the reverberatory furnace will yield a purer metal than is possible for the cupola to do, simply because it is melted separate from the fuel, and consequently cannot absorb its impurities; whilst, on the other hand, the iron in the cupola is charged in direct contact with the fuel, with the consequent result of being more or less impregnated with its impurities. This fact is incontrovertible, and speaks volumes in favor of the reverberatory, when absolutely clean iron is the desideratum.

Iron melted in the reverberatory furnace loses a portion of its oxygen during the process. This tends to harden by converting *graphitic* into *combined carbon;* hence the eminent adaptability of these furnaces for the production of iron suitable for guns, hydraulic cylinders, rams, heavy rolls, etc., as any degree of homogeneousness can be obtained by polling the molten iron in the reservoir after it has all melted, and at the same time allowing the full force of the flame to play upon its surface until the iron, by dipping test, shows the desired texture.

One great advantage claimed by the workers in malleable iron is, that iron melted in the reverberatory furnace an-

neals at a heat very much lower than would be required for iron melted in the cupola; this will in some measure compensate for the extra cost of melting in the former.

For the reduction of unwieldy masses of scrap-iron this class of furnace is indispensable, as any amount of this apparent drug can be reduced into good fluid iron with the greatest ease.

For the benefit of all such as are ignorant of the principles which govern the art of melting in these furnaces, it is needful to say that in all cases where it is desired to melt metals out of contact with the solid fuel, special combustion chambers or fireplaces must be provided, the metal being melted by the body of flame and heated gas acting upon its surface as it lays on the bed of the furnace.

To accomplish this effectively, the flame must be made to reverberate from the low vaulted roof of the furnace downwards, and the form of the roof associated with the velocity of the flame will determine what part or parts of the bed will receive the full force of the heat current.

This fact gives rise to numerous opinions as to the correct form to be given the inside of a reverberatory furnace for obtaining the maximum of efficiency, some favoring the method of placing the charge behind the bridge wall; others again maintain that the chimney end is the best for charging, because it is generally allowed to be the hottest; but however much they may vary in construction, the principles which govern, as noted above, are about the same.

The furnace represented by the illustrations accompanying this article is a very good one for general work, and very suitable for reducing or melting heavy lumps which would otherwise have to be cut up into smaller pieces before it would be practicable to melt them in the cupola.

The chief points in the representations have their dimensions figured; this will aid in arriving at a correct estimate of the proportions of the furnace shown. Its outside di-

mensions, exclusive of plates, are 30 feet 6 inches long and 7 feet wide. The whole structure is incased in wrought-iron plates joined together, as shown in plan, Fig. 13, and again by broken lines at Fig. 16.

The corners are held together with angle-irons, and the principal anchors are those shown at Fig. 16, and marked from 1 to 8, respectively. These 'chief' anchor-bolts reach from one side to the other, passing through the structure at such places as are best calculated to bind the whole firmly together, and at the same time are clear of all working parts of the furnace, as will be observed by referring to Fig. 14. where the position of each bolt is shown at figures corresponding to those marked on the side elevation, Fig. 16.

The amount of strain which this furnace is called upon to bear, owing to the intense heat and pressure to which it is subjected periodically, makes it imperative that not only the walls, but the foundation also, should be as substantially built as possible.

The foundation A, Fig. 14, can be built up solid of common material, up to the line of fire-brick, and in such form as will allow the fire-bricks when set thereon to incline from the chimney to the reservoir in a downward direction, as shown at Fig. 14; and it will be seen that all those from B to C must be kept six inches below what it is intended shall be bottom of the furnace after the sand bed has been formed upon it.

The bridge wall D, Fig. 14, must in this case be not less than 2 feet 3 inches from the face of the grate-bars, and, like the sides, roof, and fireplace, must be built with the most refractory kind of fire-bricks.

The fireplace must in all cases be built the full width of the furnace, to commence with: should it be thought desirable to contract its dimensions subsequently, the task will be an easy one.

The roof throughout its entire length is an arched one,

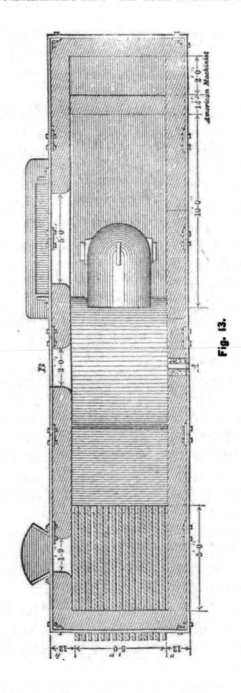

Fig. 13.

and, as before stated, must be of fire-brick; whatever filling is done above the fire-brick arches can be of commoner material.

The chimney for such a furnace would need to be from 30 to 40 feet in height, surmounted with a damper, so arranged as to be easily controlled from the bottom; this is an important feature, as the draught is regulated altogether by the damper. It is hardly necessary to say that a chimney of this sort must be built with an inside course of fire-bricks, and no matter what form the outlet from the furnace may be, it is best to build the chimney square.

The methods adopted for binding these chimneys are various, but as they are well understood by all masons accustomed to this class of work, it will not be necessary to describe them here. As to their dimensions, it is a common rule to have the inside area equal that of the air-space in the grate, but these things can only be determined by actual experience and practice. I have seen good melting done in reverberatory furnaces whose chimneys in some instances were much smaller than the rule allows; and again in other instances, when the chimney's area has been in excess of the air-space in the grate, the melting has been all that could be desired. I therefore conclude that it would be the wisest in all cases to have the area of the chimney somewhat in excess of the fireplace, as in any case the damper will regulate the draught with certainty when the height is sufficient.

A very excellent mode of building chimneys is to have them as a separate structure, resting on a sole-plate supported by four columns; this gives opportunity for making a connection with the furnace or furnaces from any direction which may be chosen.

There are two kinds of charging-doors shown : the one at *A*, Fig. 16, is on the side, and covers a hole 5 feet by 4 feet, through which the iron, heavy and light, is conveyed when

REVERBERATORY OR AIR FURNACES. 61

Fig. 14.

the charging is all done from the side aperture; the other is seen on the top of the furnace at *A*, Fig. 15, and covers a hole as wide as the furnace, 6 feet in length.

In all cases when the iron to be charged is heavy the latter method is the most convenient. As seen, the doors are lined with fire-bricks.

The manner of building a furnace here shown admits of easy access to any part for repairs, for as all the connections are made with bolts (not rivets) one or more of the plates can be detached at the place where it is needed for making alterations or repairs.

Fuel is the all-important factor for producing hot iron in reverberatory furnaces, as it is also in cupolas; and although numerous tests have been made with coke, hard coal, anthracite, and charcoal, none seem to work so well as the soft bituminous coal of the non-caking kind: it is the only fuel upon which the utmost confidence can be placed.

The importance of a good draught in these furnaces will suggest itself to the least observant, but it must be remembered that this draught will draw cold as well as hot air through the stock if there are openings left at any point for its ingress. This bad feature is to be avoided by all possible means and this can only be done by incessant watching of the fire, always endeavoring to keep a full grate of live coal, and when clinkering must be done, let it be done quickly and well, and avoid making holes in the fire, through which cold air can rush into the furnace.

The inrush of cold air is to be strictly guarded against from whatever cause; for, independent of the dangerous tendency towards chilling the furnace, there is a possibility of the chemical nature of the iron being changed by its admission.

When the draught is strong enough to force the flame with a velocity sufficient to melt the iron quickly and hot, it need not be urged any more.

REVERBERATORY OR AIR FURNACES. 63

By referring to Fig. 14 it will be seen just how much of the bottom needs to be made up with sand; it starts on the bed at B, and continues down and around the reservoir to C. If this bottom be well made with a preparation composed of eight parts fire-sand, and one each of clay and ground coke, it should last for ten heats, providing it receives from one to two hours' good firing before the first charge is piled in.

The breast seen at A, Fig. 13, E, Fig. 14, and B, Fig. 15, can be made after the manner suitable for a large cupola, but as the hole must be stopped until the tap is made, pains

Fig. 15.

must be taken to fill the cavity all through its length with fire-sand mixed with a small portion of coal-dust; this can be easily withdrawn, as it will not cake together when it becomes hot. Before tapping be sure and close the damper.

For charging purposes it is advisable to allow plenty of room at the doorways: especially is this the case when all must be charged through the side. The first layer of pigs must be set lengthwise with the furnace, a little apart, the following layers in opposite direction, but leaving spaces between each pig for the free passage of the flame; in fact,

open charging is to be observed, no matter of what nature the pig or scrap may be.

When the pieces to be melted are of more than ordinary magnitude, it is then in order to have an open top through which to lower them down with the crane; the cover for such an opening is shown in end section at *A*, Fig. 15, being simply a segment of the circle corresponding to the arch of the roof at that point, with internal flanges for carrying a course of fire-bricks built in on end; the rings *C* and *D* are for lifting the cover on and off with the crane.

The object shown as resting on the bottom represents a U. S. 13-inch mortar, weighing about 17,000 pounds. Preparation is made to sustain this weight clear of the bed, by setting fire-bricks on the bottom, to finish level with the bed when it is formed, on which to rest other blocks for carrying the load; by this means the flame can play all around the piece, and a speedy reduction of the mass ensues, if all is working right.

It will be noticed that considerable space behind remains unoccupied, all of which can be utilized if more iron than is contained in the mortar be needed; for, as before stated, this is the hottest part of the furnace.

All the iron required should be charged at the first, as it is not advisable to attempt the reduction of any additional stock immediately after the heat is down. Such attempts are attended with disaster oftener than otherwise, because the furnace cools off considerably by the admission of *cold iron* and *cold air*, making it next to impossible to melt the second charge before the iron first melted becomes cold and useless.

The hole shown at *B*, Fig. 13, and at *H*, Fig. 14, is the puddling-hole, and, as will be noticed, is directly over the reservoir. It is through this hole that the dipping is done for testing purposes; the skimming is effected through this hole also. It is very important that the molten iron be kept

REVERBERATORY OR AIR FURNACES. 65

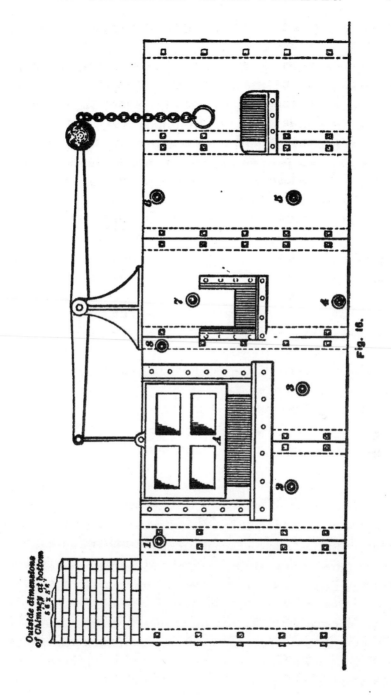

Fig. 16.

clean, as any accumulation of dirt or scum upon its surface acts like a shield, and interferes with the direct action of the flame upon its surface; this, of course, is as good as so much heat lost.

Another very important operation which is readily accomplished by means of the puddling-hole is the boiling of the metal, a process which becomes absolutely necessary when opposite grades of iron are to be mixed together, out of which it is desired to obtain a thorough blending of the

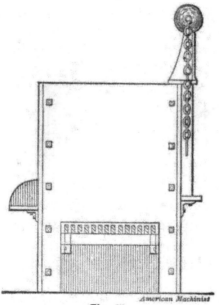

Fig. 17.

whole: this is done by thrusting down into the molten iron one or more green saplings. This, of course, creates a violent ebullition throughout the mass, and usually effects the desired result; but this, as well as the other operations, must be done with the utmost dispatch, otherwise cold air will rush into the furnace in sufficient quantity to neutralize every good effect which should accrue from these several important agencies.

Another hole is seen at *I*, Fig. 14, which enables the melter to take an occasional glimpse into the interior of the furnace, and being directly in range with the bed, he can materially accelerate the process of melting by separating such pieces as are welding together, as also by breaking up the more refractory ones: this hastens melting by increasing the surface upon which the flame can more effectually play.

The old saying that 'a stitch in time saves nine' applies with more than ordinary force to the management of these furnaces. A careful examination after each heat will reveal small and apparently insignificant faults. If these are at once remedied, these furnaces will not only last longer in good condition, but, as a natural consequence of their superior efficiency, will also melt hotter and better iron. Fig. 17 shows end view of furnace, opposite end to the chimney.

CASTING ONE HUNDRED TONS OF CAST IRON.

SHOWING THE CONSTRUCTION AND USE OF THE NECESSARY EQUIPMENT FOR POURING HEAVY CASTINGS; DAMS, RECEIVERS, AIR-FURNACES, LADLES, WITH TABLE OF CAPACITY OF ; RUNNERS, ETC.

CASTINGS weighing 100 tons and over are not made every day ; consequently there are very few foundries that may be considered as permanently equipped for such a task.

Strange as it may appear, whenever a casting of such magnitude is needed it is almost invariably made where the facilities for producing work of that description are far below the average.

One reason for this is that, on account of their extraordinary bulk, such pieces are difficult to handle and

ship; it becomes, therefore, very prudent to cast them as near as possible to the place for which they are intended.

I have in my mind a casting that weighed 185 tons: it was required for a steel-works, and was made in a foundry close by, with no facilities whatever for casting a piece of such massive proportions. Special cupolas of large capacity were erected for the production of the molten iron, and taken down again when the casting was completed.

But there are other difficulties in the way of the founder who may have been requested to produce this class of work, foremost of which is the fact that the ability of his workmen is not up to the standard of excellence that will warrant him in undertaking such jobs indiscriminately. He knows that to successfully melt and care for so large a quantity of molten iron something more than theoretic knowledge is required: there must be judgment, founded upon a wide experience in such matters, to insure success in all the various details connected with the process ; and he well knows that failure in any one of these details involves the loss of all.

If a casting requiring 100 tons of iron was ordered at a foundry where the facilities for melting were adequate to the task, and where they were provided with cranes, suitably located and of the requisite power for handling the whole amount in four ladles holding 25 tons each, the matter is then simple enough; but foundries with such ample facilities are few in number, and we must therefore continue to devise schemes that will accomplish the desired end without the aid of such extraordinary helps.

One chief help in accomplishing such a job in an ordinary foundry, and which might with profit be more generally adopted, is the dam, temporarily or permanently constructed, for the purpose of collecting therein a larger quantity of molten iron than could possibly be handled in ladles.

The reservoir of the reverberatory furnace can be utilized as a dam also, by enlarging its dimensions for special occasions, and always insures a supply of good hot iron proportionate to its capacity. This cannot be as confidently said of the dam erected on the foundry floor, because the condition of the iron in the latter will depend upon the length of time taken to melt the whole quantity, as well as its temperature when tapped or poured therein.

A thorough knowledge of the use of the dam will enable a very small foundry, with limited crane accommodations, to turn out some comparatively heavy work in a manner truly astonishing to those unaccustomed to their use.

In order to show the entire details connected with a cast of 100 tons, and to make plain the method by which this may with safety be accomplished in an ordinarily heavy workshop, I have made at Fig. 18 a rude sketch of that portion of the foundry which is occupied by the mould to be poured, as well as the arrangement of the means for pouring.

The mould, as will be seen, is round; and as the object of this writing is to explain the method of pouring only, none of the necessary appendages for building such a mould are shown, as they would have interfered too much with the direct view of the whole system to be explained.

Behind the wall, at A, is supposed to be a reverberatory furnace capable of holding 20 tons; and again behind the side wall, at B, are two cupolas, each of which melts 8 tons per hour: this would yield 48 tons in three hours, and is the amount required to fill the dam shown at C. It is unnecessary to say that the iron must be allowed to collect in the cupolas before they are tapped into the dam, and that the greatest effort be made to melt the hottest iron possible. The above is supplemented by the two crane ladles D and E, each holding 16 tons. For the

Fig. 18.

reasons previously explained, the bare shells only are shown.

This brings the total up to 100 tons of molten iron, which, if rightly managed, may be run into the mould with a dispatch that, to the uninitiated, appears marvellous.

The ladle E, as well as furnace and dam, connect directly with the main runner F, but the ladle D is supposed to supply a supplementary gate, which leads to the lowest portions of the mould, with the view of well covering such parts before the iron begins to drop down from the upper gates.

Very much of the trouble attending this method of pouring arises from the inadequate runner space provided. It is very important that all runners for this purpose should be capacious, and no effort should be spared to effect that object; the fewer the points which must be watched during the operation of pouring, the easier and safer will it be to conduct such operations.

The main runner, shown at F, Fig. 18, is supposed to be about 14 feet inside diameter, and if made 18 inches wide by 2 feet deep would hold about 20 tons; the margin of safety in such a runner as this is very large, and that is what it should be for a casting of such magnitude.

I have shown at Fig. 19 the correct form of runner best suited for work that is to be bored, and which must for obvious reasons be dropped from the top. It will be seen that a steep grade towards the inside is given at the bottom; this gives instant motion to the molten iron towards the runners, covering them at once, and thus preventing any possibility of their ' drawing air.'

Runners, spouts, and pouring basins for these occasions should be prepared in dry sand or loam, if absolute safety and clean work is aimed for. Figs. 20, 21 and 22 are plan and elevations of the requisite parts for constructing a box in which to form the basins, as seen at G and H,

Fig. 18. The end farthest from the ladle can be made open, as shown at Fig. 22; by so doing it becomes easy to make a connection with any other system of running which circumstances may necessitate.

The dam seen at *C*, Fig. 18, is supposed to be 8 feet 3 inches diameter and 4 feet deep, inside measurement, and will hold 48 tons, as before stated. It is provided with a shutter and lever for controlling the flow of iron, as seen; but in order that a better understanding of how to con-

Fig. 19. Fig. 20.

Fig. 21. Fig. 22.

struct such a dam may be arrived at, I have shown the same in plan and sectional elevation at Fig. 23.

For ordinary occasions, smaller dams can be more temporarily constructed and made up with old sand, if extra care be taken to prevent the bottom from being cut with the first iron; but for larger jobs, and especially for such a one as we now have under consideration, a strong casing of boiler-plates bolted together, as seen at *A*, must be provided, inside of which the dam must be formed by building loose bricks below until the course which forms the bottom is reached, when it is advisable to set these closer

together on a bed of loam : this will prevent any tendency to leakage.

The shutter shown at *B*, Fig. 23, may by some be thought too elaborate for such a purpose, but if they will

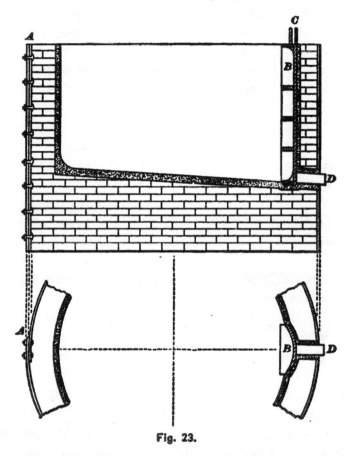

Fig. 23.

call to mind the numerous errors which have been made for want of a reliable shutter, they will hesitate before venturing an adverse criticism.

As seen, the shutter is a circular cast plate with strengthening ribs across; these ribs also serve to hold the firebricks, which must be built between them. The lugs shown at *C* connect with the lever used for raising and

lowering the shutter. The details of this arrangement are shown in plan and elevation at Fig. 24; the line at A representing the top of the dam, B the fixing (secured to the tank) which supports the lever C, and D the lugs which correspond to those seen at C, Fig. 23.

It is intended that the shutter shall be set in position with the 6-inch plug D, set behind when the wall is built and if proper provision is made it can be taken out (to facilitate drying) after the wall has been loamed over. When the shutter has been built around in the manner described, there remains little to be done in the way of fitting; after it has been bricked and loamed on the inside, let it be thoroughly dried and set back in its original position.

The round side being clean, there is very little friction; consequently it answers readily to the pressure of the lever, and enables the assistant to regulate the stream at will.

By an arrangement such as described above the hole may be made very large with safety: this, of course, leaves nothing to chance, as any degree of speed in pouring may be obtained by simply raising or lowering the shutter.

It is needless to say that all such dams as these must be thoroughly dried, and as near red-hot as possible when the first tap is made into them. As soon as the tap has been made, it is well to cover the surface of the iron with charcoal, the pieces of which are from 2 to 3 inches diameter, then fill the interstices with a finer sort, taking care that no open spots are left. As an extra precaution, cover the whole dam over the top with sheet-iron plates; by this means the iron can be kept in a good fluid condition for a very long time, providing it was hot from the start.

It will be noticed that the top of the runner is 2 feet above the floor: this, of course, means that the bottom of the dam must be as much above that level as will allow a

gradual and easy descent in the direction of the runner; also, if the great advantage of having the cupolas tapped

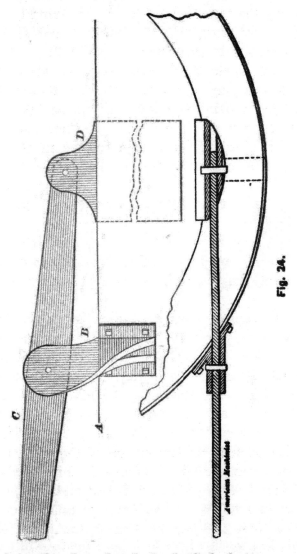

directly into the dam be desired, their bottoms must be slightly higher than the top of the dam, as seen at Fig. 18.

The crane ladles which would be required for this occasion are somewhat larger than those commonly used, and

for this reason it is well to notice some of the chief points which go towards making a good ladle.

Figs. 25, 26 and 27 are plans and elevation of a 16-ton ladle, which, when lined with brick and covered with a thin daubing of loam, must measure 54 inches diameter and 56 inches deep.

The gearing is preferably arranged so that the operator may stand on the side whilst he turns the ladle. Two very bad features in many geared ladles are corrected in the one shown; usually the bearing at *A*, Fig. 25, is too

Fig. 25.

short, in consequence of which both bearing and shaft are destroyed in quick time: this one is 12 inches long.

The other common error is to make the worm-wheel *B* too small in diameter: this makes it very hard to work, besides causing greater wear and tear on the rest of the machine; the worm-wheel for this ladle is 3 feet 6 inches diameter. By all means let all the parts of a geared ladle be machined in the best way: it is a mistake to think that anything else will do.

The shell is made of ⅜-inch boiler-plate, with a bottom

¼ inch thick, and the dimensions of the principal parts are as follows: Lifting eye (C), 9 inches by 4 inches, made from 3-inch round steel; beam (D), 10 inches deep in the middle, 2½ inches thick; slings (EF), 2½ inches diameter; middle band (G), 8 inches by 3 inches; shafts on band (H), 4 inches diameter; upper and lower bands (IJ), 6 inches by 1¼ inches; bottom bands (K), 6 inches by 1¼ inches; these latter cross each other underneath, as shown by broken lines in Fig. 25, and extend upwards to the middle band, resting thereon by a toe provided for the purpose, being further secured thereto by bolts, as seen at L, Fig. 26.

This form of lifting eye works more advantageously than any other: it is always in position for use, and the oval shape favors rapid handling, and is not as liable to fracture as round eyes are. Be sure that ¼-inch holes are drilled on the bottom for the escape of steam: this saves the bottom from raising when there is moisture lurking there.

The style of lip shown at M is to be recommended, on account of the favorable stream which is formed by it when pouring. It is well known that if the pouring is to be rapid from the start, most ladles at the beginning deliver the iron in a wide sheet, making it necessary to construct very wide basins: this form of lip controls the steam by preventing the spreading spoken of, and makes the operation of pouring much more pleasant.

It may be well to state just here that this style of ladle is the best for all sizes of crane ladles: all the difference to be made is to suit the strength to the capacity. I have a decided objection to all crane ladles that are not geared, for they are not only dangerous tools to work with, but they invariably require about 100 per cent more help to manage them.

It is wise to put a brick lining into all ladles down to 8

tons, below which capacity the bottom can be safely made by laying, first, about one inch of fine cinders, over which let two inches of soft silica sand be spread very evenly, and then rammed down hard. Such a bottom as this will never fail if the holes are kept open and the sand be thoroughly dried before using; an even daubing of one inch will suffice on the sides.

The following table gives the dimensions, *inside the lining,* of ladles from 25 pounds to 16 tons capacity, and will be found useful to all who do not care to make the necessary calculations. It will be well to notice that all the ladles are supposed to be straight ones, after the manner shown in the engravings.

Capacity.	Diameter.	Depth.
16 tons	54 inches.	56 inches.
14 "	52 "	53 "
12 "	49 "	50 "
10 "	46 "	48 "
8 "	43 "	44 "
6 "	39 "	40 "
4 "	34 "	35 "
3 "	31 "	32 "
2 "	27 "	28 "
1½ "	24½ "	25 "
1 "	23 "	22 "
¾ "	20 "	20 "
½ "	17 "	17 "
¼ "	13½ "	13½ "
300 pounds	11½ "	11½ "
250 "	10¾ "	11 "
200 "	10 "	10¼ "
150 "	9 "	9¼ "
100 "	8 "	8¼ "
75 "	7 "	7¼ "
50 "	6½ "	6½ "
35 "	5½ "	6 "
25 "	5 "	5¼ "

It will be natural to suppose that the ladles *D* and *E,* Fig. 18, have to be filled by means other than those we

have spoken of such; means may be one or perhaps two cupolas, in addition to the ones mentioned.

The correct time to start the several furnaces is an important matter, and should be figured out as closely as possible. This can always be done with a measurable de-

Fig. 26.

gree of certainty if the reverberatory furnace has been used previously, but should the latter be a new furnace, great care and judgment must be exercised to ascertain about how long it will take the 20 tons to melt. This done, the cupolas must be started at just such times as will bring about as even a finish as possible.

And now, supposing that the dam is full, the two ladles filled and in position, and all the iron melted in the re-

verberatory furnace, place a reliable man at the lever, who will be ready to obey orders, and have all the tools ready for opening the tap-hole at the reverberatory, should it prove refractory,—which will certainly not be the case if the instructions previously given for making up the tap-hole have been strictly followed out.

Let ladle *D* commence first to fill the bottom, and continue to pour until all is out. Immediately after the first ladle is started, open dam and furnace simultaneously, until the runner is about half full, when the dam may be checked, and allow the reverberatory to run clear out; but should it be found that the stream from the furnace is insufficient to keep up the requisite amount of head press-

Fig. 27.

ure, the dam can be kept open sufficient to effect this object, gradually increasing the speed at the dam as the stream slackens at the furnace, until when all the iron is out of the latter the dam may be emptied, and ladle *D* allowed to finish the cast.

The important object gained by distributing the iron as above described is, that the furnace, dam, and one of the ladles are sure of being cleaned out, thus leaving but one stream to attend to; the mould can then be filled to a nicety, without leaving too much iron in the runner.

Any surplus in the ladle can be used for other moulds which may have been purposely made for the occasion.

As it is barely possible to maintain the legitimate head pressure up to the last without leaving considerable iron in the runner, and as the runner in this case is unavoidably bulky, provision must be made for letting off the same into pig beds, formed in the immediate vicinity of the

mould, as seen at *I*, Fig. 18. This at once converts what would otherwise have been an ugly piece of scrap to deal with, into very desirable pig iron, which may be broken into smaller pieces whilst hot.

CASTINGS.

HOW TO OBTAIN THEIR MEASUREMENT AND RECKON THEIR WEIGHTS; ALSO, THE NATURE AND QUALITIES OF THE MATERIALS USED IN PRODUCING THEM, PERCENTAGE IN THE FOUNDRY, IMPORTANT FACTS, FORMULAS, TABLES, ETC.

EVERY moulder should be able to reckon the weight of the casting he makes; how many of us lack that ability need not be discussed here.

Some one says, "There is no royal road to learning." This is true indeed, and he who would obtain the ability to measure and weigh the work committed to his charge must at least master as much arithmetic and mensuration as will enable him to profitably utilize the rules laid down for his guidance in these matters.

To such as are ignorant altogether of these subjects the following short treatise on decimal fractions and kindred subjects will be of infinite service; for unless we know the meaning of the principal mathematical characters, the relation of vulgar to decimal fractions, with some knowledge of how to work these rules, all information of importance is denied us; as almost all formulas are expressed by these signs, and their solution can only be determined by correct rules.

It is not expected that even the most intelligent amongst

us will be prepared for the immediate solution of every arithmetical problem that presents itself during an active life in the foundry. No matter how thorough our education may have been at the first, rules and formulas will slip from the memory, and every day's experience gives additional evidence of the truth of the old adage, that "the key that rests, rusts." To the latter the following reminders will no doubt be found acceptable at times, and save an endless amount of annoyance.

The character or sign $=$ (called equality) denotes that the respective quantities between which it is placed are equal; as, 1 ton $=$ 2000 lbs. $=$ 32,000 oz.

The sign $+$ (called plus, or more) signifies that the numbers between which it is placed are to be added together; as, $9 + 6$ (read 9 plus 6) $= 15$. The sign $-$ (called minus, or less) denotes that the quantity which it precedes is to be subtracted; as, $15 - 6$ (read 15 minus 6) $= 9$.

The sign \times denotes that the numbers between which it is placed are to be multiplied together; as, 5×3 (read 5 multiplied by 3) $= 15$.

The sign \div signifies division; $15 \div 3$ (15 divided by 3) $= 5$. Numbers placed like a vulgar fraction also denote division, the upper number being the dividend and the lower the divisor; as, $\frac{15}{3} = 5$.

The signs : :: : (called proportionals) denote proportionality; as, $2 : 5 :: 6 : 15$; signifying that the number 2 bears the same proportion to 5 as 6 does to 15, or in other words, as 2 is to 5 so is 6 to 15.

The sign ——— (called the bar or vinculum) signifies that the numbers, etc., over which it is placed are to be taken together; as, $\overline{8 - 2 + 4} = 10$, or $\overline{6 \times 3 + 5} = 23$.

The sign . (called decimal point) signifies, when placed before a number, that that number has some power of 10 for its denominator. .1 is $\frac{1}{10}$, .17 is $\frac{17}{100}$, etc.

DECIMAL FRACTIONS.

In decimal fractions the whole number is supposed to be divided into ten equal parts, and every one of these ten parts is supposed to be subdivided into other ten equal parts, etc.

The whole numbers being thus divided (by imagination) into 10, 100, 1000, 10000, etc., equal parts, become the denominators to the decimal fractions; thus, $\frac{2}{10}$, $\frac{3}{100}$, $\frac{55}{1000}$, $\frac{754}{10000}$, etc.

Now these *denominators* are never set down, only the *numerators*, and they are either distinguished or separated from the *whole number* by a *point*, called the *decimal point*.

Thus 5.4 is $5\frac{4}{10}$, and 0.7 is $\frac{7}{10}$, 35.05 is $35\frac{5}{100}$, or 5 and decimal $\frac{4}{10}$, seven tenths, and 35 and decimal five one hundredths.

Before proceeding further in *notation*, it will be convenient for the *learner* to consider the following table, which shows the very foundation of decimal fractions:

WHOLE NUMBERS.							DECIMAL NUMBERS.						
7	6	5	4	3	2	1	.	2	3	4	5	6	7
Millions.	Hundreds of Thousands.	Tens of Thousands.	Thousands.	Hundreds.	Tens.	Units.	Units Place or Decimal Point.	Tens.	Hundredths.	Thousandths.	Ten-thousandths.	Hundred-thousandths.	Millionths.

The mixed number at the head of this table would read seven million six hundred and fifty-four thousand three hundred and twenty-one; and decimal, two hundred and thirty-four thousand five hundred and sixty-seven millionths.

By this table it is evident that as in *whole numbers* every degree from the *units* place increases towards the *left* hand by a *ten*fold proportion, so in *decimal parts* every degree is decreased towards the *right* hand by the same proportion, viz., by *tens*.

Therefore these *decimal parts*, or *fractions*, are really more *homogeneal* or agreeing with *whole numbers* than *vulgar fractions*, for all plain numbers are in effect but decimal parts one to another. That is, suppose any *series* of equal numbers, as 444, etc. The first 4 towards the *left* is ten times the value of the 4 in the *middle*, and that 4 in the middle is ten times the value of the last 4 to the right of it, and but the tenth part of that 4 on the left.

Therefore all of them may be taken either as whole numbers or part of a whole number: if whole numbers, then they must be set down without any decimal, or separating *point* between them; thus, 444. But if a whole number and one part, or fraction, place a point betwixt them thus, 44.4, which signifies 44 whole numbers and 4 tenths of a unit. Again, if two *places* of *parts* be required, separate them with a decimal point; thus, 4.44, viz., 4 units and 44 hundredths of a unit, or *one*.

From hence (duly compared with the table) it will be easy to conceive that *decimal parts* take their *denomination* from the place of their *last figure;* that is, $.5 = \frac{5}{10}$, $.56 = \frac{56}{100}$, and $.056 = \frac{56}{1000}$ *parts* of a *unit*.

Ciphers annexed to decimal parts do not alter their value; as, .50 and .500 or .5000, etc., are each but 5 tenths of a unit, for $\frac{50}{100} = \frac{5}{10}$, and $\frac{500}{1000} = \frac{5}{10}$, or $\frac{5000}{10000} = \frac{5}{10}$.

But *ciphers prefixed* to decimal parts *decrease* their value by removing them further from the decimal point; thus, 5 = 5 tenths, .05 = 5 hundredths, .005 = 5 thousandths, and .0005 = 5 ten thousandths; consequently, the true value of all decimal fractions, or parts, are known by their distance from the *units* place, which being rightly understood, the rest will be easy.

ADDITION AND SUBTRACTION OF DECIMALS.

In setting down the proposed numbers to be added or subtracted great care must be taken to place every figure directly underneath those of the same *value*, whether they be mixed numbers or pure decimal parts, and to perform that due regard must be had to the *decimal points* which ought always to stand in a direct line under each other and to the right hand of them carefully place the *decimal parts*, according to their respective values or distance from unity.

Rule.—Add or subtract as if they were all whole numbers, and from their *sum* or *difference* cut off as many *decimal parts* as are the most in any of the given numbers.

ADDITION.

Examples.—Let it be required to find the sum of the following numbers:

$$\begin{array}{r} 34.5 \\ 65.3 \\ 128.7 \\ 95.0 \\ 87.8 \\ 7.9 \\ \hline \end{array}$$

Answer................ 419.2

When the decimal parts proposed to be added (or subtracted), do not have the same number of places, you may,

for convenience of operation, fill the void places by annexing ciphers.

Without ciphers.	With ciphers
45.07	45.0700
50.758	50.7580
123.0057	123.0057
74.702	74.7020
24.8	24.8000
Ans. 318.3357	Ans. 318.3357

EXAMPLES IN SUBTRACTION.

			Without ciphers.	With ciphers.
From....	437.5	75.0534	562.	562.0000
Take.....	89.657	57.875	93.5784	93.5784
Remains..	347.843	17.1784	468.4216	468.4216
From....	345.7578	345.7578	0.547893	1.000000
Take.....	157.	157.0000	0.439758	0.997543
Remains..	188.7578	188.7578	0.108135	0.002457

MULTIPLICATION OF DECIMALS.

Whether the numbers to be multiplied are *pure* decimals or *mixed*, multiply them as if they were all whole numbers, and for the true value of their *product* observe this

Rule.—Cut off—that is, separate by the decimal point—as many places of decimal parts in the *product* as there are decimal parts in the multiplier and multiplicand counted together.

CASTINGS. 87

EXAMPLES.

(1) Multiply 3.024 by 2.23. (2) Multiply 32.12 by 24.3.

```
    3.024              32.12
    2.23                2.43
   ------             -------
    9072               9636
    6048              12848
    6048               6424
   ------             -------
 6.74352, ans.      780.516, ans.
```

The reason why such a number of decimal parts must be cut off in the *product* may be easily deduced from these examples.

In example 1, it is evident that 3, the *whole number* in the *multiplicand*, being multiplied with 2, the *whole number* in the multiplier, can produce but 6 (viz., $3 \times 2 = 6$); so that of necessity all the other *figures* in the *product* must be *decimal parts*, according as the rule directs. Or, the rule is evident from the multiplication of *whole numbers* only. Thus, suppose 3000 were to be multiplied with 200, their product will be 600.000; that is, there will be as many *ciphers* in the product as there are in both *multiplier* and *multiplicand*; now, if instead of those ciphers in the multiplier and multiplicand we suppose the like number of *decimal parts*, then it follows that there ought to be the same number of decimal parts in the product as there were ciphers in both factors.

Again, the rule may be otherwise made evident from vulgar fractions; thus, let 32.12 be multiplied with 24.3 and their product will be 780.516, as in example 2, above. Now $32.12 = 32\frac{12}{100}$, and $24.3 = 24\frac{3}{10}$, which being brought into *improper* fractions, will become $32\frac{12}{100} = \frac{3212}{100}$, and $24\frac{3}{10} = \frac{243}{10}$. Then $\frac{3212}{100} \times \frac{243}{10} = \frac{780516}{1000}$, but $\frac{780516}{1000} = 780\frac{516}{1000}$, viz., 780.516, as before. Any of these three ways sufficiently prove the truth of the above said rule, etc.

It sometimes happens that in multiplying *decimal parts* with *decimal parts*, there will not be as many *figures* in the *product* as there ought to be *places* of *decimal parts*, by the *rule*. In that case you must supply their *defect* by *prefixing ciphers* to the *product*, as in these examples:

```
     .2365            .0347
     .2435            .0236
    ------           ------
    11825             2082
     7095             1041
     9460              694
     4730            ------
   ------           .00081892
   .05758775
```

When any proposed number of decimals is to be multiplied with 10, 100, 1000, 10000, etc., it is only removing the decimal point in the multiplicand so many places to the right hand as there are ciphers in the multiplier. Thus, $.578 \times 10 = 5.78$. And $.578 \times 100 = 57.8$. Again $.578 \times 1000 = 578$.

DIVISION OF DECIMALS.

Division is accounted the most difficult part of decimal arithmetic. In order, therefore, to make it plain, it will be best to examine the chief principles of the *rule*.

Division is the rule by which one number may be speedily subtracted from another as many times as it is contained therein; that is, it speedily discovers how often one number is contained in another, and to perform that there are *two numbers* required to be given. One of them is that *number* which is proposed to be *divided*, and is called the *dividend;* the other is that *number* by which the said *dividend* is to be *divided*, and is called the *divisor*. By comparing these two, viz., the *dividend* and the *divisor* together, there arises a third number called the *quotient*,

which shows how often the *divisor* is *contained* in the *dividend*, or into what number of *equal* parts the *dividend* is then *divided*.

The *quotient* figure is always of the same value or degree, with that figure of the *dividend* under which the *units* place of its *product* stand. As for instance, let 294 be divided by 4, thus:

<div style="margin-left:2em;">
Divisor. Dividend. Quotient.

4) 294 (7 { This is not 7, but 70, because the units place of 4×7 stands under the tens place of the dividend.
 28
 ―――
 14 (3 This is only 3.
 12
 ―――
 2, remainder. Hence 73½ is the quotient.
</div>

Now if to the remainder 2 there is annexed a cipher (thus, 2.0), and then divided on, it must needs follow that the *units* place of the product arising from the *divisor* into the *quotient* will stand under the *annexed cipher;* consequently, the quotient figure will be of the same *value* or degree with the *place* of that *cipher*. But that is the next below the *units place*, therefore the quotient figure is of the next degree, or place below unity; that is, in the first place of *decimal parts*, thus, 4)2.0(.5; so that 4)294.0(73.5, the true quotient required.

This being well understood, division of decimals may in all the various cases be easily performed.

Definition.—If that *number* which *divides* another be *multiplied* with another *number* which is *quoted*, their *product* will be the *number divided*.

This definition alone, if compared with the rule for multiplication, will afford a general rule for discovering the true value of the quotient figure in division of decimals.

GENERAL RULE.

The place of decimal parts in the divisor and quotient being counted together, must always be equal in number with those of the dividend.

From this *general rule* ariseth four *cases*.

CASE 1.—When the places of *parts* in the divisor and dividend are equal, the quotient will be *whole numbers*, as in these

EXAMPLES.

```
8.45) 295.75 (35, ans.        0.0078) .4368 (56, ans.
      2535                            390
      ----                            ---
      4225                            468
      4225                            468
```

CASE 2.—When the places of parts in the dividend exceed those in the divisor, cut off the *excess* for decimal parts in the quotient, as in these

EXAMPLES.

```
24.3) 780.516 (32.12            436) 34246.056 (78.546
      729                            3052
      ---                            ----
      515                            3726
      486      .534) .30438 (.57    3488
      ---            2670           ----
      291            ----           2380
      243            3738           2180
      ---            3738           ----
      486                           2005
      486                           1744
                                    ----
                                    2616
                                    2616
```

CASE 3.—When there are not so many places of decimals in the dividend as are in the divisor, annex ciphers to the dividend to make them equal. Then the quotient will be whole numbers as in case 1.

Examples.—Let it be required to divide 192.1 by 7.684 and 441 by .7875.

```
7.684)192.100(25, ans.        .7875)441.0000(560, ans.
      153 68                         393 75
      ------                         ------
       38 420                         47 250
       38 420                         47 250
```

CASE 4.—If, after division is finished, there are not so many figures in the quotient as there ought to be places of decimals by the general rule, *supply their defect by prefixing ciphers to it.*

Examples.—Let it be required to divide 7.25406 by 957.

957)7.25406(758, or with ciphers prefixed, as per rule,

```
   6 699            .00758, the true quotient.
   -----
    5550
    4785
    ----
    7656
    7656
```

Divide .0007475 by .575.

.575).0007475(13 or .0013, the true quotient required.
```
     575
     ---
    1725
    1725
```

Note.—When decimal numbers are to be divided by 10, 100, 1000, 10000, etc., that is, when the divisor is a unit with ciphers, division is performed by removing or placing

the decimal point in the dividend so many places towards the left hand as there are ciphers in the divisor; thus,

$$10)5784(578.4, \quad 100)5784(57.84,$$
$$1000)5784(5.784, \quad 10000)5784(.5784, \text{ etc.}$$

It will be seen that these operations are the direct converse to those at the end of multiplication.

TO REDUCE VULGAR FRACTIONS TO THEIR EQUIVALENT DECIMALS, AND THE CONTRARY.

Any vulgar fraction being given, it may be reduced or changed into decimal parts equivalent to it; thus:

Rule.—Annex ciphers to the numerator and then divide it by the denominator; the quotient will be the decimal parts equivalent to the given fraction, or at least so near it as may be thought necessary to approach.

Examples.—It is required to change or reduce ¾-inch into the decimal of an inch.

OPERATION.

4)3.00(.75, ans. The decimal parts required, that is,
 2 8 $\frac{3}{4} = \frac{75}{100} = .75$ inch.
———
 20
 20

Again, $\frac{1}{2} = .5$, thus 2)1.0(.5; and $\frac{1}{4} = .25$, thus 4)1.00(.25.

Suppose it were required to change $\frac{4}{7}$ into decimals:

$$7)4.0000000000(.5714285714 + = \tfrac{4}{7}.$$

Note.—When the last figure of the divisor (that is, the denominator of the proposed fraction) happens to be one of these figures, viz., 1, 3, 7, or 9, as in this example, then the decimal parts can never be precisely equal to the given fraction, yet by continuing the division on you may bring them to be very near the truth.

For all practical purposes in the foundry, *three places*

of *decimals* are sufficiently near, the operation being considerably shortened by leaving out the rest.

When a decimal does not terminate as in the example above, the sign plus (+) is annexed, which indicates that the division could be continued.

TO REDUCE A DECIMAL TO A COMMON FRACTION.

Rule.—Erase the decimal point and write under the numerator its decimal denominator and reduce the fraction to its lowest term.

Example.—Reduce .125 inch to its equivalent common fraction.

Operation.—$.125 = \frac{125}{1000} = \frac{25}{100} = \frac{5}{40} = \frac{1}{8}$ inch, ans.

TO REDUCE A SIMPLE OR COMPOUND NUMBER TO A DECIMAL OF A HIGHER DENOMINATION.

Rule for Simple Number.—Divide by the number of parts in the next higher denominations, continuing the operation as far as required.

Example.—Reduce 1 foot to the decimal of a yard.

$$3 | \underline{1.000}$$
$$.333 + \text{yard, ans.}$$

Rule for Compound Numbers.—Reduce them all to the lowest denomination, and proceed as for one denomination.

Example.—Reduce 15 feet 9¾ inches to the decimal of a yard.

OPERATION.

feet.	inches.	qrs.
15	9	3

12 in. = 1 foot.
───────
189

4 qrs. = 1 inch.
4 | 759.00
12 | 189.7500
3 | 15.8125
───────
5.2708 + yard, ans.

TO FIND THE VALUE OF A DECIMAL IN WHOLE NUMBERS OF LOWER DENOMINATIONS.

Rule.—Multiply the decimal by that number which will reduce it to the next lower denomination, and point off as in multiplication of decimals.

Then multiply the decimal part of the product, and point off as before. So continue till the decimal is reduced to the denomination required.

The several whole numbers of the successive products will be the answer.

Examples.—1. What is the volume of .140 cubic feet in inches?

OPERATION.

```
   .140
  1728 cubic inches = 1 cubic foot.
  ─────
  1120
   280
   980
   140
  ─────
  241.920 cubic inches, ans.
```

2. What is the value of .00129 of a foot, and also the value of .015625 of an inch?

OPERATION.	OPERATION.
.00129	.015625
12 inches = 1 foot.	64
─────	─────
.01548 inches, ans.	62500
	93750
	─────
	Answer. 1.000000 = $\frac{1}{64}$ of an in.

By the same rule .75 of a foot = 9 inches, .25 of a ton = 500 lbs., .5 of an inch = $\frac{1}{2}$ inch, .0625 of an inch = $\frac{1}{16}$ inch, etc.

The following table of equivalents (found by the foregoing rules) will be found very useful:

VULGAR FRACTIONS OF 1, OR UNITY, AND THEIR DECIMAL EQUIVALENTS.

$\frac{1}{64} = .015625$	$\frac{5}{16} = .3125$	$\frac{11}{16} = .6875$
$\frac{1}{32} = .03125$	$\frac{3}{8} = .375$	$\frac{3}{4} = .75$
$\frac{1}{16} = .0625$	$\frac{7}{16} = .4375$	$\frac{13}{16} = .8125$
$\frac{1}{8} = .125$	$\frac{1}{2} = .5$	$\frac{7}{8} = .875$
$\frac{3}{16} = .1875$	$\frac{9}{16} = .5625$	$\frac{15}{16} = .9375$
$\frac{1}{4} = .25$	$\frac{5}{8} = .625$	$1 = 1.0000$

EXPLANATION OF THE RULES IN MENSURATION USED FOR FINDING THE WEIGHTS OF CASTINGS OF ALL SHAPES AND DIMENSIONS.

Before we can rightly apply the foregoing rules in arithmetic to the determining of the weights of castings, we must first ascertain the number of *cubic* inches contained in the object. Then by referring to the *table of weights* and *strength of material* (found near the end of this chapter, we find, in the first column, the weight of one *cubic inch* of whatever metal we are going to cast with. This is used as a *multiplier*, and gives us the exact weight in pounds avoirdupois of the total number of cubic inches contained in the casting.

To obtain correctly the number of cubic inches of castings more or less irregular in shape, it is necessary that the operator should have some little knowledge of *mensuration;* but as most of the books devoted to that subject are written for the high schools and colleges, in language hard to understand by the unlearned, the information they contain seldom reaches the ordinary moulder; in fact, boys fresh from school who enter our foundries are not always sufficiently advanced in their studies to know very much of this

subject. It not unfrequently happens that older boys with a knowledge of the rules in mensuration firmly fixed in their minds fail in making a practical application of their schooling when in the foundry.

In order to make this subject plain to such as are ignorant of the rules in mensuration, I propose to give as many (full) examples as will enable the student to calculate the exact weight of every description of casting, and as a means of impressing the subject more firmly on his mind, every example will be accompanied by a full explanation of the rules which govern each particular case.

The following definitions, properly understood, will materially help the understanding, and make the study of these subjects much more easy and pleasant.

Mensuration.—Mensuration is the process of determining the *areas* of *surfaces* and the *solidity* or *volume* of *solids*.

A *plane* figure is an enclosed *plane surface;* if bounded by *straight lines* only, it is called a *rectilineal* figure or *polygon*.

The *perimeter* of a figure is its *boundary* or *contour*.

Three-sided *polygons* are called *triangles*, those of *four* sides *quadrilaterals*, those of *five* sides *pentagons*, etc.

Triangles.—An *equilateral triangle* is one whose *sides* are all *equal*, as *CAD*, Fig. 28.

Note.—The line *AB* drawn from the angle *A*, perpendicular to the base *CD*, is the altitude of the triangle *CAD*.

An *isosceles triangle* is one which has *two* of its *sides* equal, as *EFG*, Fig. 29.

A *scalene triangle* is one which has its *three sides* unequal, as *HIJ*, Fig. 30.

A *right-angled triangle* is one which has a *right angle*, as *KLM*, Fig. 31.

To Find the Area of a Triangle.—Multiply the base by half the altitude and the product will be the area.

Now, supposing we have a casting answering to the form of an equilateral triangle, Fig. 28; the base CD measuring 36 inches, the altitude AB 24 inches, and the thickness 3 inches, what weight will such a casting be in cast iron? We proceed thus:

OPERATION.

Base..............................	36
Half of altitude................	12
Total area in superficial square inches.........................	432
Thickness in inches.............	3
Total cubic inches.............	1296
Weight of a cubic inch, cast iron..	.263

$$\begin{array}{r} 3888 \\ 7776 \\ 2592 \end{array}$$

Total weight in pounds..340.848, ans., nearly 341 lbs.

If we desire to ascertain the weight of such a casting in gold, we simply find the weight of a cubic inch of gold, in the table, viz., .696 for a multiplier, and proceed thus: $1296 \times .696 = 902.016$, or slightly over 902 pounds for gold.

Castings having the form of an isosceles triangle, Fig. 29, are to be figured as in the preceding example.

All such as take the form of a scalene triangle, Fig. 30, must be proceeded with after this manner: Let a perpendicular be drawn from I to the base, and proceed to form a rectangle about the figure, as shown by the broken lines. You now have two rectangles, one on each side of the perpendicular from I, and, as *triangle is equivalent to one half of a rectangle having an equal base and an equal al-*

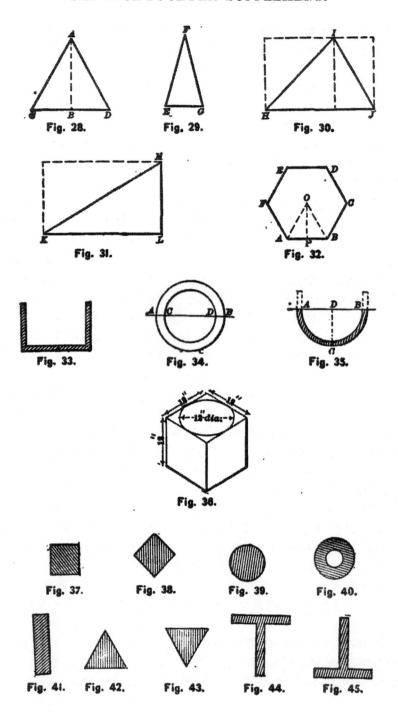

titude with the triangle, it is evident that one half each of the rectangles added together will give the area of such a triangle.

This once properly understood makes the mensuration of angles very simple. Of course, when the superficial area of all such figures is procured, it only remains to multiply by the number of inches thick, and then by the weight of a cubic inch, as before directed, to obtain the exact weight in pounds.

This brings us to the right-angled triangle, Fig. 31, which, as seen by the broken lines, is but the half of the rectangle whose base is KL and sides LM; therefore, if the weight of a casting is required that has the form of a right-angled triangle, multiply the base KL by the altitude LM, and divide the product by 2 for the area, then proceed as in the preceding cases for total cubic inches and weight.

It will be clearly understood from the above that the area of all quadrilateral figures whose opposite sides are parallel, such as the square, rhombus, rhomboid, and rectangle, is found by multiplying the base with the altitude.

Regular polygons are named after the number of sides contained in the figure, those with 3 sides being *triangle*; 4, *square*; 5, *pentagon*; 6, *hexagon*; 7, *heptagon*; 8, *octagon*; 9, *nonagon*; 10, *decagon*; 11, *undecagon*, and 12, *duodecagon*.

The rule for finding the area of a regular polygon is the same for any number of sides, so that one illustration will be sufficient to show how all such castings may be measured and their respective weights found.

RULE TO FIND THE AREA OF POLYGONS.

Multiply the sum of the sides or perimeter of the polygon by the perpendicular, demitted from its centre to one of its sides, and half the product will be the area.

Example.—Required the weight of a casting, in iron, having the form of a regular hexagon *ABCDEF*, Fig. 32, whose side *AB* is 20½ inches, and perpendicular *PO* is 17¾ inches, thickness 1 inch.

<center>OPERATION.</center>

Length of side *AB*.....................	20.5
Number of sides.......................	6
Sum of sides..........................	123.0
Length of perpendicular...............	17.75

$$\begin{array}{r} 6150 \\ 8610 \\ 8610 \\ 1230 \end{array}$$

½ | 2183.250, product.

Half of product—area...............	1091.625
Weight of a cubic inch, cast iron....	.263

$$\begin{array}{r} 3274875 \\ 6549750 \\ 2183240 \end{array}$$

Total weight in lbs........... 287.096375, ans.

If such a casting were wanted 1 inch thick in lead, then the area, 1091.625 inches, must be multiplied by .410, the weight of a cubic inch of that metal, as found in the first column of the table before mentioned.

<center>THE CIRCLE.</center>

Before attempting to determine the weights of castings that are circular in shape, it will be necessary to explain

some of the very important principles connected with this interesting figure. These thoroughly understood will make a solution of the problems much easier.

In the first place, there is no figure that affords a greater variety of useful properties than the circle, nor is there any that contains so large an area within the same perimeter or outer boundary.

TO FIND THE CIRCUMFERENCE AND DIAMETER OF A CIRCLE.

The circumference of a circle is found by multiplying the diameter by 3.1416.

The diameter of a circle is found by multiplying the circumference by .31831, or dividing by 3.1416.

Examples.—If the diameter of a circle be 12 feet, what is the circumference?

OPERATION.

Decimal multiplier 3.1416
Diameter........................ 12
―――――
Circumference required............ 37.6992 feet, ans.

If the circumference of a circle be 45 feet, what is the diameter?

OPERATION.

Decimal multiplier................ .31831
Circumference..................... 45
―――――
159155
127324
―――――
Diameter required................ 14.32395 feet, ans.

TO FIND THE AREA OF A CIRCLE.

Rule.—Multiply the *square* of the *diameter* by .7854 and the *product* will be the area.

Note.—The square of any number is that number multiplied by itself, as 12 × 12 = 144, etc.

Example.—What is the area of a circle whose diameter is 106?

OPERATION.

Diameter..................................	106
	106
	636
	1060
Square of diameter......................	11236
Decimal multiplier........................	.7854
	44944
	6180
	89888
	78652
Total area...............................	8824.7544, ans.

A right application of the rules for circumference, diameter, and areas of circles will enable us to arrive at the correct weight of any cylindrical castings, such as pipes, columns, wheel-rims, cylinders, etc., as well as circular plates and solids.

Again, a combination of all the rules is practically all that is needed for ascertaining the weight of all flat-bottomed tanks, backs, boilers, pans, etc., either round or square, as well as solids of similar form.

Let us proceed to find the weight of an 18-inch round

column 1¼ inches thick and 10 feet long. In order to obtain the correct weight it is necessary that we take the centre or middle of the thickness for our line of diameter or circumference; so it is customary to add the thickness of the casting to the inner diameter and by this means obtain the correct working diameter, but this is when we speak of castings such as cylinders, pipes, etc., the size of which are based on the inside diameter and not on the outside, as is the case in columns, wheel-rims, etc.

In the latter case it becomes necessary to subtract the thickness from the outside diameter, which, when done, makes the operation of finding the weight of an 18-inch column equivalent to finding the weight of a 15-inch pipe of the same thickness.

TO FIND THE WEIGHT OF CYLINDERS, PIPES, WHEEL-RIMS, ROUND COLUMNS, ETC.

Rule 1.—For castings the size of which is based on the *inside* measurement.

To the inner diameter *add* the thickness of metal, *multiply* by 3.1416 for *circumference* and the *product* by the *thickness*. This gives the number of superficial inches contained in the end section of the casting, which, when multiplied by the length, gives the total cubic inches contained in the whole, the weight of which is obtained by multiplying by the weight of a cubic inch of the metal to be used (found in the first column of table).

Rule 2.—For castings, the size of which are based on the outside measurement.

From the outer diameter subtract the thickness of metal and continue the operation as directed in Rule 1.

Example.—What is the weight (in cast iron) of a column 18 inches in diameter, 1¼ inches thick, and 10 feet long?

OPERATION.

Diameter of column in inches............ 18
Subtract thickness...................... 1.5 = 1½ in.

Working diameter.................... 16.5
Decimal multiplier for circumference.. 3.1416

$$\begin{array}{r} 990 \\ 165 \\ 660 \\ 165 \\ 495 \end{array}$$

Circumference..................... 51.83640
Thickness........................ 1.5 = 1½ in.

$$\begin{array}{r} 25918200 \\ 5183640 \end{array}$$

Superficial inches in end section... 77.754600
One foot in length............... 12

Cubic inches in 1 foot long...... 933.055200
.26 = weight cu. in.

$$\begin{array}{r} 5598331200 \\ 1866110400 \end{array}$$

Weight of 1 foot long........ 242.59435200
10

Total weight in pounds... 2425.94352000, ans.

Note.—The decimal multiplier is here changed from .263 lb. to .26 lb. This shortens the sum considerably without much loss practically.

Thus making the total weight of a column 18 inches diameter, 1½ inches thick, and 10 feet long, to be 2426 pounds, nearly.

CASTINGS. 105

It will be seen that I first get the weight of one foot in length, which is found to be 242¼ pounds, and then multiply by length of the column. This is a very good plan, as it furnishes very useful data for future reference.

What is the weight of a cast-iron ring or cylinder 86 inches inside diameter, 2 inches thick, and 12 inches deep?

OPERATION.

```
Inside diameter of ring..........................8 6
Thickness added.................................  2
Working diameter..............................8 8
Decimal multiplier for circumference.......3.1 4 1 6
                                         5 2 8
                                           8 8
                                         3 5 2
                                           8 8
                                       2 6 4
Circumference.......................2 7 6.4 6 0 8
Thickness............................           2
Superficial inches in end section..........5 5 2.9 2 1 6
Twelve inches long......................         1 2
Cubic inches in 12 inches long........6 6 3 5.0 5 9 2
Weight of a cubic inch...............         .2 6
                                       3 9 8 1 0 3 5 5 2
                                     1 3 2 7 0 1 1 8 4
Total weight...................1 7 2 5.1 1 5 3 9 2, ans.
```

Thus making the weight of this casting 1726 pounds, nearly.

We come now to the consideration of circular plates and circular solids; to ascertain the weight of which, the rule for finding the area of a circle is to be practically applied.

TO FIND THE WEIGHT OF CIRCULAR PLATES AND CIRCULAR SOLIDS, CAPACITY OF LADLES, ETC.

Rule.—Multiply the square of the diameter by .7854 for the superficial area, in square inches, and the product by

the thickness for the total cubic inches. This product multiplied by the weight of a cubic inch will give the weight in pounds avoirdupois.

Example.—Find the weight of a circular plate, in cast iron, the diameter of which is 90 inches and thickness 2½ inches.

OPERATION.

```
Diameter.............................. 9 0
                                       9 0
                                     ─────
Square of diameter..................8 1 0 0
Decimal multiplier for area............ .7 8 5 4
                                     ─────────
                                     3 2 4 0 0
                                      ·4 0 5 0 0
                                     6 4 8 0 0
                                     5 6 7 0 0
                                     ─────────
Total area in square inches......6 3 6 1.7 4 0 0
Total area in square inches......6 3 6 1.7 4 0 0
Weight of a cubic inch.............       .2 6
                                     ─────────
                                     3 8 1 7 0 4 4 0 0
                                     1 2 7 2 3 4 8 0 0
                                     ─────────
Weight at 1 inch thick ........1 6 5 4.0 5 2 4 0 0
Thickness...................          2.5 = 2½ in.
                                     ─────────
                                     8 2 7 0 2 6 2 0 0 0
                                     3 3 0 8 1 0 4 8 0 0
                                     ─────────
Total weight at 2½ in. thick.4 1 3 5.1 3 1 0 0 0 0, ans.
```

Showing the weight to be a trifle over 4135 pounds.

It will be noticed that instead of multiplying by the whole thickness, I first ascertain the weight at one inch thick. This, as before observed, serves as data by which to ascertain the weight at 90 inches diameter of solids at any depth whatever; thus:

What is the weight of circular solid 90 inches diameter and 24 inches deep?

CASTINGS.

OPERATION.

Weight of plate 90 in. diameter, 1 in. thick,
as found above........................1 6 5 4.0 5 +
Depth in inches............................ 2 4
 ─────────
 6 6 1 6 2 0
 3 3 0 8 1 0
 ─────────
Weight in pounds....................3 9 6 9 7.2 0

Showing that a circular solid 90 inches diameter and 2½ inches deep weighs a little over 39697 pounds.

It will be seen how, by this rule, it becomes an easy matter to measure the capacity of any ladle when the diameter and depth are known.

TO COMPUTE THE CAPACITY OF LADLES.

Examples.—Required the capacity of a ladle, the diameter of inside of lining *averaging* 2 feet and depth 2 feet.

OPERATION.

Diameter inside lining, in inches.................2 4
 2 4
 ─────
 9 6
 4 8
 ─────
Square of diameter........................5 7 6
 .7 8 5 4
 ─────────
 2 3 0 4
 2 8 8 0
 4 6 0 8
 4 0 3 2
 ─────────
Area in square inches..................4 5 2 3 9 0 4
Depth in inches......................... 2 4
 ─────────
 1 8 0 9 5 6 1 6
 9 0 4 7 8 0 8
 ─────────
Total cubic in. of space...........1 0 8 5 7.3 6 9 0
Weight of a cubic inch............. .2 6
 ─────────
 6 5 1 4 4 2 1 4 0
 2 1 7 1 4 7 3 8 0
 ─────────
Total capacity....2 8 2 2.9 1 5 9 4 0, ans.

Showing the total capacity of the ladle to be nearly 2823 pounds.

What was said with regard to the application of the rules relating to circumference and area for obtaining the weight of flat-bottomed tanks and pans will be here illustrated.

TO FIND THE WEIGHT OF FLAT-BOTTOMED TANKS, PANS, ETC.

Example.—What is the weight of a flat-bottomed pan, similar to Fig. 33, 86 inches diameter and 30 inches deep inside measurement, the bottom to be $2\frac{1}{2}$ inches and the side 2 inches thick.

We have already found the weight of the bottom, or plate 90 inches diameter, $2\frac{1}{2}$ inches thick to be 4135.1 + pounds and the ring 86 inches inside diameter, 1 foot long was 1725.1 pounds. The latter multiplied by $2\frac{1}{2}$, the inside depth, gives 4312.75 pounds, which sum added to 4135.1, the weight of the bottom, makes the total weight of such a pan 8448 pounds, nearly; thus:

Weight of 1 foot on length of side..1 7 2 5.1
$\qquad\qquad\qquad\qquad$ 2.5 = 30 in. or $2\frac{1}{2}$ ft.
$\qquad\qquad\qquad\qquad$ ─────
$\qquad\qquad\qquad\qquad$ 8 6 2 5 5
$\qquad\qquad\qquad\qquad$ 3 4 5 0 2
$\qquad\qquad\qquad\qquad$ ─────
Total weight of side or ring.4 3 1 2.7 5
Weight of bottom....4 1 3 5.1
$\qquad\qquad\qquad\qquad$ ─────
Total weight of pan........8 4 4 7.8 5, ans.

TO FIND THE WEIGHT OF A CIRCULAR RING INCLUDED BETWEEN THE CIRCUMFERENCE OF TWO CONCENTRIC CIRCLES, AB AND CD, FIG. 34.

Rule.—Multiply the sum of the *two diameters* by *their difference* and this *product* by .7854 for the *area*. Then

CASTINGS. 109

multiply the *area* by the *thickness* and again by the weight of a *cubic inch;* the *product* will be the weight of the ring in pounds.

Example.—Required the weight of a circular ring with *outside* diameter 72 inches and inside diameter 58 inches, and 2¾ inches thick.

OPERATION.

```
                                         7 2
                                         5 8
                                        ─────
Sum of the two diameters..................1 3 0
Difference of the two diameters............ 1 4
                                        ─────
                                         5 2 0
                                         1 3 0
                                        ─────
                                         1 8 2 0
Decimal multiplier for area..............  .7 8 5 4
                                        ─────
                                         7 2 8 0
                                         9 1 0 0
                                      1 4 5 6 0
                                      1 2 7 4 0
                                      ─────────
Area in superficial square inches...1 4 2 9.4 2 8 0
Thickness......................           2.7 5 = 2¾ in.
                                      ─────────
                                      7 1 4 7 1 4 0 0
                                      1 0 0 0 5 9 9 6 0
                                      2 8 5 8 8 5 6 0
                                      ─────────
                                         3 9 3 0.9 2 7
Weight of a cubic inch........              .2 6
                                      ─────────
                                         2 3 5 8 5 5 6 2
                                         7 8 6 1 8 5 4
                                      ─────────
   Total weight...............1 0 2 2.0 4 1 0 2, ans.
```

Which gives the total weight of the ring about 1022 pounds.

Note.—The rule for the above example may not be very clear to those unaccustomed to mathematical terms. For the benefit of such I would say that "the sum of the two diameters" means that the diameters 72 and 58 are to be added together. As seen, this gives a total of 130. "Their difference" means that the lesser, or 58, is to be substracted from 72, the greater, and the remainder or "difference," 14, used as a multiplier.

TO FIND THE WEIGHT OF KETTLES OR PANS WITH SPHERICAL OR ROUND BOTTOMS, ETC.

In order to make this subject as plain as possible it will be necessary to explain how the area of a sphere is found.

The surface of a sphere is equal to the convex surface of the circumscribing cylinder. This simply means that the surface of a sphere is equal to the outer surface of a cylinder whose diameter and height are both equal to the diameter of the sphere; hence the rule to find the surface of the sphere is, *to multiply the circumference by the diameter.* Consequently, when we would determine the weight of a pan that, like Fig. 35, is an exact half sphere, we have only to multiply the circumference at the mouth, *AB,* by the depth, at *CD,* which in this case is just one half the diameter.

Rule.—To the inner diameter at *AB* add the thickness, then multiply by 3.1416 to obtain the circumference, and multiply this product by the height at *BC,* and again by the thickness for the total cubic inches, which, if multiplied by the weight of a cubic inch, will give the weight in pounds.

Example.—Required the weight of a spherical pan which is an exact half-sphere (like Fig. 35). The inside diameter at *AB* to be 72 inches and the thickness 2 inches.

CASTINGS. 111

OPERATION.

Inside diameter...............................	72
Thickness added.......	2
	74
Multiplier for circumference...............	3.1416

```
            444
             74
            296
             74
            222

         232.4784
```
Full depth at *DC*...................... 38

```
        18598272
         6974352

         8834.1792
```
Thickness........................... 2

Total cubic inches 17668.3584
Weight of a cubic inch26

```
        1060101504
         353367168
```

Weight in pounds............... 4593.773184, ans.
Or nearly 4594 pounds.

Any added depth to the body of such a pan would simply increase the multiplier for depth; for instance, if 22 inches were added, as indicated by the broken lines at *AB*, the full depth would be then increased to 5 feet, and 60 inches would be the multiplier, instead of 38, as in the example.

TO FIND THE WEIGHT OF BALLS.

Multiply the *cube* of the *diameter* by .5236 and the product will be the solidity, or *cubic inches* contained in

the *figure*, which, if multiplied by the *weight* of a *cubic inch*, will give the weight in pounds.

The cube of 12 inches diameter would be 12 inches multiplied by 12 inches, the product of which is 144 square inches; these again multiplied by 12 inches produce 1728 cubic inches, which is the number of cubic inches contained in a cubic foot.

Note.—Fig. 36 will help to a full understanding of the cube.

Example.—Required the weight of a cast-iron ball 12 inches diameter.

<div style="text-align:center">OPERATION.</div>

```
Ball's diameter..................................12
                                                 12
                                                ———
                                                144
                                                 12
                                                ———
Cube of ball's diameter.......................1728
Multiplier for solidity.......................5236
                                             ——————
                                             10368
                                              5184
                                              3456
                                              8640
                                             ——————
Cubic inches in ball......................904.7808
Weight of a cubic inch................  ....   .26
                                             ——————
                                          54286848
                                          18095616
                                          ————————
Weight of a ball in cast iron............235.243008
```

So that the weight of a cast-iron ball 12 inches diameter is nearly 235½ lbs.

Should a lead ball of the same diameter be required, find the weight of a cubic inch of lead in the table, and use that for a multiplier in the place of .26, as for cast iron; as follows:

CASTINGS. 113

OPERATION.

Cubic inches in ball........................904.78
Weight of a cubic inch, lead41
 ———————
 90478
 361912
 ———————
Weight in pounds, lead370.9598, ans.

Showing that a lead ball 12 inches diameter weighs 371 pounds, nearly.

The weight of *cast-iron balls* may be determined by multiplying the cube of the ball's diameter by .137, as follows:

 12
 12
 ——————
 144
 12
 ——————
Cube.......................................1728
Multiplier, cast iron only137
 ——————
 12096
 5184
 1728
 ——————
Weight..................................236.736, ans

Or very nearly as before.

PERCENTAGE IN THE FOUNDRY.

Without some knowledge of the rules of percentage it is hardly possible for any founder to mix cast iron with the view of obtaining a certain amount of any or all of the elements therein contained.

Supposing we wish to ascertain how much silicon enters into any mixture, we must by chemical analysis find out just how much of that element is contained in each of the

brands of iron that constitute the mixture, and according to the percentage found in the brands used so will the total percentage of silicon be.

That this may be made as easy of accomplishment as possible, I have chosen for the purpose of illustration a few of the rules in percentage which bear directly upon this and kindred subjects.

Let us suppose that in a charge of 6000 pounds we have four different kinds of iron, as follows:

Sloss.....3000, contains by chemical analysis 3.35% silicon
Scrap....2000, " " " 1.5 "
Macungie. 750, " " - " 1.82 "
Crozier ... 250, " " " 1.14 "

Total, 6000

Required the total percentage of silicon contained in the whole charge.

I put it this way so that some of the questions may be used as examples, and serve the double purpose of explaining the rules and solving the problem before us.

Percentage is a method of computing by means of a fraction whose denominator is 100.

The term per cent is an abbreviation of the Latin *per centum*, which signifies by the hundred.

The *rate* per cent is the number of hundredths. Thus, 8 per cent is eight hundredths, and may be expressed $\frac{8}{100}$, or .08, or 8%.

Per cent is simply the proportion of a hundred, and is not any of the denominations of Federal money; 10 per cent is not 10 cents, nor 10 dollars, but $\frac{10}{100}$; 10 per cent of $50 = $5; 10 per cent of 85 tons is 8½ tons.

CASE 1.—To find the percentage of any number or quantity, the rate per cent being given.

Rule.—Multiply the given number by the rate per cent and divide by 100, viz., point off two decimals.

CASTINGS. 115

Examples.—(1) What is 8% of 640 pounds?

Operation.—640 × 8 = 5120 ÷ 100 = 51.20 lbs. 8% of 640 = $\frac{8}{100}$ of 640 = $\frac{5120}{100}$ = 51.20, ans.

(2) What is 50% of 3.35? (3) What is 33⅓% of 1.5?

```
      3.3 5                                1.5
         50                                33⅓
  ─────────                             ──────
100)167.500(1.675, ans.                     5
    100                                    45
    ───                                    45
    675                                 ─────
    600                              100)50.0(.5
    ───                                  500
    750
    700
    ───
    500
    500
```

(4) What is 12½% of 1.82? (5) What is 4⅙% of 1.14?

```
     1.8 2                               1.1 4
      12½                                  4⅙
   ──────                              ──────
       91                                  19
     2184                                 456
   ──────                              ──────
100)22.7500(.2275, ans.         100)4.7500(.475, ans.
    200                              400
    ───                              ───
    275                              750
    200                              700
    ───                              ───
    750                              500
    700                              500
    ───
    500
    500
```

CASE 2.—To find what rate per cent one number is of another.

Rule.—Annex two ciphers to the percentage, and divide by the number on which the percentage is reckoned.

Example.—(6) What per cent of 40 tons is 8 tons?

$$800 \div 40 = 20. \quad 8 = \tfrac{8}{40} \text{ of } 40; \ \tfrac{8}{40} \text{ of } 100 = 20.$$

(7) What per cent of 6000 lbs. is 3000 lbs.? (Sloss.)

```
6 0 0 0)3 0 0 0.0 0(.5 0, ans.
        3 0 0 0 0
        ─────────
            0 0 0 0 0
```

(8) What per cent of 6000 lbs. is 2000 lbs.? (Scrap.)

```
6 0 0 0)2 0 0 0.0 0(.3 3 ⅓, ans.
        1 8 0 0 0
        ─────────
          2 0 0 0 0
          1 8 0 0 0
          ─────────
            2 0 0 0
```

(9) What per cent of 6000 lbs. is 750 lbs.? (Macungie.)

```
6 0 0 0)7 5 0.0 0(.1 2 ⅔ = 1 2 ½%, ans.
        6 0 0 0
        ───────
        1 5 0 0 0
        1 2 0 0 0
        ─────────
          3 0 0 0
```

(10) What per cent of 6000 lbs. is 250 lbs.? (Crozier.)

```
6 0 0 0)2 5 0.0 0(.0 4 ⅙, ans.
        2 4 0 0 0
        ─────────
          1 0 0 0
```

CASE 3.—To find a number when the value of a certain per cent is known.

Rule.—Annex two ciphers to the percentage and divide by the rate per cent.

Example.—(11) 42 is 25 per cent of how many pounds of iron?

$$25 \overline{)4200}(168 \text{ lbs., ans.} \quad \text{Or, } 4200 \div 25 = 168, \text{ ans.}$$
$$\underline{25}$$
$$170$$
$$\underline{150}$$
$$200$$
$$200$$

CASE 4.—To find what number is a certain per cent *more* or *less* than a given number.

Rule.—When the given number is *more* than required number, annex two ciphers to the given number and divide by 100, *plus* the rate per cent.

When the given number is less than the required number, annex two ciphers to the given number and divide by 100 *less* the rate per cent.

(12) What amount of gold at a premium of 25 per cent can I buy for $720 in currency?

$$100 + 25 = 125 \overline{)72000}(576. \quad \text{Ans. } \$576.$$
$$\underline{625}$$
$$950$$
$$\underline{875}$$
$$750$$
$$750$$

(13) Purchased pig iron and sold it for $1680, thereby losing 20 per cent. What did the pig iron cost?

$$100 = 20 = 80 \overline{)16800}(2100. \quad \text{Ans. } \$2100.$$
$$\underline{160}$$
$$80$$
$$80$$

A careful examination of these rules and examples will show that by their aid we have solved the problem asked at the outset, for, as shown in Case 2, Examples 7, 8, 9, and 10, 50 per cent of the charge is sloss, 33⅓ per cent scrap, 12¼ per cent macungie, and 4¼ per cent crozier.

Now, sloss contains 3.35 per cent of silicon, and as we are using .50 per cent of this iron in the charge, we must know what that percentage amounts to. By referring to Case 1 we find the rule for ascertaining this: 50 per cent of 3.35 is seen to be 1.675%, as per Example 2, Case 1.

Scrap contains 1.5 per cent silicon, 33⅓ per cent of which is .5 per cent, as per Example 3, Case 1.

Macungie contains 1.82 per cent silicon, 12¼ per cent of which is .2275%, as per Example 4, Case 1.

Crozier contains 1.14 per cent silicon, 4¼ per cent of which is .0475%, as per Example 5, Case 1.

These items collected in the form of a convenient table show that the whole mixture contains 2.45 per cent, or nearly 2½ per cent, of silicon, as follows:

CHARGE OF 6000 POUNDS.

Sloss.........	3000 = 50% of charge, contains	3.35% of silicon,	50% of which is	1.6750		
Scrap........	2000 = 33⅓% " "	1.50% "	33⅓% " "	.5		
Macungie ...	750 = 12¼% " "	1.82% "	12¼% " "	.2275		
Crozier.......	250 = 4¼% " "	1.14% "	4¼% " "	.0475		
	6000 1.00		Total silicon,	2.4500		

EXPLANATION OF THE TABLE OF WEIGHTS, STRENGTH, MELTING - POINTS, SPECIFIC GRAVITY, ETC., OF METALS, INCLUDING THE CHIEF CHARACTERISTICS OF USEFUL MINERALS AND WOODS.

A vast amount of useful information may be obtained from this table if it be properly understood.

The first in the table contains a long list of metals, minerals, and woods which are in constant use, and as quite a large number of these are in great demand in the

CASTINGS.

Substances.	Weight of a Cubic Inch, in Pounds.	Weight of a Cubic Foot, in Pounds.	Weight of One Foot Square, One Inch Thick.	Weight of Bar One Inch Square, Foot Long.	Weight of Bar One Inch Diameter, One Foot Long.	Melting-points of Solids, in Degrees.	Tensile Strength or Weight required to pull a Bar One Inch Square asunder.
	Lbs.	Lbs.	Lbs.	Lbs.	Lbs.	Deg.	Lbs.
METALS.							
Iron, cast, pig.	.260	440					20.000
Iron, cast, tough	.263	450	37.5	3.12	2.45	3,477	25.000
Iron, cast, gun-iron.	.264	455					30.000
Iron, wrought.	.281	486	40.5	3.38	2.61	3,981	60,000
Steel	.283	490	40.8	3.40	2.67	2,501	90,000
Gold, cast	.696	1210				2,587	20.000
Silver, cast.	.378	651	54.6			1,250	40.000
Copper, cast.	.317	540	47.5	3.81	2.99	2,550	20.000
Copper, drawn	.321	555					60.000
Tin, block.	.263	455	38			.420	4.000
Zinc, cast.	.248	437	36.6	9.05	2.40	741	2.500
Zinc, rolled.	.263	440					15,000
Brass { Copper 3 / Zinc 1 } Yellow	.282	525	43.6	3.68	2.85	1,897	28,000
Brass, fine drawn.		525					80,000
Lead, cast	.410	710	59.3	4.94	3.48	617	1,800
Lead, rolled.	.411	712					25,000
Aluminum.	.092	160				700	
Bronze { Copper, 10 / Alum, 1 }	.272	480					70,000
Bronze { Copper, 10 / Tin, 1 }	.309	585	42.5	3.54	2.78		36,000
MINERALS.							
Bricks, common		122					225
Glass.		155					
Granite.		165					1,000
Limestone.		165					500
Sand, dry.		120					
Sand, moist		128					
Coal, anthracite.		96					
Coal, bituminous.		80					
Coke.		62.5					
WOODS.							
Lignum vitæ		75					12,000
Lancewood		60					23,000
Box		60					18,000
Cedar.		55					11,500
Oak.		55					17,000
Beech.		50					10,000
Mahogany.		50					16,000
Birch.		50					15,000
Pine, pitch		40					10,000
Pine, white.		34					
Walnut, black		40					8,000
Spruce		30					17,000
Air, atmospheric		.0759					
Water, rain		62.5					

Substances.	Transverse Strength of Bar 1 In. Sq. and 1 Ft. in Length, Weight suspended on One End.	Crushing strength or Weight required to crush a Bar One Inch Square.	Torsion.	Relative Strength to resist Torsion, Lead being 1.	Resilience or Toughness.	Specific Gravity
	Lbs.	Lbs.	Lbs.	Lbs.	L s.	Lbs.
METALS.						
Iron. cast, pig	500	100.000	400		15	7.200
Iron, cast, tough	600	120.000	510	9	25	7.207
Iron, cast, gun-iron	700	125.000	700		50	7.308
Iron, wrought	900	50.000	750	10.1	20.000	7.788
Steel	1.500	125.000	1.200	16.6	15.000	7.833
Gold, cast		35.000				19.258
Silver, cast	500					10.474
Copper, cast		100.000	350	4.8	200	8.788
Copper, drawn	220		750		40.340	8.880
Tin, block	50	15.500	60	1.4	2.500	7.291
Zinc, cast	30		30		500	6.861
Zinc, rolled	200	164.800	200			7.191
Brass { Copper, 3 / Zinc, 1 } Yellow				4.6	4.000	7.820
Brass, fine drawn		165.000	1.000		15.000	
Lead, cast	20	7.000	20	1		11.352
Lead, rolled	30		30			11.388
Aluminum						2.560
Bronze { Copper, 10 / Alum. 1 }		135.000	400			7.680
Bronze { Copper, 10 / Tin, 1 }			500	5	8.000	8.560
MINERALS.						
Bricks, common	7	2.500				2.112
Glass						2.487
Granite	25	10.000	980			2.654
Limestone	40	6.000	100			2.654
Sand, dry						1.920
Sand, moist						2.050
Coal, anthracite						1.596
Coal, bituminous						1.290
Coke						1.000
WOODS.						
Lignum vitæ	160	10.000	150			1.200
Lancewood	150		120			.960
Box	130	10.000	125			.960
Cedar	100	6.000	100			.880
Oak	150	10.000	140			.880
Beech	120	8.000	110			.800
Mahogany	120	8.000	180			.800
Birch	130	5.000				.800
Pine, pitch	100	9.000	65			.640
Pine, white						.554
Walnut, black	150	8.000	130			.640
Spruce	120	6.000				.480
Air, atmospheric						.001205
Water, rain						1.000

CASTINGS.

foundry, a knowledge of their several natures and qualities will always be serviceable.

The second column gives the weight of a cubic inch of all the metals included in the list, and serves as a multiplier when the contents of a casting have been reduced to cubic inches: for instance, a plate 12 inches square, 1 inch thick, = 144 cubic inches; if the weight is required in cast iron, find cast iron in the first column, opposite to which the weight of a cubic inch is found to be .263; then $144 \times .263 = 37.872$, or over $37\frac{1}{2}$ pounds. If such a casting were required in lead, the weight of a cubic inch is stated .41; then $144 \times 41 = 5904$, or a little over 59 pounds. Aluminum being only .092 lb. per cubic inch, would show $144 \times .092 = 13.248$, or nearly $13\frac{1}{4}$ pounds.

The third column shows the weight of a cubic foot in pounds, and may be made very serviceable at times. Suppose it were required to know the weight (in cast iron) of a piece 3 feet square and 4 feet high: then $3 \times 3 = 9$, and $9 \times 4 = 36$, the number of cubic feet contained. By the table a cubic foot of cast iron weighs 450 lbs.: then $450 \times 36 = 16200$, or 200 lbs. over 8 tons.

A cubic foot of dry sand (as shown) weighs 120 lbs., therefore the same bulk would only weigh 4320 lbs.: thus $120 \times 36 = 4320$ lbs., or 320 lbs. over 2 tons.

The fourth column gives the weight of a superficial square foot 1 inch thick; fifth, the weight of a bar one inch square and one foot long; and the sixth being the weight of a bar 1 inch diameter, 1 foot in length: all of which is very useful data to have at hand when wanted.

MELTING-POINTS.

This column gives the melting-points of the simple metals mentioned, but the melting-points of alloys are invariably below those of the simple metals composing them. For

instance, 1 tin and 1 lead melts at 370°; 2 tin and 1 lead melts at 340°; 3 tin and 3 lead and 1 bismuth at 310°; 1 tin, 1 lead, and 1 bismuth at 310°. A still lower melting-point is obtained when 5 zinc, 3 lead, 3 bismuth, and 3 mercury is used, the latter alloy being said to melt at 122°.

TENSILE STRENGTH.

The tensile strength of any material is the cohesive power, or resistance to separation, by which it resists an attempt to pull it apart in the direction of its fibres or particles.

The table gives results of tests of the various substances under ordinary circumstances, but much higher rates have been obtained when special effort has been made with the view of ascertaining the very best results possible. As stated in the table, the weights given are the number of pounds required to pull a bar one inch square asunder, or its equivalent. Instead of weights being used for this purpose, however, testing-machines are constructed, which determine the strength of materials with strains of different kinds—tensile, transverse, torsional, crushing, etc.

The bars made for this purpose are usually made to a uniform measure of one inch square of sectional area and one foot in length. To ascertain the tensile strength of this bar it is gripped tight at each end and the strain applied until it breaks or tears asunder; an index indicates the amount of strain existing at the moment of rupture.

The ultimate extension of cast iron is about the 500th part of its length.

TRANSVERSE STRENGTH.

The breaking-weights given in this table represent the number of pounds weight required to break a bar one inch

square and one foot in length, the weight suspended on one end. This means that the weight or pressure is applied one foot distant from the point where the opposite end is held fast.

The relative stiffness of materials to resist a transverse strain is as follows:

Wrought iron. 1.8 Oak095 Elm073
Cast iron 1. Ash089 Beech073
White pine... .1 Yellow pine. .067

The following table shows how great a diversity of strength may be given to the same sectional area of cast iron by simply changing the form of the casting. It will be noticed that the lowest result is 565 and the highest 2652 pounds.

Note.—A careful study of this will yield good results.

TRANSVERSE STRENGTH OF CAST-IRON BARS, REDUCED TO THE UNIFORM MEASURE OF ONE INCH SQUARE OF SECTIONAL AREA, AND ONE FOOT IN LENGTH. FIXED AT ONE END, WEIGHT SUSPENDED FROM THE OTHER.

Form of Bar.	Breaking-weight in Pounds.
Square (see Fig. 37) ...	873
Square, diagonal vertical, Fig. 38	568
Column, solid, Fig. 39 ...	573
Hollow column, greater diameter twice that of the lesser, Fig. 40 ..	794
Rectangular rim, 2 in. deep × ¼ in. thick ⎫ Fig. 41 ⎧	1456
" " 3 " × ¼ " ⎬ ⎨	2392
" " 4 " × ¼ " ⎭ ⎩	2652
Equilateral triangle, an edge up, Fig. 42	560
" " an edge down, Fig. 43	958
Beam 2 in. deep × 2 in. wide × .268 thick, Fig. 44	2068
" " " " " " " " Fig..45	565

CRUSHING STRENGTH.

What is meant by crushing strength, is the power inherent in the material to resist a compressive or pushing stress, which force would tend to shorten it.

While the effect of tensile stress is always to produce rupture or separation of particles in the direction of the line of strain, that of crushing or compressive stress may be to cause the material to fly into fragments, to separate into two or more wedge-shaped pieces and fly apart, to bulge, buckle, or bend, or perhaps to flatten out and utterly resist rupture or separation of particles.

TORSIONAL STRENGTH.

Torsional strength means the ability of the material to resist a twisting or wrenching of its parts by the exertion of a lateral force tending to turn one end, or part of it, along a longitudinal axis, whilst the other is held fast or turned in an opposite direction.

The figures given in the column under "torsion" represent the relative stiffness of the several substances mentioned.

Hollow cylinders or shafts have greater torsional strength than solid ones containing the same volume of material.

Solid square shafts have about one-fifth less torsional strength than solid cylinders of equal area.

The torsional strength of cast steel is about double that of cast iron.

RESILIENCE OR TOUGHNESS.

The term resilience is used to specify the amount of work done when the strain just reaches the corresponding elastic limit. The table shows the ultimate resilience of metals as tested in the Stevens Institute of Technology, Hoboken,

N. J., and gives at a glance the comparative ability of metals to resist forces such as bending, etc.

The resilience of phosphor-bronze is far in excess of the ordinary bronze.

SPECIFIC GRAVITY.

Specific gravity of any body is the proportion which the weight of a certain bulk of that body bears to the same bulk of another body which is taken as standard.

The standard for substances, solid and liquid, is distilled water at the temperature of 62° Fahr., a cubic foot of which weighs 1000 ounces avoirdupois, or 62.5 pounds.

The specific gravity of solid bodies is best measured by the hydrostatic balance, which gives the weight of a volume of water equal in bulk to the solid, by which it is only necessary to divide the weight of the solid in air to obtain the specific gravity.

A cubic foot of water weighs 1000 ounces. If the same bulk of another substance, as for instance cast iron, is found to weigh 7.200 ounces, its proportional weight or specific gravity is 7.2.

The weight of a cubic foot is obtained from the figures representing specific gravity or density by moving the decimal point three figures from the right, which gives the weight in ounces; and these again divided by 16 give the pounds avoirdupois in a cubic foot; thus $7200 \div 16 = 450$ pounds.

Gold is 19 and silver 10 times heavier than water, consequently the numbers 19.000 and 10.000 represent the specific gravity of gold and silver.

The heaviest known substance is iridium, used for the pointing of gold pens; its specific gravity is 23.000. Carbonic-acid gas, or choke-damp, is 300 times lighter than water, common air 800, street gas about 2000, and pure hydrogen, the lightest of all substances, 12,000 times.

FOUNDRY APPLIANCES.

INCLUDING BLOCK AND PLATE METHODS OF MOULDING; GEAR-MOULDING BY MACHINERY, AND A DESCRIPTION OF SOME MODERN MOULDING-MACHINES.

THE object of this article is to bring before the mind of the foundryman, in as brief a manner as possible, the present condition of the foundry with regard to the various appliances now in use for the production of castings. Imperfect as it may be, it will, in some measure at least, give at a glance some idea of the evolution which has been gradually taking place around us in the past, and may serve to incite the minds of some to still further efforts in the direction of improved foundry appliances.

The several moulding-machines, as we see them to-day, have not sprung into existence all at once. The process of their development has been a gradual one; and not until inventors were able to grasp some, if not all, of the chief requirements for producing a well-finished and trustworthy mould did any real success attend their efforts, even in the inferior class of work to which the limited capacity of their machines has hitherto confined them.

Before entering upon the subject of moulding-machines proper, it will be of interest to take a retrospect of the foundry appliances generally, past and present; by which means we shall be better able to judge, not only just how much advancement we have made, but also to trace almost from their inception the growth of the present mechanical appliances for moulding.

The difference between past methods in moulding as compared with the present is almost as great as that of smelt-

ing the ore, which latter can only be appreciably understood when we compare our methods at present with some of those still in use in semi-civilized countries. Fig. 46 represents a blast-furnace of the Kols, a tribe of iron-smelters of Lower Bengal and Orissa. The men are nomads, going from place to place as the abundance of ore and wood may

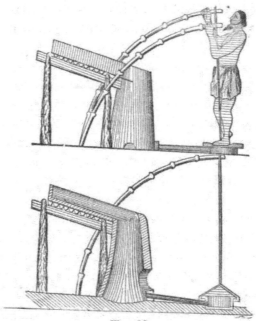

Fig. 46.

prompt them. The charcoal in the furnace being well ignited, ore is fed in alternately with charcoal, the fuel resting on the inclined tray so as to be readily raked in. As the metal sinks to the bottom, slag runs off at an aperture above the basin, which is occupied by a viscid mass of iron. The blowers are two boxes with skin covers, which are alternately depressed by the feet and raised by the spring poles. Each skin cover has a hole in the middle, which is stopped by the heel as the weight of the person is thrown upon it, and is left open by the withdrawal of the foot as the cover is raised. Variously modified in detail and in-

creased in size, these simple furnaces are to be found in several parts of Europe at the present time.

Compare the above with some of the remarkable systems of hot-blast smelting now in vogue, as described in late works on metallurgy, and the change seems truly startling; yet the principle is the same in both cases almost, the main difference being in the kind of blowing-engine used and the magnitude of the operations.

CRANES.

In nothing does the spirit of improvement manifest itself more than in the choice of cranes for foundry purposes: where once the slow and ponderous wood cranes stood, are now to be seen in some places elegant structures of steel or iron, whose every movement is controlled with a degree of accuracy unthought of by our predecessors, and comparatively unknown to many around us at this time. With the advent of electricity as a motive power, backed by a growing desire on the part of founders to apply this wondrous force to existing structures (something very easy of accomplishment), our foundries are assuming a method which, to those accustomed only to the old régime, seems almost unreal. When large bodies are being lifted they seem to shoot upwards as if propelled by magic, and lighter ones, such as parts of moulds, etc., are closed together with a degree of precision unattainable by the clumsy structures which these more effective engines have displaced. No noise, no rushing through the shop for a spare crank to supply the place of the one just broken by as many hands as could crowd around it, no anxiety of foreman or men, all proceeding with a naturalness born only of perfection, and all this owing to the fact that it has just dawned upon the minds of founders that the foundry can be made more productive if sufficient attention is only given to its needs and requirements.

FOUNDRY APPLIANCES.

The business of cranes has fortunately been taken out of the hands of the amateur crane-builders that infest almost every firm which boasts of owning a foundry, and this to such an extent as to effectually bar out every attempt on their part to ever again inflict one of their monstrosities on a patient and uncomplaining shopful of moulders. If it were only for the latter great benefit, we have reason to bless the day when the specialist in the manufacture of cranes was able to give us the perfection we have attempted to describe for less money than one of the old abortions would cost the unsuspecting victim of the once famous, but now almost defunct, 'handy man about shop.'

It is a good sign to notice the almost universal adoption of these lately invented appliances for reaching every nook and corner of the foundry with some adequate means for lifting objects hitherto lifted by hand at great risk to all concerned. The pneumatic and steam hydraulic cranes, etc., suitable for such purposes are now to be obtained at a comparatively trifling cost. From the number of such appliances now in use, there is every indication that the convenience and general welfare of the employé is receiving attention to which he has been hitherto unaccustomed.

Another labor-saving device for facilitating the rapid handling of large quantities of molten iron is becoming very popular in many of our large architectural, car, and stove shops, consisting of an overhead trolley system direct from the cupola to all parts of the shop, one man being able to pilot 1000 pounds of iron direct to the floor, and serve each hand-ladle as fast as presented, the latter operation being made very simple and clean by a hook on the band of the supply ladle, on which the moulder can rest his ladle whilst it is being filled, a suitable eye on the band of the hand ladle being provided for that purpose.

TESTING-MACHINES.

The rapidly increasing popularity of the testing-machine in the foundry is the sure indication of a desire on the part of founders for a more correct and satisfactory means of knowing just what iron they are using; the rule-of-thumb, as exemplified by the antiquated method of testing by fracture alone, is being fast relegated to the rear, its place being taken by the more positive means of the testing-machine and crucible.

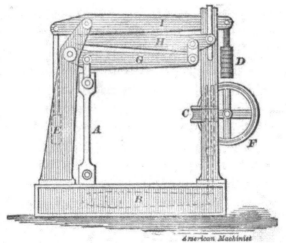

Fig. 47.

The machine shown in Fig. 47 is designed for testing the tensile strength of metals; the rod A, to be tested, is made to one square inch of section, and is held between clamps attached, respectively, to levers B and G. The lever B is acted on by a worm-wheel C, and worm operated by a hand-wheel F, bringing the tensile strain upon the scale-beam levers G, H, and I; to the long arm of the latter weights D are applied until the bar A is ruptured, or the required testing strain is reached. E is a counterbalance weight for the levers G, H, I.

How these machines are applied for obtaining a transverse test will be seen at once by consulting Fig. 48, which is self-explanatory.

Fig. 48.

TRACKS AND TRUCKS.

Where the means for transmitting moulds, cores, castings, and all other materials are lacking overhead, especially in large foundries which have assumed their present magnitude, section after section, by the process of building '*something temporarily*' for the present, as their business increased from time to time, there is now a very good substitute in a system of well-kept tracks with switches in every available direction. Specialists in this line now manufacture trucks that will turn in a 12-foot radius with ease, with loads of three tons or more, thus taking up little, if any, more room than would be required for turntables, the latter objectionable feature being by this means effectually dispensed with. The transmission of cores from the oven to their respective places, sand from the bins outside,

and molten iron from the cupola to every part of such a shop may with such an arrangement be accomplished with marvellous facility, and with an outlay for labor that is infinitesimal compared with lugging everything by hand.

Fig. 49 shows how admirably the track system is adapted to a number of shops collected together, as above described. As will be seen, connections for both supply and delivery are well provided for; the tracks were so arranged that a steam-crane lifted the iron from the cupolas onto the trucks with the least delay imaginable, and every part of these straggling places brought into intimate relation with the cupola by said means.

CONVEYERS.

May we not hope that before long the laborious and by no means desirable mode of wheeling in barrows all the material used by the sand and loam mixer, etc., will be supplanted by one or other of the much-to-be-admired systems of conveying which are becoming so common almost everywhere, except in the foundry? These means are pre-eminently adapted for foundry purposes, inasmuch as everything could then be hauled to its destination clear of the foundry floor altogether. Mines, mills, and quarries are duly supplied with fast or slow speed elevators and conveyers with a perfect discharge; grain is handled in such a manner as to leave no trailings behind, and different grades handled by the same conveyer (something very suggestive of its adaptability to foundry use); clay at the brick-yards, coal at the wharves and elsewhere, tanneries, tile and stone yards, have these splendid appliances in full swing; but, as usual, the foundry is last in the race.

ELEVATORS TO CUPOLA SCAFFOLD.

Looking at the very excellent arrangements for elevating material to the charging platform at some of our foundries,

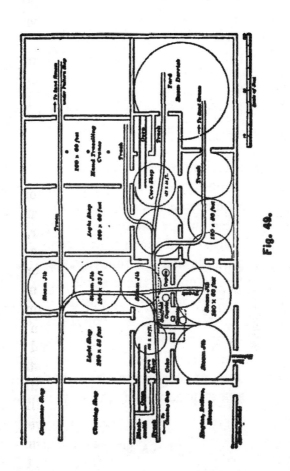

Fig. 49.

one is forced to the conclusion that improvements began first at the outside, and only very slowly found their way into the foundry proper. However, it is a satisfaction to know that the interior has at last been reached, and every part is now receiving its due share of attention in all well-regulated shops. The advent of the ordinary elevator made it possible to banish forever that slavish and expensive mode of carrying by hand all the iron and fuel to the scaffold; but it is evident that very many cling tenaciously to these time-honored notions, otherwise we should see some scheme invented, even in the meanest places, by which material could be handled more sensibly as well as profitably.

The common freight elevator may be very readily adapted to almost any foundry, and this contrivance owing to the lively competition of makers, can be furnished at a remarkably low cost. The author has had an every-day experience of 75 tons of melted iron per day at a foundry where both iron and fuel, great as was the quantity, was lifted from the foundry floor to one end of the scaffold in iron cages holding about five tons of iron, and deposited on a truck which, by means of a suitable track, was conveyed to each of the three cupolas in use, respectively. The crane used for this purpose was an ordinary jib with a reversing engine behind; and whilst it may appear a somewhat rude method compared with the best practice of the day, it was very effective.

CUPOLA SCALES.

It is a great saving of time, as well as an aid to correctness, to provide a scale with several beams and poises, so that a truck may be at once filled with the several quantities of different irons which go to make up a charge. This allows the proportional quantities to be collected on the truck instead of obliging them to be carried separately to the

FOUNDRY APPLIANCES.

cupola. The iron truck at Fig. 50 is shown on a section of railway upon the scale-platform; the beams are concealed, but are supposed to be provided with indicators, which pass through the top of the beam-box. There is no doubt that this method originated at the car-wheel foundries, where the cupola scaffold is in many instances connected with the yard direct by a line of railway on a constructed incline. It is even easier to adopt this scheme where the

Fig. 50.

truck can be run from the scale to the elevator platform on the level, and not a few of our wide-awake firms have adopted the scheme.

AND RIDDLES.

The sand riddle shown at Fig. 51 is undoubtedly the result of an evolutionary process easily traceable through all its several stages or periods: at first the tiresome and back-breaking standing with riddle in hand to receive shovelful after shovelful of sand from an associate, to be either freed from scraps or more effectually mixed and tempered; then the stick with a nail inserted at each end, one of which was to thrust into the floor to prevent slipping, the other to

protrude through one of the meshes at the front of the riddle, thus relieving the operator of nearly one half the load as he jerked his riddle back and forth; and again the mortar-mixer's screen brought into the foundry,—perhaps surreptitiously from some new building in course of erection near by.

Finally, the machine as intimated, which is supposed to give a combination of all the motions incident to ordinary riddling, saving at least half the labor, and the time also. Whilst this figure serves to show a very popular power riddle now in use at many foundries, it by no means covers

Fig. 51.

the field of invention for this end. A very good one by J. Evans & Co., Manchester, Eng., hooks the tray into slings which depend from any convenient support above by means of straps bolted on the frame. The tray is formed of a piece of $\frac{5}{16}''$ plate iron, bent round to form three sides of a rectangle, the fourth side being left open. A series of half-inch bars pass across the frame, the action of the uppermost bars being to assist in breaking up the large lumps of sand. The sieves, which are interchangeable, are laid over the lower bars. The oscillating motion is imparted to

the frame from a belt-pulley, which drives a three-toothed cam pinion: these teeth thrusting alternately the pins in the slotted piece attached to the bar which actuates the frame, communicate a rapid jarring to-and-fro motion thereto. The fine sand falls through the sieve into a bin below, and the unbroken lumps pass on and fall out at the open end.

A revolving screen, lately introduced in some of our leading shops, is no doubt the most effective machine yet seen for mixing heavy piles of sand, and promises to supersede all other contrivances yet invented for that purpose.

CLEANSING MILL.

The simple tumbling-barrel was the first attempt made to supersede the old method of cleaning small castings with old files and pieces of sandstone or emery. How well some of us can remember the army of little boys and old men employed for this purpose at all such firms as manufactured large quantities of small work. This simple machine, like all others since introduced, cleans and polishes castings by attrition, and consists of a cylindric or barrel-shaped vessel, composed of perforated slabs bolted to the two ends, having a side door for the introduction of the work, and mounted on an axis so as to be revolved by a wheel or pulley. Very many improved ones are now in use, but all aim at the one object of cleansing by the introduction, along with the castings, of slag or cinder, which, as it breaks up by constant abrasion with the castings, cleans the latter from all adhering sand, which escapes through the perforations, leaving the castings clean within the barrel. Some are now provided with an exhaust apparatus for conveying away the dust,—a very desirable acquisition, it must be said,—are friction-geared, and provided with hand-wheels for stopping and starting. Others

again are revolved on chilled truck-wheels, the heads having guides turned thereon for the purpose, thus doing away with axis on the head altogether. A great saving of time is effected when two barrels are employed, as in this case one may be kept running whilst the other is being loaded or unloaded.

LOAM-MILL.

Another of the evidences of a growth in the desire for best methods is the adoption of the mill for grinding loam,

Fig. 52.

where such a commodity is in constant demand. Old as this contrivance is, it is nevertheless a fact that in many foundries they are still pounding away on the chopping, bench, apparently ignorant of the existence of such a machine; others claim that hand-made loam is the best, but this cannot be any other than a wild statement, having no ground in fact. With such a mill as is shown at Fig. 52, loam may be ground to any consistency desired, according to the amount of clay and manure and the nature of the sand used.

FOUNDRY APPLIANCES.

The machines that are sometimes erected for this purpose are not suitable, being simply a copy of those used in cement and other factories; one chief objection to most of them is the outrigging required for carrying the gearing, which is usually on the top. The one shown at Fig. 52 is the best mill for the foundry, being provided with a chute through which the loam or clay-wash may escape when it has been sufficiently ground, and its usefulness may be still further enhanced by a system of hoppers overhead for the introduction of the sand, clay, etc.

MOULDERS' CLAMPS.

Even the ordinary light-work moulders' clamp receives some attention during this age of improvement: amongst many other excellent contrivances may be classed the ones seen at Figs. 53 and 54, the latter, although ingenious and

Fig. 53. Fig. 54.

sure, might be objected to on account of the protruding handle, but its other acceptable features will, in many instances, compensate for that. The dilapidated condition of the top edges of wooden flasks, caused by that outlandish mode of pinching now so prevalent, as well as the many

failures from jarring of iron copes whilst driving wedges, ought to impel every founder to invent something more elegant and satisfactory than are the crude devices invariably practised. In nothing does the spirit of improvement seem so backward as is the case in this particular, almost everywhere.

GEARED LADLES.

There is every evidence of shiftlessness and culpable neglect when, as is sometimes the case, we see a dozen men struggling to pour a casting from a six-ton ladle provided with no other means for such an operation than the old crutch-bars at each end. When Nasmyth, the great English mechanic, added to the pivot of a crane ladle a tangent-screw and worm-wheel by which it might be gradually tilted by one man standing conveniently near by, he made every moulder in the universe his debtor; and no founder should hesitate, on the ground of expense or for any other reason, in providing such safe means as this valuable invention secures. The difference between the two devices is a striking one, and compensates in a large measure for the very meagre conveniences supplied by our too-easy ancestors. What the writer believes to be the chief characteristics of a good geared ladle will be found on page 79.

HAY AND STRAW ROPES.

We noticed how anxious were the founders of almost every country to possess one of the hay-twisters shown at Fig. 55, when they were first placed on the market; but this may not have been occasioned by a desire to be abreast of the times so much as that their superiority over the old patriarchal ways, from a monetary point of view, was so manifest as to check all opposition to their general adop-

tion wherever large quantities of hay or straw ropes were used. However, we are willing to class this with the other evidences of a general desire for a more practical and rational adoption of any mechanical contrivance which will not only save labor, but, also add dignity to a much-abused trade.

As seen, this machine makes the hay or straw rope, and

Fig. 55.

winds it up into a coil for transportation. Rollers draw the hay from the trough, and the twisting is effected by a planetary action of the rollers longitudinally; it is then coiled on the reel.

Since the introduction of the above-described machine there have appeared others of more or less merit, but with many it remains a matter for conjecture whether there has been any substantial improvement made.

GEAR-MOULDING BY MACHINERY.

Owing to the various difficulties caused by irregular ramming, unequal expansion of patterns arising from the different degrees of dampness in the sand, as well as the lmost certain destruction of some parts of the mould during the withdrawal of the pattern, and which could at best be but approximately repaired, it is safe to say that very few gear-wheels of magnitude were ever made true before Jackson, of Manchester, England, invented his machine for forming part of the mould and spacing the teeth with mechanical accuracy in the sand, one tooth only being used for producing the whole number contained in the wheel, this one tooth being alternately raised and lowered by suitable machinery, which not only draws the pattern with absolute precision, but travels to the next tooth as precisely as could happen in the best gear-cutting machine.

Everything points to the fact that the principle of Jackson's machine was first suggested to him by the method of moulding gear-wheels which was then finding favor at most of the large millwright shops in his immediate neighborhood, and which will be found fully explained in "The Iron Founder," the scheme therein described for forming the cope and bottom bed, as well as the arms, being substantially the same as adopted by him; in fact, if the reader will carefully examine the whole subject he will see clearly that the wheel moulding machine is simply the application of a method for spacing the teeth, and insuring a better draw of the same.

Since the introduction of the above machine many others have sprung into existence, notably the Scott, Bellington and Darbyshire, Whittaker's, Buckley and Taylor's, and Simpson's. With the exception of the latter, all these machines are actuated by change-wheels for effecting the

regular movement of the same; but the Simpson machine is worked independent of such means, thus obviating any inaccuracy consequent on the wear and tear of the several wheels employed. The pitching of the teeth is somewhat after the manner of the division-plate and index-pin of a geometric lathe, and on these machines a sheet-iron drum is secured to the top of the central column of the machine, and perforated with a series of circles of holes, giving a large range of numbers suitable for different numbers of teeth. A peg is made to fit into these holes, passing through a hole in the vertical arm attached to the horizontal arm which carries the tooth-block, and so locks the machine accurately during the ramming of each separate tooth. The horizontal or carrier arm slides vertically on the central pillar, and when adjusted for height is kept in position by means of a collar upon which it rests. A slot in the arm permits of a movement upon the horizontal slide operated radially by a screw and hand-wheel; through this slide passes a screw and a guide-rod for imparting a vertical movement to the tooth-block. The tooth-block is elevated by a hand-wheel and mitre-wheel; provision is made by a hand-wheel and slot for setting the blocks of bevel-wheels at any required degree of angle.

Fig. 56 is a rough sketch of a moulding-machine for wheels when the spacing is actuated by change-wheels. It is seen that a pattern is used corresponding to a small portion of the gear to be moulded; this pattern includes two teeth and the interdental space, when spur-gears are to be moulded, and is attached to the lower end of the vertical guide-bar, which slides in ways formed at the end of a horizontal support, which has a radial position relatively to a central spindle or arbor. By this means the pattern is carried around, and, being made to descend upon the bed previously formed, gives, after ramming, the proper impression for that portion of the gear-wheel which corre-

sponds to it. It is used to mould gears from nine inches up to six feet in diameter—either spur, bevel, mitre, mortise, or worm wheels, plain or shrouded; and it is also equally

Fig. 56.

applicable to moulding fly-wheels or pulleys, either plain or shrouded.

OTHER LABOR-SAVING DEVICES—CASINGS.

Casings in which to form the outer, and in some instances both outer and inner parts of crystallizing cones for chemical works, as well as sugar-pans and numbers of kettles, etc., were a natural outcome of the ever-increasing demand for such articles, and which could not have been met by the usual practice of moulding in bricks and loam. The same may be said with regard to the rapid growth of the pipe trade consequent on the general outcry for a pure and plentiful water-supply; the creeping methods of moulding on the flat in green sand had to be abolished ultimately in favor of vertical moulding in iron casings, which

latter suggested the application of said methods to hydraulic rams, and all castings that could by this means be made without external ramming in the pits. *Vide* "The Iron Founder," page 186.

PIT RAMMING.

When the loam-moulder, in ramming up large bodies of sand in pits, sought out weights and big logs to occupy spaces of more than ordinary dimensions, thus reducing the time consumed in ramming as well as making a harder body for the mould to press against, he was sowing the seeds which ultimately blossomed into the well-kept curbs which could be fastened together at any convenient distance from the mould, making the containing of the latter independent of whatever space might be outside. The climax was reached when he confined all of his mould in suitably contrived casings, in which the mould was prepared from the outset.

WORM-PINIONS, ON END.

We can well remember when it was first suggested to mould a worm-pinion by drawing it out of the sand endwise, and by that means obviate the unsightly joint. "Pooh! pooh!" exclaimed the conservative moulders around; but just as soon as a suitable pattern, with the necessary appendages for supporting and guiding the same, was furnished, the feat was accomplished without trouble, to the very evident dissatisfaction of the doubters. Now we have some pretty long pieces of conveyer-screw formed in the sand by first forming a plain cylindrical mould, and afterwards forming the thread by screwing a short section of pattern through the mould.

SCREW-PROPELLERS.

It is very evident that there has been a steady improvement in the ways of moulding screw-propellers from the

first; the writer remembers some very roundabout methods which at that time were considered perfection. Since then, however, large numbers of patents have been granted for improved methods of sweeping, flask-forming, and ramming, all evincing that there was a keen competitive spirit abroad. Following close on the heels of some late improvements by moulding in fixed flasks from one blade pattern only, comes still another patent for forming the blades separately by a sweep and an adjustable knife, which forms the blade independent of a pattern altogether.

It is very encouraging to notice that most of these late inventions for propeller-making devices belong to practical moulders, some of whom are now working at the trade, clearly showing that we, as a class, are in the race for a legitimate share of the thinking.

BLOCK AND PLATE MOULDING.

A short review of the two methods—block and plate moulding—will serve to show that the spirit of invention was abroad in the foundries when some of the oldest of us were boys ; how much these early attempts have helped in bringing about the present elaborate systems will be apparent when a full knowledge of the modes then employed is obtained. Plaster-blocks were invented to make the moulding of thin delicate register work, as well as other long thin castings having more or less elegance of design, a more easy and safe operation, and consisted of taking plaster casts of each side of the pattern; then from both these impressions other plaster casts were taken in top and bottom match flasks, the latter then serving to ram thereon cope and nowel respectively, exclusive of the original pattern. Such moulds are in all cases an exact duplicate of the pattern, free from all the imperfections usually attending the moulding of very light work by the common practice,

The necessity for producing small work of all descriptions at a more rapid rate, and with greater accuracy, suggested the principle of what is called plate-moulding, which consists of flasks well fitted, and with planed edges to receive a plate betwixt, upon either side of which are the respective halves of the several castings connected by the running gates. The pinning of these flasks is so arranged that the cope may be set down face up, upon which the plate is then pinned, to be followed by the nowel, which is at once rammed. After turning all three over, the gate-pin is set into a socket over the main runner, the cope rammed and separated, when, after a slight jarring, the plate is lifted off, exposing all the moulds with gates ready cut, leaving nothing to be done except to set in whatever cores are needed and close the mould. Should the cope side of the plate offer any difficulty in effecting a clean lift, the nowels and copes can be rammed alternately; by this means the plate is lifted away from the mould in both cases, thus insuring a clean separation. The very excellent idea of fitting flasks interchangeably originated with these two methods.

MOULDING-MACHINES.

The stripping-plate, which constitutes one of the chief elements of the modern moulding-machine, is not by any means a new invention: some of the first were made over thirty years ago by a large manufacturer of cotton machinery in Oldham, England, for the production at a cheaper rate of pulleys, wheels, and other small work too numerous to mention. Compared with the elaborate systems of stool-plates, etc., on some of the present machines, these early efforts were no doubt somewhat rude ; still, it is evident that the principles upon which the present methods are based are one and the same with the past—the patterns projected through the plate and were withdrawn under-

neath by means of levers before the rammed flask was lifted off. Some were rolled over with the flask, and the pattern pulled through.

The question is sometimes asked by parties opposed to machine-moulding, "Is the investment in machines and other appliances for a foundry justifiable?" And the reply readily comes that "you are justified in putting a plant into a foundry, and that every part of it should be as good as it can be made." They claim, and not without reason, that, with the exception of some minor devices, the foundry employs the old pod-auger methods; and, further, that inasmuch as no man would hesitate to put new tools into his machine-shop that would save fifty per cent of what the labor costs, ought to hesitate when a similar inducement is offered in the foundry. They furthermore assert that, owing to the superintendent being invariably a machinist and not a moulder, and while he is conscious that present methods are neither economical nor progressive—being unacquainted with the work—he defers to his foundry-man, who wants his foundry improved, but considers moulding an art and not a trade, for which machines can do the thinking. The latter assertion may be correct in some instances, but we know of places where the exact reverse is the case; and even now there are many firms where machines are in active operation under the immediate supervision of superintendents who are not moulders, and where the foreman moulder devotes his whole energy to make the machines a success, and this with astonishingly successful results.

Another authority upon this subject says: "The all-absorbing question, 'What is the economy in machine-moulding?' is very difficult to answer. The product of machines will vary in different foundries as much as the product of the moulder. What may be called a fair day's work is an unsettled question. A machine that will mould 175 flasks,

16 × 16 × 10 inches deep, with two men to operate it, in one foundry, would, under precisely the same conditions, mould 250 in another. One manager may surround his machine with conveniences for handling the work and thus increase his product, while another would compel his machine-men to work under disadvantages. The treasurer and practical shopman of a foundry were observing the operations of an automatic machine, with watch in hand. A complete half mould in 16-inch nowel, 5 inches deep, had just been made and turned on the floor for inspection in ten seconds after the sand was put into the flask, when the treasurer asked the question, 'How many moulds can be made in a day?' Before any reply could be given the shopman said, 'That's not the question: the question is, How many moulds can we take care of?' A better answer could not have been given."

The conditions are not at all favorable when all the sand is handled by shovels, and the moulds carried to and fro by hand. The authority above quoted, in speaking of this, says: "Two men on this machine make 200 moulds per day, and average during the working hours from twenty-seven to thirty-four moulds per hour. These men have made and carried away 158 nowels in one hour and thirty-five minutes, and have made 200 complete moulds ready for clamping in less than five hours. The flasks used in this case were 14 × 17 × 10 inches deep, and weighed 70 pounds; the sand in the flask when rammed weighed 156 pounds. We must keep in mind that these two men must shovel into flasks over 31,000 pounds of sand and carry off the same amount in making 200 moulds; they must also handle twice 14,000 pounds of iron in flasks. 200 moulds under these conditions is too much for five hours' work, but this number is not too much for a day's work for two men. A greater product might be obtained from an additional man, or a conveyer for elevating sand to a hopper over the

machine. A system of handling the moulds after they are made would also add to the machine's capacity."

Mr. Harris Tabor, in a paper read before the American Society of Mechanical Engineers at the San Francisco meeting, May, 1892, says: "Of all the mechanical arts, that of moulding has been the most difficult to formulate and reduce to a system. Since the origin of metal-founding the moulder has been pleased to shroud his methods in certain mysteries which, to him at least, seem essential to perfect castings. There is much beyond the control of the moulder, in the art of metal-founding, which tends to make bad castings. His strongest influence upon the quality of his work lies in the skill which cannot be verified by caliper, gauge, or rule. The moulder's art is in making the mould of its proper density. Drawing a pattern from the sand after it has been rammed, and mending a broken mould, are mechanical operations easily taught: it is not so with ramming. If a touch of genius enters into the moulding it is shown in making the mould of such density that it will stand pouring without 'straining,' and be soft enough to prevent 'blowing' and 'scabbing,' with a certainty that the sand will remain in place until the iron has solidified. This is the moulder's skill, which cannot be formulated and passed down to succeeding generations in books." It is very evident from the above that Mr. Tabor knew what difficulties he had to contend with when he undertook to make a moulding-machine that would automatically overcome them all. What course he pursued may be partially gathered from what he says in another part of the paper quoted: "In the spring of 1890, Mr. A. B. Moore, who was then a Stevens Institute senior, selected the rammer machine as the subject of his thesis. We discussed the lack of data bearing upon the friction of sand, and decided jointly to make experiments. An ordinary platform-scale was used for weighing. A series of boxes 4×4 inches, 5×5

inches, and 6 × 6 inches was decided on; these boxes were supported by frames spanning the scale and resting on the ground, as seen at Fig. 57; each box was fitted with a loose bottom, which rested on the scale platform. The plunger used for ramming fitted its box loosely enough to avoid serious friction, and was connected to the weighted lever by a turned joint; the weight of the lever on the sand was found by weighing it in position. In all cases the scale was weighted to a pressure equal to 10 pounds per square

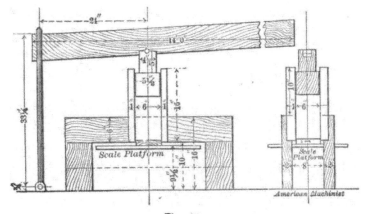

Fig. 57.

inch on the under face of the box. (This is about the density of the average mould surface.) We began with the 4-inch square box as follows: 2½ inches of loose sand was put in and compressed to 1¼ inches to give a density equal to 10 pounds on the under side, and it required a pressure of 12½ pounds on the top of the sand to produce this result. With 5 inches of loose sand, 17½ pounds pressure was required on top to give 10 pounds below; an addition of 2½ inches in the depth of sand brought the ramming pressure up to 34 pounds, and the last 2½ inches— making 10 inches—required a pressure of 42 pounds to give 10 pounds on the scales. With the 6-inch box only 11¼ pounds were needed to give 10 pounds below with 2½

inches of sand; with 10 inches, 26 pounds raised the scale-beam, or 16 pounds less than was required under precisely the same conditions with the 4-inch box. The walls of the boxes were of undressed plank to represent the average condition of wooden flasks."

THE TABOR MOULDING-MACHINE.

With the rammer system of this machine greater pressure may be given over portions of the mould which would other-

Fig. 58.

wise be too soft. When flasks are of such a size that bars are necessary, the rammers are arranged to straddle them, thus doing away with all tendency of the bars to spring; this method also avoids the necessity of tucking under the bars. When the flat platen is used for ramming, sand may be scooped away from the highest portions of the pattern until the best results are obtained. With these automatic

machines the rigid platen made of hard wood, is used for ramming, and cut boldly over the pattern; by this method it is claimed that no skill or judgment is necessary in putting sand into the flask, and the density of the mould over the iron may be made to suit any condition. The method of using flask-bars for ramming is to have them detached from the flask, and short enough to be forced down without coming in contact with its walls; the flask and sand-box are filled with sand, and the bars forced down by a flat platen; the bars are deeper where the greatest

Fig. 59.

ramming is required, and being made wedge-shaped, each bar spreads the sand until it meets the spreading influence of its neighbor. The heavy flasks are placed on trucks, which are topped with stripping-plates and contain mechanism for drawing the patterns; the trucks are run under the machine for ramming, and withdrawn to take off the mould and replace the flask. For the lighter flasks which can be lifted by hand the machine shown at Figs. 58 and 59 is made; the figure shows the floor broken to give view of the machine below the floor-line. The piston takes steam on the under side only, its weight being sufficient to return it promptly after the mould is rammed. To the piston-rod is attached the principal part of the mechanism,

consisting of a table with lugs projecting upwards and supporting the pattern-frame upon which rest the patterns. The stripping-plate frame is directly over the pattern-frame and rests on it, to which the stripping-plate is attached. The stool-plate is suspended to the stripping-plate frame and moves with it; the side levers and tumbling-shaft are for tripping after the pattern is withdrawn. The pattern-frame has an annular passage, which connects with the cylinder and admits some steam to the pattern-plate at each movement, thus keeping the patterns in a dry condition for smooth working. The stool-plate is really part of the stripping-plate frame placed below the pattern-frame, its object being to support stools, or internal parts of the stripping-plate used in holding up the green-sand cores, or heavy bodies of hanging sand while the pattern is being drawn: these stops can readily be changed to suit any pattern within the range of the machine. The ramming-head is carried by the wrought rods seen at either side of the machine. The steam-pipe enters the cylinder at the bottom, and from the throttle-valve to the cylinder serves also as an exhaust-pipe, the throttle-valve being a two-way cock by which steam is both admitted or exhausted from the cylinder. The half-flask is put on the stripping-plate, with the sand-box to hold the sand which is to be compressed, and both are filled with sand; the ramming-head is then swung forward over the flask against the stops which define its position, and the throttle-valve opened. The upward motion of the piston and attached parts carries the flask and sand up to the ramming-head, where it is rammed instantly, and upon the lever being moved again steam is cut off, and at the same time exhausted, allowing the flask to descend; the stops then engaging the free ends of side levers and arresting the downward motion of stripping-plate at a point about midway. The pattern continuing to descend is drawn from the mould, and when the

FOUNDRY APPLIANCES.

piston has returned to its lowest position the sand is struck off the flask, which is then taken from the machine. As the man removes it he presses the tripping-treadle with his foot to release the stripping plate frame, which then falls to its proper position with respect to the pattern, and the machine is ready for another mould. Water or compressed air may be used instead of steam if it is desirable, though it is believed that steam is preferable in most cases, because it is usually easily obtained without the use of special auxiliary machinery of any kind.

THE YIELDING-PLATEN MOULDING-MACHINE.

The Atlas Engine Works, of Indianapolis, Ind., are the makers of the above-named machine, a perspective view of which is given at Fig. 60. The top of this machine is

Fig. 60.

provided with a rubber bag filled with water or compressed air, and the bottom or cylinder is caused to raise by the admission of compressed air, thus forcing the flask containing the sand against the rubber bag, which, they claim, presses the sand in a manner that cannot be effected by any other known method. The makers say that amongst their several devices developed for yielding-platen mould-

ing-machines the flexible diaphragm backed by the fluid forms a wonderfully simple and effective machine. The platen yields according to the form of the pattern, thus producing uniform density of sand and perfect castings. The double rotary feature adds fully fifty per cent to the productive capacity of their original single machine. Provision is made for reasonable variance in depth of the cope and drag without adjustment of the machine. Both drag and cope patterns are on the machine at the same time. They are made alternately, and the moulds finished, covered, and clamped on the floor, ready for pouring, without increasing the labor force more than one man over that employed on the single machine. The machine is turned on its centre with little effort, and, in spite of its rapid work, is not wearing on the operatives. There is nothing to get out of order, nothing to break by strain. Wooden patterns can be used and drawn by hand, though drawing *iron* patterns through stripping-plates is recommended. The writer has stood and watched these machines in operation, and can bear testimony to the regularity as well as efficacy of their movements, which is in every respect equal to what is claimed for them, quality as well as quantity being alike phenomenal.

TEETOR MOULDING-MACHINE.

This machine provides means for holding the flask securely, and turning it over; also for jarring the pattern, and holding the same perfectly level, to allow a clean separation of the mould therefrom. As will be seen at Figs. 61 and 62, the journals of the revolving moulding table are mounted on the top of the main standards. Amongst other things claimed for this machine are the following. That nearly all patterns may be operated successfully without stripping-plate; undercut patterns, or such as have curved, tapering projections, are operated, *automatically*,

by a method of suspending such oblique parts to the main pattern by means of a slotted link, which accommodates itself to the requisite position for a clean draw. Flasks may be given such form as will suit the form of the pat-

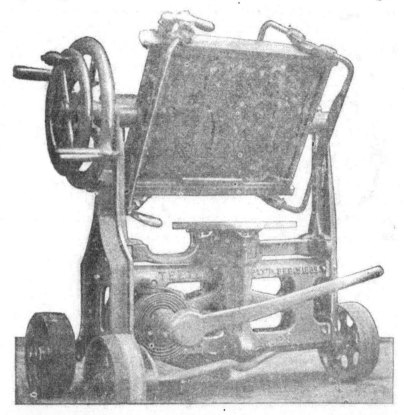

Fig. 61.

tern, in which case the general form of the intervening pattern-plate can be suited to the form of the pattern; or two machines may be employed, with separate match-plates for cope and drag.

A jarring mechanism is also provided, being mounted on extreme end of axle, on outside of the hand-wheel seen, and consists of a wheel provided with a handle and having pivoted on its rim a double-acting anchor-shaped cam,

adapted to beat sharply against the axle of the moulding-table, by being revolved rapidly, and engaging with a multiple cam ring fixed on main hand-wheel. This jarring does not shake the pattern in the mould, but gives it a general tremor sufficient to loosen it from the sand. Within the

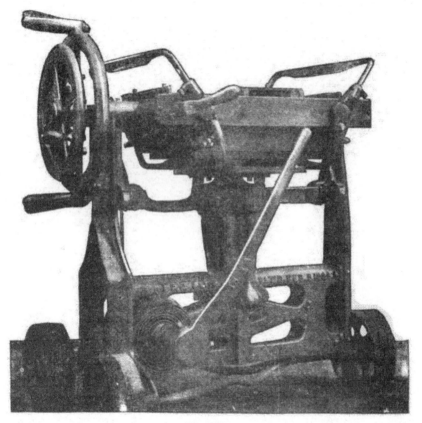

Fig. 62.

revolving moulding-table are secured four adjustable clamps, adapted to hold the pattern-plate in any position of elevation desired, to suit the comparative depth of cope and drag. The revolving moulding-table is also provided with a double set of double-acting adjustable and independent excentric bales, adapted to bind and hold the

flask and bottom board, while being turned over in revolving the moulding-table.

The patentee of the above machine suggests a method of mounting pattern match-plates without any measuring, as follows: Take one half of pattern, and drill holes at exact right angles with the joining surface set on the other half; bind well together, and drill through the other half, taking care that the hole is in exact line all through; after which secure all the half patterns intended for the pattern-plate in their respective positions thereon, and drill all holes through the same. The two halves of pattern can then be secured on each side of the intervening plate by close-fitting pins.

CHAINS, BEAMS, SLINGS, HOOKS, ROPES, ETC.,

FOR LIFTING AND HANDLING ALL CLASSES OF WORK IN THE FOUNDRY.

It is a well-established fact that the foundry is, ordinarily, run on makeshift principles throughout, but especially so with regard to the manner of handling material, whether it be the moulds or the finished castings.

If this bad feature worked advantageously either in producing more or better work, or both, there might be a modicum of excuse for pursuing such a course; but it does not. On the contrary, we find that in almost every instance more time is needed to accomplish the work, which when done is very evidently far behind in quality.

Then there is the increased danger consequent on the using of tools which are so badly adapted for the work in hand, which always engenders fear on the part of the

workman, thus in a measure disqualifying him for the work he has undertaken to perform.

But the anomaly which stands out most prominently is that it invariably takes a longer time and costs more to establish these makeshift methods than would be the case if safe and correct devices were prepared.

If the above be true, and 'true' it is, there must assuredly be something wrong somewhere. Sound judgment, backed by a good practical knowledge of all the requirements, should always suggest safe and reliable methods, even if they are more expensive at first cost. In my experience I have seldom met with opposition, from employers, to the best methods being adopted when the case has been properly put.

We are reluctantly forced to confess that most if not all of the makeshift systems in vogue arise from the fact that the man in charge is not equal to the occasion; he does the best he can, no doubt, but that is not good enough.

The subjects chosen for illustration in this article offer a wide field for thought and practice; and whilst it may be a settled fact that similar equipments for every foundry are not possible, owing to the different needs to suit special cases, yet it is safe to say that, in a general way, lifting-tackle, with some few modifications, is much the same everywhere.

It is not, as a rule, necessary to have a multiplicity of chains for handling the work in any foundry, and this may be proved very easily by a little observation. However plentiful the tackle may be, there is sure to be a favorite set or sets of chains, hooks, etc., and these are in constant demand, while the rest are usually neglected and left to rust away in some unused corner of the shop. This should at once suggest the propriety of limiting the supply to an adequate number of just such chains, etc., as are best adapted for general purposes.

Still, a too strict adherence to the system of making everything subservient to one principle of handling is to be deprecated, for the simple reason that it will be found very desirable in special cases to make radical changes in order to obtain the maximum in both quantity and quality of work to be done. Experience proves that any departure from fixed methods, which will perhaps lessen first cost as well as facilitate production other ways, is to be commended, even if the tackle made for such special purposes be not required when the job is through.

The substitution of hinges for the recognized methods of separating sometimes works wonders, and not only saves lifting-tackle and time, but enable some of our small founders to accomplish work which without their aid would have been far beyond their capacity.

The same may be said in regard to other methods, such as lifting by the use of chains and resting copes on horses provided with bearings for the swivels to turn in. This method can with profit be changed in some shops by using the beam and slings, which latter-mentioned device is eminently adapted for a wide range of work when properly managed.

Fig. 63 will serve to show several methods of handling loam work, round or rectangular, by the use of a four-armed beam or cross, on which, to favor illustration, are represented three different modes of carrying the moulds.

The cross seen at A is supposed to be made of cast-iron, and is provided with a steel centre eye, which works loose in the cross. The cross is strengthened laterally by a flange extending from the centre to the limit of the notches for holding the slings, beam hooks, or chains which are set therein.

The plain wrought-iron slings marked B, C, D, and E are useful for all ordinary lifting when the mould is suspended direct from the cross, as shown. They are also ex-

cellent adjuncts to the cross for binding purposes, because there is no particular harm done by leaving them rammed in the curbs, or pit, until the mould is cast. The plan of leaving chains, or any other tackle required for general use, in the pit is a reprehensible one, and should be avoided as much as possible.

Fig. 63.

It will be seen that by using the cross these plain slings are equally applicable to square and round moulds when the lifting lugs are cast at the middle of the square plate, as seen at *F*, *G*, *H*, and *I*.

By substituting chain-slings like the one shown at *J* and *J*, an ordinary beam, similar to the one shown at Fig. 64, may be used, and square or round moulds lifted with equal facility, the centre lugs *F*, *G*, *H*, and *I* being used for the round moulds, and those at *K*, *L*, *M*, and *N* provided for the square ones; the flexibility of the chain-sling allows of its being passed around the mould to the lifting lug with ease.

When the method of single beam and chain slings is adopted, it is advisable to make all lugs on the plates after the manner shown at Fig. 65, and the sling end of the chain should be fashioned to fit the same easy; by this means the grip is always solid, no matter what angle the chain may take when the mould is lifted.

In order to make such chains serve for both long and short moulds, beam-hooks like the one shown at O, Fig. 63, can be forged, into which hooks or slings can be linked to bring the sling chain up to the desired length.

One other method remains to be spoken of in this connection, which goes to prove what has been previously

Fig. 64. Fig. 65. Fig. 66. Fig. 67. Fig. 68.

stated in regard to adopting for every job the same mode of handling. At PP is shown the method of lifting loam moulds with the can-hooks exclusively, made with chain or long links, as shown.

To make the can-hook principle as safe as possible, strict attention must be paid to the form of the lugs provided for lifting by. Figs. 66 and 67 will explain more readily than could be done in words how this may be accomplished. At Fig. 66 it will be seen that the lug is made at an angle on the side next the hook; this allows the hook to take a firm grip well up to the root, where it is the strongest; and Fig. 67 shows a stop cast on each lug to prevent any possibility of the hook slipping off.

It will be quickly perceived that, in order to allow of

these hooks being used for the purpose above mentioned, all plates and rings must be made square, no matter what the form of the mould may be.

When it is intended that flasks shall be lifted on the same principle, all upper flanges must be formed after the manner shown at Fig. 66, or else provision can be made for

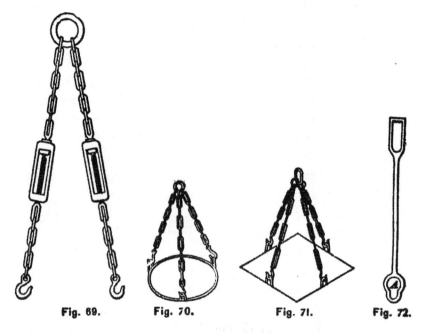

Fig. 69. Fig. 70. Fig. 71. Fig. 72.

ring-bolts at such places as will best serve the purpose, and used as shown at Fig. 68.

One of the most useful styles of chains which can be provided for the foundry is the buckle chain, shown at Fig. 69. This may be made of any degree of strength, and consist of as many legs as occasion requires. It is safe to say that any foundry lacking such appliances as these will profit considerably by providing themselves with at least two pairs, light and heavy, of just such chains as are shown at Fig. 69. How much time they will save compared with using a plain chain, when a nice adjustment is needed, is

well known to all who have had any experience in their use, and therefore requires no mention here.

Three and four legged chains, shown at Figs. 70 and 71, are a great convenience for special occasions, and their usefulness is materially augmented by having them made with a turnbuckle like those at Fig. 69. The contemptible practice of thrusting nails between the links for the purpose of adjustment is entirely obviated when these more sensible means are employed.

The beam, previously spoken of in reference to its use for loam work, and seen at Fig. 64, can be made to answer very many useful ends, chief of which is the reversing of copes by the aid of slings. The form of sling shown at Fig. 72 is perhaps as useful as any, its main feature being that the lower circle at A is forged to fit the groove of the swivel, the upper circle being necessarily large enough to slip over the guard of the same.

Another use for the beam is explained at Fig. 64, which figure serves to introduce the turnbuckle A in another phase of its usefulness. This entire rig will be seen to consist of hooks, two of which, B and C, take the first hold, any inequality of weight being regulated by the notches in the beam, while the buckle A admits of almost instant adjustment at that point, making it a very easy matter to lift all irregularly formed moulds with the greatest nicety.

This class of beam may easily be made of wrought iron, and because such beams are lighter and safer than cast iron ones, the propriety of making them of the former material will be apparent. The hole under the beam at D is a noticeable feature, and will be appreciated when any supplementary hitching must be done.

It will be well to observe here that the hook shown at O, Fig. 63, is really a part of this rig, and is very properly

called a beam hook, because ordinarily these hooks would be set in the notches, and hooks *B* and *C* slung thereon.

The variety of uses to which the turnbuckle *A* can be put will be apparent to many who are now making shift to get along by methods which are simply ridiculous, by comparison, on account of their inadaptation to the work for which they have been planned, and that have cost perhaps more than tools adequate to the work to be done would have cost.

A good sling-chain may in many instances be made to do duty for the beam and slings by the use of a stout oak timber, as seen at *A*, Fig. 73, the timber to be strengthened at the ends by an iron shoe which allows of link-pins being driven in, as seen at *B* and *C*. This combination will recommend itself as a time-saver in scores of cases where

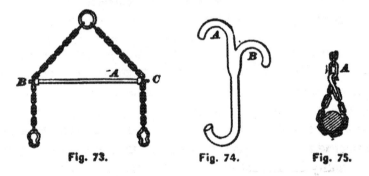

Fig. 73. Fig. 74. Fig. 75.

the object to be reversed is not too heavy to make such a means impracticable.

Fig. 74 is a *change-hook*, and, as its name implies, is used where material must be passed from one crane to the other without resting the load; its use is so common as to make any description here superfluous. *It would be well to observe, however, that inasmuch as men must necessarily be very near during the process of changing, the greatest care should be taken in selecting the stock for, as well as the forging of, this hook.*

Sometimes the eyes *A* and *B* are close-welded to the body of the hook with the view of augmenting the strength, but it is much handier for use when they are left open, as shown; therefore, to combine utility with strength, let them be made more massive.

Fig. 75 serves to illustrate how all common long chains should be made for the foundry. What is meant by common chains are all such as are composed of two strands of chain attached to a ring or link with hooks on the opposite ends; in other words, like the one shown at Fig. 69, minus the turnbuckles.

In all these there should be large links inserted at

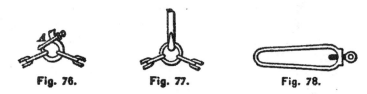

Fig. 76. Fig. 77. Fig. 78.

intervals, into which the hook could be inserted, as seen at *A*, Fig. 75. This increases the usefulness of the chain to a remarkable extent, as will be at once seen if the least thought is given to the subject.

It would be well at this juncture to call the attention of all concerned to a practice which I am sorry to say prevails in many of the foundries, of making the *shop chains* out of the *old crane chains*. Now such practice is, to say the least, a very bad one; and there need be no wonder why at such places they should have so many broken chains, with an occasional broken leg or back to save the thing from becoming monotonous.

When a chain is considered to be unfit for the crane it may be reasonably supposed that its usefulness is ended, and it should be at once consigned to the scrap-pile.

When a lift is to be taken on a very long box, with two pairs of ordinary chains somewhat short for the purpose, it

is common to see one pair set to lift each end of the box: this naturally spreads the rings in the hook after the manner shown at Fig. 76, and brings the strain front and back of the hook; the effect not infrequently of this mode is to rend the hook asunder. This may be obviated in most cases by altering the position of the chains, so that each pair will lift one side: by so doing the spread takes place in the ring, as seen at Fig. 77, and the hook is called upon to bear the whole weight direct without suffering any undue strain.

But should it be absolutely necessary to take a lift which would in any way endanger the safety of the hook, let a

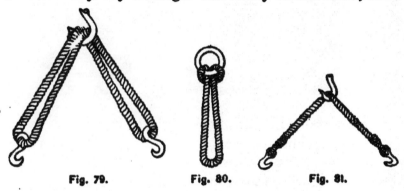

Fig. 79. Fig. 80. Fig. 81.

screw clamp be made like the one shown at Fig. 78, and applied as seen at *A*, Fig. 76. This will give stability to the hook, and allow of such lifts being taken with comparative safety.

Rope tackle is not as common in the foundries now as it used to be: this is not owing to any particular fault of such tackle, but because of the difficulty in procuring it in good shape. It is not every man who knows how to 'splice' a rope, make an 'eye,' or take a 'blackwall hitch'; so, because it is easier to order a chain with a measurable degree of certainty as to its fitness than it is to procure the rope equivalent of the same, the former has become the rule nowadays.

CHAINS, BEAMS, SLINGS, HOOKS, ROPES, ETC. 169

Still, this in no sense robs the rope of its merits: they are always useful adjuncts to foundry practice when it is practicable to obtain them. The single-spliced sling shown at Fig. 79 can be made to serve many useful purposes, such as drawing patterns, lifting cores, wood flasks, or anything which requires an uneven hitch to be made rapidly. Fig. 80 shows how readily it can be hitched fast to a ring and used for numberless purposes, either end up; and Fig. 81

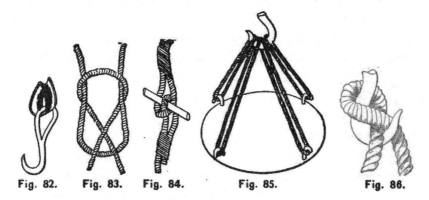

Fig. 82.　　Fig. 83.　　Fig. 84.　　Fig. 85.　　Fig. 86.

shows how a pair of light can-hooks might be improvised at short notice.

Fig. 82 illustrates the kind of eye to be used when rings, hooks, or slings are to be secured thereon for the purpose of carrying heavy loads. Figs. 83 and 84 represent how to temporarily join two slings or two eyes. Fig. 85 will serve to show how handily two or more single slings can be made useful in ways too numerous to mention, and Fig. 86 is a common hitch amongst riggers, its one excellent feature being that it can be made and unmade almost instantly.

POURING, FLOWING-OFF, AND FEEDING CASTINGS.

There is no other department of the moulder's trade in which, anomalous as it may appear, the average mechanic shows so much density as in the subject of pouring or filling the moulds with molten iron. This seems a startling announcement to make, in view of the great importance given to this subject by all who are intelligently conversant with the art of moulding; but the fact remains nevertheless, and can be proved every day by careful observation in our foundries.

What can be more ridiculous than to see the greatest care exercised in the construction of a mould, every precaution being used that not a particle of dirt remain, even in its remotest parts; and yet, strange to say, this same careful (?) moulder, after all the solicitude he has unmistakably manifested to make a clean *mould*, will spoil the *casting*, by leaving all consideration of runners until the last moment, when he seizes a rude piece of curved tin, and at once proceeds to give an exhibition of carving sand, utterly oblivious of the fact that he may make or mar the whole job at this particular time, and heedless of the warnings of such of his fellow-workmen as may have already discovered that *dirty runners make dirty castings,* no matter how clean the mould may be.

In order to emphasize the above, I would here say that where the object aimed for is to produce clean castings, all such contemptible subterfuges as gate-cutters, improvised out of tin, copper, or sheet brass, should be at once and forever abolished; as well might we expect molten iron to run

uphill voluntarily, as imagine that clean iron can be delivered to the mould through gates which have been dug into a wet joint without regard to either cleanliness or proportion.

Whatever care is needed to secure a clean casting should be extended to the gates also. When the mould is made, every precaution is taken to insure a surface on which the metal can rest undisturbed; if the same precautions were taken for the runners and gates also, we should find a difference immediately.

All leaders and gates should, where practicable, be formed by patterns having the smoothest face possible; and wherever it is possible to reach them, their surfaces should receive the same careful attention as the mould.

The indiscriminate gouging out of so-called 'spray gates' is the cause of most of the anxiety experienced in architectural foundries from crooked castings and otherwise, and where a similar practice is tolerated amongst general jobbing work, clean castings are simply an impossibility. In the former instance gates are cut at haphazard, regardless of proportion, and with such manifest ignorance of the requirements that the casting is lost, either from lack of volume in the runner, or the opposite extreme is obtained from gates of such magnitude as will draw the casting out of shape, or, as very often happens, break it altogether; in the latter case clean work is made utterly impossible, on account of the large proportion of dirt which forms in these rude and uncouth expedients.

To correctly locate and determine the best methods of running is, to my mind, one of the chief elements in the art of moulding. If proper attention was given to this important subject it would develop a line of thought and action to which most moulders have hitherto been strangers. Too frequently the exigencies surrounding a job make it almost impossible to adopt methods which would give per-

fect results, and I am free to confess that cost sometimes interferes with the adoption of means which are absolute and certain; still, that need not deter us from ascertaining, if possible, what are the right principles which, if faithfully observed, will assure success in this very important particular.

Honor demands that full discussion be given this subject; a mere generalizing fails to exhibit its numerous difficulties: and no one will deny that at this day serious defects in castings (carefully concealed) might be averted if more conscientiousness were displayed on the part of both employers and their aids. How many castings enter into the construction of buildings, and form parts of the very elaborate and ingenious mechanical contrivances in constant course of erection, which would never have had a place there if those in authority had been cognizant of the many flaws existing internally, most of which might have been avoided if correct methods of pouring had been followed!

Castings having external blemishes may be dealt with according to the judgment or conscience of the firm which make them; but internal blemishes, caused by inordinate quantities of dirt lodged in critical parts (a result in most instances of faulty pouring); gas-holes, equally dangerous, which a judicious arrangement of gates might have prevented,- these, coupled with the countless errors arising from imperfect feeding to parts having dissimilar magnitudes, cught, I think, to suggest the propriety of giving this subject a place second to none in foundry economics.

Plainly stated, the science of filling moulds with molten iron consists of three grand principles, viz.: first, *that the mould must be filled evenly, with molten iron of equal temperature throughout; second, that such iron be distributed by means which shall cause the least amount of friction on the surface of the mould; and, third, that the*

POURING, FLOWING-OFF, AND FEEDING. 173

molten iron be freed from all its impurities before it enters the mould.

How this may be accomplished will, no doubt, be a matter too tedious for some to examine into, but there are others who may be willing to study the subject earnestly; to such the following will be of interest.

In order to a clear understanding of all the points connected with the very important matter under consideration, it will be necessary to take it in detail, beginning with 'open-sand' and common covered work,—which means all such castings as do not require finishing, only of such a nature as can be accomplished with the paint-brush,—extending the inquiry until we have covered the whole ground, including such castings as must of necessity be free from spot or blemish.

Castings in 'open sand' (meaning all such as are cast without covering) are not nearly as numerous as they formerly were, and this not because of any particular fault inherent to the system, but rather that there are so few men who are competent to make this class of work successfully. Consequently, jobs are often covered, at an augmented cost, which might have been saved to the founder or his customer had the needed help for the production of such work been on hand. It is no exaggeration to say that the chief trouble with open-sand work is the pouring; when this is thoroughly understood, all other things being equal, very good work may be produced by these means.

I have seen excellent furnace-fronts, weighing-machine tables, large flooring-plates, etc., cast in open sand; and it comes very forcibly to my mind when on one occasion I cast the rim of a heavy fly-wheel with wrought-iron arms very successfully in the same way. As previously stated, the pouring is the trouble in a majority of cases.

Supposing a plate be required 7 feet by 7 feet, or 7 feet diameter and $\frac{3}{4}$ inch thick: the usual practice is to cut

guides at intervals round the edge correct to depth. Some one or more is set to watch these guides and check the further flow of metal when the supposed height is reached; but a very limited knowledge of such things is sufficient to convince us that this kind of practice is very unsure, for usually on these occasions more than one ladle would be used for pouring with, and the feeling of uncertainty which exists prevents unity of action; consequently the plate is

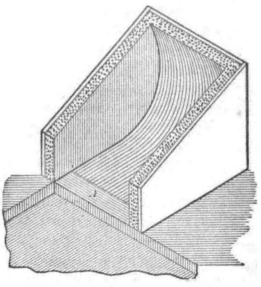

Fig. 87.

invariably imperfect, if not bad altogether, being either too thick or too thin, or perhaps thick and thin in parts.

To obviate all this uncertainty, and consequent loss and disgrace, let a *good* mould be prepared, *having the edges made up very much in excess of the thickness required*, after which proceed to construct a runner at one corner, convenient for quick handling of the ladle, as shown at Fig. 87. The runner shown is for the square plate, and is set to run along one of its sides. Spare no pains in forming it after the manner shown; have width sufficient to

permit a stream 2 feet wide, with a gradual curving surface from the back downwards. As the iron rushes over the edge it is apt to carry it away if made up with green sand; to prevent this casualty, make the edge at this spot with a dry-sand core, as seen at *A*.

For all plates answering to the dimensions given, one ladle will be sufficient for pouring with (hot fluid iron being, of course, indispensable), in which the exact quantity of iron, neither more nor less, must be tapped. It will now be seen why the sides are to be made up high. Having the correct amount of iron in the ladle, it only remains to

Fig. 88.

pour it briskly down the incline of the runner, when the stream will strike the opposite corner with a force sufficient to drive it at right angles to the next corner, and so on; being urged by the constant supply behind, it whirls uninterruptedly around the periphery, and finally settles itself evenly all over, and all this without the least anxiety on the part of the operator, whose only business it is to empty the contents of the ladle into the mould with the greatest possible dispatch, and leave it to settle of its own accord.

Figs. 88 and 89 are plan and elevation of the same runne

when applied to a round plate. The core for protecting the edge is seen at *A*, Fig. 89. It will be observed that this runner is set tangential to the circle, the idea being to strike the edge, which must be made up high, as seen at *B*. This causes a rapid rotation of the molten mass, which ultimately settles or rests at an even surface all over, all anxiety as to correct thickness being removed, as before, by having the exact quantity of iron in the ladle.

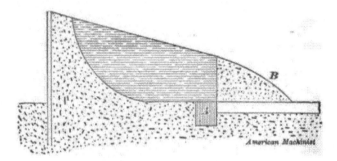

Fig. 89.

When it is desired to make a casting in open sand, the lower side of which offers some difficulty on account of ribs, hubs, lugs, or brackets which must be cast thereon, advantage may be taken of the method of running shown at Fig. 90. It will at once be seen that by placing one or more of these runners at such parts as will provide for a steady flow of iron into the mould the greatest nicety may be obtained, as any degree of pressure can be had by simply increasing or diminishing the height of the runner basin *BB*. These runners can be made very readily in dry sand, as shown at *A*.

The almost universal condemnation of open-sand work arises from the fact that moulders are cognizant of their shortcomings in this particular, and endeavor to hide behind a general depreciation of possibilities; but it is, nevertheless, certain that, if the system is worked for all it is worth, very

much of our work might be simplified, with a consequent reduction in cost of manufacture.

We will now pass to a consideration of some of the evils

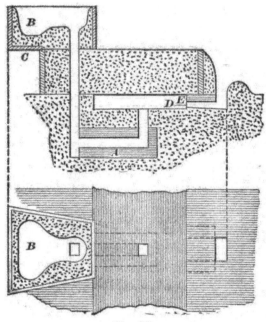

Fig. 90.

connected with the pouring of thin covered plates. Figs. 91, 92, 93, and 94 are intended to show the faults arising from the almost criminally bad methods usually resorted to for running flat work, whether for rough castings or for such as require planing.

I have purposely placed the runners in Fig. 91 in about the same slipshod manner that ordinarily prevails at every foundry where special prominence is not given to the subject of running; runners A, B, C, and D are sprays of the common type, and, as seen, are placed without any pretension to system or method. A careful analysis of this figure will help to solve some of the problems which are constantly puzzling the anxious moulder: observe that

runner *A* is set on the right-hand corner, with the end spray marked 1 connecting with the casting at the end, whilst all the others are removed towards the centre in varying distances. The shade-lines issuing from each gate, and spreading out in opposite directions, serve to show us the direction of the various streams as they enter the mould, whilst the difference in depth of shade, caused by the inter-

Fig. 91.

section of the lines, represents the commingling of the streams at the point of juncture.

A little reflection will serve to show that, because sprays 2 and 3 are so far removed from each other, the spaces *E*, *F*, *G*, etc., are left to be filled after the molten iron has spent its heat and lost most of the force with which it first entered the mould, and the same may be said of all other parts of the plate where the shade-lines do not reach, even the spaces between the sprays showing at times conclusive evidence of the lack of pressure and heat.

To expect that a casting poured in direct violation of all the laws which govern in this case should be straight, is simply preposterous; they never are, and yet some persist in their ignorant course, and wonder why they should always have so much trouble with their plates.

Is it not plain that long before the corner served by gates A and B (with a good supply of hot iron from the commencement of pouring) could be set, the corners E and H (hardly filled with dull iron at the last) would have

Fig. 92.

become cold by comparison, and shrinkage begun? In addition to which there are the accompanying 'cold shuts' incident to such practice, which of themselves are sufficient to cause crooked work, as a few vibrations are all that is necessary to cause an open fracture sometimes, thus proving that 'cold shut' practically means *fracture* pure and simple, and should always be considered such.

At Fig. 92 is shown a plate one half the width of Fig. 91, with the sprays cut closer and more equally along the entire length, excepting at A; this being purposely left

out to show how important it is that gates should be cut as seen at *B*.

As indicated by the shade-lines, heat and force are about expended at *CC*, leaving the furthermost side to be filled with iron at a much lower temperature than where the gates are, thus producing unequal rates of cooling, with the consequent drawing out of shape. As will be noticed, the spaces between the sprays exist in this case as in the other; and one only needs to make very careful inspection of plates cast this way to detect in some instances very serious

Fig. 93.

flaws, which can be overcome only by a continuous gate extending the full length of the leader.

The first of the three conditions stated at the outset is violated in both the above instances, because, as shown, these methods fail to "fill the mould with iron of *equal temperature throughout.*" We will now consider just how near it is practicable to do so in this instance. Fig. 93 shows the same casting with 16 runners equally divided over the upper surface, and Fig. 94 is a plan view of the

cope and runner box, when it is intended to pour such a casting with one ladle; a very practicable method, and one which I have successfully adopted on all occasions when it has been desired to produce a straight casting which had to be planed on both sides.

By making the basin capacious, and forming the leaders as seen, such a runner can be filled almost instantly, without danger of carrying any of the dirt down into the mould.

If Fig. 93 be carefully examined, it will be seen that, in-

Fig. 94.

stead of straggling streams issuing from the gates, as at Figs. 91 and 92, we have a constant supply of molten iron, of 'equal temperature,' spreading itself over the whole surface, and thus, as near as practicable, meeting the demands of the first proposition.

When necessity compels an uneven distribution of the chief runners, auxiliary ones may be placed in just such places as are likely to need them, as shown at *I*, Fig. 91.

Fig. 90 shows a method of pouring by introducing the iron into the mould in an upward direction, and is preferable in all cases when it is desired to keep the bottom of

green-sand moulds intact, there being less friction on the parts than is caused by the other modes of running.

The style of basin is common; yet, common as it is, there are very few moulders who have spent sufficient thought upon its making to enable them to produce one correctly. In the first place, the box itself should be of iron (not wood; this is both dangerous and costly), with a bottom extending some distance from the front, as seen at C; this allows for the box to overhang a cope without the necessity of banking behind. In addition to having the basin a little deeper at the drop, so that the stream from the ladle may fall into iron and not on the sand, it is well to leave ample space in the leader and around the down-runner, as a too limited area at these parts causes a slackness at the mouth, and the runner 'draws air' all through the cast, simply because the supply is not equal to the demand.

The figure also serves for showing how to make a flow-off gate when it is desired to run off at as low a point as possible. The flow-off gate is formed at D and covered by core E, which extends beyond the edge of the flask; the gate is fully formed after the cope has been closed as shown.

Figs. 95 and 96 illustrate modes of running which may be practised advantageously on all castings with deep sides when it is desired to accomplish good work of this class in green sand. It is well known that when all the iron for a heavy piece is poured through *one* runner direct into the mould, there is always indubitable evidence of the extreme test which the runner end is called upon to endure: all such parts as are farthest from the runner retaining in some measure their original form, whilst those parts nearest are only made passable by subsequent cleaning and chipping.

To secure an equal distribution of the iron, and thus in some measure avoid the evil spoken of, let runners similar

POURING, FLOWING-OFF, AND FEEDING. 183

to those shown at Figs. 95 and 96 be made. Leader *A*, Fig. 95, is intended to be formed by a pattern set in position, and horn gates *B* leading therefrom to the mould *C*. The main runner, shown by broken lines at *D*, can be set at any part of the leader which may be the most convenient. One essential feature in this system, when the cleanest

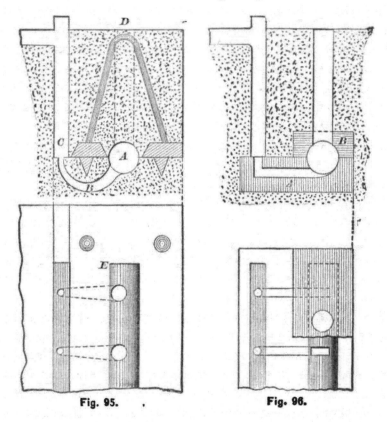

Fig. 95. Fig. 96.

work is desired, is to have the leader extend past the end gate, as seen at *E*, Fig. 95: this allows of the first rush of iron, with its accompanying dirt, finding a lodgment there, the casting being, of course, benefited just that much.

The mode of preparation for this green-sand runner is clearly indicated by the figure, and Fig. 96 shows how to make a runner equal in efficiency when it is not desired

to adopt such elaborate means. Cores *A* are made in sections and set end to end on a prepared bed, and cores *B*, with holes for down-runners, are set thereon, thus forming a complete runner, which only requires ordinary care to make it a success every time.

Fig. 97 shows an approved style of draw-runner which has undoubted advantages over the common straight ones, indicated by broken lines at *AB*. It will be seen that, in using a runner which connects with the mould at right angles, there is always more or less danger from drawing

Fig. 97.

Fig. 98.

air, if any temporary stoppage should occur in the pouring prior to the mould being filled above *A*. By the method illustrated the first portion of iron fills the runner as high as *B*, thus precluding all possibility of danger from that source. Much of the danger from scabbing may be averted by placing dry-sand cores where the iron rushes past, as seen at *C*.

Sometimes it is found convenient to run a deep-sided mould directly opposite to one of its sides, in which case, owing to the great commotion caused by the rebound, it is advisable to protect the surface in the immediate neighborhood of the gates by having dry-sand cores, as shown at Fig. 98.

POURING, FLOWING-OFF, AND FEEDING. 185

The subject of runners would be far from complete were the very useful ones shown at Fig. 99 to be omitted. These are of universal application amongst a miscellaneous class of jobbing work, and where the mould is not too deep may be relied on for producing clean work, because, being thin, they allow of the basin being filled before time is given for any dirt to pass downwards into the mould. They are best when made about $3\frac{1}{2}'' \times \frac{3}{8}''$, with a very slight taper, and much trouble in steadying may be saved by having

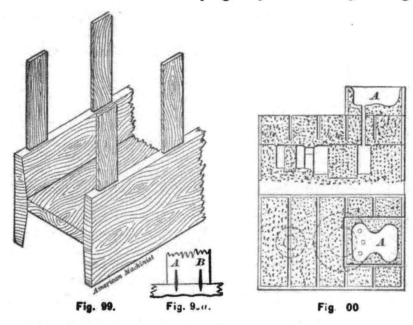

Fig. 99. Fig. 99a. Fig. 00

them spiked as shown at Fig. 99a, A and B being simply common nails driven in a short distance, and the remaining part filed to a point.

The arrangement of drop-runners does not seem to receive that amount of patronage which I think it should do. When the bottom of the mould can be made to bear the dropping test, it must be plain to any one that this mode has merits which none of the rest possess, inasmuch as the distance from the basin to the mould is reduced to

a minimum, and consequently there is less area over which the metal must pass (and gather dirt) before it enters the mould.

The crank shown at Fig. 100 is a good illustration of how particularly handy and effective this mode of running is: the basin *AA* is made large, and extends beyond the runners; this, as previously noticed, permits the iron to be poured with force sufficient to carry everything before it over and beyond the drop-gates; the increasing volume of iron serves to keep the dirt floating on the surface, whilst the mould is being fed with clean iron which drops into the molten mass below in the easiest and cleanest manner

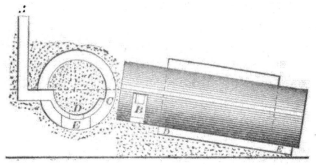

Fig. 101.

possible. No other mode of running can compare with this whenever it is practicable to adopt it; and when green-sand moulds make it impracticable, why not make the mould in dry sand, and thus secure all the advantages of this very excellent system ?

Steam-cylinders cast horizontally have always been a drug in the market on account of the danger of losing the piece from dirt which inevitably collects under the body core; and rather than go to the expense of boring out extra stock, purposely allowed for the dirt to collect in, firms are to-day making large numbers of small cylinders in dry sand, in order that they may be readily cast in a vertical position.

POURING, FLOWING-OFF, AND FEEDING. 187

One way of overcoming this difficulty is shown at Fig. 101. Let a main runner A connect with a circular runner B, prepared in the core, and extending round the same as far as C; from this circular runner a gate must be formed (in the core also) connecting with the casting after the manner shown at D; also prepare a receiver or bottom head, so to speak, as shown at E, in both elevations. The first rush of iron down B will tend to carry the dirt past the gate D and round the core towards C, where, if the pressure is kept constant, it will be held; the mould (being inclined about 6 in. in 3 feet) will give an impetus that will carry the first iron with force down to the receiver E, where whatever dirt may have washed downwards will be firmly imprisoned.

Fig. 102 illustrates a system of dams set before the castings when it is desired to produce clean work from a spray. When best results are looked for, all such gates should be connected with the patterns on a matchboard, so as to insure a good hard surface for the molten iron to pass over. Gates cut with tools are, as before stated, untrustworthy on account of the soft, broken surface yielding to the extreme heat to which they are subjected, and thus forming slag that invariably finds its way into the casting.

The form of the leader in this instance is a noteworthy feature: the iron entering at A travels rapidly along the smooth, round surface of the leader, passing the gates, and out at C, carrying a large proportion of the dirt along with it; whatever portion remains is held on the upper surface of the leader whilst the casting is being fed from the bottom. The dams D, as seen, are formed with cores, and make "assurance doubly sure" by checking any inflow of dirt, should the pouring from any cause be lacking in force.

There is no other casting that has helped the science of

running as much as the governor-ball. During the early part of my apprenticeship this job was held back for some particular man, who alone could be trusted with such an important job; and not unfrequently have I known the best men to fail time after time to produce a casting that was clean all over when turned.

Fig. 102.

The manner of running a ball which must be turned bright is shown at Fig. 103, where it is seen that the metal passes down A into the ball at B; the direction given the metal by this form of ingate causes the metal to revolve rapidly in the mould, and this causes the lighter substances which gather on the surface to collect towards the centre, as indicated by the arrows in the plan, to be ultimately ejected at the riser C.

The principle involved to keep the ball clean must natu-

rally suggest the propriety of filling other moulds from such a ball whilst the dirt is being held a prisoner in the middle of the swiftly rotating mass; and just how this may be accomplished is shown at Fig. 104, where a number of castings, directly connected with a central ball, may be fed with comparatively pure iron, with no possibility of dirt

Fig. 103.

other than may be gathered within their own limits. Unless in large castings, there need be no riser on the ball when it is used for running purposes.

Fig. 105 shows how the principle may be made general, and used for almost any class of work.

Fig. 105 illustrates two methods of running pipes or col-

umns at the flanges, the gates *AA* being intended when it is desired to run down through the cope, and the one at *B* to be used when it is thought that the former plan would be too hard on the mould at that point.

The regulation method of running square columns is

Fig. 104.

Fig. 105.

shown at Fig. 107. All such columns will run from one end, under ordinary head pressure, 17 feet at one inch thick if the iron is in good condition; beyond this it is unwise to go, especially if the column should be less than one inch. I speak now of how far metal will reach in such work; but as the method of running long columns all from one end conflicts with the first principle of filling moulds with iron of equal temperature, it is very evident that all long cast-

ings should be filled from both ends. The wisdom of the above always strikes us the more forcibly when we see any violation of these principles result in a cracked casting.

Fig. 106.

Keep all risers away from brackets, for should there be but a very slight commotion in the mould the bracket is sure to suffer if the disturbance finds a vent at that point.

When the flask will admit of running round columns at

Fig. 107.

the end, it is by all means the best plan to adopt; and the best kind of runner for this purpose is shown at Fig. 108, where main runners AA are seen to connect with a circular runner B cut round the bearing, and entering the casting

at one or more gates ample to run the column safely. Round columns will run 18 feet ⅜ inch thick from one end, providing all other things are favorable; but the remarks on square columns apply with equal force to round ones, and risks should not be taken.

Sometimes it is found advisable to change the location of the runner; if this must be done, choose some flange or collar into which the gates can be directed, either on the side, as seen at *C*, or dropped down as at *D*.

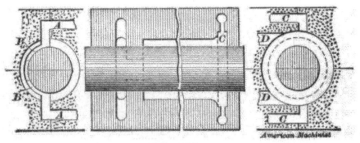

Fig. 108.

Fig. 108 shows how to run a large wheel through the hub core. The centre dry-sand core, with a hole large enough to fill the mould at a proper rate, rests on another dry-sand core in which the requisite gates have been prepared. To save making the bottom core, holes for gates may be made at *A*, indicated by broken lines; but this plan is somewhat risky if the noses against which the iron beats are not made in dry sand, as seen at *B*.

It is plain that a wheel filled after this manner is preferable to any other, as it makes what is otherwise a critical job a very safe one, and insures a good casting every time, at least so far as the running is concerned.

Fig. 110 is a plan and elevation of a spiral drum, or at least as much of it as will serve the purpose of showing how to arrange for a system of bottom gates, when such gates must be made in the pit around a brick mould. Where the

POURING, FLOWING-OFF, AND FEEDING. 193

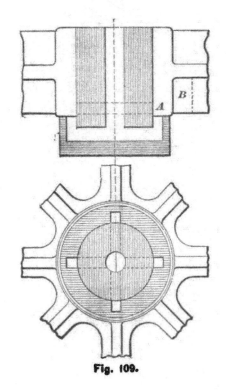

Fig. 109.

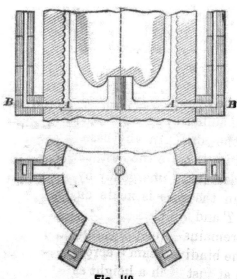

Fig. 110.

pits are damp, it is absolutely necessary to have the gates protected from the moisture.

The method shown needs no explanation other than can be discovered by a careful examination of the figure. *AA* are the gates prepared in the mould, against which are set cores *BB*, these again being surmounted by other cores, as seen, until the top is reached. If the mould is unusually long, and there is danger of the metal becoming too slug-

Fig. III.

gish to fill the upper parts of the mould correctly, then apply the gates on the top, after the manner as fully explained in "The Iron Founder," page 163.

The utility of feeding castings is questioned by some; but a little reflection will, I am sure, lead all who deny its efficacy to see the erroneousness of their conclusions.

The ball shown at Fig. 111 is supposed to be 12 inches in diameter, and suppose that such a ball was cast (without riser) with hot iron, and left to cool in the same position it was cast: it is certain that the upper surface would have

fallen in, in proportion to the amount of shrinkage which would have taken place before the crust was firm enough to sustain itself; the amount of shrinkage would of course be according to the nature of the iron it was cast with. Now if this ball when cold was split in two it would be found that the upper hemisphere would show a sponginess similar to that seen in the sectional illustration at Fig. 112. The figure quoted is a good illustration of the point under consideration, being a sectional representation of a piece of

Fig. 112. Fig. 113.

roll cast from inferior iron ; the internal shrinkage, unsupported by any system of feeding, causing the sponginess at the heart and very evident fracture at the neck.

Mortars, such as shown at Fig. 113, were formerly cast solid, with a shrink head from A up. The head was afterwards turned off, and the casting bored out to the broken lines. And yet with the head cast on, as shown, it was never deemed advisable to risk a cast without keeping the heart free from scum, so that a constant supply of hot iron could be introduced to fill up the space which gradually forms as the shrinkage takes place.

Now in the ball shown at Fig. 111 we endeavor to reach the heart of the casting through the riser A, which is made

no larger than will just serve the purpose of feeding the ball. (In the former instance no riser was supposed to be on.) If the mould now under consideration was left to take its own course after being cast, the natural feeding would occur as long as the iron in the neck of the riser remained fluid; but, as shown by the shaded lines, by the time the neck was solid there would still remain a considerable area of iron in a molten condition, and it is at this juncture that the rod B gets in its fine work by simply keeping open a communication between the upper and lower bodies by a constant supply of hot iron from the cupola. This is not, as some seem to think, a sort of pumping or forcing of the

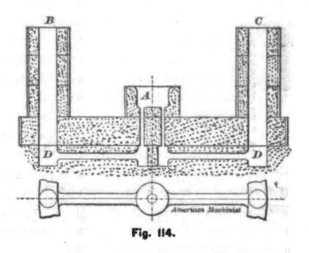

Fig. 114.

iron below; the motion of the rod exercises no influence whatever, only to preserve a free channel through which the hot iron can pass into the shrinking mass below.

Excellent results may be obtained by pressure-feeding sometimes, as illustrated at Fig. 114, which figure is intended to show how to feed the solid rim of a gear-blank by 'freezing' the runner A immediately the mould is full, and afterwards pouring hot iron alternately down risers B and C, so regulating the operation that the body of metal below

at D may be kept in motion as long as it remains in a fluid state.

The possibilities of making such a casting solid by this method of feeding are considerably enhanced by the augmented head pressure, which in this instance is 1 foot 6 inches more than would be the case ordinarily. Still it must be evident even to the least observant that this method has its limits of usefulness clearly defined, and can only be resorted to when the riser and casting are of equal magnitudes, or nearly so.

When this is the case the process of solidifying proceeds equally and uninterruptedly from the outside, *at both riser and casting*, the shrinkage of the contracting mass being made good at every step by the constant *and increasing* pressure of liquid iron, which is being forced through from above; but it must be observed that certainty of results can only be reckoned on when this entire operation is continued until the point of congelation is reached.

As proof of the above, let a riser of the same dimensions be applied to a body of larger area, and no matter how hot the supply or how high the pressure, the riser will have congealed long before the heart of the casting, as is clearly demonstrated at Fig. 111, making it absolutely imperative that the *feeding-rod* be used, as heretofore explained, or that *pressure* and *area* of riser be increased commensurate with the increased magnitude of the casting.

STUDS, CHAPLETS, AND ANCHORS.

HOW TO USE AND HOW TO AVOID USING THEM.

As long as moulds are made with cores forming a part of their general make-up, we must accept studs and chaplets as a necessary evil. Fully recognizing the fact that they have 'come to stay,' we must endeavor to use them with such discrimination as will give us the maximum of good and the minimum of evil attendant upon their use.

True, their use may be entirely discarded in many jobs, if it be thought desirable to incur the expense of furnishing suitable means for securing the work without them; and it is always in order that a good moulder, if permitted, will make such disposition of the details connected with his job as shall in some instances result in accomplishing his work independent of chaplets altogether. To wilfully eschew such practice, when practicable, is a superbness of ignorance simply astounding; nevertheless, such is truly the case, and the fact is to be deplored.

How many jobs, at very little outlay for cost, might be made after the manner shown at Fig. 115, where it is seen that the core, formed upon a true barrel A, is made to rest accurately, in finished bearings, at each end of an extension or outboard B, which forms in this case part of the flask, but may if necessary be a separate device to be firmly bolted to any flask, when occasion demands such practice! The manner of holding the core is shown at C, C, being simply caps which grip the barrel only, and are bolted, as seen. When such a mould must be cast on end, additional security will be given by providing a collar or pin, to prevent any possibility of the barrel sliding in either direction.

"Oh, well," says some one, "I've seen that done before;

that's simple enough;" all of which I grant. But surely its very simplicity ought to suggest a more frequent adoption of its principles, especially when we remember that by such means we are enabled to discard the use of chaplets, "a consummation most devoutly to be wished" in all cases. A little thought expended on the principles involved in this simple expedient will demonstrate its value as an ex-

Fig. 115.

cellent device for saving chaplets, and, what is far better, saving castings also.

Another means for the accomplishment of this desirable end is to secure cores, which would otherwise need chaplets, by a system of double seatings. (See "The Iron Founder," page 245, where cores K and L are made independent of the chaplet shown, by just such an arrangement as above advocated.)

It only requires ordinary ingenuity to make the latter method available in hundreds of instances, where the only seeming possible way of surmounting the difficulty is perhaps a rusty stud, held in position by nails picked up from the foundry floor.

Avoid *rust* as you would a viper. The sudden decom-

position of $\frac{1}{32}$ of an inch of rust spread over the surface of a stud-plate $3'' \times 5''$ will produce a mould-destroying shock, with startling effect at the point of eruption, and extending with a decreasing force to a distance of over six feet; and bar-spaces in the cope $6''$ wide and $10''$ deep, in the immediate vicinity of the offending plate, will be blown out with terrible effect sometimes, making it a positive danger to use such carelessly provided tackle.

This element of danger always exists in proportion to the amount of rust present, and whilst a small amount may not possess the explosive force above described, the gases generated are a constant source of annoyance and loss, causing blown places in parts of the casting which are not easily located; and consequently we often hear of the failure of a pump or cylinder after the engine has been running some time, and all was considered perfect. Nine times out of ten the verdict is, 'rusty chaplets.'

Another illustration of how to avoid chaplets in special cases is shown at page 197 of "The Iron Founder," where cores D and E are seen to be secured by means equally effective, yet different in principle. The method of joining cores to front plates, as there illustrated, is eminently useful, and might with great advantage be more generally adopted for a wide range of work, both in loam and sand.

There is no part of the moulder's trade which offers more opportunities for the inventive genius of the mechanic than does this particular one of avoiding the use of chaplets, and when we think of the good accruing from such practice it ought to encourage every one interested to a pursuance of such improved methods, even if the cost of production be increased thereby. What if "first cost" be increased! the results will more than compensate for the additional outlay.

If it should occur that chaplets *must* be used at places where the casting requires to be absolutely sound, the studs

STUDS, CHAPLETS, AND ANCHORS.

necessary for the job may be rammed in the centre of a round core, thoroughly dried, and coated with lead. This will leave a clean hole in the casting, which, if necessary, may be tapped for plugging. Another method, when using plain stem chaplets for thin castings, is to glue two or three thicknesses of thin paper on the end which enters the casting, with a further coating of lead, all well dried. This will keep the molten iron from direct contact with the naked chaplet, whilst the nature of the covering used will serve to soften the surrounding iron, making the subsequent tapping of the hole more easy of accomplishment.

Recognizing the fact that we cannot escape the use of studs and chaplets, and this in a large measure sometimes, it

Fig. 116. Fig. 117. Fig. 118.

behooves us to select and rightly use such as are best qualified to fulfil the mission for which they were originally designed. Figs. 116 and 117 represent the common solid stud chaplets, $1\frac{1}{4}''$ diameter, to be used when, because of danger from melting or from a lack of strength, any of the others would be too light. It must be borne in mind that studs will melt before a constant stream of very hot iron; even solid ones need protecting sometimes, which latter can be effectively done by coating the stud, as before directed.

Fig. 118 is a solid stub, $1\frac{1}{2}'' \times 3''$, for use under heavy loads, where, owing to the form of the mould, an ordinary stud could only with difficulty be made to stand. The tail A

can be pushed into the sand or loam, and made good around; by this means the stud is held firmly in its place without fear of dislocation. A very useful modification of 116 and 117 is shown at Figs. 119 and 120, which represent similar sizes to those quoted, and may be any degree of strength desirable: some very light jobs would require them no thicker than $\frac{1}{16}$ of an inch. To make these in cast iron, make them in strings carrying the upper plates A in the cope, the bottom plates B being arranged on a core print

Fig. 119. Fig. 120. Fig. 121.

corresponding to the depth between A and B, the cores for which must be pierced at correct intervals by the connecting bar C. Where studs of this kind have been introduced for the first time, it invariably happens that their ability is overestimated, and numbers of castings are lost before it is discovered that these light-cast studs melt away most miraculously when set before the stream.

I have shown at Fig. 121 how to make studs, similar to the preceding, out of wrought iron: it will be seen that bars A and A have been riveted to plate B, which, being prepared like plate C, is very easy to do; C is now set on and secured by riveting also, the parts at DD being left a little long for the purpose. Where it is thought that cast iron would be too risky, these may be substituted, as they can be made of any desired strength very quickly.

STUDS, CHAPLETS, AND ANCHORS.

Fig. 122 is a common spring chaplet intended for binding and steadying only; the usefulness of these good chaplets is in most places greatly marred on account of the ignorance displayed in their manufacture. Ask for a springer, and you will probably receive a piece of rusty hoop iron bent in the form of a horseshoe; this, of course, answers the purpose of steadying the core, but how unsightly the scar

Fig. 122. Fig. 123.

Fig. 124. Fig. 125.

it leaves on the outside of the casting! This objectionable feature can be easily overcome by a good blacksmith, or by the moulder himself, should the former worthy functionary be *non est* at that place, by following the instructions given, and fully illustrated by the following figures.

At Fig. 129 the vise jaws hold a piece of iron equal in dimensions (less the thickness of the hoop iron) to the thickness of the chaplet required, against which the hoop iron has been jammed and hammered over, Fig. 130 showing the position of the same after the operation has been

again repeated. This leaves the springer as shown at Fig. 122, but only requires the ends hammering back, as seen at Fig. 132, to make the very useful chaplet shown at Fig. 123. By the method above described a really good and useful chaplet can be obtained at very short notice.

The several operations required to produce the double-hoop iron stud, Fig. 125, are shown in their order at Figs.

Fig. 126. Fig. 127. Fig. 128.

134, 136, and 138; and any modification of this class of studs, such as the one shown at Fig. 124, which may be made with or without the tail A, may be very readily made by the simple manner described, which gives an elegant chaplet with an absolutely true face, thus obviating the trouble previou ly spoken of.

A most effective and proper stem chaplet is shown at Fig. 126, its chief characteristic being that the head A is forged with the stem, and additional strength allowed at the juncture. A good blacksmith finds no difficulty in forging chaplets of this class with heads 2 inches across;

STUDS, CHAPLETS, AND ANCHORS.

this, of course, leaves no excuse for using those abortions which are supposed to be riveted fast, but almost always separate at the first blow of the hammer.

Plainly stated, the plain wrought one shown at Fig. 127 is the stud *par excellence* of them all, as it can be made to answer for an almost unlimited number of emergencies, as will be noticed more fully further on.

Fig. 128 represents a class of stud that, in some special instances, may be made very useful and handy; the one shown is 1" diameter at the stem A, and $2\frac{1}{8}$" diameter at plate B. Being cast iron, these chaplets are apt to snap off below the casting, leaving an unsightly scar; to prevent this, let the pattern from which they are cast be nicked, as

Fig. 129. Fig. 130.

seen at C, a little above the thickness of the casting for which they are intended; what remains after the upper portion is knocked off can then be chipped true to the face.

When practicable, it is always best to place these chaplets in their respective positions on the pattern, and ram them in the cope, to be afterwards withdrawn, and the front edge of the hole enlarged by a taper plug made for the purpose. By this mode of procedure two very important ends are gained, viz., accuracy as to position, and freedom from anxiety with regard to the edge of the hole, which, being clear of the chaplet, allows for its easy motion in either direction without fear of damage to the cope.

To those unaccustomed to the use of a variety of studs and chaplets, Fig. 131 will be of interest. and serve the

purpose of an object-lesson; it is the sectional elevation of a 36″ × 36″ column having internal webs formed by cores, and as all these cores are entirely surrounded with iron, they must of necessity be supported, steadied, and anchored

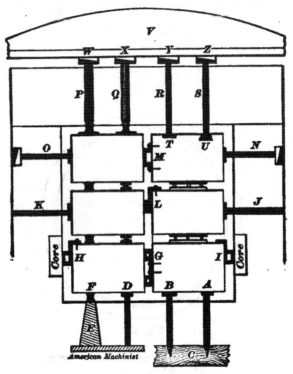

Fig. 131.

down by a system of studs or chaplets, or, as is seen in this case, it may be a combination of both.

Beginning with the two lower cores, it will be seen that three different means are shown for supporting them, the right-hand core being upheld by ¾″ stem chaplets A and B, which are driven firmly into the block of wood C, previously set down 12′ below the surface for this purpose.

The left-hand core is upheld by a method much superior to the other, especially when the weight to be borne is great;

STUDS, CHAPLETS, AND ANCHORS. 207

in this case one of the same chaplets used at AB is used at D, but because the foundation is iron a blunt end is best. An entirely different mode of procedure is necessitated when the square supports E are used, as in this event all the supports E must be set in position when the bed is formed for the bottom of the mould, the pattern being set

Fig. 132.

Fig. 133.

Fig. 136.

exactly over them; all that is then necessary, when ready for the cores, is to set on each support a stud like the one seen at F, which is supposed to be similar to Figs. 116 or 117.

It will be observed that chaplet Fig. 125 is permanent at G, being nailed fast to the right-hand core; whilst at H and I springers, Fig. 124, are used for the purpose of binding the whole together. The dry cores shown at this place

are for the special purpose of permitting this to be done effectually.

Stud chaplets corresponding to Figs. 116, 120, and 119 are set between the remaining cores; the blunt stem chaplets J and K, Fig. 126, being the permanent rests against which the cores are pressed by springer L. At the top cores a chaplet similar to Fig. 123 is nailed fast at M, and chaplets NO are pressed inwards by the application of wedges behind, as seen.

Chaplets like Fig. 128 are used on the left-hand top core

Fig. 135. Fig. 134. Fig. 137.

at PQ; this may be done when dependence can be placed on the surface of such chaplet being sufficient to resist the upward pressure without crushing the core. In any case, however, the plain studs R and S, Fig. 127, are the best, as ample provision can be made to meet every emergency by the placing of suitable blocks when the core is made on which the stud can rest, as seen at T and U.

One other very important thing remains to be done, and the system is complete, viz., to set the binding-beam V across the cope, resting on the outer edge at just such a height as will permit of *two* wedges, *not one*, being used for the pur-

pose of securing the studs as seen at *Y* and *Z*. Imperfect wedging at the last is a frequent cause of disaster, and only ignorant or very careless men are derelict in this particular. Especially should care be exercised when cast-iron wedges are the only ones obtainable; in this event a piece of wrought iron should be set in immediate contact with the stud, with the wedges over; by pursuing this course a cracked wedge will be likely to create less havoc than might be the case otherwise.

Fig. 133 illustrates how to use chaplets like Fig. 125, when it might be difficult to set studs into the mould proper. By simply nailing them fast to the core, the latter

Fig. 133.

Fig. 139.

becomes in some measure self-centring—a thing to be desired in quite a number of jobs.

Fig. 135 shows three kinds of fast chaplets for use in dry-sand work when the position of the mould must be changed for casting. The one at *A* is to be set in to exact depth when the mould is green, while those at *B* and *C* are equally applicable to both loam and dry sand, as they can be firmly attached to any part of the mould, when dry, without fear of displacement; the one at *C* is eminently useful when a stud is required to be fastened on a covering-plate or cope.

Fig. 137 shows how cores may be firmly held in dry-sand moulds, that must be turned on end, with chaplets of the type shown at Fig. 126 exclusively, all of which can be inserted when the mould is green. For some kinds of light

work for which there is constant demand this is an admirable method, and saves both time and labor.

How to close moulds almost as readily in green sand by using similar chaplets is shown at Fig. 139, anchorage for

Fig. 140.

Fig. 141.

which is obtained by casting pockets in the flask opposite to where the chaplet is required to be set, into which are driven wood plugs. All that is needed then is to sharpen the chaplets to a length suitable for taking a firm grip in the wood, and the end is accomplished. A good illustra-

STUDS, CHAPLETS, AND ANCHORS.

tion of the usefulness of this scheme is given at Fig. 140, which is a partial representation of the section of a cylinder-head cope immediately over one of the suspended cores. Usually these cores, six or eight in number, are held in place by three bearings or prints to each core, which serve the purpose of anchoring to the cope as well as to carry off the gas, and all of these must be tapped and plugged after the core has been taken out.

Instead of the three prints mentioned above, let pockets be provided in the flask-bars at A, and pursue the course previously explained; there will then be three firmly fixed chaplets B in the cope, on which to rest the core, one hole in the centre being sufficient through which to carry the

Fig. 142. Fig. 143. Fig. 144.

air and effect an anchorage. A double-threaded gas-pipe C, which enters the core-iron by means of a nut cast therein at D, serves the double purpose of vent-pipe and anchor, as will be seen by a careful inspection of the figure. The question of economy should at once decide in favor of this proposed scheme, for only eight holes require plugging, instead of twenty-four, as in the former instance. The possibilities for other jobs by this method are truly marvellous, with the margin of safety increased tenfold.

To all who may be still digging holes and driving chaplet-blocks A after the manner seen on the right hand of Fig. 141, I would ask them to look on the other side of the figure, where a round cast-block $3\frac{1}{2}''$ diameter across the edge at B, extending $5''$ down to a point at C, is driven down, on which stud D is resting, and say whether the end cannot

212 *THE IRON-FOUNDER SUPPLEMENT.*

be much better served by the method suggested. For cores up to 12" this little block is a wonder, very few believing

Fig. 145.

Fig. 146.

the amount of weight they will safely bear until they have tried them.

Fig. 142 shows the top half of a 12-inch pipe, on which a chaplet of the common riveted type has been used; the

thin plate A has yielded to the combined influence of heat and pressure, with the result shown. Fig. 143 shows a decided improvement in the form of chaplet, but the bulkiness of the button A makes it absolutely necessary that thickness be added at B, which gives a very unsightly appearance to the casting. Both of these evils can be totally remedied by adopting the loose stud A, resting on a stud-plate rammed in the core, as seen at Fig. 144.

Fig. 145 represents a half column in green sand 4 feet diameter, with dry-sand core resting on curved stud chaplets of the type shown at Fig. 118. Foundation-plates A,

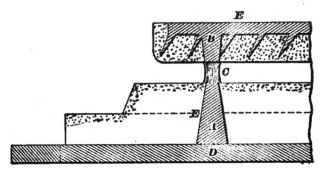

Fig. 147.

3 ft. 6 in. × 1 ft., with supports B (cast on), extending up to and assuming the curve of the casting, are set down solid with the curved surface of the supports flush with the pattern when the bed is formed, thus giving solid bearing for the studs C. Should there be danger of the core yielding, provision must be made by inserting suitable bearings, which will meet the studs C.

Fig. 146 shows how to provide for using the same kind of studs in a hollow cone 4 ft. diameter, 3 ft. 6 in. deep, in green sand, with dry core in sections.

Cores of whatever magnitude may be made to rest with the greatest degree of safety on stud chaplets when suitable provision is made, as seen at Fig. 147. The figure is a sec-

tional view of the lower edge of a loam mould of large dimensions, the core of which must rest positively on stud chaplets; this, as shown, is made possible by the aid of square supports A, set down on the foundation-plate D, and built in along with the lower courses, which forms the bottom of the mould at E. The studs B, cast on the core covering-plate F, directly opposite to the supports A, complete the arrangement, and permit of any amount of added weight above being supported with safety by stud chaplets C.

Figs. 148 and 149 will serve to explain some modes for

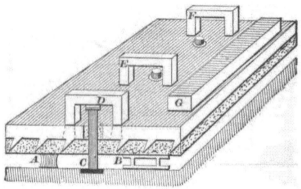

Fig. 148.

securing chaplets in both sand and loam work. Fig. 148 is a partial view of the top covering-plate of a loam-mould, with the upper edge of core revealed, on which are resting stud chaplets A and B, but there are times when under heavy pressures the loam must yield; it is then important that other means of resistance be provided. The stud C can then be resorted to, there being no difficulty in making it fast when clamp D is cast directly over the hole made to receive it.

If it be required that the studs shall pass through the covering-plate after the mould is closed, then cast in the clamps clear of the holes, as seen at E and F, and pack the

studs by means of the bar *G*. This expedient is far superior to any of the modes of securing studs by means of outside rigging.

Fig. 149 shows a portion of cope flask *A*, on the front end of which, at *B*, is shown the sort of cast girder needed for very heavy work; this, as seen, must be made fast to the flask by clamps or bolts at *G* before the chaplets are wedged. The style of bar shown at *C* is intended for regular use on ordinary work; it must be understood that the end at *H* is

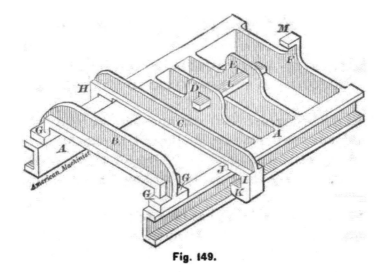

Fig. 149.

similar to that at *I*, but is pulled in under the flange to allow of the latter end passing clear of the flange at *J*, when it can be pushed back until one half of the clamp end at *K* is equally divided under the flanges at both sides. Supposing the box flange to be $2\frac{1}{2}$ inches wide, this will give one inch, good, at both ends, and is amply sufficient for wedging purposes; this combination of bar and clamps is a very useful contrivance for all ordinary work, and saves considerable trouble.

For all work that is repeated day after day, it pays well to rig a flask after the manner shown at *D E*, or *F*, as in

the former instance; the bar *L* passed through the holes *D* and *E* serves for an almost instant adjustment of the chaplet; the same may be observed with regard to the single bar expedient at *F*, where the chaplet can be inserted before the cope is turned up for closing, after which a couple of wedges under *M* decide the matter even quicker than is possible by the former arrangement.

HIGH-CLASS MOULDING.

EXPLAINED BY A DESCRIPTION OF DIFFERENT WAYS OF MOULDING A FOUR-WAY VENTILATING-SHAFT.

The following excellent example may with propriety be termed advanced practice in the art of moulding. Unvaried success in producing castings of this type is only possible when the most skilful workmen are employed to produce it.

This particular casting has been selected for illustration on this occasion, because in its numerous and varied phases under altered circumstances, superinduced by the lack of facilities in some foundries for making such work readily, it presents a wide range of difficulties, that can be successfully met only when the best efforts of the most adroit artisan are put forth.

At Fig. 150 is shown the plan and elevation of a four-chambered ventilating-shaft 4 feet diameter, 11 feet long, and 1¼ inches thick all through. The casting as seen is simply a plain cylinder, with internal webs that intersect each other at right angles at the centre, extending throughout its entire length, and forming four separate compartments, or chambers.

Founders having no facilities for moulding such a casting

vertically in loam, but who are in every sense well equipped for its production in halves in green sand, would naturally hesitate about sub-letting the job at a considerably advanced figure, if bolting the halves together violated no part of their contract.

Fig. 151 is plan and elevation of the half casting for this purpose, showing the web at *A* to be slightly reduced in thickness, and still further lightened by the eight openings, marked from *B* to *I*, respectively, for one half; six similar openings in the other half to be set exactly between, as indicated by the broken lines, giving space sufficient for a bed of cement that is to be applied for the prevention of leakage from one chamber to another.

The subject now resolves itself into the moulding of two castings, one of which, the half, is to be cast horizontally in green sand with dry-sand cores, and the whole one vertically in loam, with cores after various methods, to be illustrated further on. As previously stated, these castings are good examples of their kind, calling forth and developing ideas of moulding, which, if intelligently understood, may be made of universal application.

We will first consider the half one in green sand (Fig. 151), and before we sit in judgment on what appears so plain a job, let us examine into some of the chief features connected with it.

Firstly. The core weighs in the neighborhood of seven tons, a large proportion of which weight must be borne on studs necessarily. This of course must be provided for by preparing good foundations for the studs and a more than ordinarily solid core, the latter to be divided in such manner as will be most convenient for drying, handling, setting, and anchoring.

Secondly. The pressure under this core is over twenty tons, and this pressure must be resisted by a judicious distribution of chaplets and studs, which must rest on suitably

provided iron bearings in the cores, as the latter must be held in position by a greater weight above, or, what is bet-

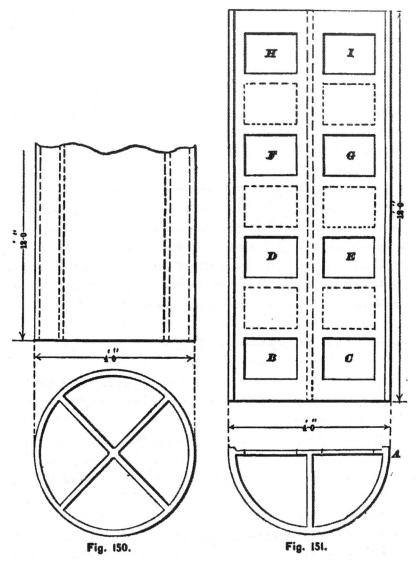

Fig. 150. Fig. 151.

ter, by a system of binders sufficiently strong to resist the upward pressure. We must not omit to remember here that pressure is exerted in every direction as long as the

metal is in a molten condition; consequently the green-sand mould needs to be well made if it is expected to retain its original shape under such a test.

Thirdly. As such a casting would weigh about three tons, it would be judicious to divide the iron, pouring one half at each end by a system of runners cut under the core, as described in chapter on "Pouring," etc., page 192. This would strengthen the ends of the casting by insuring a supply of hot iron at those parts to the last, and would sensibly lessen the damage from abrasion, which is unpleasantly noticeable when large quantities of iron enter the mould at one place.

Starting with the above knowledge of the chief requirements, we are more than half-equipped for the undertaking before a blow is struck. How much of this power of introspection is lacking amongst us as a class is only too well known, and to the lack of this ability to judge of the needs and requirements in the case most of the disasters that are constantly occurring may be traced: plainly demonstrating that we as moulders are not equal to the demands made on our ingenuity and judgment, because of the almost universal ignorance which prevails among us as a class.

The magnitude of this job demands a reliable substitute for the prevailing method of 'rolling over,' and this may be found in the bed-sweep, or former, shown at Fig. 152, consisting of two boards A and B, equal to the circle of the shaft-pattern, and held together by the straight edges C and D, the length of which corresponds to the length of the pattern. There must be width sufficient to make the ramming of the remainder an easy matter after the pattern has been set upon the formed bed.

Let the reader turn to Fig. 153, which is a sectional view of the whole mould when everything has been achieved up to the closing of the cope; but before we attempt any description of the methods adopted for the accomplishment

of what is there seen, it will be best to understand the system of coring as here applied. Literally speaking, this job can be made with two cores formed on strong arbors full

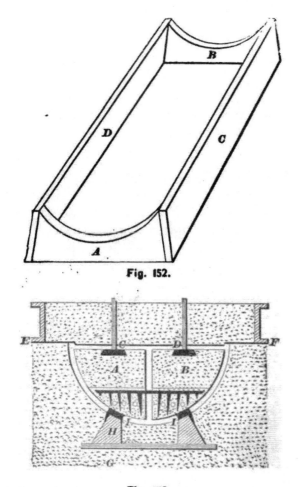

Fig. 152.

Fig. 153.

length of the casting; but preference may with considerable reason be made of the means herein represented, inasmuch as it accomplishes the object with equal facility by a number of pieces that are soon dried, and can be readily handled, whilst the arrangement of the core-iron for the

bottom sections of core, makes, what in either case would be a tedious undertaking, a very simple piece of work.

To set these cores on either side of the web separately would be a critical operation, on account of the tendency to slide off the studs towards the centre. This difficulty is effectually met in this case by uniting the two bottom sections of cores at the bearing C, Fig. 154, also at A and B, at which points the core-iron is allowed to pass through the

Fig. 154.

casting, thus making one firm core out of both. The irons are easily snapped off when the casting is cleaned.

Fig 154, D, shows the end view of frame for making this section of core. The frame is made one foot longer than the half of the shaft, and simply rests over the core-iron, as shown by broken lines at D. This frame and a smooth plate is all the core-box required for this part of the job, as the core can be easily turned over when dry, and lifted into the mould with ropes round the cross-bars at B, D, and E.

By this means staples for lifting are unnecessary, and the surface is consequently left clear for the upper sections of core to rest on.

The upper cores A and B, Fig. 153, four in number, may be made on a smooth plate with the upper face down, to be reversed again when dry, in which event sides and ends with a temporary preparation for the circle on one side will be all the core-box needed at this part. Remembering the amount of pressure that this core is called upon to resist, there must be no mistake about having the stud-plates C and D, Fig. 153, to rest firmly, iron and iron, on whatever system of core-irons may be used for the purpose. On the other hand, remembering the amount of weight that the bottom sections must sustain, equal attention must be paid to the selection of material that will hold the weight without fracture at the point of contact with the stud. But should the strength of the material used be found inadequate to the work, then make such an arrangement as will insure the stud to press directly against the core-iron, in which case, assurance is made doubly sure.

Supposing our cores to be all ready, we will at once proceed to make the mould, giving reasons for the several operations as we proceed. The mould, as shown at Fig. 153, is contained in the floor; but it is far preferable to have a lower box constructed of stout sides, with external flanges to correspond with those at E and F, the depth of which may be about 2 feet, standing out of the floor about half its depth. These sides must be connected with extra-strong cross-bars extending down under the job, making it only necessary to clamp or bolt the two flanges at E and F together in order to secure anything that may be cast therein. The upper flange can be utilized for holding down cores, as in this case, after the manner shown in chapter on "Studs, Chaplets," etc., page 215.

After a good cinder-bed has been laid down at G, 12

inches below the bottom of the mould, ram solid to within 6 inches, and set down the bed-former, Fig. 152, at such depth as will bring the pattern, when set thereon, even with the joint of the flask at E, Fig. 153. The former will serve as a guide for placing the anchor-plates H in such numbers and position as will best serve the purpose of supporting the cores. A knowledge of the weight these must carry will suggest the propriety of having them on solid ground; otherwise they will be pressed downward, and a consequent diminution of the thickness at the bottom of the casting ensue.

The anchor-plates satisfactorily set, proceed to ram old sand within the frame to within one inch of the surface, when the whole must be vented down to the cinders, after which the facing sand can be applied by treading an extra thickness all over as evenly as possible; the surplus can then be struck off to the frame. After the frame has been lifted out, continue the ramming to the edge of the formed bed, set on the pattern, and proceed to ram along the remaining portion of the pattern in the usual way.

This mode of bed-forming will be found infinitely superior to any other for 'bedding in' for not only large circular, but all classes of work with surfaces more or less irregular.

As we close this mould we realize very sensibly the advantages gained by the methods adopted for moulding it. We know that the foundations H are solid; that the studs II, in consequence of the wedge attachment at the back, are immovable thereon; that the bottom section of cores, safely held together by the cross-bars, cannot be changed from their position, and constitute a safe bed whereon to set the upper cores, A and B, without fear of failure. All this, we say, conspires to make the closing of this mould a marvel of simplicity, dispatch, and safety.

As a loam job, to be cast whole and in vertical position, we encounter a new order of things altogether: the re-

quirements are so much different from the case we have been discussing as to make the business of moulding this shaft in loam appear another trade.

As we propose to mould this in its entire length, a sufficient height of oven and crane, as well as depth of pit, are prime requisites. It might be that an indifference as to inside finish could be taken advantage of, and the labor on the core considerably reduced thereby. A method of moulding under such circumstances will be shown, as well as a more elaborate one, in case it should be necessary to separate the parts in order to a perfect finish, inside as well as outside.

Whilst it might not, in this particular instance, be desirable to adopt a system of dry-sand cores, yet changes of design might make such a course indispensable; therefore a method calculated to meet the altered circumstances will be discussed and suitably illustrated as we pursue the subject.

It would be superfluous to go through every detail connected with the moulding of such a casting; therefore, in dealing with this subject, we shall pass over all the ordinary processes of loam-moulding (fully discussed and illustrated in "The Iron-Founder" page 147), and confine ourselves to those parts only that possess more than ordinary interest to the workman.

To those who may be unacquainted with this particular class of work it may be well to state that a quadrant of 4 feet diameter does not make a very stable structure, in loam, when built to the height of 12 feet, and some method must be devised whereby the divided core may not only be handled, but conveyed in and out of the oven, and finally to the pit for casting.

We will first consider how best to make such a mould if it were allowed to deliver the casting with no more finish to the inside webs than could be given them by reaching from the outside. Under such circumstances the cores

HIGH-CLASS MOULDING. 225

might be built stationary on the foundation-plate, but, as before said, something must be done to save the fabric

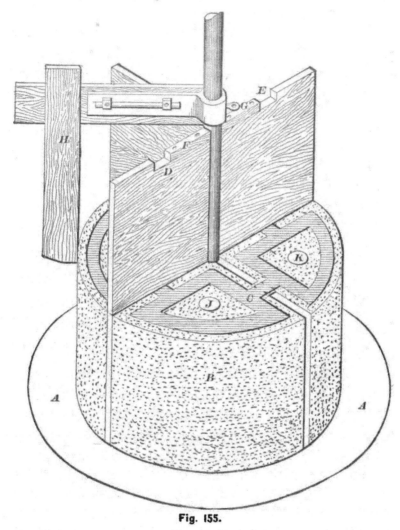

Fig. 155.

from settling out of shape during the process of transit from the centre to the oven and back.

Fig. 155 is a representation of such a core under course of construction after the cope has been struck and lifted away. The outside bearing is seen at A, and cores B are

built a short distance up, where a break is made for the purpose of placing the first of four similar plates, or frames, that are to be built into the cores at intervals of 2' 10¼", which distances would bring the last one 6" from the top. It is at once observed that the four quadrants are joined together, and form, as it were, a whole cast frame by allowing the connection to pass through the web at C; it will also be noticed that V's are formed round the connecting piece to insure a clean break, uniform with the casting, when the irons are broken out.

Patterns for the webs are, in this case, made 2' 10¼" long; eight pieces only are needed, as the under ones can be drawn when the building has reached the top edge of the upper one. It will also be seen at C, D, and E that provision for the connecting web is made by cutting out a portion of the pattern, the pieces F and G being necessarily made loose and pinned, this permits them to be taken out after the web pattern has been withdrawn.

In this case the core-sweep H need be but a few inches longer than will finish off each length of core as they are built. In building these cores have all plates 1¼" clear of the casting, and be sure that the brickwork is very open, well cindered, and all loam as porous as possible. The holes JK indicate that a short length of 4" pipe is to be used for building up to, drawing it up as the work progresses; the cindered spaces leading up to that point guarantee a sure connection at each course as they are laid.

It is important that that portion of the core-plates which passes through the casting should be as free as possible from sand and blackening, otherwise they might be found loose when the irons were broken out of the cores.

In order to reach the inside for a superior finish we must lift out two opposite cores. How this may be done will be shown by the aid of Figs. 156 and 157, where the whole process is delineated in detail, cores A and B, Fig.

HIGH-CLASS MOULDING. 227

156, being the ones to be lifted out. Referring to Fig. 157, we see the foundation-plate at A; bearing for the cope at

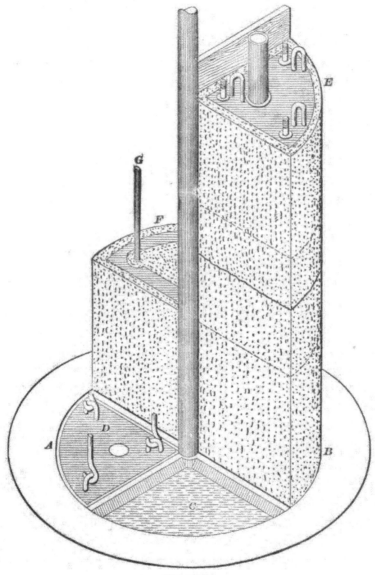

Fig. 156.

B; cope-ring at C; and the inside lifting-plates, with a portion of the cores built, are seen in position. It is always

preferable to have the inside plates made as seen, so that their own impression forms the joint, and leaves them altogether free from loam.

The manner of setting these inside plates is as follows: First, strike a bed for the bottom, lay out the quadrants, and, after cleaning and oiling the plates, set them in their exact position opposite each other, bed them down solid, and then build on a course and strike off a little above the plates all over; this gives the bed for the ribs as well as

Fig. 157.

the bearing for the cope-ring at B. The bed, as formed by the plate, is shown at C, Fig. 156, whilst the plate in position would appear as seen at D in the same figure.

In this case it is best to have the web patterns made full length, set into position, and used as bearings on which to run a strickle vertically, thus obviating the use of the sweep-board altogether—a thing most devoutly to be wished for when the cores are very long, as in this instance.

The webs being all set in position, place the bolts as seen at D, with a wedge underneath to keep them up snug, and if a template is prepared answering to the position of the bolt-holes in plate at E, it may be lowered around the tops of the bolts and screwed fast to the webs, thus serving the double purpose of keeping the webs in place and hold-

ing the bolts in position whilst the cores are being built. For reasons obvious, a four-inch perforated pipe is prepared for each of these cores; to be built in the centre and stand out through the covering plate, as shown at F and G, Fig. 157, the object of this being that a plate, or cross, Fig. 159, with holes cast corresponding to the position of the pipes, may be firmly wedged around the pipes during the time that the cores are being moved about on the foundation-plate. Holes cast in the covering-plate through which the pipes pass, as seen at Fig. 157, can be utilized for the purpose of stiffening the whole structure after the mould is closed.

These cores are to be further strengthened by building in plates, as shown at F, Fig. 116, at about three places before 6″ from the top is reached, when the plate shown at E is to be set on as seen, and the nuts screwed down. The handling of these cores is done by the three staples seen, which, when a three-legged buckle chain is used, can be easily regulated to a plumb-line.

The pipes, in conjunction with the building-rings, stiffen the core laterally, as well as serve the purpose of a direct medium through which the gas can pass away freely at the top. The same precautions are to be taken in this case, as in the last, to have an open-built core with cinders forming a channel towards the holes in the pipe at every course.

As before explained, the cores C and F are to be stationary, consequently there will be nothing except the perforated pipe, and about six of the building-plates used in their construction. The bolt G is shown simply to give some idea of how core A would appear when that height had been reached.

Of course it becomes an easy matter to finish the inside of this mould when these opposite cores are taken away, as illustrated above.

The simplest method of making full-length dry-sand

cores for this casting is shown at Fig. 158. To be sure in this case 8 cores, each 6 feet long, could be used effectually if it were necessary to adopt that mode of procedure; but we set out to discover a means of making them in one length, supposing that a contingency might on some occasion present itself which would admit of no other solution to the difficulty.

The chief prerequisites in this case are: first, an arbor

Fig. 158.

or core-iron as light as possible, and yet strong enough laterally to stand turning up on end without springing; second, that the end bearing must be iron, and independent of the sand core; and third, that means be taken to insure a safe elevation of the core, and having the same, to hang plumb for closing in the mould.

The end section and side elevation of a suitable arbor for such a core is shown at *A* and *B*, Fig. 158, the dimensions being 2″ thick and 12″ deep, on which wings *C* are to be firmly wedged, as seen at *A*. The bottom wing must be made extra strong, and must have a stud 3″ diameter

HIGH-CLASS MOULDING. 231

cast at each corner, and when the core-iron is placed in the core-box these studs must rest against the bottom of the core-box, as seen at *G, H, J,* and *K.* These studs must be placed to correspond with bearings set upon the foundation-plate, and even with the seatings formed to receive the core; by this means the weight of the core is made to rest independent of the sand seating.

As seen, this bottom wing is securely held both ways by wedged pins inserted at holes *L* and *M*, provided for the purpose. Other holes, not seen, are to be used at intervals in a similar manner, with the view of distributing the

Fig. 159.

weight of the core along the bar, and not depending entirely on the wedges which bind the wings to the bar.

Additional stiffness may be given to this core at the bottom by casting intermediate studs 1' diameter on the wings at *N, O, P, R, S,* and *T,* as far back as is thought necessary. This core can be made readily in a box after the manner shown at *UU*, the rolling over being effected by securing a stout wood frame at *VV*, filling in with old sand and bricks, and bolting or clamping the core-plate thereon, taking care to wedge between the plate and core-iron at *W* and *X* before rolling over, the latter precaution being necessary when the arbor is heavy, as in this case.

Six inches of sand, rammed solid to the face, is all that would be required for a core of this description; the remaining portion, or heart of the core, can be cinders.

Once dry, the rest is simple, as the core can be safely transorted by means of the holes Y and Z, the latter hole being made oblong for the purpose of regulating the swing when closing into the mould. The mode of swinging is shown at Fig. 160 and consists of a wood block A about 18"

Fig. 160.

square, rammed firmly in the floor for about 2¼ feet, the top end of which must have a groove cut thereon nearly as deep as that portion of the arbor that extends past the end of the core, and about the width of the same.

The elevation of this core is easily accomplished by means of the shackle B, which is made to fit the arbor, and is provided with a threaded pin that precludes all possibility of the shackle spreading.

SECTIONAL MOULDING FOR HEAVY GREEN-SAND WORK.

INCLUDING DRAWBACKS, CRITICAL GREEN-SAND CORES, ETC.; OR, SOME THINGS BEYOND THE CAPACITY OF THE MOULDING-MACHINE.

A CASUAL observer of the foundry business to-day, more particularly such foundries as make a specialty of match-work, with and without the moulding-machine, would be apt to make a very serious mistake, and imagine that brains were a superfluous commodity, that need not be taken into account when the question of hiring moulders was uppermost. It would appear at the places above noted that the moulder has been reduced to a mere automaton or patent 'Kodak,' with this immense disadvantage, that before the button is touched for you to 'do the rest' the operator must move considerable sand and perform an amount of athletics truly astonishing, clearly demonstrating the fact that no matter at whatever degree brains might be rated in this undertaking, muscle is most assuredly at a discount.

A little thought will serve to dispel some of the illusions which are apt to creep in while contemplating this interesting subject. All this remarkable display of muscular energy has most undoubtedly been forced upon us by the ever-increasing demands of manufacturers for a larger number of castings at reduced rates, and is but the natural outcome of a healthy rivalry and legitimate competition by intelligent founders to secure the lion's share of this largely augmented business.

'The Moulding Machine has come to stay,' no matter how much opposition may be brought to bear against it; and, on the whole, I cannot see why there should have been such widespread opposition to its more general adoption. Other trades have proved how utterly impossible it is to stem the tide of modern improvements in labor-saving machinery; it therefore behooves us to accept the inevitable, and gracefully welcome the iron man as one of the 'fraternity.' Wherever the machine can be utilized for the production of castings, a truer and more perfect duplicate of the pattern is obtained in consequence of the absolute regularity and precision of the whole operation; the ramming or pressing of the sand around the patterns being in every instance the same, while the withdrawal of the patterns and the subsequent closing of parts insures a degree of accuracy impossible of attainment by the ordinary processes.

It is gratifying to notice that the various improvements in electric and pneumatic cranes are being taken advantage of around the moulding-machines, making it infinitely easier for the operators, and naturally enabling them to accomplish a larger amount of work. I am looking forward to an early application to this industry of some of the numerous admirable methods of mixing and conveying which might be readily adopted, and thus aid in handling the immense amount of sand that must be used every day. "This is a consummation most devoutly to be wished."

Admitting that the moulding-machine has well-established claims for recognition, and also that superior castings, within certain limits as to magnitude and diversity of parts, can be produced by its use, yet there will, I presume, always be a very big margin of castings to make demanding the ripest judgment and calling forth the highest order of constructive ability for their successful accomplishment.

SECTIONAL MOULDING FOR GREEN-SAND WORK.

Scientific papers and trade journals hasten to inform their readers of the immense number of castings produced in an hour by the aid of some new contrivance, and every reflective moulder gets a twinge once in a while when he learns of the almost superhuman efforts made by some one of his craft to 'beat the record' and produce a larger amount of work in a given time than has ever before been accomplished, but we seldom hear much of the patient plodding and anxious hours, and weeks in some instances, which have been industriously spent to produce some of the very intricate and critical work that is being made in our best foundries every day.

To rightly determine who do this work is not a very hard matter, simply because the bad and mediocre moulders constitute the large majority, making it absolutely impossible for genius to fail in commanding attention, no matter how modest and unassuming the individual may be.

To have the confidence of one's employer or foreman is a source of inward satisfaction to any man; but, gratifying as this most assuredly is, it is as nothing compared with the infinite pleasure which accompanies a sense of your ability to help those around you who unfeignedly acknowledge your superiority and disinterestedly seek your aid. To command such proud distinction should be the aim of every young moulder who aspires to a leadership among his fellows; but unless the aspirant for such high honors determines to master the first principles of his trade, no such eminence awaits him; he may rest assured that no amount of pretence or bombast will successfully take the place of talent when the latter quality is absolutely essential.

With the view of inculcating first principles in the minds of such moulders as are anxious to examine into and obtain a more extended knowledge of these subjects, I

propose taking up the several principles one by one, using familiar illustrations in order to their proper elucidation.

When we say that a mould, in the ordinary acceptance of the term, consists of an upper or cope part, in which the impression of the top side of the pattern is carried; and a lower, or nowal part, containing the impression of all the remaining parts of the pattern,—we have perhaps said sufficient to satisfy the ordinary seeker after knowledge of a general kind. How far this generalizing comes short of the real thing can only be understood by such as are more or less skilled in the multitudinous intricacies attending practice of a higher order.

Aside from the special ability which enables the moulder to manipulate the material out of which he fashions his mould, there is constant and imperative demands on a mature judgment, coupled with a measure of constructive ability sufficient to enable him to carry and secure all the parts of his mould, not only accurately, but with absolute safety; and, be it remembered, he must meet every exigency entirely unaided by any of the 'helps' which his more fortunate brethren in the iron industries can so easily avail themselves of.

Presuming that the student in these things has been correctly instructed in all that pertains to a knowledge of moulding common objects, we will inquire into methods and principles called forth in the moulding of work greater in magnitude and more elegant in design. One of the chief essentials for moulding the class of work above mentioned is to separate the mould into as many parts as will enable the workman to extract his pattern undamaged. as well as to leave his mould as free from fracture as possible; and, at the same time, easy access for finishing, setting, and securing cores, etc., must be provided for.

As previously stated in "The Iron-Founder," page 171, it is much easier to accomplish all this in loam than in sand,

SECTIONAL MOULDING FOR GREEN-SAND WORK. 237

for what might be a comparatively easy job if done in loam, becomes at once a critical undertaking when attempted in green sand. It is to the latter class of work that this present writing is devoted.

Figs. 161, 162, and 163 represent cross-sections of a class of work commonly met with in almost all of our tool and engine shops, the first being that of an ordinary lathe

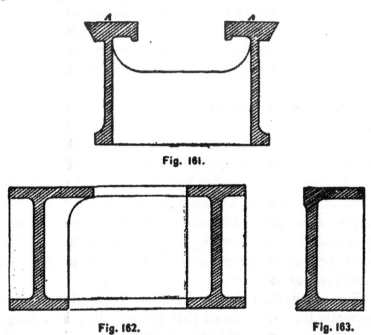

Fig. 161.

Fig. 162. Fig. 163.

bed, while the latter may be taken for either engine or machine foundations. Choice has been made of these common objects simply because they offer the best opportunity for a review of the underlying principles which must govern the moulder who essays the accomplishment of all such jobs, and the treatment of these will serve as a guide, and apply to all others of a like nature.

One great feature in all castings similar to Fig. 161 is to obtain a perfect and clean surface at the parts A, A, and this can only be accomplished by casting the mould in the

position shown at Fig. 164. This method insures a comtively clean surface at those parts, whilst the sullage, which always forms and rises into the upper parts of the mould, finds a lodgment where it is less objectionable.

When the mould is wide, as in this case, and the outside projections, A and B, are narrow, the inside can be lifted out and the mould finished without much trouble; but to effect this properly we must first have those portions of

Fig. 164.

the pattern marked A, B, C, and D made separate from the body, as shown at Fig. 164. The body can then rest on the bottom surface of the mould, and the loose pieces, in suitable lengths for drawing, laid against it afterwards.

The reasons for this arrangement will be fully appreciated if it be understood that when the body of the pattern has been withdrawn from the sand, the core G can be lifted out with perfect freedom, and the inside pieces C and D can be taken away without damaging the joint at H, H. The pieces A and B can be then drawn inwards, the operation being materially facilitated by having ample draught at I, I.

So much for the general features connected with moulding this job; but we have not considered how all this is to be done. The casting may be 12 or perhaps 30 feet long: if the former length, then one lifting-plate would suffice;

but in the event of the latter, it might be advisable to have two or more lengths of core, divided at convenient intervals at the cross-bars. The principle of a lifting-plate for this class of work is shown in plan and side elevation at Fig. 165, and an end elevation of the same is shown at Fig. 164. In all cases plates of this kind must be made proportionate to the weight to be borne upon them, and due

Fig. 165.

consideration must be given to such a distribution of the lifting-handles as will insure the least amount of spring or bend in the plate.

All lifting-handles should be made as wide as is practicable with a straight turn, as shown at *J*, Fig. 164; this allows of an easy adjustment of the hook, and thus insures a straight lift on the core—something which cannot be as easily done when round eyes are used.

In bedding down plates of this kind great care should be taken to have them as much above the surface to be lifted as will allow the irons to rest thereon, with only as much sand between as will permit of a solid bedding down

of the iron. Too much care cannot be taken to insure a good job here, for it must be remembered that this is the foundation upon which all the weight of the core must rest, and no reliance can be placed on soft sand.

Additional stiffness is imparted to cores of this description by alternate layers of irons laid crosswise during the process of ramming, as seen at *K* and *L*, Fig. 164; and all corners may be still further strengthened by an occasional gagger being set therein in a diagonal position.

Fig. 166 is a plan view of cross-iron intended for use on such work; all edges next the casting are chamfered, but that portion which rests on the plate is left flat, and some

Fig. 166.

increase of thickness made in order to meet the requirements before mentioned.

An entire change of procedure is made necessary when this job is contracted in width. If the opening betwixt the sides is considered too small for safety in green sand, then recourse must be had to a system of dry-sand cores; but a reference to Fig. 167 will show how a very small opening may with safety be utilized in the moulding of such jobs in green sand.

Several methods present themselves for overcoming this difficulty, first of which we will notice the one as previously explained, and made possible on such a reduced plate by setting the same with its upper surface on a level with the bottom bed, as seen at *A*, upon which surface are laid narrow strips of cast iron held together by internal webs, as seen at *B* in elevation and plan; these, standing a little above the surface to be lifted, allow the core-iron *C* to rest solid thereon, making it impossible for any damage to ensue, no matter what weight the superincumbent core

SECTIONAL MOULDING FOR GREEN-SAND WORK. 241

may be. The core is still further stiffened by the rods marked 1 to 7, respectively, in plan Fig. 167, and in end elevation at A, Fig. 168; these latter combine with the cross-irons and corner gaggers to make this core, narrow as it is, almost if not altogether as firm as the one previously de-

Fig. 167.

scribed. It will be seen at D, Fig. 167, how to make a wide handle on a single stem, and this particular item is worth remembering, as it will prove very useful in a life's experience among this class of work. I need not mention that the pattern is to be in this case as for the last; consequently the pieces E and F are entirely loose at the

first move of the core, thereby obviating all danger of dragging down sand at the neck when the core is lifted out.

Should it be thought desirable to lift away the outsides of such a mould and leave the core standing, the iron strips B could rest on solid bearings provided for the purpose, and iron stakes could be driven down to answer the purpose of irons A, Fig. 168. In all other respects the opera-

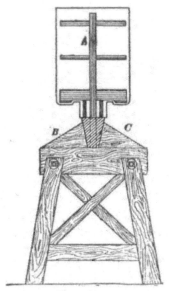

Fig. 168.

tions would be similar to those previously explained, excepting that on account of pieces E and F having to be withdrawn after the sides were taken away, sufficient draught must be allowed to make the operation easy and safe, and the projections at G and H must necessarily be made loose to fall down after said pieces were drawn out.

Two important items in side lifting-plates, or "drawbacks," merit some attention here, which, if once properly understood, makes the rest comparatively easy. First find out how much projecting sand is to be carried, and make the

plate wide enough to allow the irons as much length back as will more than compensate for the weight in front, as seen at *I* and *J*, Fig. 167. The other item is to so place the lifting-handles *K* that a correct lift may be taken with the least amount of trouble. It will be seen that in this case the lifting-handle *K* is set a little forward to make up for the extra weight on front, and also that the handle itself is wide, as before explained ; and therefore any discrepancy can be easily rectified at the point of suspension.

Ordinarily, a common drawback of this kind is rammed up and the hole entirely filled during the operation, to be subsequently dug around when the mould is to be separated; but if all of the cope be contained within the limits of the drawback, this extra labor may in a great many instances be saved by casting taper-holes at intervals along the back of the plate, as seen at *L*, into which stout bars can be driven, as seen at *M*, Fig. 167; these serve as supports for boards or plates, thus obviating the extra digging and ramming previously spoken of.

A careful scrutiny of the right-hand side of Fig. 167 will make it apparent that all this may be accomplished in a more elegant manner than has hitherto been suggested, but it must be observed that what we have been saying in reference to side plates is intended to apply only when the nature of the order would not warrant us in adopting more systematic methods, at an enhanced cost.

The rig shown consists of an inverted lifting-plate *N*, to which, by means of brackets *O*, a back plate *P* is attached; the hinges *R*, upon which the whole side is to be turned, are placed at suitable intervals along the back plate, taking care to have them in close proximity to the brackets. The position of the cheek when turned up is indicated by the broken lines at *T*.

This method is very simple, as will be noticed. The bottom hinges *U* are cast fast to the long bar *V*; this,

when cast, is rammed firmly into the floor, with its upper edge parallel to the bottom bed. Additional rigidity is given by inserting a stout bearing-plate *W*, and wedging under the hinge, as seen. The upper hinges are to be bolted on the back plate after all has been firmly secured. The fixing *S* is in this case necessary to obtain the required leverage for turning the side over on its hinges, and, as seen, is secured to the bracket by set-screws at the top.

Fig. 169.

I have shown at Fig. 168 how to rest long narrow cores, such as we have been discussing. The rig is simply a common wooden horse, with wedges *B* and *C* nailed fast thereon; by this means the core can be safely housed, and the finishing proceeded with as comfortable as if it were hanging in the crane.

When the jobs are not too ponderous and it is desired to reach every part of such moulds, the method described at page 45 of "The Iron Founder" is most assuredly the best; for by the method there explained everything is con-

SECTIONAL MOULDING FOR GREEN-SAND WORK. 245

tained within the limits of the flask, and all the extra labor involved by bedding in the floor is entirely saved.

I have shown at Fig. 169 a cheap makeshift for small jobs of this class: this whole outfit consists of a plate A, cast in one piece, on which is placed a wooden frame stiffened at the waist by iron bars B, C, and D, after the manner

Fig. 170.

Fig. 171.

as before explained at Fig. 167. This frame may be fitted with a wood cope, or an iron one can be used temporarily if the order will not allow of an entire iron rig being made.

It sometimes happens that projections occur at certain places along the length of foundations, etc., which, if provided for by the methods as previously described, would necessitate the use of some very unwieldy plates. Fig. 170

illustrates how such a difficulty may be overcome by a very simple arrangement ; the figure includes plan showing the wide projection extending from the regular web B, B; it will be seen that the back of the lifting-plate C has not been made wider at that point, thus making the surface to be lifted at A very much wider than the lifting-plate

Fig. 172.

itself, which, if not provided for, would inevitably collapse when the plate was lifted away.

The staples E, seen in end section above, are cast in the lifting-plate in the position shown at D, D in the plan; and, as shown in the figure, serve the purpose of wedging down the bar F, seen to rest on all the irons, and thus securing them firmly to the plate. By this means the irons become as one with the plate, and absolute safety is assured.

Fig. 171 shows how the same results may be obtained by casting irons in the lifting-plate; but for general purposes

the other mode is by far the best, especially when the rig must be used more than once. The crank end at A can be made very useful on special occasions, and materially helps to stiffen a critical corner that would otherwise be dangerous to risk in green sand.

Fig. 172 represents a method for lifting out the inside core when the web extends round the end of the plate. A very neat and effective method of carrying such a core is

Fig. 173.

here shown: the cross-irons extend to within a short distance of the end of the plate, and the remaining portion is cared for by the crank-irons A, set in at right angles to, and resting firmly on the cross-irons.

The conditions on such a job are very much changed when the inner web is widened as shown at Fig. 173. This emergency is well met by introducing a grate, or 'grid,' cast for the purpose, which, as in all the other cases mentioned, must have a sure rest on the plate, to which it must be firmly secured by bolts at the holes indicated. When from any cause whatever the plate does not stand high enough to rest the grid upon, then recourse must be

had to packing, as in all cases of this nature we must have iron and iron: a strict adherence to this rule will save many a blunder.

Fig. 174 shows how to carry away a deep overhanging side in green sand, and is simply the application of the principle set forth at Fig. 170. The section of lifting-plate *A*, with

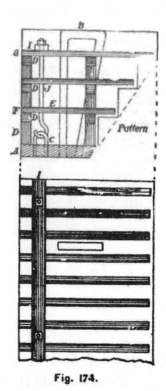

Fig. 174.

handle for lifting *B*, also staple *C* for securing, is shown, on which studs *D* for the support of bars *E* are resting. On these bars the first row of irons *F* are seen in position. The same process at the two upper tiers brings us to the top row of irons *G*, on which the bar *I* is placed and securely anchored, the bolts *J* having been previously set in position before the ramming commenced. The value of this kind of lifting-handle is again forcibly demonstrated

in this instance, as by changing the angle a little almost every inequality of weight may be provided for.

If a side must be carried away, exposing a web or projection of more than ordinary dimensions, it is just as well to make a flask drawback to cover the whole thing; this will serve the double purpose of fitting the lower surface and carrying away the side. Extra precautions must in

Fig. 175.

this case be taken to provide suitable bearings at each corner of the flask; these must rest on anchor-plates set down solid below the mould. Fig. 175 is the representation of just such a mould as would require the arrangement we have been describing. At A we have the surface level with the floor, whilst the surface B, at right angles to A, extends to another similar surface directly under the flask C. With such an arrangement as is here illustrated, such work, difficult as it may seem, becomes comparatively simple.

HYDRAULIC CYLINDER-MOULDING UNDER DIFFICULTIES;

OR, BIG CASTINGS IN LITTLE FOUNDRIES.

To my certain knowledge there are no men, as a class, more ambitious of distinction in their profession than foundry proprietors. Especially may this be said of such founders as have not the room space or power in their foundries necessary for the safe handling of heavy castings difficult to mould, owing to their great size and complexity of design.

Many and ingenious are the efforts put forth to accomplish work that at first sight strikes them as being beyond their ability to make; but on further reflection, and urged by the principle above spoken of, they have ultimately decided to make the effort, cost what it might.

Moulders who have done all their moulding in shops provided with every convenience for different kinds of work, and whose every need and requirement has been anticipated by one or more heads that have been trained scientifically as well as practically to a thorough knowledge of founding in all its multitudinous branches, know little or nothing of the skill and perseverance practised in the small and less-favored shops to mould castings which to them would be a comparatively easy task.

When a graduate from one of the paragon foundries undertakes to mould similar work in the latter-mentioned places, particularly if it should happen to be one of the meanest, he immediately discovers the truth of the above, and mentally resolves to keep his faculties on the alert; otherwise his deficiencies as a thorough moulder will be at once detected. His discovery of the non-existence of con-

veniences and tools hitherto looked upon by him as indispensable for making such work almost unmans him; but when, upon hinting the advisability of procuring these costly adjuncts, he observes the grim, far-away look on the countenances of his new shopmates, he not unfrequently retires from his new field of operations a thoroughly disheartened man. This, of course, is decidedly wrong; a moment's reflection should convince him that the cause of his present embarrassment is the natural result of his past environments, which latter, aided by his present opportunities, would, if taken advantage of, insure for him a bright and useful future.

To transport a mould or casting weighing 20 tons, in a foundry more than adequately equipped with 50-ton power cranes of the latest improved patterns, is the simplest matter imaginable. How such moulds must be divided up, and what devices must be planned to move the same weight where the capacity of the cranes do not exceed from 7½ to 10 tons, is best known to many of the ambitious proprietors of small foundries, who are every day demonstrating possibilities beyond even what we are now considering.

I am aware that the consideration of the following subject will be provocative of a smile among the luminaries whose effulgent light is dispensed only in the paragon shops previously spoken of; but let such be reminded that we are attempting the accomplishment of this job in a small foundry, where the means are far below its legitimate requirements.

Let it be required to mould a plain hydraulic cylinder 2' 10" outside diameter, 1' 2' inside diameter, and 14' 0" long, including 2" 0" for head, at a foundry where every facility exists for the immediate execution of such an order. Almost certainly there will be a 'plug' pattern ready at hand, requiring but a very slight alteration to make it suitable for the job; flasks are sure to be found in

sufficient numbers to make up the required length; and in all probability a core-barrel, with or without tripod, will be found also,—thus making a full rig wherewith to commence the moulding of this casting on the instant of the order's reception.

Owing to the skill and foresight exercised in the management of such an establishment, the place assigned for the ramming of this class of work is separate from and independent of the regular run of crane work, and is also in direct communication, by rail or crane, with the oven; neither is there any interference with such regular work by the constant monopoly of the crane attendant upon the ramming up of such jobs, owing to the fact that this contingency has been anticipated and a separate crane provided for the purpose.

The exercise of due alacrity on the part of the coremaker produces core and mould simultaneously at this place in an incredibly short space of time, and as there is power sufficient to lift all the mould together if need be, that particular item requires no consideration whatever. In all probability there will be from 25 to 40 feet clear above, in which case the length of the core gives no concern whatever, being simply hitched on and suspended with tripod attached, lowered into the mould, centred, and secured. Subsequent operations connected with casting and shipping are, owing to such excellent means, very light events, and merit no notice here.

How different is all this when we undertake to mould this cylinder in a shop 50 feet square, having cranes capable of lifting only 10 tons, with a height from floor to crane-hook of $12\frac{1}{4}$ feet, and without either pattern, flask, or core-barrel wherewith to make the job. Under circumstances of this nature we must either incur the expense of new patterns and flasks, or go back to the time-honored practice

HYDRAULIC CYLINDER-MOULDING. 253

of 'making it in loam.' The latter method is what we propose to explain as we proceed.

In the first place, this casting will weigh about 16¼ tons; this, of course, necessitates the division of the metal, for pouring with, into at least two portions, each of which must be less than 10 tons, the latter weight being the limit of the crane's capacity.

Next, there must be such a separation of the copes forming the outside of the mould as will permit the core to be inserted at about midway of its length, the remaining portion to be lowered over the core subsequently. Another important item in the general arrangement is to place the lower part of the mould into the pit at such depth as will allow the core when suspended to swing clear of it, and as the core exclusive of lifting-tackle is about 14' 6" long, it must of necessity travel in a trench dug in the floor from the point where it has been suspended to the pit. The labor of digging this trench will naturally suggest the keeping of these two points as near together as is consistent with safety.

As before stated, when there is unlimited height, the core, with its necessary appendage, can be lowered down into its place after the outside has been all set; this allows the core to swing from the tripod clear of the mould during the operations of closing; but in this instance the core, owing to the altered circumstances, must first find a resting-place at the bottom of the mould, until the remaining part of the mould has been closed over, after which the tripod can be attached and the core freed from its temporary anchorage.

For the benefit of moulders whose experience has not embraced this particular phase of the trade, I shall, by the aid of the accompanying illustrations, endeavor to make plain how best to mould such a job in loam, where the conditions for doing so are about equal to those related above.

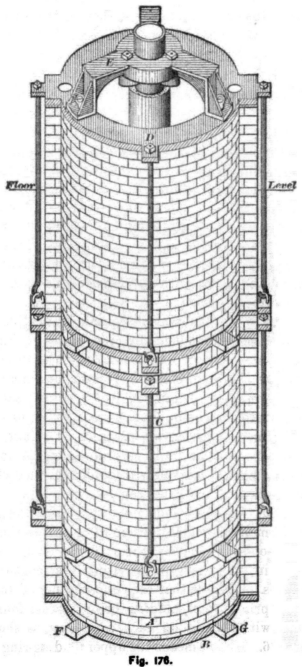

Fig. 176.

A glance at Fig. 176 will give a good general idea of the whole apparatus required for constructing the mould; the other figures will be found useful, and aid the mind in arriving at an accurate knowledge of its numerous details.

We will first consider the mould proper, which consists of lower section A, that is seen to be built upon a stout foundation-plate B, of such form and dimensions as will permit a double course of bricks beyond a suitable thickness of loam. Provision is also made for building in a system of running-gates down opposite sides of the mould. The form of this foundation-plate, as well as all cope and binding rings used on the job, may be seen at A, Fig. 177, that being a plan view of the top of the mould, exposing top binding-plate, tripod, and one runner-basin, the latter being purposely drawn out of place in order that a sectional elevation of the same with its connections lower down could be obtained, as seen.

How much of the mould is contained in this lower section will be seen at a glance by referring to B, Fig. 177; the bottom connection of one of the running-gates spoken of is shown at C; the opposite one (not shown here) must be taken for granted. A tapered iron block 4″ square on its upper surface is to be built in, as seen at D, for reasons that will be made clear as we proceed. The two upper sections of cope may be built separately, closed together when green, finished, marked with guides for final closing, and then blackened and dried separately.

To meet all the conditions previously laid down, it is necessary to make an equal division of the copes above the bottom section; this makes them about 6′ 3″ each in length, and in order to give the requisite strength to the structure it is important that each cope be bound together as seen, the principle of binding being to cast four additional lugs, with staples on each cope-ring, as shown at C, C, Fig. 176. By this means the upper binding-ring can be

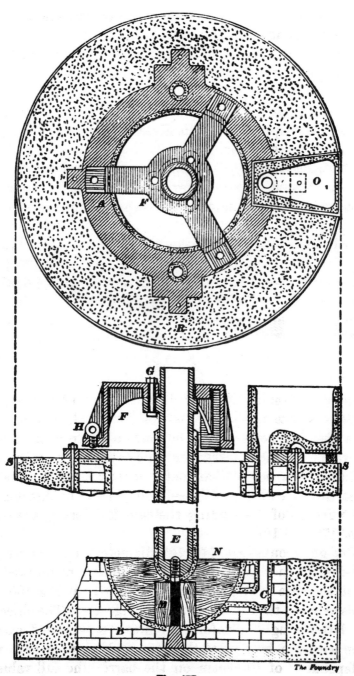

Fig. 177.

drawn down firmly, and thus make of the whole courses of brick one unyielding fabric.

The upper cope is a fac-simile of the one described, excepting that, instead of placing the binding-ring one course of bricks below the joint, as in the lower, it is in the higher placed on the top course of bricks, with its smooth side uppermost; this gives a better surface for the tripod E to rest upon.

The core-barrel, 10" diameter outside and 1" thick, in this case need not be over elaborate, nor possess any element of fitting beyond the capacity of the ordinary

Fig. 178.

foundry blacksmith; a careful examination of Fig. 177 will explain all its parts, internal and external. Three lugs, with holes for bolts, are to be cast on 8" from the top, as shown in all the figures; and midway betwixt these lugs and the top a hole $2\frac{1}{4}$" diameter must be cast on opposite sides, through which a 2" steel bolt-pin can be inserted for the purpose of suspending the core for closing, as seen at Figs. 178 and 180.

The gudgeon A, Fig. 178, $2\frac{1}{4}$" diameter, is purposely provided with an eye for lifting by, but must be screwed out when the core has been suspended, as seen at Fig. 180, and replaced with the one shown at E, Fig. 177. The object of the latter plug is twofold: at first it is screwed exactly even with the bottom of the core, and forms a sure rest, independent of the loam on the barrel, the full value of

which arrangement will be apparent when the test of its merits are exhibited further on.

At FF, Fig. 177, are shown plan and projected elevation of the tripod to be used on this occasion for the final suspension of the core. As seen, it consists of three legs or stands, connected by a stout central ring which encircles the core-barrel; three holes, corresponding to the position of the holes in the lugs, are cast in the central ring for bolts G to pass through. The height of these lugs on the barrel determines the depth of the tripod, and it is always advantageous to allow for a steel bearing about 1″ thick to rest upon the top ring for the screws H to work upon.

Before commencing to close this mould, let me draw attention to the cross or cradle, shown at Fig. 179, and explain its use. It is composed of two half-circular boards 2″ thick, halved in the centre and strengthened by four corner-pieces, as seen. The outer circle at J corresponds to the curve at the bottom of the mould, whilst the curve at K answers to that of the core. An iron pin L, $2\frac{1}{4}″$ diameter, is let into and extends through the cross; this pin, as seen again at M, Fig. 177, stands flush at both ends, the lower end resting upon the stud or block D, whilst the upper forms an immovable support for the core, the whole weight of which is carried by the screwed plug E, previously spoken of.

This cross, as will be plainly seen at N, Fig. 177, forms a cradle, which fits the mould exactly and gives a central guide for the core, the bearing for which is, by this contrivance, a direct connection of the barrel with the foundation-plate irrespective and independent of either the mould or core.

When this cradle has been set into the bottom section of the mould, lift on the lower piece of cope and proceed to swing the core. As stated at the outset, this can only be done by lowering the bottom end as much into the floor as

HYDRAULIC CYLINDER-MOULDING. 259

is lacking in height of crane for effecting a clear swing. Fig. 178 shows the core resting, at each end, in a trench dug for this purpose; and Fig. 180 is a rough representation of the core A, swinging in the crane and issuing from the trench B, over the mould in pit C.

In this case the trench would require to be about 3 feet deep; the lower cope standing at that distance below the floor-line, as shown, would bring the top of the mould, when all is closed, about 3′ 6″ above.

When the core has been lowered into the guide below

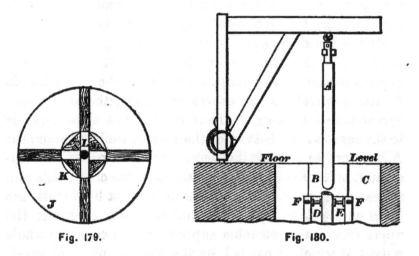

Fig. 179. Fig. 180.

and centred by packings which must be firmly wedged at three or four places round, take care that each packing is placed opposite the binding-ring, as shown at F', F, Fig. 180. It will here be seen why we make these copes so strong: the binding-ring serves the double duty of keeping the mould in good shape and acting as a firm buttress against which to steady the core until the upper cope has been placed, when, if the core is found to be correct at that point also, the work may be continued; but if it should be found necessary to move the core over a little at the top, then loosen the lower braces and proceed to pack above as be-

fore, using the inner edge of the top binding-ring as a buttress.

The tripod may now be lowered over the barrel and made fast thereto, after which bring the set-screws H, Fig. 177, firmly down on the steel packings until the tripod bears the whole weight of the core. If this is done carefully there will be no further centring to be done.

The whole mould, exclusive of the bottom section, is to be now lifted in order to take out the cradle N, and make good the bottom of the core; but before proceeding to do the latter, let the plug E, Fig. 177, be screwed $\frac{1}{4}''$ farther in: this will permit a covering of loam at that part, and prevent damage from the molten iron.

By placing a runner-basin O, Fig. 177, at each of the down-pouring gates P and R, we obtain a correct plan view of the top of such a mould when the outside has been rammed level with the top, as seen at SS, which point, as before stated, stands about 3' 10'' above the floor-line.

For obvious reasons, I have omitted showing the cross and slings used for binding purposes; but it is well to say that there must be no bungling here, as there is an upward pressure under this core of about $3\frac{1}{2}$ tons. Use a good cross, and let the packings come directly over the ends of each wing of the tripod.

Granted that the conditions for melting iron in this shop are about equal with the majority of our small foundries, and remembering the weight of this casting, we cannot conscientiously withhold our meed of praise for all such founders as can successfully produce such work creditably under circumstances so adverse.

THE FOUNDING OF STATUES IN IRON AND BRONZE.

EXPLAINING THE 'CIRE PERDUE' AND OTHER PROCESSES; WITH A REVIEW OF THE ART AS PRACTISED BY THE ANCIENTS, AND UP TO THE PRESENT TIME.

AFTER a careful review of the subject of founding in its relation to sculpture and the fine arts, as ably presented by eminent authorities, past and present, the writer ventures in this article to give a brief outline of its history up to the present; with such technical instructions as will at least leave an intelligent knowledge of the several modes of producing in metals a true representation of the original inspirations of the sculptor.

When stone, bone, and horn were the only materials upon which mankind spent its efforts upon such articles of common use as they then needed, it might be then called the stone age. The bronze age did not by any means come into existence at once, but by a very slow process of development. The native copper they had with them for the fashioning of articles by beating, etc.; but no doubt a gradual application of fire for melting was followed by some sort of rude moulding for the purpose of obtaining casts from different objects, which ultimately brought about the art of mixing metals, copper and tin alloy, forming bronze, being the chief amongst them during this age. It was not until metallurgy was a well-established science that iron came into general use, and that assuredly accounts for the rapidity with which it at once asserted its supremacy for almost all uses in science and art.

There is no doubt that the arts of man in times past have been considerably influenced by local surroundings.

Pure native copper in great abundance is found in North America, and iron seems to have been worked by some portions of the Africans, owing to a peculiarity of its nature, from the earliest ages. No knowledge of the use of metals was shown by the natives of Australia, New Zealand, or the northern portion of the continent of America when they were first discovered. In the southern continent, however, strange to say, they were not ignorant of the art of working metals when they were first discovered by the Spaniards in the sixteenth century. It was found that the Peruvians and Mexicans could work with considerable skill in gold and copper, but had not as yet found out anything about iron.

It would appear that the change from the bronze to the iron age took place in Greece within the time included in the most learned parts of its history, while the Romans, it is certain, had possessed a knowledge of treating iron ore from the earliest days of their existence as a nation. Iron was known to the Celtic and German tribes when the southern races first went among them for the purpose of trading, etc.; and some parts of northern Europe to this day maintain a supremacy in the manufacture of iron not as yet attained by their almost immediate neighbors. The art of making steel was first acquired by the Romans.

The metal which seems to have found most favor in Europe during the earliest ages was gold: this may have been on account of its being found in many parts in such condition as admitted of easy working by beating, etc., into articles of adornment for the person, as well as other decorative uses, its beautiful and shining quality, no doubt, being its chief attraction. We find that tin was from the earliest times an article of commerce and trade in the south of England; and when we consider the fact that copper also was mined in large quantities in close proximity to the tin mines, we may, without any stretching of the imagina-

tion, conclude just how these two metals were ultimately combined to form the wonderful alloy which we call bronze, and which, no doubt, was the beginning of the change that determined the duration of the stone age. The first processes were undoubtedly the beating and shaping of native malleable copper, followed by the melting of the metal and running into moulds; and finally the discovery that by the same process of smelting the ores could be made to yield whatever copper they contained, which, being mixed with other metals in suitable proportions, resulted in the ability to produce whatever kind of metal the needs and requirements of the early workers in metals called for.

When the art of smelting iron had at length become generally known, and arms, as well as the numerous other articles for which it was better adapted than bronze, had been successfully made, fully demonstrating its superiority over the latter metal for such purposes, the iron age may be said to have arrived.

It will be evident to all that there must have been considerable attention given to the subject of metallurgy in these early ages before they could have successfully accomplished the manufacture of wrought-iron goods, as above described; and it is almost certain that the Britons, isolated though they were at that time, knew how to manipulate the metals before Julius Cæsar landed with his armies in that country: still, a great impetus may have been given to the business by that event.

Chius seems to have been honored by the establishment of a school of sculpture in marble as far back as 660 B.C., and it was in this place that Glaucus is supposed to have introduced the art of welding iron, 692 B.C. Mention is also made by several authorities of the beautiful metal utensils which were produced at this time, as the enormous caldron with projecting griffins' heads, and a support formed of kneeling figures seven ells in height (Herodotus, IV. 152).

Pausanias (III. 17, 6) describes, as the oldest example of sculpture in bronze which he had seen, a statue of Jupiter at Sparta; the work of Clearchus of Rhegium, who was by some called a scholar of Dædalus. It was made of plates of bronze beaten out to the form of the figure, and then secured together by fine nails, from which it would seem that the arts of casting, or even of soldering, were then not known.

Theodorus of Samos is supposed by some to have been the inventor of casting in bronze, but Ulrichs argues that there must have been two artists by that name, because the one who invented bronze casting must have lived before 576 B.C., previous to which date this art may be inferred to have been known from the remarks of Herodotus (V. 82) that the Epidaurians were ordered by an oracle to obtain figures of Damia and Auxesia.

The rival schools of marble sculpture, and the first of which we have any distinct record, are Chius, and Magnesia on the Meander. Bathycles was the leader of the latter school, and Pausanias tells us that he was the author of the figures and reliefs on the colossal throne of Appolo at Amyclae. As to the date of these schools he does not decide, but supposes about 546 B.C. The schools of Argus and Ægina appeared about 508 and 452 B.C., and bronze would seem to have been the material worked with by the former school, whose head was Ageladus, the tutor of Myron, Polycletus, and Phidias. The school of Ægina obtained a great reputation for the quality of the bronze used, and their design and workmanship were greatly esteemed.

Onates, whose works consisted of immense groups, as well as other statues of gods and heroes (single), most of which were produced in bronze, was a graduate of the latter school. Anaxagoras, who executed the bronze statue of Zeus, 15 feet high, for Olympia, to celebrate the battle of Platea, was the immediate successor of Onates.

The school of Magna Grecia is worthily represented by Pythagoras, whose works were all executed in bronze. The subjects of his choice were invariably male figures, on which he worked with marvellous skill, in order to bring out a pronounced representation of muscular attitude as expressed under extreme bodily or mental strain. His statue of Philoctetes at Syracuse was executed in order to show forth the expression of pain, and it is said that his success was such as to move spectators when viewing it.

The Athenian Phidias is supposed to have been born about 500 B.C. With his advent a new order of things prevailed, as he possessed a knowledge of the art coupled with technical skill hitherto unapproached, and his influence spread far and wide. Originally a painter, he subsequently turned the whole force of his genius to sculpture, producing, among other great works, the colossal statue of Athene the Promachos, which, according to Pausanias, was ordered by the Athenians, and paid for out of the Persian booty. When finished, it was erected on the Acropolis, the top of the spear in her hand and the crest of her helmet being visible at sea from Cape Sunium.

Scopas of Parus, 380 B.C., settled in Athens. He was a great bronze sculptor, especially in the portrayal of feeling, which he infused into all his figures, whether human or divine. He maintained his reputation for unapproachable work about thirty years.

Lysippus of Sicyon also appeared about this time. He had been formerly employed by the Corinthian sculptor Euphranor, as one of his workmen in bronze; but disdaining the lower walks of his profession, he studied hard, and was ultimately rewarded by being esteemed by all as a sculptor of genius. A remarkable feature in this man's career was the immense number of works which passed through his hands, which are supposed to amount to the enormous figure of about 1500 groups and statues, two of

which may be considered massive productions, being the statue of Jupiter at Tarentum, 60 feet high, and the statue of Hercules at the same place.

Chares, the founder of the school of sculpture at Rhodes, is preëminently noted for having produced the bronze statue of Helius at Rhodes—an immense piece of work, measuring 105 feet in height. This colossal figure remained standing about sixty years, when it was destroyed by an earthquake.

The plastic arts were in a degraded condition about the fourth century, coarse in workmanship as well as wanting in the higher principles of design. The lack of expression in works of art at that time shows that at the most it was but imitative of the past. The sixth century produced an entirely new class of sculpture for decorative purposes. This was under the influence of Justinian, who favored the Byzantine style, which latter can only be considered a high-class order of metal-work suitable for decorative purposes, and all such as were used for decorating the church being their highest aim to produce. No doubt this lapsing into working of precious metals resulted from the objections raised by the Church at that period against all efforts at modelling figures which might captivate the senses.

The whole Christian world was influenced by the art of Byzantium up to the twelfth century; and as they had become the greatest workmen in the precious metals at that time, the artists from all over Europe flocked to that city, making it the centre as well as the school of art-work.

The Saxon period found the English with but very few attempts even of stone buildings, much less sculpture, and the arts at that time were mainly represented in some few specimens in gold, silver, and copper. True there was some rude sculpture attempted during the Norman period, but nothing of importance in this line is noticed until after the

thirteenth century, when we find that considerable encouragement was given to art-work by Henry III. The two bronze figures in Westminster Abbey, modelled and cast by William Torell of London, about the year 1300, will, however, bear comparison with some of the best works of that day. These castings are considered perfect as specimens of the *cire-perdue* process, one representing the crowned head of Henry III., and the other that of the head of Eleanor. William Austen of London was the artist who modelled and cast the effigy of Richard Beauchamp, 1439, and no work of the fifteenth century has received greater praise. Hubert Le Sœur, a French sculptor, who died about 1670, modelled and cast the bronze equestrian statue of Charles I. at Charing Cross, supposed to be a fine specimen of art-work.

English sculpture during the eighteenth century was mostly in the hands of Flemish and other artists, Rysbrack being one of the chief amongst them. The more modern public statues of London are, as a rule, somewhat tame and uninteresting, with one brilliant exception, which is the Wellington monument in St. Paul's Cathedral, the almost life-work of Alfred Stevens (1817–1875). The monument consists of a sarcophagus supporting a recumbent bronze effigy of the Duke. At each end is a large bronze group, one representing truth tearing the tongue out of the mouth of falsehood, and the other, valor trampling cowardice under foot.

There is no doubt of Stevens' work being made more valuable apparently from the fact that there were so few artists of his day who might be considered good. The Athlete struggling with a Python, by Sir Frederick Leighton, is elegant, both in conception and design, but is marred irreparably by the methods adopted for casting—so common now in England, casting in sand being preferred to the nicer method of the *cire-perdue* or waste-wax process.

This latter process consists of modelling the statue in wax, upon a previously prepared core, around which the cope is formed, and the whole thoroughly burned. The wax escapes during the firing, and the space is filled with metal. The original model is, of course, lost.

The twelfth and thirteenth centuries found the sculpture of France the finest in the world, but it declined again towards the end of the fifteenth century. Jean Goujon (d. 1572) was the ablest French sculptor of his time; he combined great technical skill with refinement in modelling. With the exception of the two Coustons, who were remarkable mainly for their technical skill, no sculptor of merit appeared in France during the seventeenth century; but a century later Jean Antoine Houdon (1740-1828), a sculptor of most exceptional power, produced the standing colossal statue of St. Bruno at Rome, and other statuary of remarkable merit. The existing French schools of sculpture are esteemed as the most important in the world; technical skill, combined with an intimate knowledge of the human form, are possessed by many living sculptors to a degree never before attained.

Germany continued under the influence of Byzantium until the twelfth century, which fact the bronze pillar reliefs by Bernward at that time plainly show. The thirteenth century found this country far behind France in artistic progress; but some fine examples of fourteenth-century sculpture are to be found in Nuremberg, also at Prague, where the equestrian bronze group of St. George and Dragon are to be seen in the market-place. For three generations, during the fifteenth and sixteenth centuries, the family of Vischer were among the ablest sculptors in bronze, and few bronze sculptors have ever equalled Peter Vischer in technique. His chief early work was the tomb of Archbishop Ernest in Magdeburg Cathedral (1495). The finest series of bronze statues of the first half of the

sixteenth century, viz., twenty-eight colossal figures round the tomb of the Emperor Maximilian, are to be seen at Innsbruck. Andreas Schlüter of Hamburg (b. about 1662) produced the colossal statue of Frederick III. which stands on the bridge at Berlin.

It was about the fourteenth century that Florence and the neighboring cities became the chief centres of Italian sculpture, till in the fifteenth century Florence had become the chief art city in the world.

No grander specimens of bronze statuary are to be found than the equestrian Gattamelata statue at Padua, done by Donatello, and that of Colleoni at Venice, the work of Verrochio and Leopardi. It was about this time that Michael Angelo, the greatest master of them all, made his appearance, and eclipsed all others by the grandeur of his noble work. The sixteenth century saw a decline in Italian sculpture, although John of Douay (1524–1608) produced his bronze statue of Mercury flying upwards, now in the Uffizi. He also cast the fine bronze equestrian statue of Cosimo de Medici at Florence. Benvenuto Cellini (1500–1569) produced the colossal bronze Perseus at Florence.

The description of the great gold lions of Solomon's throne, and the laver of cast bronze, supported on cast figures of oxen, shows that the artificers of that time had overcome the difficulties of metal working and founding on a large scale; and Herodotus tells of the enormous number of colossal statues for which Babylon and Nineveh were so famed. The late excavations in the Tigris and Euphrates valleys, and the recent discovery of some bronze statuettes, shown by inscriptions on them to be not later than 2200 B.C., proves the early development of this branch of art among the Assyrians.

Early Greek sculptors seem to have executed nearly all their sculpture in metal, preferably to marble; and how much superior in technique theirs was to some of our mod-

ern works is very clearly demonstrated by the great bronze lions of the Nelson Monument, London, which show in a marked manner how much inferior is the coarse sand casting, now prevalent in England and elsewhere, to the more delicate *cire-perdue* process.

The Japanese are great masters in all manipulations of metals and amalgams, and possess secret processes unknown to workmen elsewhere, showing a great mastery of their material in both designing and moulding.

Casting is, in all probability, the oldest method of metalwork, and this has passed through three stages: the first, solid castings, such as were made in ancient times by forming moulds in clay, stone, or sand, and pouring in the fluid metal until the hollow was full. The next stage, according to examples now in the British Museum, was to introduce an iron core, in order to save the bronze or even more valuable metal. The latter method most certainly had its disadvantages, as the casting must necessarily split on such a rigid core. The third stage, which appears with some modifications to be the method now adopted, was the employment of a clay or sand core, round which the figure was cast as thin as possible to save metal. This process was very successfully practised by the Greeks and Romans; and whilst their exact methods are not certainly known, it is more than probable that they were acquainted with the *cire-perdue* process, which was so largely practised at a later day by the great European artists in bronze, and still followed to this day.

In times past the moulding as well as the casting of a statue was invariably done by the sculptor, whereas at the present time, by the use of a clay model or a plaster cast of the same, the business of sculptor and moulder have become distinct specialties.

One great objection to the very elegant process of *cire perdue* is that the work of the sculptor must be repeated

as often as failure to reproduce his efforts occurs in the foundry; consequently the whole system of statue moulding has been undergoing a complete change of late in order to keep the model first supplied by the sculptor intact, and always ready for a repetition of the work should circumstances demand it.

Models, in clay or plaster, of large statues are now supplied by the sculptor, from which a correct impression in plaster is at once obtained by the founder. Such a model of an antique bronze of the Townley Venus is shown at Fig. 181, a plaster impression of which is obtained by first marking off two or more main divisions of the model and noting the parts which, owing to the peculiar depressions on the surface, would fail to separate from the model without fracturing the part; these found, a separate piece of mould is formed in plaster at such places, the outer surfaces of which will leave their impression in the outer copes. The copes are formed by running plaster over the model, the several divisions of which are obtained by constructing a wooden or clay boundary at the points where it has been determined to separate them, and are held firmly together by skeleton frames constructed with iron bars which are laid in the plaster during the process of covering the model. After these divisions have been made in this manner, one by one, and have become sufficiently set or hardened, they are carefully lifted away, set down on their backs, and the false pieces or cores withdrawn from the model and set in their respective seatings in the copes. A correct impression of the model, no matter how intricate its form, is thus obtained, over which, after well oiling, the requisite thickness is laid on in wax by repeated coats applied with a brush. The mould being now ready for forming the core within, a suitable core-iron is formed by attaching cross-bars to one or more main central rods, such cross-bars reaching into the remote parts of

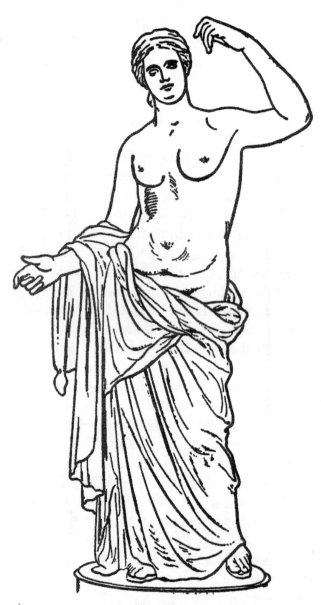

Antique Bronze of the Townley Venus.
Fig. 181.

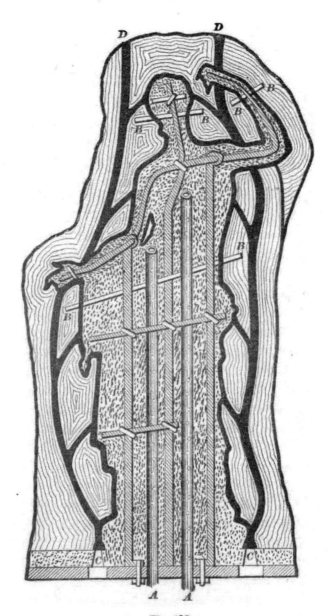

Fig. 182.

the core as seen at Fig. 182; this skeleton core-iron is then placed in position inside the prepared mould, and, after making the necessary preparations, by means of pipes, *AA*, for conveying away the gases from all remote parts, the composition or cement is poured therein from the highest part of the mould. The cement commonly used for cores in bronze castings is composed of two parts of finely ground fire-bricks to one part plaster of Paris, mixed with water to the consistency of cream.

The setting or hardening of cores formed from these materials takes place very soon, so that the plaster copes may be taken away almost immediately. By exercising care, this may be done without much, if any, damage to the surface of the newly-formed wax model. The core, surrounded with its wax fac-simile of the original model, is now stood on a suitably provided base, and only needs the requisite anchors for keeping it in position when the wax has been melted out, which emergency is met by inserting, at suitable places, rods of bronze through the core, as seen at *BB*, Fig. 182, the ends of which standing out some distance from the figure, are made secure by being cemented firmly into the cope, when the latter is duly formed.

The next process is to connect the wax of the figure with a number of holes provided at the base, as shown at *CC*, by means of outlets composed of the same material; also, to attach wax-running gates, *DD*, at such places and in such number and size as will insure a safe and clean pour. The gases generated inside the mould when it is cast are led away at the top by means of vents direct, or they may be formed in the same manner as the gates in wax.

After inlets, outlets, and vents have been all secured to their respective places on the figure, the whole surface is painted over with a fine composition of some kind; some use fine brick-dust mixed to a consistency with thin glue water, whilst others prefer the white of egg, or molasses,

with the brick-dust, according to the nature of the work. When about one quarter inch of this composition has been laid over the surface and become moderately hard, the common or ordinary loam, with a plentiful admixture of horse manure or cow hair, may be applied, and a backing of bricks built round, after the usual manner. It is usual, in some cases, to surround the bricks with iron curbs at once, so that all danger from the jarring incident to pit ramming may be avoided.

Whatever method of firing be adopted, it is necessary that these moulds, inside and outside, be thoroughly dried.

As will be readily seen, the wax thickness, followed by gates and vents, will begin to flow out at the lower apertures, CC, Fig. 182, as soon as the heat begins to take effect, and a constant flow will continue until every portion of wax will have run out, leaving the core and cope held in their true relative positions by the bronze rods BB, previously spoken of.

When the whole has been thoroughly dried, it only remains to plug the lower apertures CC, through which the wax has escaped, form the runner-basin, and all is ready for running in the metal.

The wax used for the above purpose is composed of one part each of tallow, turpentine, and pitch to ten parts of wax. The fine surface of these moulds absorbs more or less of the carbon of these ingredients, and by this means is rendered sufficiently refractory to resist the burning quality of the molten bronze, and it is to this happy combination that the beautiful results of the *cire-perdue* process is owing.

Sometimes these main copes, as provided by the method explained above, are at once filled with the core composition, after the skeleton core-iron has been placed therein, the copes being then taken away and the thickness pared off by the moulder, after which they are again adjusted

round the core, and the space run full of wax. The process is to be then continued, as before explained.

The moulding of statuary in cast iron is almost as exclusive a business as that in bronze. The various manipulations must necessarily be more difficult, because the materials used for constructing the moulds being more open, are proportionately less tough, and, consequently, greater ingenuity is demanded to construct the moulds so that they will endure safely the handling to which they are subjected.

Cast iron in a molten condition, being hotter than bronze, remains fluid longer; this, added to the fact that when the former metal is used the castings must be much thicker than the ones in bronze, makes it much more difficult to obtain a smooth surface, because as long as the metal is in a fluid state, and aided by the pressure behind, it is melting the non-refractory particles of sand on the surface, and forcing its way into the coarser materials of which the mould is made. To obviate this as much as possible is one of the chief processes in the production of cast-iron statuary, and no expense is spared to obtain the most refractory facings known.

For cast-iron statuary the sculptor must first secure the services of a competent moulder, who proceeds to form the core according as he is directed. Of course the moulder must follow the instructions of the sculptor in everything pertaining to the contour of the core, but he must use his own judgment in arranging all the supports, anchors, vents, etc., according to the nature of the work before him. After the core has been duly formed by the moulder the sculptor proceeds to form his figure thereon, using fine clay for the purpose, which, like any ordinary piece of loam work, forms the thickness, and is taken off when the impression has been obtained. The moulder in building his cope around the figure takes cognizance of all its irregularities, and provides for a correct separation of all its

parts with as little damage as possible to the original design. According to the depth and direction of the various depressions on the surface of the statue, so will the number and complexity of the divisions of his mould be. During the process of building provision is made for pouring by placing running-gates at favorable points; hooks and staples are inserted in the various small pieces, or false cores, which must necessarily be formed separate from the main copes, these hooks being afterwards used for fastening them to the main cope before the final closing of the mould. The separating of the mould is a delicate operation, requiring considerable experience and judgment on the part of the moulder.

After all the parts have been built around the statue the edges of the joints are made even, and guide-marks made, so that the final closing may be facilitated; they are then taken away, one after another, carefully, till all have been removed, after which the clay figure or thickness is removed, and the mould, inside and outside, treated after the manner usual for ordinary loam work, dried thoroughly, closed together, rammed in the pit, and cast.

The system of moulding colossal statuary in pieces, to be afterwards joined together by pinning, etc., is fast gaining favor where the old prejudices regarding the supposed discredit of producing statues piecemeal have disappeared, and very many of these figures, including the Statue of Liberty, New York Harbor, are now made in this manner. Cost for transportation, risks in moulding, chances for unsoundness, and weight of metal used in moulding colossal statuary by the old methods are by this means considerably reduced, whilst it is claimed that all seams can be so neatly fitted as to defy the keenest scrutiny to discover where the junctions have been made. It is also claimed that by this separation into convenient sections they can be easily made in sand, which gives a better impression and greater regu-

larity of thickness; also, that the thickness can be easily arranged to give the most metal where the greatest strains exist.

The process of moulding in sections is to divide the plaster model at such places as will be most favorable for moulding, due consideration being given to the parts which will best hide the points of junction, when they are joined together. The cutting is done with small saws, and after the several pieces have been provided with the requisite tenons and mortises for joining together when cast, and any weak parts strengthened by cross-stays, should the model be hollow, they are ready for the moulder.

The flasks for this class of work are not necessarily different to those in ordinary use, except that the nicest fit is indispensable. Three pieces of flask are needed, one being simply a frame; the other two, although constituting upper and lower flasks, are to be both barred, and for that reason may be both called copes. On account of the irregularities of the surfaces they are usually made with loose bars. These flasks are always best when they are made interchangeable. For moulding the outside of the piece of model which we will suppose to be a portion of the body of Fig. 181, one half of the model is set into the frame-piece as a roll-over flask; the ends are then rammed flush with the model, and the outside formed by ramming false cores all round if necessary. These false cores overcome all difficulty with regard to broken and uneven surfaces, as they can be made to separate at such places and in a direction favorable to a clean lift. When these false cores have been all formed out of fine tough sand, suitably strengthened with irons, and provided with the necessary lifting-staples, also the running-gates set therein at the proper places, a joint is made over all with parting-sand and the first cope set thereon and rammed. This done, the cope is lifted and set down on its back, the false cores are taken

off the model and placed in their respective places in the cope, which now presents the exact impression of this side of the model, and must, after due preparation, be used for ramming the first half of the main core.

The opposite side of the model is now treated exactly as was the first up to the point of lifting the cope, which, when rested on its back, must not have the false cores placed therein, as in the first cope, until they have been utilized for forming the upper half of the main core. As before stated, the first half being duly prepared by laying thereon a thick coat of parting-sand, a layer of core-sand is then spread all over, and the core-iron placed in position; and after due provision has been made for vents and supports—somewhat after the manner shown at Fig. 182—the lower half is rammed level with the joints of the first cores; the upper half is then formed by placing the false cores of the second half in their respective order over the lower ones, continuing the ramming of the main core inside as they are thus set over alternately; thus, step by step, continuing the process until the last false core has been so placed, and by this means the main core formed. The false cores are now lifted away and secured into their respective seatings in the second cope.

All that now remains to be done is to shave off the thickness at this half of the main core, cover with the roll-over flask, fill with sand, and ram hard enough to support the core, which, when the two flasks have been fastened together, is reversed, the cope lifted off, and set down on its back like the other. The false cores are now lifted off the main core and secured in their seatings when the remaining half of the main core is shaved down, the moulds finished and blackened, and all is ready for the oven.

All sands for false cores and other intricate parts of the outside of moulds, made like the above described, should be

of a fine, tough, but open nature; whilst that for the cores should be chosen principally for its openness.

For very small statuary in bronze it is only necessary to make a small block core out of the porous cement, which, though porous, is very tenacious, and admits of being cut and filled to any form required. When this has been formed and due allowance made for thickness, the artist proceeds to lay on the wax, on which he may, according to his ability, bring out the most delicate lines and curves imaginable. When the figure has been completed on the wax thickness, it only remains to thrust a few wires through the whole, and surround it with an iron flask, filling the space between with the porous cement. By the application of heat the wax is caused to run from the mould at the bottom, through holes provided for that purpose, and, as the core is held in a correct position by the wires which are firmly fixed in both the inner and outer cement bodies, the mould, when dry, can be turned with the holes on top; the latter serving the purpose of running-gates for filling the space, previously occupied by the wax, with metal. The greatest care must be exercised in this, as in the other methods, to have the mould thoroughly dry and free from steam, and besides vents from the core, there must be free vents from all points in the casting in which air or steam might get confined. By this means the most remote and delicate parts of the mould are reached by the fluid metal, and a good impression of the whole of the original wax figure obtained.

The figure to be produced in bronze may, if not too large and unwieldy, be worked direct after this manner: A plaster cast of the figure, previously wrought and finished, or any other finished object, is the pattern from which the moulder takes an impression in two halves. These impressions are carried off the model in stout iron skeleton frames, after the manner previously described. The mate-

rial from which they are made being, in this case, composed of a mixture of one third plaster of Paris to two thirds fine brick-dust, made to the right consistency with water, not only enables the moulder to take a good impression of the model, but being made porous by the brick-dust introduced, may be used as moulds proper for the outside. Sheets of fine clay are now rolled out, and spread evenly all over the surface as thick as it is intended the metal should be. When this has been done the moulds may be clamped together, and the inside filled with the same mixture as for the copes; but if the core is large or complicated, the skeleton core-iron must be used as in the cases before mentioned, not forgetting to make provision for carrying away the gas from the heated core, etc. The mould can now be again separated, the core lifted out, and the thickness removed; and as it is really composed of a top and bottom flask, the joints may be utilized for carrying the air and steam from the interior of the mould to the top by means of gutters cut therein. If it is thought advisable to run the metal into the mould at any point below the top, gates may also be prepared in said joint. When copes and core have been thoroughly dried, the closing proceeds in the regular way, excepting that all studs required for holding the core in position must be made of bronze.

All that remains to be done after the upper half has been closed over is to bind the whole firmly together with stout iron clips provided for the purpose, elevate the mould to the required angle, make the pouring-basin, and cast. The nature of the materials used for both core and cope in this instance admits of no half-measures in drying—this must be absolute.

The model or pattern, in this instance, is saved.

No country equals France for the number of its fine-art foundries, the principal ones being in and about Paris. The most systematic methods prevail, and no effort is spared

that will enable them to maintain the supremacy which at this day rightfully belongs to them; economy is studied in every detail of management as exactly as it is in the best-managed factories of the day. Some of their inventions for the treatment of art-work in the foundry are of world-wide reputation, and must be seen to be fully appreciated.

The Egyptian bronze consisted, according to Bessari, of two thirds brass and one third copper. Pliny says that the Grecian bronze was formed by adding one tenth lead and one twentieth silver to the two thirds brass and one third copper of the Egyptian bronze, and that this was the proportion afterwards made use of by the Roman statuaries.

The modern bronze is commonly made of two thirds copper fused with one third brass, and recently, owing to the great demands for ornaments and decorative furniture, lead and zinc in small proportions have been added. These additions, it is said, increase the fusibility of the alloy, and facilitate the process of casting.

In mixing plaster, never pour the water on the powder, but shake the powder into the water, taking care that it does not run into lumps. Proceed in this manner till the powder comes to the level of the water and then stop, if a thin plaster is wanted; a little more if a stronger plaster is needed. Amateurs commit the error of being too hasty in their movements, stirring the whole as it is being poured, and using too much of it. When the whole of the gypsum has been poured in, allow the ingredients to remain undisturbed for a few seconds, and then stir gently with a spatula; when it has assumed the consistency of cream, pour at once into the mould; it will then set in ten minutes, and be ready for taking out in half an hour.

THE ART OF TAKING CASTS.

EXPLAINING THE SUBSTANCES USED : PLASTER OF PARIS, BEESWAX, DOUGH, BREAD-CRUMBS, GLUE, ETC.; TO TAKE A CAST IN METAL FROM ANY SMALL ANIMAL, INSECT, OR VEGETABLE; TO TAKE A CAST IN PLASTER FROM A PERSON'S FACE; TO TAKE CASTS FROM MEDALS; TO TAKE CASTS IN ISINGLASS; ELASTIC MOULDS, ETC.

In order to obtain a cast from any of the above-mentioned objects the first operation is to procure a mould, by surrounding the thing to be copied with some material which can be pressed into all the various parts of the figure. This will be the mould, which, when it has become sufficiently hard, is to receive some substance, by pouring or otherwise, that will correctly fill all its parts, and become when set an exact counterpart of the original figure. The manner of moulding will always depend upon whatever is to be copied; should there be no projecting parts, or cavities undercut, the method is simple enough, as it is only necessary to surround it with the mould-forming substance and withdraw the same direct.

SUBSTANCES USED FOR FORMING THE MOULD.

Plaster of Paris, wax, metal, and other substances are used for this purpose, according as the urgency of the case demands. Plaster of Paris, prepared as described in article "Statue Founding," and brought to the consistency of cream, may be poured to any thickness required, always observing the precaution to oil well the object to prevent the plaster from adhering.

A very good mould, when it is required to use the same frequently, may be made from the wax mixture given in the article mentioned above; but in all cases where the position of the model is vertical or in any position liable to more than ordinary rough treatment, it is best to form the mould of modeller's clay, such as described in article "Pattern Modelling in Clay," page 189. This may be applied to the surface in sheets, previously sprinkled with whiting to prevent sticking when it is to be removed.

BEESWAX, DOUGH, BREAD-CRUMBS.

The above-mentioned substances are excellent materials for taking impressions of small objects; especially are they serviceable when it is desired to make moulds for seals and other things of a like nature. Should the relief show any marked irregularity of surface which would prevent its impression being taken clean and without fracture, then remedy this by filling the cavities, adding the same, with due consideration to the original, when the impression has been taken.

Any departure from a plane surface, such as cylindrical or other forms, must necessarily be divided into as many parts as will admit of a clean separation from the model, such parts to be afterwards joined together for casting. One way is to compress the clay well over all parts of the model in thickness sufficient to make a good firm mould, which, when it has hardened somewhat, is then divided with a suitable knife at such parts as will permit the several divisions to be easily withdrawn. Before lifting them away draw lines or gutters at all the joints so that the closing together may be facilitated. After lifting away they must be allowed to dry, but care must be taken to keep them in proper shape. If proper care and judgment is used in choosing the places for dividing the mould, much labor may be saved and better work effected.

After the divisions have been dried, it only remains to oil the surfaces well, and place them together again in proper order, with the hole upwards. The mould is then ready for the plaster, when the necessary binding together has been done. It is not necessary to make these objects solid; if weight and cost of plaster is an object, a core may be inserted, and thus reduce the thickness as desired. Statuettes, figures, busts, etc., may, in similarly prepared moulds, be cast of either bronze, zinc, or lead, with this proviso, that under no circumstances must this be attempted if the mould be not absolutely dry; otherwise the steam, rapidly generating, will cause a sudden explosion, which may endanger the lives of those near by.

TO TAKE A CAST IN METAL FROM ANY SMALL ANIMAL, INSECT, OR VEGETABLE.

After a box sufficiently capacious to hold the object has been provided, and well oiled in the inside, the animal must be suspended by a string or strings; the several parts of the animal or leaves of the vegetable must be adjusted to a natural position, and a piece of wood, of suitable dimension to form a gate or runner, must be attached to the body or main part of the object, and at all the extremities wires must be so set as that a clear passage for metal or air may be secured throughout the whole mould. After these have been all properly secured to their respective places, a sufficient quantity of plaster and brick-dust, in the proportions before explained, must be prepared and poured within in such manner as not to disturb either the object to be cast or to remove any of the connections. A short time suffices for setting of this plaster, when the running stick and wires may be withdrawn and the box taken away, after which the mould must be subjected to a moderate heat for some time, gradually increasing the

same until a red glow is obtained. This burns the object within to such a condition as to make the operation of cleaning out the ashes an easy matter. The passages provided for runner and vents serve to allow of blowing a current of air through the mould, and by this means freeing it of every vestige of the article placed therein, and leaving behind a cavity which, when filled with metal, will answer to the form of the original. Sometimes it is somewhat tedious to extract all the ashes, and much shaking and blowing with the bellows are required to effect a thorough cleansing; but if it be practicable to fill the mould with quicksilver the operation is measurably shortened, as the metal carries all the dust before it as it passes through and out at the runner and vents.

When the cast is of brass or copper, have the mould very hot, but a cooler mould will do for either lead or tin. Tap the mould gently as the metal is poured, and allow everything to become cold before extricating the casting, which latter operation requires great care when there are parts of more than ordinary fineness and delicacy. A little water will help to soften such parts of the mould as persist in adhering too strongly.

It may not always be convenient to obtain the fine-powdered brick-dust for this purpose, in which case Stourbridge clay, well washed and mixed with equal parts of the finest sand, will answer. Pounded pumice-stone and sand in equal parts, to the same proportion of plaster of Paris, make very good moulds.

TO TAKE A CAST IN PLASTER FROM A PERSON'S FACE.

When it is desired to take a cast of a person's face the person must lie down on his back, his hair being previously so arranged as to prevent any of it interfering with the operation. A paper tube is then inserted into each

nostril, so that the breathing may not be interfered with. Salad or some other pleasant oil must be applied to the face to make the separation easy. The plaster is then poured, in small quantities at a time, till the whole face has been covered to the required thickness, about one-fourth to three-eights of an inch being a sufficient quantity if the operation is smartly performed. But a short time is required for the plaster to set, and it may be removed at once and used for a mould in which to form a clay head, at the same time rectifying the closed eyes and otherwise perfecting the clay model. This model is now used to obtain another cast in plaster in as many parts as are necessary to effect a clean withdrawal, which, when oiled and placed together again, form the final mould for the plaster cast, which must inevitably be a fac-simile of the person's face.

TO TAKE CASTS FROM MEDALS.

Either plaster of Paris or melted sulphur will answer for this purpose. First oil the medal with a brush dipped in olive-oil, and after surrounding the medal with a strip of paper, cut to the depth of the required mould, brush the surface of the medal over with a little plaster made to the consistence of cream, and then fill up the rest. The idea of brushing a small quantity all over the surface before filling in the rest is to make sure that the air is all expelled from the surface, and thus prevent bubbles forming there. After it has set hard, remove, and allow it to dry; a fire will be necessary if the weather is cold or damp. If the object operated upon after this manner is more than ordinarily large, use fine plaster on the surface, and a rougher and cheaper kind to fill in with.

If hot sulphur is poured upon silver medals they will tarnish very badly.

When a mould, after being cast as above described, is to

be used for a sulphur cast, let it be prepared as follows: Mix, in a bottle, one ounce of oil of turpentine with one-half pint of boiled linseed-oil. After well shaking this mixture, subject the mould to repeated dipping until it has absorbed all the oil it can contain, when, if it is kept in a dry place for a few days, its surface will have become very hard and fit to cast sulphur thereon. Whether the cast be sulphur or plaster which is taken from this mould, a similar process to the one adopted for obtaining the mould may be followed, not neglecting to oil the mould, excepting that in the case of sulphur a ladle will be required for melting.

TO TAKE CASTS WITH ISINGLASS.

Isinglass dissolved with water at a gentle heat is all that is required for this purpose. The solution when ready must be carefully brushed with a fine brush over the surface of the medal, and then allowed to dry. As soon as it is hard it may be raised from the surface, and upon examination a most beautiful impress of the medal will be found.

Any color may be imparted to the cast by adding coloring to the solution, and if desired, the appearance of gold may be imparted by laying a little gold-leaf on the rough side.

ELASTIC MOULDS.

Moulds may be made elastic for plaster of Paris casts which have more or less undercarving of the model. Take 8 parts glue, 4 parts molasses, mixed and boiled together, and to this add 1 part of boiled linseed-oil gradually stirred in. This mixture must be cast over the model whilst hot; when cold it may be easily removed and prepared by oiling for the plaster cast, which when set can be removed without damage, as the undercut parts, being elastic, recover their original position again.

PATTERN-MODELLING IN CLAY.

THE art of carving, so far as producing patterns for the foundry is concerned, is fast dying out, and the wood-carver's place is being taken by the clay-modeller, who not only produces the same work with equal accuracy and distinctness, but, owing to the nature of the case, can produce it quicker piece for piece, as well as duplicate his work to an extent unlimited.

No matter how intricate and difficult the design may be, the carver must of necessity work out the whole quantity needed for the pattern required, making the cost of production assume very great proportions in all jobs of more than ordinary magnitude.

With the modeller it is very different: all that is required, when a considerable quantity of a similar design is to be produced, is to model one piece of convenient length, from which 'piece' any quantity may be cast with remarkable facility, and afterwards joined together.

The modeller, like the carver, is not to be classed with the regular artificer or mechanic, inasmuch as it requires in both cases more or less of inborn genius, making it therefore hardly possible for any one to attain to any distinction in that calling unless his inclinations tend in that direction naturally; this being the case, good modellers are few, and consequently the remuneration for their work is proportionately high. How important this art is becoming to the manufacturer can be readily understood when we observe that in almost every technical school throughout the country a modelling department has been added.

Plainly speaking, the work of the modeller, in this instance, is to copy the drawings made by the designer, pro-

ducing such copy in plastic clay, an impression of which is then taken in plaster, from which 'plaster cast' a fac-simile in wax is produced.

The clay used for modelling is specially prepared with the view of retaining its plasticity at least as long a time as the model requires for its manipulation; ordinarily, dry clay kneaded with glycerine is used, but for extraordinary work, that requires more than an ordinary length of time to produce, the clay is made from the following ingredients: clay, 3; sulphur, 6; oxide of zinc, 1; fatty acids, 2; fats, 10; first saponify the zinc-white with oleic acid, which then mix with the other fatty acids; add sulphur in flowers and the clay in a dry powder.

The mode of procedure, after the clay has been brought up to the right consistency, is to lay on the prepared frame or board as much of the clay as will be sufficient to work out the design.

If the work required be simply strips of moulding, etc., to be set in certain parts of the pattern already made, but lacking such moulding, then all that is needed is to nail strips of wood, as thick and as wide apart as the moulding is to be, on a suitable board; this is then filled in, and the design modelled thereon. But should the piece be of a more elaborate nature, such as a piece of statuary or other more difficult design, then a proper frame for the purpose must be made, on which the whole of the design is to be worked out.

The modeller works the clay with his fingers usually, this being considered the most artistic method, although it is necessary for him to use a few tools of bone or steel in parts where without them it would be impossible for him to produce a sharp or elegant finish.

When a correct model has been made, of such form as will admit of a direct withdrawal from the sand, it is simply oiled all over, and a plaster cast taken from it; the cast will,

of course, be a correct impression of the model. Over this impression strips of clay, rolled out to the desired thickness, are pressed carefully, so as to obtain an equal thickness all over; another plaster cast is then taken of the back or rough side. These together form, as it were, top and bottom flasks, and before separating them they are to be pared even at the edges, or, what perhaps is better, depressions may be formed in the lower joint before taking the upper impression; this of course insures a perfect fit of the two parts.

After separating the parts, the clay thickness can be taken out, gates and vents cut, mould cleaned and oiled, and again closed together securely; it is then ready to receive the molten wax.

In the case of models which will not admit of direct withdrawal, as before mentioned, the impression in plaster must be obtained by dividing the surface into sections, prepared in such manner as will permit of easy separation, or, as the moulder would say, 'drawbacks' are made; and most assuredly this part of the business does tax the skill of the modeller, as he cannot possibly accomplish his final cast in wax until he has moulded his model in plaster, or, to be more plain, he must produce cope and core in plaster by the use of the clay thickness before he can produce a fac-simile in wax of the model he fashioned.

It may be here said that the marks of the several divisions which the modeller must make serve as a guide to the moulder when he receives his pattern to work from.

It will be observed, also, that wherever such divisions must take place that will be the place to cut the wax pattern when it is found practicable to mould the same without having recourse to the sectional partings, by simply drawing out each separate part in the direction most favorable for leaving a clean impression. To run a wax cast successfully, it is important that the fluid wax enter the

mould at as many places as will assure a rapid filling of the mould as well as force out all the confined air; otherwise the work will be scarred and blurred. To obviate this it is best to force the molten wax in at the lowest point of the mould, leaving the top open for the air to escape through; but as this would be impracticable in many instances, other means must be adopted for the accomplishment of this end.

The mixture for this wax is as follows: paraffin wax, 26 pounds; beeswax, 13 pounds; resin, 12 pounds; linseed-oil, 4 pounds; the resin and oil to be well boiled together before adding the other ingredients.

Any ordinary boiler with a faucet at the bottom for withdrawing the liquid will serve the purpose of melting, and the degree of liquidity will be determined according to the nature of the piece to be cast.

After casting and trimming it is necessary to give the patterns a thick coat of bronze varnish; this, of course, destroys all tendency to sticking in the sand. It is also important that one of the plaster sides be used as a face-board on which to ram the pattern in the sand.

TO MOULD A SPIRAL POST.

Post-moulding seldom claims much attention, such work being usually considered beneath the notice of moulders who have graduated with high honors; but here is one, I think, which demands careful examination before it is passed over as a common job.

Fig. 183 represents the post, which is seen to be a spiral figure composed of two strands $\frac{3}{4}''$ diameter, interlacing each other and separated by the distance of $\frac{1}{4}''$. The total length is 2 feet, the ends being solid and $2''$ diameter.

TO MOULD A SPIRAL POST.

If the reader will observe Figs. 184 and 185, he will at once see how almost impossible it would be to make this job, by using loose cheeks, in green sand. Fig. 184 shows the form of the joints at that particular place, where the two spirals set parallel; and Fig. 185 shows the altered form of the joints when the pattern is at an angle of 45 degrees. We will assume the ever-changing form of the joint intermediate to these positions shown, and decide that, however careful we might be, the job, if made in green sand, would be at best but a very rough one.

It is my purpose here to show how best and cheapest to obtain a set of core-boxes from which good cores can be made and joined together in such form as will, by the use of a block print on the pattern, as shown at Fig. 186, make the job a very simple one.

In this instance the block prints might extend beyond the spirals at the ends, leaving only the plain ends out; but, as will be seen farther on, I have other motives for making the junction as shown, and do not desire to make other drawings.

Fig. 187 shows section of a wood box, the inside dimensions of which correspond to the size of the block print on pattern, the ends being made to receive the pattern in such position as will, when the four cores are joined, make a perfect fit at the ends.

The first process is to fill all the lower part of the box with clay, as seen at A, and proceed to form the whole joint along the pattern, as seen at B, after which oil over the surface and fill space B with plaster.

After giving due time for the plaster to set hard, the position of the box can be changed, and each side treated similarly, when you will have four plaster casts answering in form to Figs. 184 and 185.

It only remains to separate the four parts, and take a plaster cast of each, as seen at Fig. 188, and the core-boxes

are made, which with ordinary care will produce cores as true as the plaster casts from which they were made.

The pattern when made must be separated diagonally, as shown at Fig. 189.

Another mode of moulding such a job is to have the spirals separate, made of steel, and very accurately finished to a slight taper. Tight iron boxes, the outside dimensions of which must be made to correspond with the block print *A*, Fig. 186, provided with adjustable ends through which the ends of the spirals must protrude, allow for ramming the spirals within the box in green sand.

The patterns can then be twisted out endwise, and the ends of box taken off; it is then ready for the mould, which, as in the other case, is best if made diagonally, as seen at Fig. 189.

The latter method facilitates production to a considerable extent, but, owing to cost of preparation, is not to be thought of unless the order is a very large one.

THE "BERLIN" FINE CAST-IRON WORK

How these interesting works of art originated calls for more than ordinary notice. It appears that during the struggle between Prussia and France, under the first Napoleon, the ladies gave up their jewels to the government to assist in resisting Napoleon, and received in exchange similar articles made of cast iron. Some of these iron ornaments and chains are remarkable specimens of fine cast work, one chain 4 ft. 10 in. long, having 180 links, weighing no more than $1\frac{2}{3}$ ounces. Some of the separate pieces of which these articles are made up are so small, that it is said there are nearly 10,000 in a pound weight. Professor Ehrenberg, the renowned microscopist, states that

the iron of which they are composed is made from a bog-iron ore, and that the sand is a kind of tripoli, also containing iron. Both are composed of the remains of animalcules.

MALLEABLE-IRON CASTINGS.

THE PROCESSES OF THEIR MANUFACTURE EXPLAINED, INCLUDING ANNEALING, PRACTICAL AND THEORETICAL.

THE process of decarbonizing cast iron, in order to produce malleability, has been known for over 150 years. It was described in 1722 by Réaumur, a distinguished French metallurgist and philosopher, and patents for its application to the production of malleable-iron castings were granted to Samuel Lucas, of Sheffield, England, in 1804, and fifty years later to Brown and Lennox.

Lucas, in his specifications, describes it as a method of separating the impurities from crude or cast iron without fusing or melting it, and of rendering the same malleable and proper for several purposes for which forged or rolled iron is now used; and also, by the same method, of improving articles manufactured of cast iron, and thereby rendering crude or cast iron applicable to a variety of new and useful purposes.

All this, as we now well know, was accomplished by simply casting such articles in any desired shape, and afterwards making them malleable by extracting the carbon from them.

This new industry rapidly developed, as was natural, seeing that so many articles difficult of forging could be made with comparative ease this way, and thus reduce the cost of production immensely. Foundries specially de-

voted to the production of this line of work multiplied in all directions, and every effort was put forth to establish the business on a sure basis. Success attended these efforts to a marked degree, for the quality of the work done was so high as to almost defy the shrewdest to distinguish whether the products were malleable or only malleable cast iron.

The present extent of the business may in some measure be estimated from the fact that, in addition to the already large plants in this country, there is now in course of erection at West Troy, N. Y., a malleable-iron foundry to cost $100,000. The main foundry is to be 75 × 427 feet, with three eils, each 75 × 375 feet, and in close proximity to the main building is the annealing-room, a building 80 × 450 feet.

The castings produced by this method are sometimes called 'run steel,' and very large pieces, such as gear-wheels, etc., are often cast and subsequently decarbonized. Screw-propellers also are thus produced, in combination with 'case-hardening,' or conversion of the surface metal into steel by a subsequent process.

Hydraulic cylinders, which under ordinary circumstances would require to be cast six inches thick, are by this process made absolutely safe and water-tight at about half the thickness.

A great variety of articles formerly made by the blacksmith are thus produced in a more economical and correct manner than could be by forging. Bridle bits, parts of blocks, snuffers, various forms of builders' and domestic hardware, some kinds of culinary and other vessels, and numerous other things are thus produced. Many of these are subsequently case-hardened and polished.

A certain amount of polish may be imparted to malleable cast iron without case-hardening, but the lustre is by no means so brilliant. It may also be turned in the lathe

with about the same results as wrought iron, excepting that the tools suffer more under the operation.

The specific gravity of malleable cast iron is a trifle less than cast iron.

The softness and flexibility of this iron is remarkable, almost approaching wrought iron, yet it is almost impossible to weld it; but it may be joined together by fusion, or brazed to steel and wrought iron by the aid of hard solder. Another of its characteristics, peculiar to wrought iron or soft steel, is that thin pieces may be bent double when cold, but it is very seldom that the operation can be duplicated by bending it back again without fracture.

It would appear as if malleable cast iron was the intermediate state between gray iron and steel, possessing a higher tenacity, with increased toughness, than the former, but differing from the latter in having a lower ductility, less tenacity, and in containing graphitic carbon.

Malleable cast iron, if plunged red-hot into water, is hardened, but the process of tempering cannot be reliably performed, as in steel. At a moderate red heat it is possible to forge some of the best qualities, but if it is overheated it crumbles away as soon as it is struck.

Owing to the non-removal of constituents other than carbon by this process, it is essential that a fairly pure cast iron be employed if it is desired to obtain a good malleable metal. English firms prefer the various brands of hematite, whilst in America the several brands of unquestionably good charcoal-iron are selected from.

The mottled irons are invariably preferred for this purpose, for the simple reason that the soft gray iron, whilst it may be best for ordinary purposes, on account of its superior fluidity, is totally unfitted for this work, because its carbon, being wholly or almost in a graphitic state, leaves the castings porous and weak after it has been abstracted from them by the process of decarbonization to

which they are subjected. The white irons would be the best, having all their carbon in the state of chemical combination; but, on account of the latter-mentioned condition, all such irons, when melted, are very sluggish, and consequently unfit for pouring into the moulds. This accounts for preference being given to the medium or mottled irons. These irons are sometimes further strengthened by the addition of steel or wrought scrap, the proportions of which alloys can only be determined by close observation and constant practice.

From the above general observations it will be seen that all soft gray irons are totally unfit for the production of malleable cast iron, and that a decided preference is given to mottled charcoal and all such irons as have been smelted from hematite ores.

Claude Wylie, in his instructive work, "Iron and Steel Founding," says: "A short time ago we visited a foundry in England, where we were told they were making steel castings, and found the metal used to be old and burnt fire-bars, of which they had an unlimited supply. These fire-bars were melted in an ordinary quick-melting cupola, the castings were made in ordinary green sand, and after the sand was removed from them they were passed into an annealing furnace with a large proportion of hematite ore, and there brought to near melting-heat—in fact, some of the boxes we noticed had a portion of them melted off; in three days they were ready for use. The old fire-bars remelted would be most suitable metal for the purpose, containing no graphitic carbon, and little if any silicon. The castings we saw afterwards were all that could be desired as malleable cast; they bent and chipped like malleable iron, but could not be welded."

The moulding of malleable-iron castings need not differ in practice materially from that which is followed in the production of ordinary cast-iron work, and it is usual to

say that similar methods are followed. Whilst this statement may be true partially, it is very evident that their practice is on the whole much superior to anything we see ordinarily in our best iron-foundries. A most complete system of match-plates, in conjunction with the almost faultless precision of the moulding-machines lately invented, conspire to make the moulding of malleable-iron castings a more accurate and reliable system than is dreamed of by those unacquainted with their methods.

Proprietors of iron foundries all over the country are becoming keenly alive to their own shortcomings in this particular, and are even now hastening to copy the methods so successfully inaugurated by their fellow-craftsmen in the malleable shops.

On account of the lesser fluidity of the iron used for malleable-iron castings, it is usual to cut larger running-gates into the moulds, but care is taken in selecting the best place for such gates, so that there will be no fracture caused should it be forcibly torn off by the extra contraction and brittleness of the iron used—a very common occurrence.

Very much of the common class of work is cast from an ordinary cupola after the regular manner, and not a little is melted in clay crucibles with a natural draught at the small places, but the reverberatory furnace is no doubt the most suitable means of supplying the right quality of metal for malleable-iron castings. The iron, when melted in reverberatory furnaces, escapes immediate contact with the fuel, and consequently does not absorb any of its impurities; and, furthermore, any excess of carbon in the iron charged will be considerably lessened by the oxidizing action of the flame during the process of melting.

For heavy crucible-melting in England, it is common to use a Siemens regenerative furnace, any degree of heat desirable being more certainly obtained at a much less cost

for fuel than is possible by the old methods. The peculiar feature of this furnace is that the waste heat is employed to heat up both the gaseous fuel and the air requisite to burn it, before they are introduced into the chamber in which they undergo combustion.

An explanation of the theory of malleable cast iron is given by Alder Wright, in Ency. Brit, who says: "In order to carry out the conversion of cast iron into malleable cast iron in this way, the articles to be treated are packed in cast- or wrought-iron chests in oxide powder; the chests are then stacked, one above another, in a kind of reverberatory furnace, and gradually heated up to a red heat, which is maintained for the requisite time, after which they are annealed by slow cooling. With charcoal pig pretty free from silicon, sulphur, and phosphorus, and with fuel in the furnace free from any large quantity of sulphur, a soft, but tough, tenacious, and readily malleable, skin is produced; if, however, the heating is continued for some time after the whole of the carbon originally present has been removed, the articles become brittle, owing to the formation of the oxide of iron disseminated through the mass, just as copper, bronze, and analogous substances are rendered brittle through a similar cause.

"This circumstance, together with the known character of the chemical actions of carbon dioxide on iron and carbon at a red heat, indicates the nature of the processes taking place during the decarbonization. The ferric oxide, and the heated air in contact with it, first oxidize the carbon in the outermost film to carbon dioxide; this then passes inwards by the process of 'occlusion' (gradual solution of gases in solids), and reacts upon the carbon of the next layers, in accordance with the equation

$$CO_2 + C = 2CO,$$

the carbon dioxide thus formed first becoming dissolved in

the iron, and subsequently, when the iron is saturated therewith, gradually diffusing outwards, becoming converted into carbon dioxide as soon as it comes in contact with either the ferric oxide of the packing, or the partially oxidized iron of the outer film, which, when free from carbon, reacts on the carbon dioxide thus:

$$yCO_2 + xFe = Fe_xO_y + yCO.$$

"In the outermost layers, accordingly, there is always a tendency to the formation of iron oxide in virtue of this reaction, and simultaneously a tendency to the reduction of this oxide by the agency of the carbon oxide which is being formed in the interior layers and travelling outward; as long as this latter action keeps the former in check, the accumulation of iron oxide in the outer layers does not take place to such an extent as to deteriorate materially the tenacity of the malleable-iron skin, but when the carbon of the core has been so completely removed that the supply of carbon oxide from the interior almost ceases, the formation and accumulation of iron oxide in the outer layers goes on, rendering them more or less brittle. In the inner layers the removal of carbon by the penetration of the dissolved carbon dioxide, and its reaction on the carbon, is continually progressing, the decarbonization gradually creeping inwards, as it were, until finally the innermost central parts become decarbonized also. The non-removal of sulphur, silicon, and phosphorus during the process is due simply to the fact that these elements are not acted upon by the occluded carbon dioxide as the carbon is, and consequently, not being oxidized, cannot be eliminated. The iron oxide used becomes partially reduced during the operation; in order to make it fit for use over again, it is moistened with a solution of sal-ammoniac, and exposed to the air in order to rust, and so reoxidize it.

"The whole process is in effect an exact inversion of the

chemical changes taking place during the manufacture of blister steel from malleable iron by the process of cementation, and differs from the ordinary puddling method for the purification of cast iron in this salient respect, that in the latter case the formation of the oxide of iron by the effect of heated air, and its direct addition in the form of 'fettling,' give rise to the production of a fluxed mass, in which is incorporated a notably larger amount of oxide of iron, which reacts on the carbon, sulphur, silicon, and phosphorus, oxidizing them and converting them into products which are either gaseous, and escape (carbon and sulphur dioxides), or are non-metallic, and fusible, and hence separate from the iron as a fused slag or cinder."

Annealing or cementing furnaces are simply furnaces in which an article is packed in the powder of another substance, and therewith subjected to a continued heat below the fusing-point. The article is changed by a chemical reaction with the powder.

Bar-iron packed in charcoal and heated in a cementing-furnace becomes steel, the iron absorbing some of the carbon from the charcoal.

Cast iron, packed in powdered hematite or smithy scales, and similarly heated, becomes malleable, the oxygen of the hematite or scales absorbing some of the carbon in the iron.

With some few slight modifications, the cementing-furnace for producing blistered steel will answer the purpose of annealing or decarbonizing cast iron. Some of the late improvements in this country provide for the flame passing all round the chamber without coming into actual contact with the boxes containing the castings to be annealed. Access to this chamber is obtained at one end, where the boxes can be inserted or withdrawn at any time without interfering with the continuous working of the furnace. The saving in fuel, as well as to the furnace, will be greatly ap-

preciated, as it allows of almost uninterrupted working, the consequence of which is that the expenses for repairs, incident to a periodic stoppage, are avoided.

The Siemens regenerative gas-furnace is much used in England, for the annealing-furnace as well as for melting with. As arranged for this purpose, the furnace has four longitudinal main flues, divided by partitions into a number of smaller flues; the two exterior flues receive the heated gas, and the two interior ones the hot air. Over these is a closed arched muffle in which the annealing-boxes are placed. The hot gas and the hot air, being kindled, pass beneath at the sides and over the top of the arch of the muffle. The furnace is never permitted to cool entirely, the boxes being allowed to cool on the floor.

It is necessary that all castings, previous to being placed in the annealing-boxes, should be freed from every particle of sand; this is done either by abrasion in the tumbling-barrel, scrubbing with wire brushes, or pickling in dilute sulphuric acid. If the latter method is adopted, the castings should be thoroughly washed and dried before being placed in the annealing-boxes.

The annealing-boxes, sometimes called saggers, are usually made of cast iron, the same nature as the castings to be annealed therein. For ordinary purposes they are about 13 inches in depth and width and about 16 inches long, and if carefully used they will last from 15 to 20 heats. For heavier and larger pieces special boxes are made to suit the requirements, wrought iron sometimes being used for the purpose, but these latter warp and twist out of shape in a very short time.

The articles when cleaned are, in some places, imbedded within the annealing-boxes in powdered iron oxide, viz., a pure red hematite ore, as free as possible from all earthy matter; at other places smithy and rolling-mill scales or some analogous substance is used; they are then kept at a

red heat in the annealing-furnace for as long a time as required, when a diminution is produced in the amount of carbon contained, so that the cast iron becomes more or less converted into soft iron.

When the action is pushed to the extreme, all or almost all of the carbon is removed, that in the outer layers disappearing first. Should the heating not be continued long enough to remove all the carbon, that which remains is found in the innermost layers, which constitute a core of more or less decarbonized cast iron with an outer skin of malleable iron.

The powdered iron ore mentioned above is sometimes objectionable, on account of the earthy matter which is sometimes mixed with it, more or less; this latter when present in too great quantity is fused by the intense heat of the furnace, and adheres to the castings in the form of scoria; this not only interferes with the decarbonizing of the casting, but requires to be scrubbed off by a second hard application of the tumbling-barrel, or some other means equally efficacious.

On the other hand, the scales are entirely free from such impurities, and do not interfere with the legitimate operations of annealing. As before noticed, the scales lose some of their oxidizing properties at every heat, but that is effectively renewed by the application of dilute sal-ammoniac, and allowing them to rust again. By this means they can be used over and over again along with the new, which is added to make good the waste. When the ore is used it is previously ground and sifted; what passes through an $\frac{1}{8}$-inch sieve is rejected, as it contains too much earthy matter.

Packing the boxes is an important part of the annealing process. A quantity of the ore or scales is first placed on the bottom, on which, separate from each other, the first layer of castings is placed; these are then covered to a

depth of ¾ inch with the ore or scales, on which the second layer of castings is placed, separate as before, and the operation continued until the box is nearly full, when the lid is carefully set in, resting on a final layer of the ore or scales; the covers are carefully luted, to prevent the admission of air. The boxes are usually inserted into the oven in pairs.

Long practice on the part of the furnaceman qualifies him for judging how long a time each kind of casting requires for complete decarbonization; the heaviest are assigned to the hottest parts of the furnace, marked in such manner as will enable him to give to each class a period of heat proportionate to their bulk. For these reasons it is customary to place the castings in each box as near alike in bulk as possible.

The oxide which forms on the castings during the process of decarbonizing is a reliable indicator of the quality or degree of malleability obtained, the operator being able to judge of this according to the hues presented.

No matter how clean the scales may have been, all castings after being taken from the furnace require more or less cleaning to make them at all presentable.

The capacity of annealing-furnaces varies somewhat, but they usually treat from 650 to 1200 pounds at one heat. The length of time required is from two days to two weeks, according to bulk; but, as explained at another place, they must not be kept at too high a temperature, nor remain too long. or the result will be opposite to what is desired— the castings will be hard instead of soft. Usually the heat is gradually slackened for about 15 hours before taking out the boxes, and the latter are allowed to become cold before taking out the castings.

CHILLED CAR-WHEELS.

FULL INSTRUCTIONS FOR PATTERN, MOULDING-FLASKS, CORES, CHILLS, METAL MIXING, CASTING, ANNEALING, TESTING, WITH AN EXPLANATION OF THE THEORY OF CHILLING CASTINGS.

AMERICAN car-wheels are generally made of chilled cast iron. Some wheels are cast with spokes, and others, for light purposes, are made with a single plate betwixt the hub and the rim; but the 'Washburn wheel,' which has an arch at the central portion, adjacent to the hub, the apex of which is connected by a curved web to the rim, as shown at Fig. 190, is the one most generally manufactured in this country, the large number of extensive plants engaged in their production giving ample testimony to their popularity.

These wheels are subjected to very hard usage, and must naturally sustain shocks and strains of an extraordinary nature; consequently none but the very best brands of soft strong iron are used in casting them. Moreover, these irons must possess the quality of taking a 'chill' readily, the depth of which may vary from $\frac{1}{4}''$ to $1''$, according to the mixture. The proportioning of these several brands of iron to obtain the requisite strength and depth of chill is unquestionably the most important operation in their manufacture.

The part of the wheel to be chilled is, of course, the outer circumference, or 'tread,' including the flange. This surface, to the depth of half an inch or more, is by the process of 'chilling' converted into white iron of a hard, crystalline, but brittle nature; almost like steel physically and chemically, excepting that it cannot be tempered.

When the rims of these wheels are broken the fracture should show a bright steel color at the chilled part, gradually diminishing in hardness towards the body of the wheel, where it should be soft and tough. In the following brief review of their manufacture we shall confine ourselves as near as possible to the practical side of the subject. Beginning with the pattern, and following the casting through

Fig. 190.

all the various processes, including annealing, we shall discover how much work, mental and physical, there is expended in the making of a chilled car-wheel.

PATTERN.

A true and well-made pattern is a chief desideratum in the manufacture of chilled wheels, for not only is it possible that chill cracks, which are manifestly more frequent when some particular pattern is used, but also other defects which a crucial series of tests prior to a final delivery reveals, may

most assuredly have their origin in a faultily balanced and unevenly thicknessed pattern.

Knowing that a wheel pattern cannot escape more or less rough treatment in the foundry, it is only common-sense and wise on the part of the pattern-maker to make all exposed parts of his pattern out of hard wood. Some places prefer to turn up an iron pattern for this class of work.

It is a common practice to make the chamber core-boxes of iron, after the manner shown at Fig. 191, in which

Fig. 191.

boxes the cores remain until they are dry. The operation of making the core is plainly shown; the lower side A, A, with prints for vents B, being made in the core-box itself, while the upper side C is formed by the sweep D, which, as seen, is made to travel around the top, guided by the centre-pin E, and form the upper side of the core.

Ordinarily this completes the making of this core until it has been dried; but if the method suggested be adopted, it will be necessary to place a template with three evenly divided holes over the core when it has been swept off, by

the aid of which a small iron bearing can be pressed into the core level with the surface, and directly under each chaplet's place in the cope, as seen at A, Fig. 192. The object of this is that a short-shouldered stud $\frac{3}{8}''$ diameter may be used instead of the heavier one usually employed for that purpose.

Even the centre core, simple as it may seem, is worthy of more than ordinary attention in this case. Nothing should be left to chance, as we may rely upon it that a flattened core placed out of truth will naturally interfere with that equality of cooling so essential to success in this work. To avoid this it is advisable to use iron core-boxes that will give a perfectly true core every time.

MOULDING, FLASKS, CORES.

The whole operation of moulding a chilled wheel is clearly shown at Fig. 192, which is a representation of the entire mould when closed and ready for casting.

It is usual to hold all the parts together by clamps or bolts, at the lugs provided for the purpose (those for cope and chill are to be seen in the figure), having separate ones for pinning the nowel and chill together; the cope, not requiring pins, necessarily being bolted fast to the chill when it is placed thereon for ramming.

This figure shows the application of strong pins and keys A, A for all the parts, thus obviating the annoyance consequent on the use of either of the former-mentioned methods; a few keys being in every sense an effective substitute, and requiring only a blow from the hammer to either fasten or loosen them.

The plan view in this figure explains at once the class of cope in general use, and gives the position of all lugs as well as that of the swivels, or trunnions B, B, which are cast on the chill only.

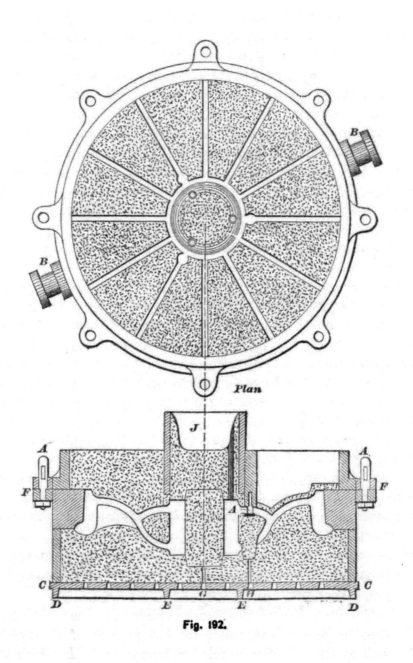

Fig. 192.

The perforated bottom plate C, C is represented as strengthened by an outer ring D, D and an inner one E, E, which are connected by cross-ribs; this plate may be pinned and keyed after the manner shown for cope and chill. The only way to make this method of pinning absolutely effective in any case is to have all lugs made extra strong and large, to make the pins as short as possible, and in this particular instance the latter should be not less than $1''$ diameter at the thread and $1\frac{1}{4}''$ above the shoulder at F, F.

However true the pattern may have been made, it will avail but very little in producing a true casting if care is not exercised in ramming up the mould. This operation must of necessity be intelligently performed, and all good wheel-moulders are cognizant of the fact that hard, even ramming is the only way to success in this work. The sand chosen for the bottom of the mould should be of a very open nature, and used not over moist. That for the cope may be selected with a view to having good adhesive qualities in combination with those mentioned above, as every effort is made to make the sand hang in the cope without the aid of lifters or nails, if possible.

The best efforts of leading proprietors have been constantly directed towards improving their methods of moulding chilled wheels, until now, by the adoption of the pneumatic system, it has been made all but perfect; the latter power is manageable to a remarkable extent, moving either fast or slow, as it may be desired. This is productive of an increased output with a diminished expenditure of labor, thus making it advantageous to employer and employé, as the latter usually works by the piece.

The operations of moulding are, first, to place the cope on its back with the chill attached, into which the pattern is then placed, and the nowel pinned on and rammed, to be afterwards vented. The bottom plate is then made

fast to the nowel, and the whole turned over by means of a double sling made to fit the swivels on the chill, and bowed sufficient to allow the entire set of flasks to turn over clear of everything.

When over, and resting *level* on the floor, the cope is rammed and vented, and the pouring-basin J formed, after which the chill is lifted off and reversed. This brings the cope along with it, exposing the impression of the top or cope side, the impression of the lower or nowel side being seen when the pattern is lifted out. There remains little to be done now except finish and blacken these two parts, and place the chamber and centre cores in their respective places; the cope can then be again reversed and closed over after the studs A have been inserted, as shown.

These studs form a handy and effective means of holding down the chamber core, and require no attention after the mould is closed. The vents from the cores are taken away at the bottom plate after the manner shown at G and H.

CHILLS.

With very few exceptions, chills are invariably made of cast iron.

How deep the chill may be formed in castings cannot safely be determined by any other means than actual previous test of the mixtures to be used.

The depth of chill in a casting is to some extent dependent on the bulk of metal contained in the chill.

The smallest possible thickness of chill necessary to produce a desirable chill on car-wheels when the mixture is in every sense favorable is about the same as the thickness of the rim to be chilled; but on account of the hard usage to which they are subjected it is usual to make them much heavier. Still, this increased thickness produces very little increase in the depth of chill obtained by the thinner ones.

The chill reduces the temperature of the metal with which it comes into immediate contact almost instantly; but if the casting is of very heavy proportions, the chill should be made thick enough to effectively absorb whatever heat must subsequently pass from the casting outwards, and thus prevent the already chilled surface from being remelted.

Metal for chills should be of the same nature as that used for the castings which are to be cast therein, viz., extra strong and fine-grained. All irons of a highly graphitic nature should be discarded on account of their openness of grain.

The chances for chill cracks will be materially lessened by having the flasks level for pouring; likewise, if the iron is allowed to cool before running it into the mould to as low a degree as will just run a smooth surface on the chill without seaming, there will be less danger of the above unpleasant experience.

It is claimed by some that a deeper chill results from having the chill made hot; whether this be so or not, it is always preferable to have them at least warm enough to prevent any moisture from settling upon them.

Chills for car-wheels should be bored out, and well polished to a very smooth surface, after which the surface is to be slightly rusted by the application of some dilute acid. This rust is to be afterwards rubbed off, and the surface touched over with a thick paste composed of black-lead and oil before casting. There must be none of the paste left on the chill; the idea is to rub the lead well into the pores of the metal, and thus prevent the molten iron from finding a lodgment there.

When not in use, place all chills in a dry place, and cover the polished surface well with grease, taking care to clean well when they are again brought into use.

THEORY OF CHILLING CASTINGS.

The chill acts upon the surface of the molten iron by rapidly absorbing the heat at the point of contact. This brings about rapid cooling, and cast iron is hardened by rapid cooling, as may be satisfactorily proved by casting four plates, equal in area, but of different thicknesses, from the same ladle of iron. The one at $1''$ thick will be gray and soft; the one at $\frac{1}{2}''$ thick will be perceptibly harder and more dense; the one at $\frac{1}{4}''$ thick will be still harder, with evidences of mottle in parts; and the one at $\frac{1}{8}''$ thick may be absolutely white, plainly showing that the change from gray to white has been effected by the difference in the rates of cooling.

How this change occurs is explained thus: It is supposed that whilst cast iron is in a molten state all its carbon is held in combination, and that when this carbon amounts to some $2\frac{1}{2}$ or upwards per cent of the iron, and especially when the fused substance is rapidly cooled, the metal solidifies in an almost homogeneous mass, possessing somewhat different properties from those of good steel; we then term it *white iron*, on account of its color and fracture. Under other conditions, especially when a longer time is allowed for solidification, a more or less complete separation of *graphite*, and consequent production of a cross-grained crystalline structure, results, the product being then termed *gray cast iron*.

The question as to whether the carbon which does not separate in the graphitoidal state on cooling is combined or not, is one about which great divergence of opinion exists. However, it is a well-established fact that by melting and very rapidly chilling certain kinds of *gray cast iron* they are more or less converted into *white* or *mottled iron*, the amount of '*combined*' *carbon* largely increasing, and

that of *graphitic* carbon correspondingly decreasing. The converse change can be brought about in some kinds of *white iron* by fusing and very slowly cooling them, a notable separation of *graphite*, and diminution in the quantity of *combined* carbon present, being thus brought about.

The above facts lead us to these conclusions, that by the sudden cooling of the molten iron, caused by its intimate contact with the chill at the rim of the wheel, the carbon at that portion is held in chemical combination with the metal, any separation of combined carbon into graphite being prevented by the rapid cooling spoken of.

On the other hand, the natural separation of graphite, superinduced by the slower process of cooling which takes place at the inner parts, goes on with an easily discernible tendency to a maximum degree of softness at the centre of the wheel, that point being the last to become cold; consequently we have a rim hard as hardened steel on the tread, the remaining parts becoming gradually softer and more tough as the centre is approached.

METAL MIXING, CASTING.

As previously affirmed, the mixing of the metal for car-wheels to be chilled is preëminently the chief feature in this remarkable industry, and can only be accomplished satisfactorily when conducted by some responsible person whose only business it is to make selections from an intelligently graded stock of irons, chiefly charcoal, which are supposed to possess qualities suitable for this class of work especially. By unremitting attention to the results of tests made daily from small cupolas provided for the purpose, he so proportions his mixtures as to bring about the required depth of chill.

Any attempt to give mixtures for such work is rendered

futile on account of the variations in the quality and nature of the iron supplied, as most all of the iron received at these works must be tested by the fracture, and graded by the mixer in a manner intelligible only to himself.

To insure a thorough mixing of the iron when melted, so that no portion of the metal used shall vary in the slightest degree from what has been previously determined by the mixer, a large tank or receiver, geared for turning, is provided, which stands immediately in front of the cupolas and receives the molten iron from each at as many spouts as there are cupolas. The capacity of these tanks varies, according to requirements, from 10 to 20 tons.

By means of this method a large supply of well-mixed metal is constantly on hand for filling the casting ladles, which are usually run under the lip of the receiver on trucks. When filled, they are quickly run towards the crane (each floor in most cases being provided with an independent crane) for casting.

Where so large an amount of iron is handled by this means, it is important that everything be hot to commence with—both ladles and receiver; therefore a plentiful supply of charcoal is always on hand for that purpose, the surface of the receiver being especially cared for in this respect.

Almost as soon as cast, preparations are made for releasing the wheels, which must whilst red-hot be dispatched to the annealing ovens, where, by a slow process of cooling, the tension of the particles of metal is equalized, and the wheel rendered more able to stand the hard wear and tear of railroad usage.

ANNEALING.

The process of annealing chilled car-wheels requires some address and experience to perform it in the best possible manner, and varies in the degree of heat applied, as well

as in the period of cooling, according to the nature of the metal operated upon.

Considerable attention has been directed to this subject, the object being to make the web soft and tough, that it might withstand the jar and strain incident to use, and at the same time have a hardened rim that will bear the wear.

In order to accomplish this, ovens or annealing pits are provided in sufficient number and capacity to take in all the wheels as they are cast. These ovens, usually set level with the floor, are so arranged that a constant emptying and refilling may be kept up without interruption, and are sometimes made of sheet-iron cylinders lined with brickwork, the whole resting over a flue or heat-chamber, which connects with a furnace, from which latter the heat passes through the chambers into the ovens at the bottom. A very small amount of fuel is sufficient for this purpose, the object being to simply prevent the castings from cooling too rapidly.

Three days is the usual time allowed for annealing.

The processes of annealing are not, however, the same at all places: some merely place the wheels in a pile in cylindrical pits provided with non-conducting jackets, which protracts the period of cooling, and contributes to the effectiveness of the operations.

Another method is to pile them in the oven symmetrically, and allow a blast of air to be carried through the centres of the hubs which form a continuous duct to the top, as seen at Fig. 193. Dampers may be placed at the inlet A, also at the chimney B, affording means for regulating the passage of air, and thereby modifying the rate of cooling. By this means the wheels are induced to commence cooling at the centres, the cooling gradually extending outwards. In this instance the heat is at no time sufficient to 'draw the chill,' and for this reason is to be preferred to some other methods which are open to objection on that account. The figure

shows only seven wheels, but it is common to pile from 10 to 15 in one pit.

In some other places layers of charcoal are placed between the wheels as they are piled in the pit, which is so arranged

Fig. 193.

that the quantity of air may be graduated to regulate the combustion.

Another method is to insert intervening rings, so placed as to separate the chilled tire from the web which is to be annealed. The interior space around the hubs is filled with

charcoal, and the outside space around the tires is filled with sand. The charcoal, being ignited by the heat of the wheels, burns slowly and anneals the web, while the sand protects the tread from the same action; thus, it is claimed, retaining the chilled surface which it has acquired in casting.

An improvement on the preceding method is claimed for a mode of introducing the air-draught, and in the mode of isolating the tires. The wheels are piled upon supporting rings at the bottom of the oven, so that a passage is formed by the holes through the hubs for cold air, and another passage around the tread of the wheels for the draught, for burning the charcoal which is distributed upon the perforated flanges of the ring interposed between each wheel. The openings in the base of the annealing oven are the means of admission of atmospheric air to aid in the combustion, and this supply is graduated to suit the requirements of the case. Another opening admits the air to pass upwards through the hubs.

It is needless to state that where chilled wheels are made in great quantities the very best appliances for handling are indispensable. For a long time steam and hydraulic power has been utilized at all such places, the latter principle serving a good purpose at the annealing-pits, where red-hot wheels must be handled quickly; but of late compressed air has come into use for power in the car-wheel foundries, with eminent success.

The use of compressed air has been adopted at numbers of places where steam was found to be objectionable on account of the noise when escaping, and the general dampness around; also at other places where it was thought desirable to avoid the annoyance from leaking and loss of time usually incident to a hydraulic system.

Whatever principle of oven is used, it is important that the wheels, as soon as set almost, be taken out of the flasks

and placed therein whilst red hot, and before any of the strains incident to unequal cooling should come upon them. This is done with a marvellous degree of alacrity at some places by aid of the splendid equipment provided: the wheels are rapidly relieved from the flasks, placed on trucks, and run to the ovens direct, where they are again as rapidly lifted and piled into the ovens, and straightway covered up. In some shops the annealing ovens are in the immediate vicinity of the moulding floor, in which case they are piled direct as they are lifted out of the sand; where this can be done it is unquestionably the better plan.

TESTING.

After the allotted time for annealing has expired, the wheels are lifted out of the ovens and transferred to the cleaning rooms, where the fins and sand are removed, after which they undergo such a testing as would naturally startle any one accustomed only to the lower grades of cast iron.

No effort is spared to discover flaws of any description; cracks soon reveal themselves under the heavy sledging they receive, and dirt-spots are soon discovered by the sharp pick which in most places is freely used over the surface. The chill also receives its share of attention, to make sure that it is deep enough or not too deep, a fault either way condemning it at once.

FIRE-CLAYS AND FIRE-BRICKS.

THE principal constituents of fire-clay are silica and alumina, accompanied by small proportions of iron, lime, magnesia, water, and organic matter, being sufficiently free from the silicates of the alkalies to resist melting at very high temperatures.

Fire-clay may be looked upon as a special term for the gray clays of the coal-measures, interstratified with and generally in close proximity to the seams of coal, in beds varying from a few inches to many yards in thickness. They are locally known as 'clunches' and 'underclays,' and are supposed to represent the soil that produced the vegetation from which the coal was formed.

It is found chiefly in the coal-measures, and varies considerably in its quality of refractoriness. The gray color of the coal-measure clays is to some extent due to the presence of carbonate of iron, which if present in too great quantity is prejudicial to the clay when required for fire-brick.

The Stourbridge fire-clay contains silica 73.82, alumina 15.88, protoxide of iron 2.94, alkalies 0.90, water 6.45, which chemical analysis shows a preponderance of silica in this as compared with the tertiary clays, which all contain a much larger proportion of alumina.

Fire-clay taken from the coal-measures has an average contraction of 2 per cent, $\frac{1}{4}$ of an inch for drying and burning being the amount which a Stourbridge brick (9 inches long) contracts when the clay is not previously mixed with some burnt material.

A close, tough nature in the clay used for making fire-brick is opposed to its usefulness, as it all the more readily yields to the melting influence of the fire; allowing that the bricks are of similar chemical properties, the coarse open ones are always the best, being more refractory.

To obtain the best service from fire-bricks under almost any condition, they should be burnt until the contraction has all taken place, and besides being of a similar texture all through, they should show a buff color. This can only be accomplished by careful firing. To discover the true quality of fire-bricks, they should be broken, and if they show a dark discoloration in the heart it is an

evidence of too quick burning, and is conclusive proof of their inferiority. There are different ways of accounting for the destruction of a fire-brick when in common use: should they be too open they will crumble and waste, and if the material has been used with a too free admixture of small stones they are apt to split; and then there is the constant action of the heat itself, which is ever melting away at the exposed parts.

The method usually adopted for the manufacture of fire-bricks is to incorporate with the clay about one third of broken fire-bricks. In this case a double purpose is served—the waste is used and the brick made less liable to contract. Sands of a silicious nature are also employed for this purpose. The bricks are either moulded with soft clay mixture direct from the pug-mill, or a drier mixture is prepared for compressing into iron moulds by the use of machinery, which gives a cleaner brick, taking less clay to make the joints when building—something to be desired.

GANISTER.

SIMPLY speaking, ganister is composed of certain proportions of ground quartz, or silicious rock, sand, and fireclay. It is extremely refractory, and on this account is largely used as a lining for Bessemer converters and other vessels in the manufacture of steel. It enters largely into the mixtures for forming the moulds intended for steel castings. The ganister preferred for linings in the neighborhood of Sheffield, England, is a peculiar silicious deposit found under a thin coal-seam in that district; it is of almost conchoidal fracture, therein differing from ordinary sandstones, and containing a few tenths per cent of lime

and about the same amount of alumina, with small quantities of iron oxide and alkalies, the rest being silica.

GRAPHITE OR PLUMBAGO.

Graphite or Plumbago, the 'black lead' of our foundries, and used almost everywhere for the purpose of protecting the surface of moulds against the great heat to which they are subjected from the molten iron, is used largely in the production of crucibles also, not in the pure state, but in admixture with fire-clay: the proportion of the former varies with the quality from 25 to nearly 50 per cent. These are the most enduring of all crucibles, the best lasting out 50 or 60 meltings in the brass foundry, about 45 with bronze, and 8 to 10 in steel melting. The best Ceylon graphite is employed, usually, in all the principal crucible works on the continent of Europe, and in the graphite-producing localities of Canada and the United States. It is used also in the manufacture of black-lead pencils. It is notable that plumbago is occasionally found in masses of meteoric iron, and that a substance of similar physical and chemical characters is produced in the blast-furnace during the preparation of cast iron, the same element being unpleasantly found in the ladles when the metal melted from irons rich in graphite becomes dull. Graphite is polymorphous, has a bright metallic lustre of a steel-gray color, and when pure is absolutely free from grit; when pulverized and rubbed between the fingers, and the polish produced in the same way is instantaneous and very bright, being like a darker shade of polished silver. It is very refractory in closed vessels, but combustible in air or oxygen at a high

heat. It is infusible. The laminated and foliated varieties are difficult to pulverize, reducing to scales instead of grains, and if it is wanted very finely divided, must be ground in water. These varieties are found in Ceylon and in some of our own States and in Canada. A good granulated graphite is found in Sonora, Mexico, and that from Japan is of the same character; but the granulated kind best known to commerce is found in Bohemia and Bavaria, which is cheap in price, but poor in quality for use in the arts. It is from the latter kind that the cheap foundry leads are manufactured, but not being very refractory, it always gives poor results. Graphite is the purest carbon next to the diamond, but requires a higher heat to burn it, and leaves a reddish ash if the specimen contains a trace of iron, as most of it does.

FUEL.

To rightly understand the nature of the different kinds of fuel at our command, it will be convenient to examine each kind separately, beginning with fluid inflammable bodies, then peat or turf, then wood-charcoal, coke, and lastly, wood or coal in its natural condition, with the ability to yield a copious and bright flame. The fluid inflammables may be taken as distinct from the solid, for this reason, that they may be burned upon a wick, and by this means be made the most controllable sources of heat; but as a rule they are seldom used for producing it, owing to the cost. Alcohol and the several oils are the kinds which form this class of fuel. Alcohol, when used as a fuel, should be strong, and free from water, to obtain the best results from it.

We may burn oils with wicks similar to alcohol, but they are not by any means as satisfactory. Of course we

may employ numerous small wicks, or use the argand burners to prevent the soot accumulations consequent on the simple wick; but at best we can scarcely avoid the charring of the wicks in any case which prevents them from absorbing the requisite quantity of oil required to maintain a steady heat.

Peat or turf cannot be used for maintaining great heats, for the simple reason that it is too spongy and light. This, of course, increases its bulk, and prevents us from supplying a sufficient quantity to make good the rapid consumption which is inevitable where violent heat must be kept up. Peat is supposed to give about one-fifth of the heat produced by an equal weight of charcoal.

Wood-charcoal will give out an extreme degree of heat. Dalton obtained a result equivalent to melting 40 pounds of ice with one pound of charcoal, but Tredgold considers 47 pounds of ice melted to be the real average effect of one pound of charcoal.

Coke has several properties common to wood-charcoal, but is a more suitable fuel for long-continued and intense heats, because, containing the combustible matter in a more condensed form, it is consumed much slower, and can be charged in less bulk. The principal reasons for its being preferred to charcoal for melting purposes are, that it affords a greater quantity of heat before it is consumed, and at less expense.

Wood and crude coal are much different in their natures to their charcoals, inasmuch as, when a plentiful supply of air is allowed them, they will afford a copious and bright flame; whilst smoke-laden and sooty vapors ensue if the air allowed is limited in quantity; the heat also is considerably diminished when the latter condition prevails. The hottest wood fires are those produced with dry wood. The kind of wood is also a cause of some difference; lime-tree wood is supposed to give out most heat in burning.

As regards the different kinds of coal, they may be classified from various points of view, such as their chemical composition, and their behavior when subjected to heat. They all contain carbon, hydrogen, oxygen, and nitrogen, forming the carbonaceous or combustible portion, and some quantity of mineral matter which remains after combustion as a residue or "ash." The nearest approach to pure carbon in coal is furnished by anthracite, which yields above 90 per cent. This class of coal burns with a very small amount of flame, producing intense local heat, and no smoke. It is especially useful in blast-furnaces and cupolas, but is not as suitable for reverberatory furnaces as some of the other kinds. The most important class of coals is that generally known as bituminous, from their property of softening, or undergoing apparent fusion when heated to a temperature far below that at which actual combustion takes place. The proportion of carbon in bituminous coals may vary from 80 to 90 per cent.

The common fuel in India and Egypt is derived from the dung of camels and oxen moulded into thin cakes and dried in the sun. It has a very low heating power, and gives off acrid ammoniacal smoke and vapor whilst burning.

Liquid fuel in the form of natural petroleum, and the creosote-oil from coal-tar distilleries, have recently been adopted for heating steam-boilers and other purposes. Though a dangerous substance, it becomes perfectly manageable when blown into a heated combustion-chamber as a fine spray by means of steam-jets, where it is immediately volatilized, and takes fire. The heating-power is very great, one ton of creosote-oil being equal to 2 or $2\frac{1}{4}$ tons of coal in raising steam.

Natural gases, consisting principally of light hydrocarbons, have now become an acknowledged agent for heat producing; puddling and welding furnaces as well as steam-boilers, etc., are entirely fired by the gas from wells bored

for oil, some of which are over 1200 feet deep. The oil is conveyed to the several works through a line of pipe extending, in some instances, many miles in length, and is delivered at a pressure of two atmospheres.

ANNEALING.

ANNEALING is the process by which metallic and other mineral productions are converted from a brittle to a comparatively tough quality, presumed to be caused by a new arrangement of their constituent particles. In a considerable number of bodies that will bear ignition it is found that sudden cooling renders them hard and brittle, while, on the contrary, if they are allowed to cool very gradually, they become softened or annealed. We have, however, noticed several alloys of copper (brass in particular), in which sudden cooling has the reverse effect—that of annealing it. The process of annealing requires ability and experience to perform it properly, and varies in the degree of heat applied, as well as in the period of cooling, according to the nature of the metal or other substance operated upon. In the annealing of steel and iron the metal is heated to a low redness, and suffered to be gradually reduced in its temperature, covered up on a hearth. Ovens are constructed for this purpose, wherein the pieces of metal, according to their massiveness and the quality it is desired they should possess, are placed and retained at a low heat for days, and sometimes weeks together. The annealing of glass is performed precisely in the same manner.

HOW TO REPAIR BROKEN AND CRACKED CASTINGS.

THE FOUNDRY METHODS OF 'BURNING' ALL CLASSES OF WORK FULLY EXPLAINED AND ILLUSTRATED.

To say that more than half the attempts to repair castings by the process of 'burning' are failures, is by no means a random statement; and there are large numbers of intelligent moulders with practical experience in this somewhat abused branch of the trade who are convinced of its truth.

How it is that failures occur so often does not always strike the average moulder, and he is forced to retire from his sometimes self-imposed task as gracefully as he knows how, and find consolation for his wounded pride behind that oft-quoted refuge of the ignorant, viz., 'It can't be done.' But this is only another proof, added to the many already adduced, that our education comes far behind in matters of this description; and we must, for some time longer at least, continue to grope in the dark.

If past experimenters in the art of burning had been more intelligent, the list of failures would most unquestionably not have been as numerous; for the simple reason that, possessing a knowledge of the nature of such undertakings, impossibilities would have been more rarely attempted. They would have at once consigned to the scrap-pile most of the defective castings, *knowing* that any attempt at *burning* must inevitably result in a waste of time and ultimate loss.

Even when the advisability of attempting a 'burn' is left to the judgment of the most scientific amongst us,

there is a lack of positiveness in his utterances and manner. He is well aware of the countless circumstances which are against success, and takes care to supplement his grave advice by quoting a few of the adverse possibilities in the case, and invariably ends by asking his more practical associate how similar cases have resulted in his past experience.

It may be well to observe here, that past experience in this business is not by any means to be always taken as reliable data. Difference in construction and proportion of parts, one casting from another, are easily overlooked in similar castings, making them, whilst similar, not alike. Quality and nature of the iron contained in the castings are sure to differ, and even should these conditions approximate somewhat, there may be structural differences, caused by the different temperature of the metal with which the castings were poured; in one instance hot and fluid, giving homogeneousness and strength, and in the other dull and sluggish, with the resulting overlapping cold-shuts, and all the other weakening influences incident to cold pouring.

Before attempting to repair any important casting by burning, consider well its general make-up, the variations of form, differences of thickness, rigidity, general or only partial; then think how this is going to be affected by the extreme heat which must be applied to the parts in the immediate vicinity of the place to be fused.

Expansion is an irresistible force, and just as soon as this extreme heat is imparted to one part of the casting the adjacent parts are acted upon at once: if there is sufficient elasticity in the general make-up of the casting to allow of this thrust taking place without fracture, there is a possibility of its resuming its original shape when contraction takes place. This is the difficulty met with when it is attempted to join together, by fusion, the cracked arms

HOW TO REPAIR BROKEN CASTINGS. 331

of wheels, bed-plates broken in mid-section, cracks or holes in cylinders, condensers, etc.

The mere fact of fusing the fractured surfaces, and thus joining the broken ends together by leaving a quantity of molten iron between, is very easy of accomplishment on fairly soft iron, but to avoid the dangers consequent on the operation of doing this is a difficulty not to be overcome so easily.

Now, if it were safe and practicable to heat up to nearly melting-point all castings to be burned, and then fuse the fractured parts instantly, the dangers from imperfect fusion or breakage would be reduced to a minimum; but all who have had any real experience in this unsatisfactory phase of the moulder's art know how almost impossible it is to meet all these conditions. Just in proportion as these conditions fail of being met will the measure of success be.

The above considerations, taken in conjunction with the fact that the parts melted must become, when cold, as much smaller as their full amount of shrinkage measures, whilst the remaining parts, no matter how much the casting may have been expanded by the regularly employed methods of heating, do not shrink as much by fully 75 per cent, will explain why it is next to impossible to successfully accomplish such jobs when the fracture is remote from the extremities of the casting.

When the fracture is at the extremities, as at the corners of plates, pieces of propeller-blades, etc., or when two whole sections are to be attached either by fusing the broken pieces together, or by casting on a new piece entirely, as in fractured shafts, rolls, etc., all difficulty ceases. These latter, having freedom endwise for expansion, leave nothing to be done except to make sure of a perfect fusing of the broken surfaces, whilst in the previously mentioned instances differences in degree of temperature, caused by unequal distribution of parts with the consequent unequal

expansion, are sometimes sufficient in themselves to produce disaster from breakage. This danger is supplemented by the before-mentioned fact that, inasmuch as there are differences in the amount of shrinkage betwixt the new parts and the old, there always remains this important factor, that if the parts immediately adjacent to the added metal are held rigid by the strength of those behind them, they cannot possibly follow up the full shrinkage of the new metal, and a forcible separation must therefore take place.

Aside from this, should the rigidity spoken of not exist, the internal strains produced may act with such force upon the unequally distributed metal as to rend the casting asunder at its weakest place.

Two good illustrations of the difficulties we have been discussing are shown at Figs. 194 and 195. The pillow-block

Fig. 194. Fig. 195.

cap, Fig. 194, being 6 inches thick, a rising head, 4 inches diameter, was placed at A, and accidentally broken off whilst hot, tearing out a portion of the casting, as shown at B. The party in charge insisted upon burning at once, and proceeded to demonstrate his ability by first heating the casting red-hot, placing a core around the damaged part, and pouring about 1500 pounds of blazing-hot iron direct upon it, working the surface with a bent rod during the operation of pouring. So far as melting the surface was concerned, he was eminently successful, the result being a hole over $3\frac{1}{2}$ inches deep and about 7 inches diameter.

After the superfluous iron had been removed, and the surface well filed, I examined the job critically, and found that the above conclusions were verified unmistakably: the newly added metal had very perceptibly shrunk away from the rigid walls of the casting, forming a core of metal more or less disconnected at the sides, as shown at C, D. It was not until oil had been allowed to run into the fissure and had been again attracted to the surface by rubbing soft chalk over it, that my friend could believe such a thing, although to a willing mind the fact was plain to the sight before recourse was had to the latter-mentioned aids.

It will be plain from the above, that it is always desirable to limit the area of new metal, and thus lessen the total shrinkage, by ceasing to pour as soon as the fusion is effected.

Fig. 195 shows end section of a 24-inch cylinder 1¼ inches thick; any attempt to mend such places by these means invariably ends as shown.

It may be asserted by some that it is a common practice to successfully (?) burn holes in round and square columns, and even to attach lugs and brackets by this means; but I am very much afraid that if the results were carefully looked for by a responsible party, most of such attempts would be found more or less faulty, and that the extent of damage done would be always in proportion to the amount of new iron introduced.

One reason why so much of this class of work passes muster is, that the paint effectually hides the fault from sight, and there being no subsequent trial by pressure from steam, air, water, etc., the extent of such damage is never ascertained, unless the casting should collapse when the load comes on.

I have in mind an eminent structural engineer and iron manufacturer, whose belief in the truth of the above is so strong that he will not allow burning to be practised on

any casting which will be called upon to sustain a constant load.

There is no doubt that risks are taken oftentimes with apparently satisfactory results, but this does not prove the case, and it is always safest to try again whenever there is a doubt in the case. In fact, taking into consideration the amount of time and labor in transporting, heating, and all the subsequent manipulations entailed by a 'big burning job,' it is in the end made almost as costly an operation as moulding over again, to say nothing of the probabilities of failure always attendant upon such efforts.

For the successful treatment of such castings as are considered safe to operate upon by the process of burning, there are some few conditions which are indispensable to the production of a correct job. If the casting to be operated upon is very hard, the chances for success are materially lessened; the brittleness of hard iron being proportionate to its hardness, this latter objection must be added to the difficulty of effecting perfect fusion. *The softer the iron the more readily will it fuse.*

The same may be said with reference to the iron used for burning with. If the iron used for burning be hard, it loses its heat rapidly, and so conduces to failure in effecting a junction by its inability to cut into the surface acted upon; whilst soft iron, with its carbon principally graphitic, is more fluid, and retains its heat for a longer time. *The hotter the iron the more speedy and effectual is the operation.*

All surfaces to be operated upon should be cleansed thoroughly from every particle of foreign matter, such as sand, grease, etc. If there is any doubt whatever, let a new surface be formed by chipping, drilling, filing, or any other way that will aid in presenting a pure, raw surface to the action of the molten iron.

Open burning along a crack is wonderfully expedited

HOW TO REPAIR BROKEN CASTINGS. 335

by having one lip at least of the pouring-ladle made after the manner shown at A, Fig. 196; very many failures are attributable to the mean appliances provided. A self-acting skimmer, the surface of the iron protected from the action of the air by two inches of charcoal, and a ladle-lip like the one shown, will give good results invariably.

As before stated, there is but one rule in regard to heating the castings to be burned; that is, to make them as hot

Fig. 196.

as practicable for working around. In order to accomplish this as near as possible, make all the necessary preparations beforehand; let the new portions of mould, cakes, cores, runners, etc., be made in loam or dry sand of hard, tough texture, and, remembering that the casting will be hot, be sure to provide for a quick and easy adjustment of all the pieces by a judicious paring of the joining parts, so that everything will fit at once, and no time be lost. The pieces thus prepared can be dried during the time the casting is being heated.

It is always advisable to adopt a method of slow cooling or annealing after the operation of burning is performed; a very good place for this purpose is the oven when it can be spared conveniently: in fact, with all castings having

complicated parts some method of annealing is indispensable. *The slower they are cooled the better.*

Sometimes a casting is broken after the manner shown at *A*, Fig. 197. When it is thought best to burn such a job on its flat, and the broken piece cannot be found, let a casting be made answering to the form required, taking care to cut away the skin at the part to be joined; these can then be laid together and fused, as will be explained farther on. Much anxiety and trouble might be saved sometimes if, when immediately the casting is poured and there is a doubt as to its soundness, the cope was lifted, and the

Fig. 197.

holes, if any are found, were burned at once whilst the casting is red-hot.

Another important feature in burning on a new piece, such as a tooth of a wheel, etc., is to so place the casting that the molten iron will be sure to pass over the whole surface, and also to make such an outlet at the *lowest* part of the fracture as will insure a steady outflow of the cooled iron after it has been forced over the surface to be fused; Fig. 198 shows a spur-gear fixed so as to answer these conditions.

If after failure to effect a junction it is thought advisable to make a second attempt, be sure to cut the burnt portion away until the good graphitic iron is found; the partially decarbonized iron previously in contact with the molten

iron would effectually preclude all possibility of a second fusion at that place.

Burning on to or attaching cast iron to steel when the surface to be acted upon is considerable, is attended with much difficulty on account of the conditions previously spoken of; but here again it is worthy of notice that the nearer the two metals can be brought together in temperature before pouring, the less danger there will be of ultimate rupture from internal strains. To this end the steel

Fig. 198.

to be cast on should be heated to as high a temperature as possible, and set into a suitably prepared dry mould, the latter to be instantly closed, and very hot iron dropped from a considerable height directly upon it.

Fig. 199 shows a temporary method of casting a flange on a pipe. This is not a burning process; as the pipe to be thus treated must first have a notch cut round its circumference, as seen, and being set on end in the floor the flange is formed by means of a pattern, using a covering flask and gating in the usual manner. The rigid pipe naturally interferes with the contraction of the new flange, so that this method is limited to pipes of small diameter. Wrought pipes can readily be provided with extemporized flanges of this kind, the thread end forming an excellent fastening.

Going back to Fig. 197, we will endeavor to show how a

casting of this kind may be repaired. The figure represents an elbow-pipe 36 inches diameter, with square base attached. Should the piece at *A, A* be broken off, it may be fused to the casting by following the directions given. Let the casting, previously made as hot as practicable, be sunk into the floor, and place the first core, *A*, Fig. 200, directly under the fracture, evenly divided as seen; the piece to be attached is then set in its place, slightly apart from the main piece, so that the molten iron can find its way uninterruptedly between; cores *B, C, D,* and *E* are then set in position as shown at Fig. 201. These cores are then to be

Fig. 199. Fig. 200.

backed firmly with sand, as shown at Fig. 200, and weighted down; the pig-bed *F* is then formed, and all is ready for the iron.

With a ladle, after the manner shown in Fig. 196, a steady stream of hot iron can be continuously directed along the line of the fissure. Core *D* being as high as the side cores *C* and *B*, prevents the iron from escaping in that direction; it must therefore all pass out over core *E*. The latter core being raised only one inch higher than the casting, permits the cooled iron to flow rapidly away into the pig-bed *F*. When these jobs are so placed that the travelling back and forth can be accomplished by means of the racking-gear on the crane, the operation is materially facilitated. An assistant with a rod of iron to feel along the bottom will soon discover when both sides of the fissure are fused; at which

HOW TO REPAIR BROKEN CASTINGS. 339

point it is advisable to cease pouring, for reasons already adduced.

Core E being one inch higher than the casting, and the latter being set level in the floor, will allow sufficient iron to remain in the channel for finishing; therefore when the pouring has ceased it is only necessary to cover the molten surface well with charcoal, and to subsequently lay a few hot scraps over all to prevent too rapid cooling at that part. It is not wise to overdo this piling on of scrap as some do:

Fig. 201.

all that is required is to bring about equal cooling of the whole piece as soon as possible.

It might be thought best to repair this or any other similar job with the web on edge, in which case all that would be required would be to set cores A and B, as seen at Fig. 202, with the additional cores C and D, as seen at Fig. 203. These cores must all stand 3 inches higher than the edge of the casting; the opening E allows the cooled iron to pass into the pig-bed until the whole surface has been fused, when a clay plug on the end of the cupola man's 'bodstick' can be inserted at E, the pouring continuing uninterruptedly in the mean time, until the metal flows out at the opening F. This opening, being as in the other cases

one inch above the surface, leaves ample metal for finishing purposes.

To burn a tooth on a wheel is not a difficult matter if proper means are taken for doing it; the difficulty consists rather in preventing the casting from breaking during the operation. If the wheel to be thus mended is a spur, it is best to set it down in the floor on solid bearings in about the position shown at Fig. 198, *A, A* being the floor-line. Joints *A* and *B* can then be formed, and flask *C* fashioned

Fig. 202. Fig. 203.

to suit. A tooth pattern being made to fit the broken surface correctly, the flask is rammed and the impression taken in dry sand facing, the pouring-gate *D* being formed at the same time. The outlet *E* is cut, as seen at the lowest point of the tooth, runs under the flask, and is connected with the pig-bed *F*, when the final preparations are made.

When joint *B* is formed, it may, if thought desirable, be secured to the wheel and there remain. The under side of the wheel adjacent to the broken tooth must be formed in dry sand after the most approved fashion; by this means the wheel can be lifted off the bearings and taken elsewhere to be heated. When the cope is dry and the wheel hot enough, the latter is again set down in its original posi-

tion, the cope placed on and secured, and the pig-bed made. Inasmuch as this style of burning is essayed in a closed mould it depends entirely on experience and judgment as to how much iron is required for complete fusion by this method. When sufficient for the purpose has been run through, stop the outlet at *G*, as previously instructed, but don't cease pouring until the metal shows at *D*.

To burn a tooth on a bevel-wheel is in all respects similar to the preceding case, except that, owing to the angle

Fig. 204. Fig. 205.

of the teeth being favorable for the purpose, the wheel may be set level on the floor, as seen at Fig. 204.

To connect the two broken ends of a cracked wheel or pulley-arm is perhaps as critical a job as could be attempted, and requires more than ordinary watchfulness in heating the casting. Fig. 205 represents the arm resting, with core *A* set directly under the crack, and cope *B* with gate *C* rammed over the top; the outlet is shown at *D*. As this operation is to be effected in a closed mould also, and fusion produced only by constant contact with the flowing metal, and not by friction of the fluid iron over the surface, as more or less occurs in the preceding cases, there must be no mistake about the iron being as hot as it is possible to make it.

This is one of the instances where there must be no more new metal added than is absolutely necessary to effect a junction, otherwise the local shrinkage of the added metal will be sufficient to separate it again, even after a good join

has been made. Fig. 206 shows position of runner, form of covering flask with running gate *A* and outlet *B*. A very excellent way to insure a good clean surface, which will yield quickly to the fusing influence of the molten iron, is to drill ¼-inch holes along the entire crack clean through; a very small amount of hot iron is then required to effect a perfect junction of the two parts. The heating of such castings as these may be done after the manner described

Fig. 206. Fig. 207.

for gear-wheels, but the greatest circumspection must be exercised, otherwise disaster will ensue, as the casting will break elsewhere.

As previously affirmed, the burning of shafts, rolls, propeller-blades, etc., is more easy of accomplishment than any of the other cases cited. All that is necessary is to have the casting hot, and all the parts to be added, as well as all cores needed, previously prepared in dry sand. We will suppose a 24-inch roll with the neck broken off close to the body: this will necessitate the burning on of a new 14-inch neck with wabbler attached. Fig. 207 shows a section of said roll endwise in the floor, with its broken end upwards

HOW TO REPAIR BROKEN CASTINGS. 343

and level with the floor-line at *A, A*. The two flasks *B* and *C* containing mould for neck and wabbler, also rising head *D*, are shown as set thereon and ready for filling with iron.

When the casting has been rammed up to the top, and the joint *A* is formed level all round, flask *B* is set central

Fig. 208.

thereon, as seen at *B*, Fig. 208, and a cast plate, with a hole equal in diameter to the neck, is carefully placed on the flask. This plate, if heavy enough, may act as weight for holding down as well as shield to protect the top joint. The connection of the outflow with the pig-bed is then made as seen at *E*, and all is ready for the iron, of which, for a job of this description, from 1500 to 2500 pounds, according to temperature, is needed. Fusion of the whole

surface is best accomplished by directing the stream at different parts alternately, and at the same time rubbing the surface over with a ¾-inch rod bent for the purpose. The person whose business it is to test the operation as it progresses will soon discover the points least affected, and direct the stream of molten iron to be changed accordingly. As soon as the whole surface has been fused the outlet is plugged, and that portion of the mould filled to within an inch or two of the top. The surface of the molten iron in the mould is then freed from all scum and dirt and the plate lifted off, after which, when the joint has been cleaned, flask C is placed in position and secured. When this has been done the remaining portion of the mould is filled through the rising-head D, nearly level with the top, and the same system of feeding is followed out as for a roll cast ordinarily.

BEAMS OF CAST IRON.

When a beam is supported in the middle and loaded at each end, it will bear the same weight as when supported at each end and loaded in the middle; that is, each end will bear half the weight.

Cast-iron beams should not be loaded to more than one fifth of their ultimate strength.

The strength of similar beams varies inversely as their lengths; that is, if a beam 10 feet long will support 1000 pounds, a similar beam 20 feet long would support only 500 pounds.

A beam supported at one end will sustain only one fourth part of the weight which it would if supported at both ends.

When a beam is fixed at both ends and loaded in the middle it will bear one half more than it will when loose at both ends.

When the beam is loaded uniformly throughout it will bear double.

When the beam is fixed at both ends and loaded uniformly throughout it will bear triple the weight.

The strongest rectangular bar or beam that can be cut out of a cylinder is one of which the squares of the breadth and depth of it, and the diameter of the cylinder, are as 1, 2, and 3, respectively.

Girders cast with a face up are stronger than when cast on a side, in the proportion of 1 to .96, and they are strongest also when cast with the bottom flange up.

A cast-iron beam will be bent to one third of its breaking-weight if the load is laid on gradually; and one sixth of it, if laid on at once, will produce the same effect if the weight of the beam is small compared with the weight laid on. Hence beams of cast iron should be made capable of bearing more than six times the greatest weight which will be laid upon them.

Cast and wrought iron beams having similar resistances have weights nearly as 2.44 to 1.

Cast-iron beams and girders should not be loaded to exceed one fifth of their breaking-weight, and when the strain is attended with concussion and vibration this proportion must be increased.

WROUGHT OR MALLEABLE IRON.

The difference between wrought or malleable iron and cast iron is that the former is almost free from carbon. All the processes adopted for converting cast into wrought iron have for their object the removing of the carbon from the cast iron.

Phosphorus, sulphur, and silicon in various quantities are almost always present in the cast iron, and it is equally important that these deleterious ingredients be taken away also.

Before wrought iron can be produced from the cast iron the latter must be subjected to the several processes of *refining, puddling, shingling* or *hammering*, and *rolling*.

The *refinery* usually consists of a flat hearth, made with sand, and surrounded with a water-jacket, through which a stream of cold water is kept constantly flowing, to prevent the jacket from melting. Tuyeres which connect with blowing-engine are set so that a stream of air may be made to play direct upon the hearth. The precise angle at which these tuyeres are set is supposed to play an important part in this operation. Sometimes the iron to be refined is run direct from the blast-furnace into the refinery; but when the crude iron is to be refined, the hearth, which is about 4 feet square and 20 inches deep, is filled with coke and ignited, and, by the aid of the blast, brought to a high temperature. The pig iron is now thrown on and additional coke piled on. When the full blast has been applied the mass soon melts and settles to the bottom, where, it may be said, the process of refining really begins. By constant stirring with a bar the attendant brings every portion of the mass under the influence of the blast, which is kept constantly

blowing over it. This causes the carbon of the pig iron to unite with air which is rushing in at the tuyeres, and pass away as carbonic-oxide gas. Whatever silicon is present unites with the oxygen and forms silica, and the oxygen uniting with the iron forms the oxide. The silica of the sand uniting with oxide of iron produces a slag of silicate of iron.

After the metal has been subjected to this refining process long enough to have parted with most of the impurities spoken of, it is run out into a cast-iron bed covered with water, where it quickly cools, as water is kept constantly flowing over it. Being only partially decarbonized by this process, it is next broken into pieces of suitable size for the puddling furnace. The loss of iron by the process of refining amounts to about 10 per cent.

Puddling means a further refining of the iron after it has left the blast-refinery, and is performed in a reverberatory furnace or 'puddling-furnace,' the sole or bed of which is about 6 by 4 feet; at one end is the fireplace, 3 feet square. The body of the furnace is divided from the fire by a brick bridge; the furthest end of the furnace is contracted to 18 inches in width, where it joins a brick chimney 40 feet high, having a damper at the top. The bed is made with a slight incline to the back, where a rapid descent is made to the bottom of the chimney, where the 'floss-hole' is made for the purpose of removing the slag or cinder which forms during the operation. To prevent the direct contact of the fuel with the iron the bridge between the fireplace and the bed is made high. The fireplace is provided with a door in front for the purpose of firing and regulating, another one being also provided on the working side. The puddling of the metal is done through a hole in the side directly against the bed of the furnace, and another hole of larger dimensions is provided for charging the metal and cleaning the bed.

White pig iron, or at least all such irons as have their carbon in a combined state, are esteemed best for puddling, because they become pasty during the operation, and are more easily worked than the gray irons, which have their carbon in the graphitic state; the latter class of irons do not become pasty previous to melting.

All districts do not adopt the 'refining' process for the production of wrought iron, and in others they do not charge the puddling furnace exclusively with refined iron; but where the grades of wrought iron are inferior, the crude iron is charged in the pig at once without previous preparation in the refinery furnace.

Puddling is accomplished by two methods: the old way, viz., 'dry puddling,' is usually adopted for the iron which has been previously refined, the decarburization in this case being produced principally by a strong current of air rushing through the furnace; the new way, viz., 'wet puddling' or 'boiling,' is a process by which the oxidizing of the carbon is effected, principally by hematite, magnetic ore, basic slags, and other materials that are easily reducible, but to some extent by the air also.

With some slight difference from local and other circumstances, the processes of puddling are in a general way conducted as follows: A charge of about 500 lbs. of iron, along with some hammer cinder and scals of iron, is placed upon the bed of the furnace, immediately after the preceding charge has been withdrawn. If the furnace is in good shape and working well, this charge will be melted in about half an hour; it is then subjected to a vigorous stirring up, with a long bar, by the puddler for a length of time until it begins to boil. The appearance of boiling is caused by the formation and escape of carbonic oxide, which, as it exudes from the mass, forms innumerable jets of blue flame all over the top of the molten mass. By degrees, as the carbon of the pig iron becomes more and

more oxidized, a separation of the malleable iron takes place, in the form of pasty balls; these being worked together into masses of about 80 pounds in weight by the operator, he at once lowers his damper and opens the door of the furnace; these balls are now immediately withdrawn and conveyed to the 'squeezer' or hammer.

Shingling is the process immediately following that of puddling or boiling, and consists in first passing the balls through a revolving-toothed machine, which receives the puddled balls, as they are drawn soft from the furnace, and compresses or squeezes them till the greater portion of the cinder is forced out; or else they are at once hammered under the helve or steam-hammer, without the preliminary process of squeezing. When the balls have undergone the shingling process they receive the name of *slabs* or *blooms*, and are now ready for passing through heavy rollers, which for this purpose are termed 'forge' or 'puddle-bar' rolls; this process reduces them to the form of flat bars. When it is required to make superior grades of iron these flat bars are subsequently cut up into short lengths, and are then placed in piles and reheated in a furnace provided for that purpose, and again cut, piled, and heated; but this time it is passed through the forge rolls, after which it is again passed through the 'mill-train,' consisting of what are usually termed the 'bolting' or 'roughing rolls,' and, finally, through the 'finishing' rolls.

When plates or sheets are to be made, the rolls are plain; but if bars are required, they are grooved to the form and dimensions of the bars required.

Inferior kinds of fuel can be utilized when the Siemens regenerative furnace is employed for puddling and heating.

STEEL.

STEEL contains carbon in proportions varying from .5 to 1.8 per cent, and it is this amount of carbon that makes the difference between it and wrought or malleable iron.

Steel resembles cast iron very much in appearance when it contains a large percentage of carbon, but we know that it does not contain as many impurities.

By the addition of carbon during the direct reduction of pure iron ore either in the furnace or crucible, steel may be made; but the lack of uniformity in the production by this means is against the general adoption of this method. Some of the finest kinds of steel are still made by the process of 'Cementation,' which indirect method is to first convert the cast into malleable iron, by extracting the carbon from the former, and again adding carbon by a process of heating in the cementing-furnace after the manner as follows: A cementing-furnace is provided with troughs, supported beneath the arch of the furnace so that the fire may have free access to their whole exterior surfaces. Inside these troughs the bar iron is imbedded in charcoal, being arranged in tiers, with interposing layers of charcoal, so that none of the bars come in contact. After the troughs have been filled as described, a last bed of charcoal is finally closed over with fire-brick covers or prepared sand, the heat is gradually increased within the furnace, by this means infusing the solid body of the iron with more or less of the carbon contained in the charcoal. The heating is kept up for a length of time, according to the quality of steel it is desired to make.

The bars during this operation undergo a very remarkable change: they lose their toughness and become brittle, their whole surface being covered with 'blisters,' supposed

to be due to the evolution of carbonic oxide arising from the combination of carbon with a trace of oxygen existing in the iron. It is as important, and perhaps more difficult, to rid the iron of its silicon, phosphorus, and sulphur, than it is to secure a certain proportion of carbon in the resultant steel.

Blistered steel, being more or less porous, requires to be made close and homogeneous before it can be used for the many purposes to which a fine class of steel is necessary. One of the methods adopted to effect this object is to convert the cemented bars into 'shear steel,' by first cutting the former into short pieces, heating in the furnace in convenient stacks, which when brought to a welding heat are drawn out and worked under the forge hammer. By this means the blister steel is converted into a more malleable and compact bar, suitable for edge-tools and kindred uses. By doubling the *single-shear steel* upon itself and reheating, and again subjecting the same to be hammered and drawn, the product is called 'double-shear steel.'

Cast steel is also made from blister steel, by melting the latter in crucibles and casting into ingots. The finest cutting instruments are made from this product, as it is generally considered to be the finest and best class of steel made, being more dense than any of the others.

Steel is largely made now by the process of puddling, direct from the pig iron, after the manner of making wrought iron. Another process is to granulate the pig iron, and add in the crucible oxides of iron, manganese, and fire-clay, which when fused together produce cast steel.

The process of making steel by the Siemens-Martin method, is to melt pig iron with a certain proportion of wrought-iron and Bessemer-steel scrap, supplementing the above by an addition of about 7 per cent of spiegeleisen. The Siemens regenerative furnace is used for melting within this instance.

Bessemer steel is made by driving a blast of air through the melted iron, and continuing the operation till by oxidation all the carbon and silicon originally in the pig iron has been burned out, at which point a given amount of molten spiegeleisen is added; the latter containing a previously ascertained percentage of carbon, permits of steel being made by this means with any desired proportion of carbon. The spiegeleisen immediately mixes with iron in the vessel, and restores its fluidity in a wonderful manner.

How steel is made by the Bessemer process may be summed up as follows: A cupola or reverberatory furnace is used for melting the pig iron, which when sufficiently liquid is run into the 'converter.' The latter vessel, made of wrought iron, is suspended on trunnions, which allow it to be turned up by means of hydraulic machinery. The lining of these converters is usually fire-brick or ganister, and their capacity may be 2 or 12 tons. The seven tuyeres at the bottom have each a number of perforations about $\frac{1}{4}$ inch in diameter. When the converter is in operation the blast is forced through these perforated tuyeres at a pressure of about 20 pounds per square inch, which is sufficient to keep the molten iron from penetrating them.

Whilst the air is being blown through the molten iron for the purpose of burning away the carbon it contains, the mouth of the converter emits showers of sparks, with a continuous dazzling flame, until the operation ends. It takes about 25 minutes to expel all the carbon. Usually this is termed the first blow. The converter is now lowered, with its mouth in position to receive the molten spiegeleisen, the quantity of which metal is in proportion to the amount of carbon required in the whole heat; another blow through for a short time, and the whole is thoroughly mixed, and the mass has become cast steel.

The ladle for pouring the ingots is attached to the end of a long arm connecting with hydraulic machinery in the

centre of the casting-pit. The latter pit is generally contrived to command two converters, and the ingot moulds are placed around it in range of the ladle as it is swung from mould to mould when casting. When the ladle has been brought into position under the converter, the latter is tilted by machinery and the ladle filled. Then the process is completed by filling the moulds through a hole in the bottom of the ladle, controlled by a lever and plug.

As soon as set, the moulds are removed, and the ingots, whilst red-hot, are at once conveyed to the steam-hammer, which by repeated heavy blows condenses the steel to the required density.

ENAMEL FOR HEAVY CASTINGS, PIPES, ETC.

CLEAN and brighten the iron before applying. The enamel consists of two coats,—the body and the glaze. The body is made by fusing 100 lbs. of ground flints and 75 lbs. of borax, and grinding 40 pounds of this *frit* with 5 lbs. of potter's clay, in water, till it is brought to the consistence of a pap. A coat of this being applied, and dried, but not hard, the glaze-powder is sifted over it. This consists of 100 lbs. of Cornish stone in fine powder, 117 lbs. of borax, 35 lbs. of soda-ash, 35 lbs. of nitre, 35 lbs. of sifted slaked lime, 13 lbs. of white sand, and 50 lbs. of pounded white glass. These are all fused together; the *frit* obtained is pulverized. Of this powder, 45 lbs. are mixed with 1 lb. of soda-ash in hot water, and the mixture when dried in a stove is the glaze-powder. After sifting this over the body coat, the cast-iron article is put into a stove, kept at a temperature of 212°, to dry it hard, after which it is set in a muffle-kiln to fuse it into a glaze.

The inside of pipes is enamelled (after being cleaned) by pouring the above 'body' composition through them while the pipe is being turned around to insure an equal coating; after the body has become set, the glaze-pap is poured in in like manner. The pipe is finally fired in the kiln.

BLACK VARNISH FOR IRONWORK.

ASPHALTUM, 1 lb.; lampblack, ¼ lb.; resin, ½ lb.; spirits of turpentine, 1 quart; linseed-oil, just sufficient to rub up the lampblack with before mixing it with the others. Apply with a camel's-hair brush.

VARNISHES FOR PIPES AND IRONWORK.

COAL-TAR, 30 gallons; tallow, 6 lbs.; resin, 1¼ lbs.; lampblack, 3 lbs.; fresh-slaked lime finely sifted, 30 lbs. Stir all thoroughly together, and apply hot.

ANOTHER.

Tar-oil, 20 lbs.; asphaltum, 5 lbs.; powdered resin, 5 lbs. Heat all together in an iron kettle, but be very careful to avoid ignition.

VARNISH FOR PATTERNS.

ALCOHOL, 1 gallon; shellac (best), 1 lb.; lamp or ivory black, sufficient to cover it.

CEMENT FOR CAST IRON.

CLEAN borings or turnings of cast iron, 16 parts; sal-ammoniac, 2 parts; flour of sulphur, 1 part. Mix them well together in a mortar, and keep them dry.

When required for use, take of the mixture, 1 part; clean borings, 20 parts. Mix thoroughly and add a sufficient quantity of water. A little grindstone dust added improves the cement.

MINERAL WOOL, ETC.

THE PHENOMENA OF ITS PRODUCTION EXPLAINED.

THE somewhat peculiar and strange phenomena sometimes noticed when the iron has been nearly all melted down in the cupola, and which consists of a fibrous substance very much resembling wool, is formed in the cupola when the blast impinges on the surface of molten slag within, the latter being, by this action, blown into filaments of a glassy fibrous nature.

The manufactured article is used as a non-conductor to prevent freezing in water-pipes, etc. The method of making it in some of the iron-smelting districts is as follows: The pig-iron furnace is provided with a tap an inch in diameter, out of which a continual stream of slag is allowed to flow, and to fall a distance of 30 inches, at which point the falling stream is met by a strong blast of cold air, the effect of which is to separate the slag into myriads of hair-like threads, as white as snow, resembling the finest wool.

TO DISTINGUISH WROUGHT AND CAST IRON FROM STEEL.

Elsner produces a bright surface by polishing or filing, and applies a drop of nitric acid, which is allowed to remain there for one or two minutes and is then washed off with water. The spot will then appear a *pale ashy gray* on wrought iron, a *brownish black* on steel, and a *deep black* on cast iron. It is the carbon present in various proportions which produces the different appearances.

TINNING.

1st. Plates or vessels of brass or copper, boiled with a solution of stannate of potassa mixed with turnings of tin, become, in the course of a few minutes, covered with a firmly attached layer of pure tin.

2d. A similar effect is produced by boiling the articles with tin filings and caustic alkali or cream of tartar. In the above way chemical vessels made of copper or brass may be easily and perfectly tinned.

NEW TINNING PROCESS.

The articles to be tinned are first covered with dilute sulphuric acid, and when quite clean are placed in warm water, then dipped in a solution of muriatic acid, copper, and zinc, and then plunged into a tin bath to which a

small quantity of zinc has been added. When the tinning is finished the articles are taken out and plunged into boiling water. The operation is completed by placing them in a very warm sand-bath. This last process softens the iron.

KUSTITIENS METAL FOR TINNING.

MALLEABLE iron, 1 lb.; heat to whiteness. Add 5 oz. regulus of antimony, and Molucca tin, 24 lbs.

CRYSTALLIZED TIN PLATE.

CRYSTALLIZED tin plate is a variegated primrose appearance, produced upon the surface of tin plate by applying to it, in a heated state, some dilute nitro-muriatic acid for a few seconds, then washing it with water, drying, and coating it with lacquer. The figures are more or less beautiful and diversified, according to the degree of heat and relative dilution of the acid.

Place the tin plate, slightly heated, over a tub of water, and rub its surface with a sponge dipped in a liquor composed of four parts of aqua fortis and two of distilled water, holding one part of common salt or sal-ammoniac in solution. Whenever the crystalline spangles seem to be thoroughly brought out, the plate must be immersed in water, washed either with a feather or a little cotton (taking care not to rub off the film of tin that forms the feathering), forthwith dried at a low heat, and coated with a lacquer varnish; otherwise it loses its lustre in the air.

If the whole surface is not plunged at once in cold

water, but if it be partially cooled by sprinkling water on it, the crystallization will be finely variegated with large and small figures. Similar results will be obtained by blowing cold air through a pipe on the tinned surface while it is just passing from the fused to the solid state.

TO TIN IRON POTS AND OTHER DOMESTIC ARTICLES.

The articles are cleaned with sand and, if necessary, with acid, and put in a bath prepared with 1 oz. cream of tartar, 1 oz. tin salt (protochloride of tin), 10 qts. of water. This bath must be kept at a temperature of 190° Fahr., in a stone-ware or wooden tank. Bits of metallic zinc are put into and between the different pieces. When the coat of tin is considered thick enough, the articles are taken out of the fluid, washed with water, and dried.

TO TIN CAST-IRON STUDS AND CHAPLETS.

Pickle the castings (or studs) in oil of vitriol, then cover or immerse them in muriate of zinc (made by putting a sufficient quantity of zinc in some spirit of salt); after which dip them in a melted bath of tin or solder.

Wrought chaplets are treated in the same way.

CASE-HARDENING CAST IRON.

1st. Cast iron may be case-hardened by heating to a red heat, and then rolling it in a composition composed of

equal parts of prussiate of potash, sal-ammoniac, and saltpetre, all pulverized and thoroughly mixed. This must be applied to every part of the surface, then plunged, while yet hot, into a bath containing 2 oz. prussiate of potash and 4 oz. sal-ammoniac to each gallon of cold water.

2d. Salt, 2 lbs.; saltpetre, ½ lb.; rock alum, ¼ lb.; ammonia, 4 oz.; salts of tartar, 4 oz. Pulverize all together and incorporate thoroughly. Use by powdering all over the iron while it is red-hot, then plunging it in cold water.

TO CHILL CAST IRON VERY HARD.

Use a liquid made as follows: Soft water, 10 gals.; salt, 1 peck; oil of vitriol, ¼ pint; saltpetre, ¼ lb.; prussiate of potash, ¼ lb.; cyanide of potash, ¼ lb. Heat the iron a cherry-red, and dip as usual; if wanted harder, repeat the process.

TO SOFTEN CAST IRON.

Steep it in 1 part of aqua fortis to 4 parts of water, and let it remain in 24 hours.

TO SCALE, CLEAN, OR PICKLE CAST IRON.

Vitriol, 1 part; water, 2 parts. Mix and lay on with a ladle, or cloth tied in the form of a brush, enough to wet the surface well; after 8 or 10 hours wash off with water.

TO REMOVE RUST FROM CAST OR WROUGHT IRON.

We have never seen any iron so badly scaled or incrusted with oxide that it could not be cleaned with a solution of 1 part sulphuric acid in 10 parts water. Paradoxical as it may seem, strong sulphuric acid will not attack iron with anything like the energy of a solution of the same. On withdrawing the articles from the acid solution they should be dipped in a bath of hot lime-water, and held there till they become so heated that they will dry immediately when taken out. Then if they are rubbed with dry bran or sawdust, there will be an almost chemically clean surface left, to which zinc will adhere readily.

TO SCOUR CAST IRON, ZINC, OR BRASS.

Cast-iron, zinc, and brass surfaces can be scoured with great economy of labor, time, and material by using either glycerine, stearine, naphthaline, or creosote, mixed with dilute sulphuric acid.

TO SOLDER GRAY CAST IRON.

First dip the castings in alcohol, after which sprinkle muriate of ammonia (sal-ammoniac) over the surface to be soldered. Then hold the casting over a charcoal fire till the sal-ammoniac begins to smoke; then dip it into melted tin (not solder). This prepares the metal for soldering, which can be done in the usual way.

TO DEPOSIT COPPER UPON CAST IRON.

The pieces of cast iron are first placed in a bath made of 50 parts hydrochloric acid, specific gravity of 1.105, and 1 part nitric acid; next in a second bath, composed of 10 parts nitric acid, 10 parts of chloride of copper dissolved in 80 parts of the same hydrochloric acid as just alluded to. The objects are rubbed with a woollen rag and soft brush, next washed with water, and again immersed until the desired thickness of copper is deposited. When it is desired to give the appearance of bronze, the copper surface is rubbed with a mixture of 4 parts sal-ammoniac and 1 part each of oxalic and acetic acids dissolved in 20 parts of water.

TO BRONZE IRON CASTINGS.

Iron castings may be bronzed by thorough cleansing and subsequent immersion in a solution of sulphate of copper, when they acquire a coat of the latter metal. They must be then washed in water.

BRASSING CAST IRON.

Iron ornaments are covered with copper or brass by properly preparing the surface of the castings so as to remove all organic matter which would prevent adhesion (described elsewhere), and then plunging them into melted brass. A thin coating is thus spread over the iron, and it admits of being polished or burnished.

GREEN BRONZE ON CASTINGS.

Coat the surface of the iron (first cleaned by acid and well etched) with ferrocyanide of copper applied with linseed-oil. Before this coating is entirely dry apply bronze powder by means of a fine brush, and then polish with a burnisher. When the surface is entirely dry, wash and etch to the color desired. The use of the alkaline sulphides for the etching produces olive-green and black colors, which closely resemble those of the Japanese bronzes.

BRONZE FOR CAST IRON WITHOUT THE USE OF METAL OR ALLOY.

The article is cleansed, coated with a uniform film of some vegetable oil, and then is exposed in a furnace to the action of a high temperature, which, however, must not be strong enough to carbonize the oil. In this way the cast iron absorbs oxygen at the moment the oil is decomposed, and there is formed at the surface a thin coat of brown oxide, which adheres very strongly to the metal, and will admit of a high polish, giving it quite the appearance of fine bronze.

TO GALVANIZE GRAY-IRON CASTINGS.

First cleanse the castings in an ordinary tumbling-barrel in the usual manner. When the sand has been all removed,

take them out and heat one by one, plunging, while hot, in a liquid composed as follows : 10 pounds hydrochloric acid, and sufficient sheet zinc to make a saturated solution. In making this solution, when the evolution of gas has ceased, add muriate or preferably sulphate of ammonia, 1 pound, and let it stand till dissolved. The castings should be so hot that when dipped in this solution and instantly removed they will immediately dry, leaving the surface crystallized, like frostwork on a window-pane. Next plunge them while hot and perfectly dry in a bath of melted zinc, previously skimming the oxide on the surface away, and throwing thereon a small amount of sal-ammoniac. If the articles are very small, enclose them in a wrought-iron basket on a pole, and lower them into the metal. When this is done, shake off the superfluous metal and cast them into a vessel of water to prevent them adhering when the zinc solidifies.

TO GALVANIZE CAST IRON THROUGH.

To 50 lbs. of melted iron add 1 lb. of pulverized pure zinc. Scatter the zinc-powder well over the ladle, then catch the melted iron (hot), stir it well up with an iron rod quickly, and pour at once.

JAPANNING CASTINGS.

CLEAN them well from the sand, then dip them in or paint them over with good boiled linseed-oil; when moderately dry, heat them in an oven to such a temperature as

will turn the oil black without burning. The stove should not be too hot at first, and the heat should be *gradually* raised to avoid blistering; the slower the change in the oil is effected the better will be the result.

The castings, if smooth at first, will receive a fine black and polished surface by this method.

TO ENAMEL CAST IRON AND HOLLOW WARE.

1st. CALCINED flints, 6 parts; Cornish stone or composition, 2 parts; litharge, 9 parts; borax, 6 parts; argillaceous earth, 1 part; nitre, 1 part; calx of tin, 6 parts; purified potash, 1 part.

2d. Calcined flints, 8 parts; red lead, 8 parts; borax, 6 parts; calx of tin, 5 parts; nitre, 1 part.

3d. Potter's composition, 12 parts; borax, 8 parts; white lead, 10 parts; nitre, 2 parts; white marble, calcined, 1 part; purified potash, 2 parts; calx of tin, 5 parts.

4th. Calcined flints, 4 parts; potter's composition, 1 part; nitre, 2 parts; borax, 8 parts; white marble, calcined, 1 part; argillaceous earth, ½ part; calx of tin, 2 parts.

Whichever of the above compositions is taken must be finely powdered, mixed, and fused. When cold the vitreous mass is to be ground, sifted, and levigated (rubbed to a fine impalpable powder) with water; it is then made into a pap with water, or gum-water.

The pap is smeared or brushed over the surface of the articles, dried, and fused with a proper heat in a muffle. Clean the articles perfectly before applying the pap.

USEFUL INTEREST RULES.

For finding the interest on any principal for any number of days. The answer in each case being in cents, separate the two right-hand figures of the answer to express it in dollars and cents.

Five per cent.—Multiply by the number of days, and divide by 72.

Six per cent.—Multiply by the number of days, separate the right-hand figure, and divide by 6.

Eight per cent.—Multiply by the number of days, and divide by 45.

Nine per cent.—Multiply by the number of days, separate the right-hand figure, and divide by 4.

Ten per cent.—Multiply by the number of days, and divide by 35.

Twelve per cent.—Multiply by the number of days, separate the right-hand figure, and divide by 3.

Fifteen per cent.—Multiply by the number of days, and divide by 24.

Eighteen per cent.—Multiply by the number of days, separate the right-hand figure, and divide by 2.

Twenty per cent.—Multiply by the number of days, and divide by 18.

INTEREST TABLE,

At Six Per Cent, in Dollars and Cents, from One Dollar to Ten Thousand.

$	1 day.	7 days.	15 days.	1 month.	3 months.	6 months.	12 mos.
	$ c	$ c	$ c	$ c	$ c	$ c	$ c
1	00	00	00¼	00½	01½	03	06
2	00	00¼	00½	01	03	06	12
3	00	00¼	00½	01½	04½	09	18
4	00	00½	01	02	06	12	24
5	00	00½	01¼	02½	07½	15	30
6	00	00¾	01½	03	09	18	36
7	00	00¾	01¾	03½	10½	21	42
8	00	01	02	04	12	24	48
9	00	01	02¼	04½	13½	27	54
10	00	01¼	02½	05	15	30	60
20	00¼	02½	05	10	30	60	1 20
30	00½	03½	07½	15	45	90	1 80
40	00¾	04½	10	20	60	1 20	2 40
50	01	06	12½	25	75	1 50	3 00
100	01½	11½	25	50	1 50	3 00	6 00
200	03	23¼	50	1 00	3 00	6 00	12 00
300	05	35	75	1 50	4 50	9 00	18 00
400	07	46½	1 00	2 00	6 00	12 00	24 00
500	08	58¼	1 25	2 50	7 50	15 00	30 00
1,000	17	1 16½	2 50	5 00	15 00	30 00	60 00
2,000	33	2 33¼	5 00	10 00	30 00	60 00	120 00
3,000	50	3 50	7 50	15 00	45 00	90 00	180 00
4,000	67	4 66½	10 00	20 00	60 00	120 00	240 00
5,000	83	5 83¼	12 50	25 00	75 00	150 00	300 00
10,000	1 67	11 66½	25 00	50 00	150 00	300 00	600 00

At Seven Per Cent, in Dollars and Cents, from One Dollar to Ten Thousand.

$	1 day.	7 days.	15 days.	1 month.	3 months.	6 months.	12 mos.
1	00	00	00¼	00½	01¾	03½	07
2	00	00¼	00½	01¼	03½	07	14
3	00	00¼	00¾	01¾	05¼	10½	21
4	00	00½	01	02½	07	14	28
5	00	00½	01½	03	08¾	17½	35
6	00	00¾	01¾	03½	10½	21	42
7	00	01	02	04	12¼	24½	49
8	00	01	02¾	04¾	14	28	56
9	00	01¼	02¾	05¼	15¾	31½	63
10	00¼	01½	03	05¾	17½	35	70
20	00¼	02½	06	11¾	35	70	1 40
30	00½	04	09	17½	52½	1 05	2 10
40	00¾	05½	12	23¼	70	1 40	2 80
50	01	06¾	15	29¼	87½	1 75	3 50
100	02	13½	29	58	1 75	3 50	7 00
200	04	27¼	58	1 16⅔	3 50	7 00	14 00
300	06	40¾	87½	1 75	5 25	10 50	21 00
400	08	54½	1 17	2 33¼	7 00	14 00	28 00
500	10	68	1 46	2 91½	8 75	17 50	35 00
1,000	19½	1 36	2 92	5 83¼	17 50	35 00	70 00
2,000	39	2 72½	5 88	11 66⅔	35 00	70 00	140 00
3,000	58	4 08¼	8 75	17 50	52 50	105 00	210 00
4,000	78	5 44¼	11 67	23 33¼	70 00	140 00	280 00
5,000	97	6 80¼	14 58	29 16⅔	87 50	175 00	350 00
10,000	1 94	13 61	29 17	58 33	175 00	350 00	700 00

WEIGHTS AND MEASURES.

MEASURES OF LENGTH.

4 In. make 1 Hand.
7.92 In. " 1 Link.
18 In. " 1 Cubit.
12 In. " 1 Foot.
6 Ft. " 1 Fathom.
3 Ft. " 1 Yard.
5½ Yds. " 1 Rod or Pole.
40 Poles " 1 Furlong.
8 Fur. " 1 Mile.
69$\frac{1}{12}$ Miles " 1 Degree.
60 Geographical Miles make 1 Degree.

SCRIPTURE LENGTHS.

The great Cubit was 21.888 in. = 1.824 ft., and the less 18 in. A Span the longer = ½ a cubit = 10.944 in. = .912 ft. A Span the less = ⅓ of a cubit = 7.296 in. = .608 ft. A Hand's Breadth = ¼ of a cubit = 3.684 in. = .304 ft. A Finger's Breadth = 1.24 of a cubit = .912 in. = .076 ft. A Fathom = 4 cubits = 7.296 ft. Ezekiel's Reed = 6 cubits = 10.944 ft. The Mile = 4000 cubits = 7296 ft. The Stadium, $\frac{1}{10}$ of their mile = 400 cubits = 729.6 ft. The Parasang, 3 of their miles = 12,000 cubits, or 4 English miles and 580 ft. 33.164 miles was a day's journey—some say 24 miles; and 3500 ft. a Sabbath day's journey—some authorities say 3648 ft.

LIQUID MEASURE.

4 Gills make 1 Pint.	2 Gals. make 1 Peck.
2 Pints " 1 Quart.	31½ Gals. " 1 Barrel.
4 Quarts " 1 Gallon.	54 Gals. " 1 Hhd.

SCRIPTURE MEASURES OF CAPACITY.

The Chomer or Homer in King James' translation was 75.625 gals. liquid, and 32.125 pecks dry. The Ephah or Bath was 7 gals. 4 pts., 15 in. sol. The Seah, $\frac{1}{3}$ of ephah, 2 gals. 4 pts., 3 in. sol. The Hin = $\frac{1}{6}$ of ephah, 1 gal., 2 pts., 1 in. sol. The Omer = $\frac{1}{10}$ of ephah, 5 pts., 0.5 in. sol. The Cab = $\frac{1}{18}$ of ephah, 3 pts. 10 in. sol. The Log = $7\frac{1}{12}$ of ephah, $\frac{1}{4}$ pt., 10 in. sol. The Metretes of Syria (John ii. 6) = Cong. Rom. $7\frac{1}{2}$ pts. The Cotyla Eastern = $\frac{1}{100}$ of ephah, $\frac{1}{4}$ pt. 3 in. sol. This cotyla contains just 10 oz. Avoirdupois of rain-water. Omer, 100; Ephah, 1000; Chomer or Homer, 10,000.

MEASURES OF SURFACE.

144 Square Inches make 1 Square Foot.
 9 Square Feet " 1 Square Yard.
$30\frac{1}{4}$ Square Yards " 1 Rod, Perch, or Pole.
 40 Square Rods " 1 Square Rood.
 4 Square Roods " 1 Square Acre, or 43,560 sq. ft.
 10 Square Chains " 1 Square Acre.
640 Square Acres " 1 Square Mile.

Gunter's Chain equal to 22 Yards or 100 Links.

GUNTER'S CHAIN, ETC.

7.92 inches constitute 1 link; 100 links one chain, 4 rods or poles, or 66 feet, and 80 chains 1 mile. A square chain is 16 square poles, and 10 square chains are 1 acre. Four roods are an acre, each containing 1210 square yards, or 34,785 yards, or 84 yards 28 inches each side.

Forty poles of 30.25 square yards each is a rood, and a pole is $5\frac{1}{4}$ yards each way.

An acre is 4840 square yards, or 69 yds. 1 ft. $8\frac{1}{2}$ in. each way; and 2 acres, or 9680 square yards, are 98 yds. 1

ft. 2 in. each way; and 3 acres are 120½ yds. each way. A square mile, or a U. S. section of land, is 640 acres; being 1060 yds. each way; half a mile, or 880 yds. each way, is 160 acres; a quarter of a mile, or 440 yds. each way, is a park or farm of 40 acres; and a furlong, or 220 yds. each way, 10 acres.

Any length or breadth in yards which, multiplied, makes 4840, is an acre; any which makes 12.10 is a rood, and 30.25 is a pole.

An English acre is a square of nearly 70 yds. each way; a Scotch, of 77¼ yds.; and an Irish, of 88½ yds.

MEASURES OF SOLIDITY.

1728 Cubic Inches make 1 Cubic Foot.
27 Cubic Feet " 1 Cubic Yard.

AVOIRDUPOIS WEIGHT.

27 11/32 Grains make 1 Drachm (dr.) or 27 11/32 Grains.
16 Drachms " 1 Ounce (oz.) or 437½ "
16 Ounces " 1 Pound (lb.) or 7000 "
28 Pounds " 1 Quarter (qr.).
4 Quarters " 1 Hundred-weight (cwt.).
20 Cwts. " 1 Ton.

TROY WEIGHT.

24 Grains make 1 Pennyweight, or 24 Grains.
20 Pennyw'ts " 1 Ounce, or 480 "
12 Ounces " 1 Pound, or 5760 "

APOTHECARIES' WEIGHT.

20 Grains make 1 Scruple.	8 Drachms make 1 Ounce.
3 Scruples " 1 Drachm.	12 Ounces " 1 Pound.

45 Drops = 1 teaspoonful, or a fluid Drachm;
2 tablespoonfuls = 1 oz.

DRY MEASURE.

8 Quarts make 1 Peck.
4 Pecks " 1 Bushel.
8 Bushels " 1 Quarter.
36 Bushels " 1 Chaldron.
1 Bushel equal to $2815\frac{1}{4}$ cu. in. nearly.

A bushel of Wheat is on an average 60 lbs.; Barley or Buckwheat, 46 lbs.; Indian Corn or Rye, 56 lbs.; Oats, 30 lbs.; Salt, 70 lbs. 14 lbs. of Lead or Iron make 1 Stone; $21\frac{1}{4}$ stone, 1 Pig. 1 Bbl. of Flour contains 196 lbs.; Beef or Pork, 200 lbs. The Imperial Gallon is 10 lbs. avoirdupois of pure water; the Pint, $1\frac{1}{4}$ lbs. 1 gal. Sperm Oil weighs $7\frac{1}{4}$ lbs.; 1 gal. of Whale Oil, 7 lbs. 11 oz.; 1 gal. of Linseed, $7\frac{3}{4}$ lbs.; 1 gal. of Olive, $7\frac{1}{2}$ lbs.; 1 gal. of Spirits of Turpentine, 7 lbs. 5 oz. Proof-spirits, 7 lbs. 15 oz.; 1 gal. of Ale, 10.5 lbs.

FRENCH MEASURES.

MEASURES OF LENGTH.

	English Inches.
Millemetre ..	.039371.
Centimetre ..	.39371.
Decimetre ..	3.9371.
Metre	39.371, or 3.281 ft., or 1.09364 yds., or nearly 1 yd., $1\frac{1}{4}$ nail, or 443.2959 French lines, or .513074 toises.
Decametre ..	393.71, or 10 yds., 2 ft., 97 inches.
Hecatometre ..	3937.1, or 100 yds., 1 ft., 1 in.
Chiliometre ..	39371, or 4 fur., 213 yds., 1 ft., 10.2 in.; so that 1 chiliometre is nearly $\frac{5}{8}$ of a mile.
Myriometre ..	393710, or 6 miles, 1 fur., 136 yds., 6 in.

An inch = .0354 metres; 2441 in. = 62 metres; 10,000 ft. = 305 metres nearly.

SUPERFICIAL OR SQUARE MEASURE.

Are—a square decametre 3.95 English perches, of 119.6046 sq. yds.
Decare 1196.0460 sq. yds.
Hecatare . . . 11960.46 sq. yds., or 2 acres, 1 rood, 35.4 perches.

MEASURES OF CAPACITY.

	Cubic Inches, English.
Millilitre06103.
Centilitre61028.
Decilitre	6.1028.
Litre, a cubic decimetre	61.028, or 2.113 wine pints.
Decalitre	610.28, or 2.64 wine gals.
Hecatolitre	6102.8, or 3.5317 cu. ft., or 26.4 wine gals.
Chiliolitre	61028, or 35.3170 cu. ft., or 1 tun, 12 wine gals.
Myriolitre	610280, or 353.1700 cu. ft.

SOLID MEASURE.

	Cubic Feet, English.
Decistre for fire-wood	3.5317.
Stere, a cubic metre	35.3170.
Decastre	353.1700.

In order to express decimal proportions in this new system, the following terms have been adopted: The term *deca* prefixed denotes 10 times; *heca*, 100 times; *chilio*, 1000 times; and *myrio*, 10,000 times. On the other hand, *deci* expresses the 10th part; *centi*, the 100th part; and *milli*, the 1000th part,—so that *decametre* signifies 10 metres, and *decimetre* the 10th part of a metre, etc., etc. The *metre* is the element of long measures; *are*, that of square measures; *stere*, that of solid measures; the *litre* is the element of all measures of capacity; and the *gramme*, which is the weight of a cubic centimetre of distilled water, is the element for all weights.

TABLE OF THE AREAS OF CIRCLES AND OF THE SIDES OF SQUARES OF THE SAME AREA.

Diam. of Circle in Inches.	Area of Circle in Sq. In.	Sides of Sq. of same Area in Sq. In.	Diam. of Circle in Inches.	Area of Circle in Sq. In.	Sides of Sq. of same Area in Sq. In.
1	.785	.89	31	754.77	27.47
1½	1.767	1.33	31½	779.31	27.92
2	3.119	1.77	32	804.25	28.36
2½	4.909	2.22	32½	829.58	28.80
3	7.069	2.66	33	855.30	29.25
3½	9.521	3.10	33½	881.41	29.69
4	12.566	3.54	34	907.92	30.13
4½	15.904	3.99	34½	934.82	30.57
5	19.635	4.43	35	962.11	31.02
5½	23.758	4.87	35½	989.80	31.46
6	28.274	5.32	36	1017.88	31.90
6½	33.183	5.76	36½	1046.35	32.35
7	38.485	6.20	37	1075.21	32.79
7½	44.179	6.65	37½	1104.47	33.23
8	50.266	7.09	38	1134.12	33.68
8½	56.745	7.53	38½	1164.16	34.12
9	63.617	7.98	39	1194.59	34.56
9½	70.882	8.42	39½	1225.42	35.01
10	78.540	8.86	40	1256.64	35.45
10½	86.590	9.30	40½	1288.25	35.89
11	95.03	9.75	41	1320.26	36.34
11½	103.87	10.19	41½	1352.66	36.78
12	113.10	10.63	42	1385.45	37.22
12½	122.72	11.08	42½	1418.63	37.66
13	132.73	11.52	43	1452.20	38.11
13½	143.14	11.96	43½	1486.17	38.55
14	153.94	12.41	44	1520.53	38.99
14½	165.13	12.85	44½	1555.29	39.44
15	176.72	13.29	45	1590.43	39.88
15½	188.69	13.74	45½	1625.97	40.32
16	201.06	14.18	46	1661.91	40.77
16½	213.83	14.62	46½	1698.23	41.21
17	226.98	15.07	47	1734.95	41.65
17½	240.53	15.51	47½	1772.06	42.10
18	254.47	15.95	48	1809.56	42.54
18½	268.80	16.40	48½	1847.46	42.98
19	283.53	16.84	49	1885.75	43.43
19½	298.65	17.28	49½	1924.43	43.87
20	314.16	17.72	50	1963.50	44.31
20½	330.06	18.17	50½	2002.97	44.75
21	346.36	18.61	51	2042.83	45.20
21½	363.05	19.05	51½	2083.08	45.64
22	380.13	19.50	52	2123.72	46.04
22½	397.61	19.94	52½	2164.76	46.52
23	415.48	20.38	53	2206.19	46.97
23½	433.74	20.83	53½	2248.01	47.41
24	452.39	21.27	54	2290.23	47.86
24½	471.44	21.71	54½	2332.83	48.30
25	490.88	22.16	55	2375.83	48.74
25½	510.71	22.60	55½	2419.23	49.19
26	530.93	23.04	56	2463.01	49.63
26½	551.55	23.49	56½	2507.19	50.07
27	572.56	23.93	57	2551.76	50.51
27½	593.96	24.37	57½	2596.73	50.96
28	615.75	24.81	58	2642.09	51.40
28½	637.94	25.26	58½	2687.84	51.84
29	660.52	25.70	59	2733.98	52.29
29½	683.49	26.14	59½	2780.51	52.73
30	706.86	26.59	60	2827.74	53.17
30½	730.62	27.03	60½	2874.76	53.69

WAGES TABLE.

SALARIES AND WAGES BY THE YEAR, MONTH, WEEK, OR DAY, SHOWING WHAT ANY SUM FROM $20 TO $1600 PER ANNUM IS PER MONTH, WEEK, OR DAY.

Per Year	Per Month.	Per Week.	Per Day.	Per Year.	Per Month.	Per Week.	Per Day.
$	$ c.	$ c.	$ c.	$	$ c.	$ c.	$ c.
20 is	1.67	.38	.05	280 is	23.33	5.37	.77
25	2.08	.48	.07	285	23.75	5.47	.78
30	2.50	.58	.08	290	24.17	5.56	.79
35	2.92	.67	.10	295	24.58	5.66	.81
40	3.33	.77	.11	300	25.00	5.75	.82
45	3.75	.86	.12	310	25.83	5.95	.85
50	4.17	.96	.14	320	26.67	6 14	.88
55	4.58	1.06	.15	325	27.08	6.23	.89
60	5.00	1.15	.16	330	27.50	6.33	.90
65	5.42	1.25	.18	340	28.33	6.52	.93
70	5.83	1.34	.19	350	29.17	6.71	.96
75	6.25	1.44	.21	360	30.00	6.90	.99
80	6.67	1.53	.22	370	30.83	7.10	1.01
85	7.08	1.63	.23	375	31.25	7.19	1.03
90	7.50	1.73	.25	380	31.67	7.29	1.04
95	7.92	1.82	.26	390	32.50	7.48	1.07
100	8.33	1.92	.27	400	33.33	7.67	1.10
105	8.75	2.01	.29	425	35.42	8.15	1.16
110	9.17	2 11	.30	450	37.50	8.63	1.23
115	9.58	2.21	.32	475	39.58	9.11	1.30
120	10.00	2 30	.33	500	41.67	9.59	1.37
125	10.42	2.40	.34	525	43.75	10.07	1.44
130	10.83	2.49	.36	550	45.83	10.55	1.51
135	11.25	2.59	.37	575	47.92	11.03	1.58
140	11.67	2.69	.38	600	50 00	11 51	1.64
145	12.08	2 78	.40	625	52.08	11 99	1 71
150	12.50	2 88	.41	650	54 17	12 47	1.78
155	12.92	2 97	.42	675	56.25	12.95	1.85
160	13.33	3.07	.44	700	58.33	13.42	1 92
165	13 75	3.16	.45	725	60.42	13.90	1.99
170	14.17	3.26	.47	750	62 50	14 38	2.05
175	14.58	3.36	.48	775	64.58	14.86	2.12
180	15.00	3.45	.49	800	66.67	15 34	2.19
185	15 42	3.55	.51	825	68.75	15.82	2.26
190	15.83	3.64	.52	850	70.83	16.30	2.33
195	16.25	3 74	.53	875	72.92	16 78	2.40
200	16.67	3.84	.55	900	75 00	17 26	2 47
205	17.08	3.93	.56	925	77.08	17.74	2 53
210	17 50	4.03	.58	950	79.17	18 22	2.60
215	17.92	4.12	.59	975	81.25	18.70	2.67
220	18 33	4.22	.60	1000	83.33	19 18	2.74
225	18.75	4.31	.62	1050	87 50	20.14	2 88
230	19.17	4.41	.63	1100	91.67	21.10	3 01
235	19.58	4.51	.64	1150	95.83	22 06	3.15
240	20.00	4.60	.66	1200	100 00	23 01	3.29
245	20.42	4.70	.67	1250	104.17	23.99	3.42
250	20.83	4 79	.69	1300	108.33	24.93	3.56
255	21.25	4.89	.70	1350	112.50	25.89	3 70
260	21.67	4 99	.71	1400	116.67	26.85	3.84
265	22.08	5.08	.73	1450	120 84	27.80	3.98
270	22.50	5.18	.74	1500	125 00	28.77	4.11
275	22.92	5.27	.75	1600	133.34	30.68	4.38

NOTE.—If the desired sum is not in the table, double some number; for instance, if the salary or wages is $2000, double the sums opposite $1000, and so on with the rest.

INDEX.

A

	PAGE
Addition and subtraction of decimals	85
Air-furnaces, how to construct	57
Alcohol and oils as fuel	325
Anchors, when and how to use	198
Ancients, founding of statues by the	261
Annealing, English methods of	304
Annealing, explanation of	317, 328
Annealing-furnaces, capacity of	306
Annealing, packing the boxes, or "saggers," for	304, 305
Anthracite coal	53, 326
Antique bronze of the Townley Venus	272
Antiquity of working in brass and iron	1, 261, 270
Apothecaries' weight	369
Appliances for foundries	126
Arbors and loose wings for long dry sand-cores	230
Area of circles and sides of squares of the same area	372
Art work of the Hebrews, Babylonians, Ninevites, and Assyrians	269
Avoirdupois weight	369

B

Basin, pouring	182, 186, 255
Beams, advisibility of making wrought-iron	165
Beams and crosses, description of	159
Beam and slings for reversing copes	161, 165

	PAGE
Beam hooks ..163, 165	
Beam or cross bar, how to set the binding	208
Beams, some information about...............................	344
Bedding in, methods of.......................................	222
Bed-forming, improved method of.............................	223
Bed fuel in cupola ...	44
Bed sweep, "rolling over" substituted by the.................	219
Bellows ...	13
Berlin fine cast-iron work...................................	295
Bessemer converter described.................................	352
Bessemer steel, the production of............................	352
Big castings in little foundries.............................	250
Blakeney cupola..	48
Blast ...	13
Blast, ancient methods of producing..........................	5
Blast-furnaces, examples of early............................	36
Blast pressure, explanation of	50
Blister-steel, the production of.............................	350
Block and plate moulding.....................................	146
Blooms and slabs...	310
Blowers and blowing engines...............................13, 51	
Blowers, some primitive......................................	127
Blowing-engines, the first steam.............................	6
Boiling the metal in the reverberatory furnace	66
Brains *versus* muscle.......................................	233
Brassing iron castings.......................................	361
Brass, Scripture evidence of working in	1
Brick cores, importance of open and well-cindered joints in...	226
Bronze age, the...261, 263	
Bronzing cast iron without metal or alloy....................	362
Bronzing iron castings361, 362	
Block and plate moulding.....................................	146
Buckle chains, instructions for making	164
Burning, arguments for and against...........................	329
Burning, a suitable ladle for................................	335
Burning, illustrations of and instructions for...............	385
Burning in closed moulds.....................................	341
Burning, setting cores for...................................	338
Burning rolls, instructions for	343
Byazntium, the art school of	266

C

	PAGE
Can hooks, how to lift flasks with	164
Can hooks, how to lift loam rings with	163
Capacity of ladles, to find the	105, 107
Carbon, graphitic and combined	315
Carving, modelling a cheap substitute for	289
Car wheels, chilled	307
Case-hardening cast iron	358
Casting, development of the art of	270
Castings, hidden faults in	172
Castings in iron, who made the first	3
Castings, theory of chilling	315
Castings, weight and measurement of	81
Cast iron, case-hardening	297
Cast iron, decarbonizing	296
Cast iron, English patent (1544) granted for making	3
Cast-iron mixtures	22, 315
Cast-iron pipes	9
Cast iron, softening and hardening elements in	27
Cast iron statuary, who first made	2
Cast iron, to chill	359
Cast iron, the ancients unacquainted with the uses of	2
Cast iron, to pickle	359
Cast iron, to soften	359
Cast iron, Turner's theory on	25
Casts in metal from an animal, insect or vegetable, to take	285
Casts in plaster, the art of taking	283
Cast steel, the production of	351
Catalan forge	13
Catalan furnace, the	86
Cementation, making steel by	350
Cement for cast iron	355
Change hook, how to make a	166
Change-wheel gear moulding-machine, description of	143
Chains, description of	16, 159
Chains, four-legged	165
Chains, how to make common	167
Chains, importance of having the best	167
Chain-slings, how to make	162, 163, 166

	PAGE
Chains, three-legged	165
Chains, important to have large intervening links in	167
Chaplet bars, improved	215
Chaplet blocks, wood and iron	211
Chaplets fast to cores, how to make	209
Chaplets, how to make and use	198
Charcoal iron, characteristics of	26
Charging the cupola	45, 54
Chemical analysis, determining mixtures by	10, 12
Chemical analysis, mixing cast-iron by	24, 26
Chemist, metallurgical	24
Chemistry in the foundry	10, 12, 24, 315
Chill cast-iron very hard, to	359
Chilled car-wheels, annealing of	317
Chilled car-wheels, annealing-pits or ovens for	318
Chilled car-wheels, core-box for	309
Chilled car-wheels, flasks for	310
Chilled car-wheels, how to make	307
Chilled car-wheels, mixing iron for	316
Chilled car-wheel, mould view of a	311
Chilled car wheels, patterns for	308
Chilled car-wheels, testing	321
Chilled castings, instructions for annealing	318
Chills for car-wheels, description of	313
Chimney, length of air-furnace	60
Chinese blowing engine	15
Cinder beds, the use of	222
Circle, to find the area of the	102
Circle to find the circumference and diameter of the	101
Cire Perdue, or lost wax process, production of bronze statuary by the	2, 267, 270, 275
Cleansing mills, exhaust	9
Clamps, moulders	139
Clay thickness for statuary moulds	281
Clean moulds ignorantly destroyed	170
Cleansing mill	137
Coal, different kinds of	326
Coke, properties and uses of	326
Cold-shuts, what produces	179
Colebrookdale Foundry, an account of	4

INDEX.

	PAGE
Collian cupola furnace	49
Colored casts in isinglass	288
Combined carbon in cast-iron	28, 315
Combustion, science of	50
Comparison of loam and green-sand	236
Conveyers for hauling material	9, 132, 234
Copper on cast-iron, to deposit	361
Core-barrel, description of	257
Core-barrels, loose gudgeon for	257
Core-boxes, cheap and simply made	221
Core-cement for bronze castings	274, 281, 286
Core-irons for cores of statue moulds	271
Cores for statues, how to make	271
Cores, how to effectually unite ponderous	221, 226
Cores, lifting out green-sand lathe-bed	288
Cores, systems of dividing	220
Cottar-pins for chill flasks	310
Covering-plate, passing studs through the	214
Covering-plate, studs cast on	214
Crane-ladles, dimensions for	76
Crane-ladles, how to line up	77
Cranes, description of various	128
Cranes, electric and pneumatic	234
Cranes, improvements in	8
Crooked castings, a prime cause for	179
Cross or four-armed beam, to make a	161
Crushing-strength of metals and other substances	120, 124
Crystallized tin-plate	357
Cupola, a common	39
Cupola charging, direct methods for	9
Cupola, depth of bottom of	44
Cupola, first charge of iron in	45
Cupola, height of	41
Cupola, location of	39
Cupola-man, importance of a good	38, 54
Cupola scaffold, improved methods of conveying material to the	9
Cupola, table of particulars for	42, 43
Cupola, tuyeres for	46
Cupola with drop bottom	37
Cupola with solid foundation	37

Cupolas, fuel for.. 52, 226
Cupolas, lining and repairing................................... 53
Cupolas, melting capacity of 41
Cupolas, some patent... 48
Cupolas, total melting capacity of 51
Cylinders cast horizontally, to obtain clean................ 186

D

Dam, how to preserve hot metal in a......................... 74
Dam, shutters for a.. 73
Dam, to construct a large....................................... 72
Dams, collecting large quantities of iron in................ 68
Dams for spray-runners.. 187
Decarbonization, time required for.......................... 306
Decimal fractions, how to perform........................... 83
Deep lifts in green-sand moulding............................ 249
Depth of bottom of cupola...................................... 44
Diagrams illustrating the flow of molten iron in moulds... 178
Dirty runners, effect of.................................... 170, 187
Division of decimals... 83
Division of labor, deterioration of skill caused by the.... 10
Double-hoop iron stud, to make a............................ 204
Double seatings, method of.................................... 199
Double shear-steel... 351
Draw-backs carried on flasks.................................. 249
Draw-backs, hinges applied to................................. 243
Draw-backs, how to construct.................................. 242
Draw-backs, how to save digging around..................... 243
Drawing air, the cause of, and how to prevent............. 183
Draw-runners, examples of...................................... 184
Drop-runners, a description of................................. 185
Dry measure... 370
Dry-sand cores, how to suspend long.................... 230, 253
Dry-sand cores, some difficult................................. 230

E

Education, importance of sound................................ 265
Egyptian bronze, mixture for................................... 282

	PAGE
Elastic moulds, preparation for	268
Electric cranes	128, 234
Electric system of melting cast iron	12
Elevators for cupola scaffolds	132
Enamel for castings	358, 364
Engine and machine foundations, to mould	237
Equal distribution of iron in the mould, how to obtain an..	180, 182
Evans's sand-riddle	136
Evolution of the iron founder's art	1, 261
Exhaust tumbling-barrel	137
Experiments in burning not always successful	329, 332
Eyes for rope tackle	169

F

	PAGE
False cores, how to manipulate	278
Fan blowers	15, 17
Feeding by pressure explained	196
Feeding castings	170, 194
Feeding castings, reasons for	194
Feeding, use of the riser in	196
Finished surfaces, how to obtain clean	237
Fire-brick, how to judge	323
Fire-clay and fire-bricks	321
Flask-drawback, how to make and use a	249
Flasks for statue moulding	278
Flowing off, head pressure	170, 182
Flow-off gate, how to form a	182
Fluxing the charges, instructions for	52
Foremen, demand for superior	10
Forge or puddle-bar rolls	349
Former, an ingenious bed	219
Foundation-plate and cope-rings	254
Foundation plate, studs built on	214
Foundations for cores	206
Foundations, importance of good	223
Founders, old-time itinerant	4
Founding, explanation of the term	1, 23
Founding not sufficiently recognized in our schools of technology	11

	PAGE
Founding, students needed in the art of	236
Foundries, comparison of large and small	251
Foundries, graduates from large	250
Foundry appliances	126
Foundry arithmetic	81
Foundry cupolas	84
Foundry equipment, improvements in	8
Foundry proprietors, ambition of	250, 300
Fountain runners	176, 181
Fracture, imperfect running one cause of	179
Fracture, unreliability of judging iron by the	25
French measures	370
French sculpture	268, 281
Friction in the mould during pouring, how to avoid	181
Fuel for cupolas	52, 326
Fuel, nature and value of different kinds of	325

G

Galvanizing gray iron castings	362, 363
Gannister, explaining the nature and uses of	328
Gate cutters, improper use of	170, 171
Gate cutting, faulty	170
Gates, how to form clean	171
Geared ladles	9, 76
Gear moulding by machinery, history of	143
Gear moulding machines	9
German sculpture	268
Girders for flasks	215
Governor-balls, science of running clean	188
Graphitic carbon in cast iron	28, 315
Graphite or plumbago, the nature and uses of	324
Grate or grid, the utility of the	247
Gray foundry irons	81, 315
Grecian bronze, mixture for	282
Greek bronze statuary, superiority of	269
Green bronze on castings	362
Green-sand and loam work compared	286
Green-sand copes, supporting cores in	211
Green-sand cores, how to make and handle very narrow	240, 244

INDEX. 383

	PAGE
Green-sand moulds, anchoring cores in	210
Green-sand moulds, the art of dividing	236
Green-sand moulds, to carry large areas of projecting sand in	245
Gunther's chain	368

H

Handling material	159
Handy contrivances for wedging studs and chaplets	215
Hay rope, machines for spinning	9, 140
Heat waste in cupolas, preventing	11
Heavy cores, supporting	258
Height of cupola	41
Herbertz's steam-jet cupola	21
High-class moulding	216
Hitching, unsafe	167
Hollow-ware moulding, the first known example of	5
Hooks, description of	159
Horn gates, use of	183
Horses for reversing copes	161
How to keep metal hot in dams	74
Hydraulic cylinder conveniences for moulding	252
Hydraulic cylinder moulding under difficulties	250
Hydraulic cylinder, pattern and core-barrel for a	251

I

Improvements in foundry appliances	134
Inability of foremen	160
Instructions for mounting "match plates"	159
Interest rules and tables	365, 366
Iron age, the	261, 263
Iron-founding, process of	1
Iron founder's art, evolution of the	1, 261
Iron, gray, mottled, and white	315
Iron oxide for annealing castings	304
Iron smelting, the art of, known to the ancients	2, 261
Iron, scripture evidences of working in	1
Iron sculpture, methods adopted by the ancients to produce	2

	PAGE
Iron, the science of filling moulds with molten	172
Isinglass, to take casts in	288
Italian sculpture	269

J

Japanese fine art work	270
Japanning castings	363
Jupiter and Hercules, ancient statues of	266

L

Labor saving devices in the foundry	8
Ladles, dimensions for all sized	78
Ladles, how to construct geared	75, 140
Lathe-beds, core lifting plate for	288
Lathe-bed moulding, examples in	287
Lathe-bed, pattern for a	288
Lifting handles, how to make	288, 241, 243, 248
Lifting tackle	160
Lining and repairing cupolas	53
Liquid measure	367
Loam and green-sand work compared	236
Loam mills	9, 138
Loam-moulding, change of method to save cost in	224
Loam-moulds, method of stiffening	255
Loam-moulds, vertically cast	223, 253
Loam-work, binding and lifting long cores in	228
Loam-work, building critical cores in	225
Loam-work, sectional arrangements in	226, 253
Long castings all from one end, dangers of running	190, 219
Lugs on loam plates	163, 254

M

Machine and engine foundations, to mould	287
Machines for moulding gear-wheels	142
Mackenzie cupola	48
Mackenzie pressure blower	19

INDEX.

	PAGE
Malleable cast-iron, the theory of	301, 305
Malleable-iron castings	296
Malleable-iron, sixteenth-century systems of producing	3
Malleable-iron castings, annealing furnaces for	303, 304
Malleable-iron castings, gates required for	300
Malleable-iron castings, making moulds for	299
Malleable-iron castings, melting iron for	300
Malleable-iron castings, processes for annealing	303
Malleable-iron castings, softness, flexibility, and specific gravity of	297
Malleable iron castings, the proper quality of pig-iron for	298
Machinery, the first castings for	7
Manganese in cast-iron, influence of	29
Main blast-pipe, diameter of	45
Match plates, how to mount, etc.	159, 300
Measure of surface	368
Medals, to take casts from	287
Melting points of alloys	121
Melting points of metals	119, 121
Melting, science of	34
Mensuration, definitions in	96
Mineral wool, explanation of	355
Mixing cast iron	22, 315
Mixing iron, the use of tanks for	317
Modeller's clay, ingredients for making	290
Modelling in clay, pattern	289
Modelling in clay, instructions for	290
Model or pattern, how in moulding statuary to save the	280
Models of statues in plaster	271
Modern improvements, foundries now supplied with	234, 250
Modern moulding-machines	147
Mortars, method of casting	195
Mould, facility in closing a large green-sand	223
Moulders, past and present	6
Moulders, want of education amongst	219
Moulding a four-chambered ventilating shaft	216
Moulding, advanced practice in high-class	216
Moulding, danger of generalizing the subject of	236
Moulding-machines	9, 126, 147, 284
Moulding-machines, their utility discussed	148, 300

	PAGE
Moulding, past and present	216
Moulding statuary in sand	277
Moulding statues from plaster models	271
Moulds, a handy device for separating	245
Moulds for plaster casts, bees-wax, dough and bread-crumbs as.	284
Moulds, lifting irregular-formed	165
Moulds, to fasten chaplets to	209
Moulds, to make elastic	288
Multiplication of decimals	86

N

Natural gas as a fuel, the great value of	327
Nelson monument, the	270

O

Open-sand casting	178
Open-sand, fly-wheels in	178
Open-sand moulds, incompetency of moulders to construct	178
Open-sand plates, difficulty of casting	174
Open-sand plates, to successfully cast	174
Open-sand work, decreased cost for	176
Outside runners and gates for loam work, how to arrange	198, 255
Overhead trolley for conveying molten iron	8
Overhead trolley system	129

P

Peat and turf as fuels	326
Percentage in the foundry	113
Phosphorus in cast iron, influence of	29
Pickling, scaling and cleaning cast-iron	359
Pig iron, bought and sold on analysis	27
Pig iron, capacity of furnaces, 1740, for producing	8
Pig iron, chemical substances found in	27, 315
Pig-iron truck and foundry scales	135
Piston blowers	15
Pit-ramming, methods for obviating	145

	PAGE
Plaster blocks..	10
Plaster cast from a person's face, to take a.......................	286
Plaster core-boxes, how to make................................	294
Plaster for moulds or casts, how to mix........................	282
Plaster models of statues for the founder.......................	271
Plaster moulds, to prevent patterns from adhering to...........	283
Plate moulding and plaster blocks.............................	146
Polygons, to find the area of...................................	99
Pneumatic cranes...	129, 234
Portable furnaces in olden times...............................	4
Pouring-basin, how to construct a.............................	182, 255
Pouring castings, the art of.....................................	170, 173, 182, 255
Pouring heavy castings...	67, 68
Pouring, to obtain the minimum of friction whilst.............	181
Precious metals, scripture evidences of working in............	1
Pressure in moulds..	218
Puddling described..	347
Pythagoras, the great sculptor.................................	265

R

Ramming chill car-wheels, the art of..........................	313
Refinery-furnace, description of a.............................	346
Refining, puddling, shingling and rolling.....................	346
Réaumur's methods of making pig iron, 1722..................	3
Regenerative furnace, Siemens................................	300, 304
Remelting cast iron, effect of.................................	28
Repairing broken castings by burning.........................	329
Reverberatory furnace, charging-doors for....................	60
Reverberatory furnace, charging the...........................	63
Reverberatory furnace, fuel for................................	62
Reverberatory furnace, sand bottom for.......................	63
Reverberatory or air furnaces.................................	55
Revolving screen for mixing sand.............................	137
Risers, when to place, etc......................................	191, 196
Riveted chaplets, inadvisability of using......................	212
Rolling-mill, invention of the..................................	7
Rolls and shafts, burning......................................	342
Roots' pressure blower..	19, 20
Roman bronze, mixture for....................................	283

	PAGE
Round columns, how to run	191
Rope can hooks	169
Rope hitches, to make	167
Ropes, description of	159, 168
Rope tackle described	168
Rotary blowers	19
Roughing and finishing rolls	349
Riddles, screen, sliding, swinging, and revolving	135
Rules for finding the weights of castings	95
Runner for open-sand plates	174
Runners, heavy work	71
Runners, reasons for the superiority of drop	185
Running pipes at the flanges	190
Rust from cast or wrought iron, to remove	360
Rusty studs, why we should avoid	200

S

Sand friction, experiments on	150
Sand for statues	279
Sand riddles, improved machine	135
Saxon and Norman periods of sculpture	266
Scales, improved cupola	134
Scales, smithy and rolling-mill	304
Schiele's compound blowing fan	17
Scotch irons, the requisite elements in	28
Scrap, how to melt fine	32
Scrap, how to melt massive pieces of	57
Scrap pile, value of the	23, 33
Screw clamp for crane-hook	168
Screw propellers	145
Screw propeller, how our forefathers moulded the	8
Screw propellers, improved methods of moulding	145
Scripture lengths	367
Scripture measures of capacity	368
Sculptor and moulder, relationship of	270, 276
Sculptor, reproducing in metal the work of the	261
Sculpture, ancient schools of	263
Sectional moulding for heavy green-sand work	288
Shackle, use of the	232

INDEX. 389

	PAGE
Shear-steel, single and double	351
Shear-steel, the production of	351
Shingling described	349
Shrinkage, the cause of inequality in	179
Shutters for dams, how to make and fit	78
Siemens regenerative furnace	349, 351
Signs in mensuration	82
Silicon in cast iron, influences of	30
Silicon, properties of	24, 25
Silicon, W. I. Keep on	31
Simpson's gear moulding-machine, description of	143
Single-spliced rope sling	169
Slag in cupolas, how to manage the	52
Slings, description of	159, 161, 165
Smeaton's blowing-engine	15
Smelting, Indian mode of	127
Smelting in olden times	36
Smelting, the ancients' skill in the art of	2, 261
Soft and hard iron for burning	334
Softening cast iron	359
Soft castings, to produce	28
Soldering gray cast iron	360
Solidity, measures of	369
Special preparations, cases requiring	161
Specific gravity of metals and other substances	120, 125
Spiral drum, how to gate a	194
Spiral post, to mould a	292
Sponginess, how shrinkage causes	195
Springers, use of	207
Spring chaplets, how to make and use	203
Square columns, how to run	190
Statuary, building copes for	275
Statuary in cast iron, how to mould	276
Statuary in sections, how to mould large	277
Statuary, method of making small	280
Statuary or modeller's wax, composition for	275
Statues, founding of	261
Statuettes, busts, etc., in plaster, to make	285
Statue of Liberty, New York Harbor	277
Steam hydraulic cranes	129

	PAGE
Steel, burning on to	337
Steel, discovery by the Romans of making	262
Steel, manufacture of	350
Stem chaplets, cast and wrought	204
Stevens Institute, a good word for the	11
Stewart rapid cupola	49
Straw ropes, machine-made	140
Stripping-plate, the	10, 147
Studs and chaplets, an object lesson in	206, 258
Stud plates, use of	222
Studs and chaplets, danger from melting of	201
Studs and chaplets, how to avoid using	198
Studs and chaplets, how to wedge down	208
Studs and chaplets, how to render harmless all	201
Studs and chaplets, supporting great weights on	213, 231, 258
Studs and chaplets, to prevent slipping in	201, 213, 223
Studs, danger of melting cast iron	202
Studs, explanation of the use of	198
Studs for chilled car-wheel cores, improved	310, 313
Studs, how to make wrought iron	202
Studs, how to make light cast iron	202
Sturtevant pressure blower	17
Substances used for forming plaster moulds	283
Sulphur casts of medals, etc	287
Sulphur in cast iron, influence of	29
Supporting studs	214, 231
Swinging long cores, method of	253, 257, 259

T

Table of instructions for working the cupola	42, 48
Table of ladles from 25 pounds to 16 tons capacity	78
Table of weights, strength, melting points, specific gravity, etc.	118
"Tabor" moulding-machine, description of the	152
Technical schools, modelling taught in	289
Technological schools, more substantial recognition of the foundry demanded in the	11
"Teetor" moulding-machine, description of the	157
Temperature, important that iron enter the mould at an even	180
Tensile strength of metals and other substances	119, 122

INDEX. 391

	PAGE
Testing bars, description of	122
Testing chilled car-wheels	321
Testing machines	122, 130
Testing the nature and quality of cast iron	10, 83
Theodorus of Samos	264
Theory of chilling castings	315
Thin covered plates, how to run	177
Tinning	356
Tinning iron pots, etc.	358
Tinning metal, Kustitiens	357
Tinning studs and chaplets	358
Torsional strength of substances	120, 124
Toughness of metals	120, 124
Tracks and foundry trucks	131
Tracks, uses of well-laid	8
Transverse strength of metals and other substances	120, 122, 123
Tripod, illustrations and explanation of the	255, 258
Tromp blower, description of the	37
Troy weight	369
Tumbling-barrel, exhaust	137
Turnbuckles	165, 166
Tuyeres for cupolas	37, 46

U

Underground blast-pipes	89

V

Varnishes for iron-work	354
Varnish for patterns	354
Vent-pipe, anchoring cores by means of the	211
Vents, how best to insure perfect	229

W

Wages table	378
Washburn wheel	307
Wax, forming gates and vents in	274, 291

	PAGE
Wax, how to pour plaster moulds with modellers	291
Wax patterns, varnish for	292
Wax thickness for statuary moulds	271, 280
Wax used by modellers, ingredients of, and how to make	292
Weights and measures	867
Weight of a cubic foot of metal	119, 121
Weight of a cubic inch of metal	119, 121
Weight of balls, to find the	111
Weight of circular plates and circular solids, to find the	105
Weight of cylinders, pipes, wheel-rims, columns, etc., to find the	103
Weight of flat bottomed tanks, pans, etc., to find the	108
Weight of pans with spherical or round bottoms, etc., to find the	110
Wheel-arm, burning a broken	841
Wheels, centre core-runners for	192
Wheel-tooth, how to burn on a	836
Wind-box, or chamber	89
Wood-charcoal, value as a fuel of	826
Worm-pinions on end, moulding	145
Wrought and cast iron from steel, to distinguish	853
Wrought iron, processes for manufacturing	846

Y

"Yielding platen" moulding-machine, description of the	155

Z

Zinc, cast iron, or brass, to scour	860